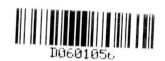

SHADOW AND SUBSTANCE

Andrew Lanyon (Cornwall, England), "Watch the Birdie," 1987.
Oil on card. H. K. and B. A. Henisch Collection.

SHADOW AND SUBSTANCE

Essays on the History of Photography

In Honor of Heinz K. Henisch

Edited by Kathleen Collins

The Amorphous Institute Press 1990

SHADOW AND SUBSTANCE

Essays on the History of Photography

Edited by Kathleen Collins

Published by The Amorphous Institute Press
1050 East Square Lake Road
Bloomfield Hills, Michigan, U.S.A. 48013
(313) 280-1900

First Edition

Library of Congress Catalog Card Number 90-81581

ISBN 0-910331-01-4 pbk. (alk. paper)

The paper used in this publication meets the
requirement for permanence established by the
American National Standards for Information
Sciences, "Permanence of Paper for Printed Library
Materials" (ANSI Z39.48-1984).

Cover design: Claudia Mauner

Text design, layout, and typesetting:
Jay and Janis Ruby

Printed by Thomson-Shore, Dexter, Michigan, U.S.A.

To Heinz K. Henisch

With deep appreciation
for his contributions
to the history of photography

In Memory of

William Culp Darrah (1909-1989)

Petr Tausk (d. 1987)

and

Arthur Gill (1915-1987)

CONTENTS

Beware lest you lose the substance by grasping at the shadow.

Aesop

Secure the Shadow Before the Substance Fails.

Nineteenth-century
studio photographers'
advertising slogan.

Of those for whom you fond emotions cherish,
Secure the shadow e'er the substance perish.

Mr. J. Newman's
American Daguerreotype Portrait Rooms
Cape Town, South Africa

I'll sell the shadow to support the substance.

Sojourner Truth

My dearest Miss Mitford, do you know anything about that wonderful invention of the day, called the Daguerreotype?— that is, have you seen any portraits produced by means of it? Think of a man sitting down in the sun and leaving his facsimile in all its full completion of outline and shadow, steadfast on a plate, at the end of a minute and half! The Mesmeric disembodiment of spirits strikes one as a degree less marvellous. And several of these wonderful portraits...like engravings — only exquisite and delicate beyond the work of the engraver — have I seen lately — longing to have such a memorial of every Being dear to me in the world. It is not merely the likeness which is precious in such cases — but the association, and the sense of nearness involved in the thing...the fact of the *very shadow of the person* lying there fixed for ever! It is the very sanctification of portraits I think — and it is not at all monstrous in me to say what my brothers cry out against so vehemently...that I would rather have such a memorial of one I dearly loved, than the noblest Artist's work ever produced.

Elizabeth Barrett Browning

The most transitory of things, a shadow, the proverbial emblem of all that is fleeting and momentary, may be fettered by the spells of our "natural magic," and may be fixed for ever in the position which it seemed only destined for a single instant to occupy.

William Henry Fox Talbot

PREFACE

The principal purpose of this book remains at the time of publication what it was at the time of its conception: to honor Heinz K. Henisch for the role he has played in the development of photo-historical studies as an academic discipline. The original occasion was his 65th birthday, an event joyfully celebrated in 1987, under the generous sponsorship of Stanford and Iris Ovshinsky and The Institute for Amorphous Studies, and happily remembered to this day. For many practical reasons, this *Festschrift* could not be among the tokens of friendship offered on that very day, but it was hoped to provide it soon thereafter.

Meanwhile, it was found that the mills of book production (like all those other mills!) grind very slowly and, as 1988 came and went, the notion was conceived to link the book also to the 150th anniversary of the announcement of Daguerre's invention of photography, as part of the world-wide celebrations of 1989. That opportunity, alas, was also missed, but the editor feels that decimal divisibility should not be regarded as the beginning and end of all good things.

Triumphantly, with great pleasure, and in a spirit of cordial affection, the contributors dedicate this *Festschrift* now to Heinz Henisch, on the occasion of his 68th birthday, and link it also to the 151st anniversary of the invention of photography. That alone should be sufficient to secure a unique place for it in the photo-historical literature.

ACKNOWLEDGEMENTS

We wish to thank all of the institutions and individuals who have allowed us to reproduce images and items from their collections. We are grateful to *History of Photography* (Taylor & Francis, London), *Scienza e Cultura* (University of Venice), *Image* (George Eastman House), and *Archivaria* (Association of Canadian Archivists) for allowing us to republish material from their research journals.

Bridget Henisch was a valuable and trustworthy collaborator at every stage of this project. She proved her loyalty to a higher cause by not divulging prematurely news about this book, information to which her husband might have felt entitled by virtue of thirty years of marriage.

Fifty-four contributors from fifteen countries are represented in this volume: Germany, Austria, Switzerland, Poland, the U.S.S.R., Belgium, Norway, Italy, England, Scotland,New Zealand, India, Israel, Canada, and the United States. We are indebted to them for their knowledge of a wide range of subjects within this relatively new field of research, for their willingness to contribute original essays and arrange for illustrations, and for their unflagging patience.

A talented New York City graphic artist, Claudia Mauner, produced the delightful artwork and design for the cover. She brought considerable insight to the task of accommodating Heinz Henisch's surrealist prejudices.

We wish to acknowledge the substantial contribution of time, materials, and expertise by Jay and Janis Ruby, who oversaw the design, layout, and typesetting of the manuscript. Credit for the book's style and elegance goes entirely to them. Indeed, without their assistance there would be no book at all.

We thank Dr. Brian Schwartz, Gazaleh Koefod, and Bonnie Farmer, who all contributed time, energy, and imaginative solutions at some stage of this project.

Drs. Stanford and Iris Ovshinsky sponsored a symposium at the Institute for Amorphous Studies in honor of Dr. Heinz Henisch in May 1987, which was attended by scholars from around the world. On that occasion, papers were read by physicists *and* photohistorians, not such strange bedfellows after all, considering photography's interdisciplinary beginnings. This volume of essays resulted from that symposium. We are grateful to the Ovshinskys for their recognition of Dr. Henisch's accomplishments in *both* fields. Heinz K. Henisch is, after all (in his spare time) a Fellow of the American Physical Society and of the Institute of Physics in London, Editor of the *Materials Research Bulletin*, a Professor of Physics at Penn State, and the author of about a dozen books and around 150 research articles in that field. We congratulate Plenum Press on the publication in 1988 of a Festschrift that honors Dr. Henisch's accomplishments in Physics: *Disorder and Order in the Solid State: Concepts and Devices*, edited by Dr. Roger W. Pryor, Dr. Brian B. Schwartz, and Dr. Stanford R. Ovshinsky. We are assured by them that their book title carries no double meaning.

Michael Collins provided us with a fine and inspiring example of perseverance in the face of obstacles.

When we were younger and more malleable, Dr. Heinz K. Henisch was our dissertation director in the history of photography at Penn State. We may be forgiven, perhaps, for using this occasion to thank him for introducing us to the subject. We hope that he will not rescind our degree for those errors of spelling, punctuation, grammar, style, logic, or fact that may be found in these pages. Such errors are entirely the fault of the contributors.

Kathleen Collins

The Phenomenon of Henisch:
An Introduction to Das Übermenschlichkeit

Estelle Jussim

He is, after all, the only person I know who has more than one doctorate, and what is worse, the two doctorates are in arcane scientific subjects like semiconductors and crystal growth in gels. I hope he's happy, because I can't for the life of me figure out how such a genial chap, full of love for chipmunks and other small fauna (including his phenomenal wife, Bridget, who is not large but manages quite nicely, thank you) could possibly investigate such hypnotically stupefying nonsense. We all know — that is, those of us who are in the know, or know him, or something like that — Heinz Henisch, affectionately known as Hersheleh, or Dahhrling, must be at the very least a hopelessly schizophrenic individual. Not only does he dally with physics, but he positively *loiters* around photographs, spending much of his spare time fondling their history, their idiosyncracies, their exceptional ability to convey information about material culture, the family (not necessarily the nuclear family or the extended family, but something we might call the stiffly-posed-in-the-studio family), and all sorts of other jolly things, including art and horses.

Now, take his journal, *History of Photography*. Why, it was simply outrageous when it first appeared, and hasn't calmed down since. You must realize that it was quite a shock to those of us weaned on the traditional fifty-pound histories of French, German, and English photography to suddenly discover that there had been cameras, not to mention

photographers, in Bulgaria, Latvia, Turkey, Beluchistan, Pakistan, and New Jersey! Students fainted, curators blanched, critics immediately repaired to their favorite bars, historians giggled, doctoral candidates defenestrated themselves, and I, for one, shouted "Bravo! Bravo!" For I discovered that *History of Photography* was, in fact and in deed, an international journal, culling choice scholarship from places like India and Japan and all the European countries. Moreover, *History of Photography* not only helped to establish the history of photography as a legitimate university discipline, in America's terribly conservative Art History departments, but incredibly, Henisch has kept the journal alive for more than *thirteen years*. (The tenth anniversary celebration by the publishers in London was punctuated by news that the Queen herself had decided to subscribe to the journal. Now, *that's* class!) If you know anything about scholarly journals, you will know that if they survive more than two issues, everyone jumps up and down with joy and consumes quantities of cheap champagne.

I was delighted to discover that this phenomenal editor was a Professor of the History of Photography in the Department of Art History at Pennsylvania State University, an institution world-renowned for being located in the exact geographical center of the state, making it impossible to visit Henisch without an eight-hour drive from practically anywhere. My first trip was well worth the trouble, however, as his

charming wife demonstrated how to make Photographer's Cheesecake, a concoction mostly of eggs left over from coating albumen paper back in the nineteenth century. (I believe she used fresh eggs, but that may be merely hearsay.) Heinz, for his part, introduced me to his many photographic treasures, an adventure not soon to be forgotten, as I was almost pitched headfirst down the narrow and dark stairs leading to his lair. But his enthusiasm, his irrepressible good humor, his extensive knowledge of the most bizarre aspects of photography, his clutch on my arm, all gave me an inkling of what his students must endure. You must realize that he is famous for asking his history of photography classes this significant question on all his exams: "What is the title of the textbook for this course?" Believe me, the responses would astonish you.

Heinz Henisch has distinguished himself by becoming a Fellow of the Royal Photographic Society and an honorary member of the Deutsche Gesellschaft für Photographie (which resides in the unlikely spot of Cologne, West Germany). He has lectured everywhere, and his audiences clap loudly when he demonstrates how to give a slide lecture when you have a carousel projector without a projection lamp. Not many people can get away with this. He is planning to write a handbook for lecturers who must visit Venezuela, Bolivia, Israel, or New Jersey, and this promises to be a best seller. The handbook will include such chapters as "Early nineteenth-century lecterns and their habits," "Shake hands with your remote controls," and "What? No extension cords?"

Henisch must bear the onus of having been the professor responsible for the establishment of photohistorical studies at Penn State, for this is one of the few programs in this discipline that leads to the Ph.D. in the History of Photography. Under his smiling tutelage, several exceptionally distinguished and weighty (nine-pound) dissertations have been delivered. A stickler for perfection in the use of the hypothetical-evidentiary mode of research, Henisch is remarkable for being able to keep his dual areas of expertise from confounding each other. It is true that his knowledge of physics and chemistry has given him a substantial edge on other contenders in the field of the history of photography, for he would as soon explain to you why a cyanotype is blue as why a chipmunk has bulging cheeks. Things like that, important things, are every ready on his lips. One can, if one is swift enough and diplomatic enough, excuse oneself at such junctures and go and talk to his wife, who will understand your escape and feed you good things. She is his helpmate in more than just the

usual ways. She, too, suffers from the same savage addiction to photographs, and has written charming notes for *History of Photography* (her not-so-secret passion is for Crimean War photographer James Robertson). To see the two of them huddled ecstatically over a photographic find is to realize that photographs are, indeed, and in fact, good enough to spend considerable amounts of money on, even when you might rather go to a good movie.

In conclusion, it is obvious that Heinz and Bridget Henisch make a remarkable team, she with her delightful contributions to medieval and other British history (she is, one must admit, British), he with his two caps on, one for sleeping and the other to keep out the cold. It is one of the great pleasures of my life that I know them, and it is one of the great honors of my career to have been invited to write an introduction to this Festschrift in honor of Heinz's glorious sixty-eighth birthday. We say, "Three cheers!" to this multi-dimensional phenomenon of science and art, of good humor and gracious editorship, *Dr. Dr. Heinz Henisch*. Long may he wave!

Heinz K. Henisch and the History of Photography at The Pennsylvania State University

Hellmut Hager

The establishment of the history of photography as a specialization offered in the Department of Art History at the Pennsylvania State University would never have come about without the initiative and commitment of Heinz K. Henisch, who, in the most felicitous way, combines in his background the approach of the scientist with that of a historian and connoisseur. The development that led to the introduction of the history of photography course into the curriculum can be traced to a specific event. On April 19, 1972, Heinz Henisch, Professor of Physics at Penn State, gave a lecture at Penn State about the "Beginnings of Photography" that so impressed the audience and the members of the Department of Art History that there was a spontaneous desire to include a yearly course in the history of photography among the departmental offerings.

Heinz Henisch developed a formal course entitled "History of Photography," which was offered as a trial run in the spring term of the following year (1973). It met with such remarkable success that the course was soon permanently established as "Art History 450," offered once each academic year. Dr. Henisch was appointed Professor of the History of Photography in 1974.

The objective of the course is to familiarize advanced undergraduate and graduate students with the circumstances that led to the invention of photography, its establishment as an art form, and its further development. The course includes an investigation into the impact of photography on certain genres and media in the visual arts, such as portraiture, landscape painting, and wood engraving, and an examination of the crucial question of the interrelationship between painting and photography. Special attention is devoted to the various photographic processes and to the quick spread of the new medium from France and England through Europe and the rest of the world.

In the Department of Art History, the study of the history of photography is not limited to the confines of a single course. Professor Henisch's lectures guide the student from questions basic to the discipline to the discussion of the most challenging query: what makes a photograph a work of art? These lectures serve as a foundation for individual research supervised on the graduate level by Heinz Henisch. To date, four students have chosen topics in the history of photography for their master's theses and have completed their degrees with M.A.'s in Art History. Two other students worked on the most advanced level in the history of photography and were awarded Ph.D.'s. Dr. Gillian Greenhill is now Assistant Professor of Art History at Manhattanville College in Purchase, New York, and teaches the history of photography courses there. Dr. Kathleen Collins works as curator, archivist, and editor, and has directed projects in the Prints and Photographs Division of the Library of Congress and in various other collections.

Professor Heinz K. Henisch was elected Fellow of the Royal Photographic Society in London in 1976. He was elected Senior Fellow of the Pennsylvania State University's Institute for the Arts and Humanistic Studies in 1978, the only scientist ever to have been included in this select group, in recognition of his accomplishments in the field of the history of photography.

He has always realized the importance of enlarging the audience for this new discipline by providing access to it for the university community at large. In 1974 he created the "History of Photography Events," which bring, on an annual basis, a series of distinguished speakers to our campus in a successful attempt to widen our perspective and to supplement the offerings available on the campus. Those who are familiar with the geographic isolation of Penn State and State College, Pennsylvania, will understand that this was an initiative of great consequence for the community. Penn State's Institute for the Arts and Humanistic Studies and its Directors, Dr. Stanley Weintraub and Dr. George Mauner, have supported Dr. Henisch's efforts unfailingly. The distinguished lecturers in this series have included Van Deren Coke, Graham Smith, Peter Bunnell, Estelle Jussim, William Darrah, Weston Naef, Naomi Rosenblum, Ulrich Keller, Roy Flukinger, Tim Gidal, Gisèle Freund, Gene Thornton, Keith McElroy, Lee Fontanella, Mark Haworth-Booth and Larry Schaaf. Each spring, a growing contingent of students and friends of the history of photography await with great anticipation the announcement of the year's History of Photography Events, a most convincing sign of appreciation.

In an attempt to disseminate knowledge of this new field, Heinz K. Henisch founded a scholarly journal in 1977, *History of Photography: An International Quarterly*, published by Taylor & Francis, London. It is the only international research publication in the field, has published the essays of photohistorians in dozens of countries, and has an international audience.

Professor Henisch frequently lectures on the history of photography at other institutions, thereby carrying the Penn State flag to the University of Mexico, Mexico City (1980); the University of California, Riverside (1980); the University of Michigan, Ann Arbor (1981); Rice University, Houston, Texas (1981); Evergreen House, Baltimore, Maryland (1981); the Library of Congress (1985) and many other places. It was a special pleasure for me to invite Professor Henisch to participate in my lecture series at Penn State: "Rome, the Eternal City— Discoveries and Observations" (1983/1984). His

paper, "Roman Antiquities in Early Photography," was well received and is included in volume two of *Papers in Art History from The Pennsylvania State University*.

In March 1984, Dr. Henisch (in collaboration with Professor Jay Ruby from Temple University, Philadelphia) conceived and organized a one-day conference on "Photography in Pennsylvania" at Penn State. He also arranged for a travelling exhibition from the Gernsheim Collection: "The Formative Decades: Photography in Great Britain, 1839-1920" to be shown at the university's Palmer Museum of Art. Dr. Roy Flukinger, the original curator of the exhibition, came from Texas to lecture about the significance of the photographs on display. Professor Jay Ruby again collaborated with Dr. Henisch on a one-day international symposium in October 1988 at Penn State, which complemented an exhibition, "The Photographic Experience," consisting of more than five hundred items from the B. A. and H. K. Henisch Collection, shown from September to November 1988 in the university's Palmer Museum of Art. Dr. Henisch was the curator of the exhibition and, with his wife Bridget, prepared an illustrated catalog published by the Penn State University Press. The exhibition and symposium are intended as an early, local celebration of the 150th anniversary of the invention of photography, announced by Talbot and Daguerre in 1839.

Heinz K. Henisch's vigorous and successful efforts in establishing the history of photography as an area of specialization at Penn State is one of the most impressive success stories in the Department of Art History. I am proud and delighted to report here on his achievement, on the occasion of his sixty-eighth birthday, and add my hopes for frequent and fruitful further efforts in the future.

Amorfosode to H.H. with Love

Dear Heinz, I'm sure for all I speak
Когда я грустно говорю,
Que c'est un moment triste, unique,
Un occasione tragico,
That we must say Good-bye to you

Für viele Jahren haben wir
Наш очень интересный труд
Ensemble, en amitié sincere
Gemacht; mit hoffentlich ganz gut
And even quantifiable fruit.

But buried in computor wonder
Peux tu te rapeller que nous
Amici vechie, 'n altro mondo
Vielleicht auch sitzen, gleich wie Du,
С компютером, and think of you?

<div align="right">
Felicity Ashbee
Aug= 1987
</div>

Greetings from Germany

When I hear Heinz Henisch's name mentioned (as happens every so often when questions of photographic history are discussed) my thoughts go back to a number of years of a good and useful collegial relationship.

It all started when, about a dozen years ago, I received a letter from a professor at The Pennsylvania State University, who was unknown to me then. He inquired about the activities of Carl Dauthendey, a 19th-century German photographer, who was the father of a famous German poet, Max Dauthendey. That was when Heinz Henisch founded and became editor of the journal *History of Photography*.

At that time I was the chairman of the History Section of the Deutsche Gesellschaft für Photographie (the German Photographic Society). It was quite natural that a regular exchange of ideas developed, and once in a while we had a discussion of difficult problems that came up when looking at historically doubtful sources.

What made this relationship so enjoyable was the conviction that in factual matters we were almost always in complete accordance, and even agreed on questions of taste. More than that it was the feeling that one had, consistently, that Heinz Henisch was as fair, as helpful, as reliable as one would wish of a good and close personal friend.

Now that Professor Henisch has his sixty-eighth birthday behind him, all that I can wish is that he will be able to keep up his fruitful activities in good health and happiness.

Bernd Lohse

William Culp Darrah - A Remembrance[1]

Jay Ruby

"I have endeavored to trace, however imperfectly, the effects of photography upon the social history of America, and in turn the effect of social life upon the progress of photography."

Robert Taft, *Photography and the American Scene*, 1937.

Photohistorian William Culp Darrah died at the age of 80 on May 21, 1989 shortly before he was to deliver a major address describing his research on women who were professional studio photographers in the 19th century. The study is an important contribution to a neglected aspect of the history of the medium and fortunately it is included in this volume. To those of us interested in the social history of photography, particularly its vernacular forms, Darrah will be greatly missed.

Like many others, I am the grateful recipient of his generosity. My own research into the history of photography has been measurably improved by the afternoons I spent in Bill's Gettysburg home. He lent me images from his extensive collection and always had a word of encouragement and an insightful comment. His work helped to turn the attention of those interested in photohistory away from the adoration of masterpieces and toward the commonplace, the vernacular and the ordinary expressions of the medium. He conducted his studies outside the charmed circle of art historical pundits whose pronouncements included the notion that stereoviews and card photographs were produced by hacks and therefore unworthy of serious consideration. As a consequence he was unphased by the fact that in a mere decade his work went from being outside the mainstream to being in the center of the so-called new photohistory. It is an irony that Bill was too kind to point out.

William Culp Darrah was born on January 12, 1909, in Reading, Pennsylvania, of Scotch-Irish and Pennsylvania German ancestry. He graduated from the University of Pittsburgh in 1931 where his career in science began. In a few years, he moved to Harvard where he became an instructor and researcher in biology and botany. In 1942 he was hired by Raytheon Electronics in Waltham, Massachusetts, as a research engineer. After World War II, Darrah joined the faculty of Gettysburg College, first teaching a course on contemporary civilization and developing their adult education program. In 1963 he was awarded a full professorship at Gettysburg, where he remained until his retirement in 1974. The college granted him an honorary degree of Doctor of Humane Letters in 1977. Bill is remembered by many of his former students as a loving and giving teacher who had a major impact upon their lives. The energy he devoted to his academic and research career did not diminish with his retirement. In spite of the fact that he suffered from heart trouble and cancer, he remained actively involved in writing and presenting his ideas until his

death. William Darrah is survived by his wife of over 50 years, Helen, and his daughters Barbara Ann Smith and Elsie Louise Morey.

In addition to a career as educator, geologist, historian and botanist, Darrah was author of 13 books and numerous articles. Among those publications you may not be so familiar with are *The Principles of Paleobotony* in 1939, *The Exploration of the Colorado River* in two volumes in 1950, *Powell of the Colorado* in 1951 and *Pithole: The Vanished City* in 1972.

It was in 1943 while researching his book on Powell and the exploration of the Colorado River that Darrah first became interested in photographs Initially he saw the images only as documentary sources for his historical studies but soon he became enamored with photographs in their own right, particularly with stereoscopic views. He started his own collection of stereo cards which by the 1970s became one of the most comprehensive in the world. By 1964 when he published *Stereo Views*, Bill Darrah had become a photohistorian.

For the next 25 years he continued to collect stereoviews and *cartes de visite*. With the mind of the scientist he developed taxonomies, checklists, and annotations; in short he conceived of his collection not as a means of satisfying his personal likes and dislikes but with the idea of preparing data for analysis. The outcome of his many years of collecting, ordering and studying resulted in a second publication, *The World of Stereographs* in 1977. According to an obituary written by T.K. Treadwell of the National Stereoscopic Association this book and his earlier one on stereoviews did more to generate interest in the subject than any other work before or after. In 1981 Bill published what was to be his most influential work, *Cartes de Visite in Nineteenth Century Photography*. The books are exhaustive compilations of the names of practitioners with examples of their work, and represent the first efforts to describe the range of practice of these two photographic formats in the U.S.

I believe the work of William Darrah will last for some time. His books will be used by generations of scholars, collectors, and enthusiasts as standard reference works long after the current post-modern purveyors of gobbledygook and picture-speak have been forgotten. Darrah was one of the earliest photohistorians to follow the path first blazed by Robert Taft in his 1937 book, *Photography and the American Scene*, where the idea of a social approach to photohistory was first introduced.

In the preface to *The World of Stereographs*, Darrah states the point of view that dominated all his photographic work. "I have avoided criticism of specific stereographs as works of art, primarily because I have disciplined myself to accept each image in terms of the purpose for which it was originally intended. If the photographer achieved what he set out to do, credit is properly due him. If one adopts such an attitude, the conflicting philosophies of photography as an art, which have plagued photography since its inception, have minimal relevance to the vast majority of stereographs."

Darrah was a scientist who believed in the necessity of acquiring a proper data base before attempting any analysis, let alone, interpretation. Too many people interested in photohistory have waited for the data to come to them and have assumed that most data can be found simply by going to the major museums and other urban cultural institutions. They overlook the virtual gold mine awaiting researchers who search for their data in less obvious places. We need photohistorians willing to follow the example of Darrah and do some field work and produce systematic surveys of the locations of images. We also need dedicated collectors, amateur historians, local historical societies and other cultural institutions to scour the countryside for our photographic heritage. Pennsylvania has a glorious and important photographic past. We have had pioneers like Robert Cornelius and the Langenheim Brothers but we also have had thousands of almost forgotten practioners who through their efforts to make ordinary images for everyday people changed the way in which we perceive ourselves and our world. Bill Darrah reminded us that we need to know about both the genius and the journeyman.

REFERENCES

1. This article first appeared in *The Photo Review*, Vol. 12, No. 4 [1989] and is reprinted here with the kind permission of Stephen Perloff, editor and publisher.

James David Forbes and the Early History of Photography

Graham Smith

James David Forbes [Figure 1] was professor of natural philosophy at Edinburgh University from 1833 to 1859 and principal of the United College of St. Salvator and St. Leonard at the University of St. Andrews from 1860 until his death in 1868. Schooled in elocution by Mrs. Siddons, the great tragic actress, he was considered "one of the most winning and effective lecturers of his time." Forbes also had a distinguished scholarly career in physics and in geology. His discovery of the polarization of radiant heat won him the Rumford medal of the Royal Society in London in 1838, and his later work on the composition and movement of glaciers earned him the informal titles "explorer and surveyor of the Alps" and "father of Alpine adventure."[1] In addition, Forbes was a knowledgeable participant in the early history of photography in Great Britain and on the Continent.

William Henry Fox Talbot sent Forbes a photogenic drawing on February 27, 1839, only six days after reading his paper, "An Account of the Processes employed in Photogenic Drawing," before the Royal Society in London. The photograph is lost, but the letter that accompanied it is preserved among the Forbes papers in St. Andrews University Library. It is evident from the first sentence that Talbot was responding to an enquiry from Forbes, since he begins by explaining that Forbes's letter was only forwarded to him that day, "or I should have replied to it sooner." The letter continues:

I beg your acceptance of the enclosed photograph representing a gauze ribband — : I believe it is fixed, but you can try whether it is or not; if the sunshine should injure it I will change it for another. I described my process in its most essential particulars to the Royal Society last Thursday; and the account was copied into the Literary Gazette & Athenaeum of Saturday. There are however various minutiae, which if attended to improve the results.

Talbot remains on the topic of photography when he refers to Sir David Brewster, then Principal of the United College of St. Leonard and St. Salvator at St. Andrews:

The only objection I can possibly have to Sir D. Brewster's showing the few specimens I sent him, is that they give no adequate idea of the method, or of any part of it, being in fact the only things that I happened to have disposable the morning I sent them. But I begged him to understand that so far from being the *ne plus ultra* of photogenic performance they were literally the ne *minus* ultra, and I hope he said so to the friends to whom he may have shown them.

Talbot refers briefly to Daguerre's "secret" and to the fact that it was for sale "for 10,000 L." He also intimates that he intends to make "fresh experiments on the subject" and writes that he has high hopes for improving the "sensibility" of his paper. The letter ends with a brief discussion of Forbes's experiments

9

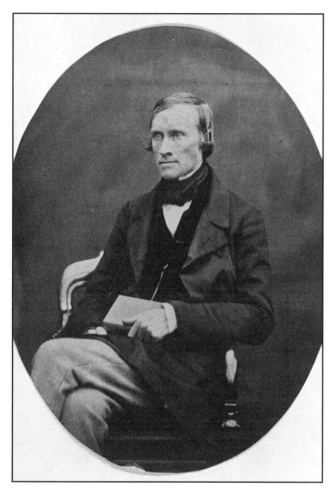

Figure 1. Unknown photographer, portrait of James David Forbes, ca. 1860. Albumen print from collodion negative, oval 148 x 115 mm. Courtesy St. Andrews University Library, St. Andrews, Scotland.

on "the question of the penetration of solar heat into the earth."

This letter is interesting on several counts, not least being Talbot's use of the word "photograph" rather than "photogenic drawing." Sir John Herschel disliked Talbot's terms "photogenic drawing" and "photogenics" and articulated his objections in a letter written on February 28, the day after Talbot wrote his letter to Forbes:

> Your word *photogenic* recalls van Mon's exploded theories of thermogen and photogen. It also lends itself to no inflexions and is out of analogy with lithography and chalcography.[2]

Talbot's letter to Forbes makes it clear that he was already moving towards the terms "photograph" and "photography."

Forbes declared himself "extremely much pleased with the lace specimen of Photogenics" in his letter of acknowledgment, dated April 2, 1839.[3] In addition, this letter indicates that Talbot had also sent Forbes two pieces of prepared paper. Forbes admitted to having spoiled the first, "having left it [in the camera obscura] until it became uniformly dark," but wrote that he was "preserving the second small piece until a bright day shall favour the experiment." Forbes also mentioned that "Dr. Fyfe a Chemist here has been making some good experiments with the *phosphate* of silver, but he finds extreme difficulty in fixing his results."

Forbes's participation in the early history of photography was not limited to Great Britain, however. In fact he was one of the first British scientists to see Nicéphore Niépce's and Louis Jacques Mandé Daguerre's photographs. On May 16, 1839, Forbes went to see Daguerre's "pictures" with François Jean Dominique Arago and five others. He later recorded his impressions in his journal:

> Daguerre's pictures…astonish us all, me especially, for tho' I had formed the highest expectations from the descriptions & should have been miserably disappointed had they been entirely contradicted still I own that I had lost all hope of seeing anything equal to my first expectations. I was most agreably surprised to find them far more than fulfilled on every point. The promptitude & minuteness may be described even if it be necessary to see the objects to be convinced of the wonder, but the beauty of the effect cannot. They were far better lighted than I expected, & the Camera Obscura drawings from still life — busts — drapery &c astonish me more perhaps than any other. Many views of the Seine & of houses with paratonerres[?]. One on the Boulevard taken at morning noon & night with the varied shading. One view of boats on the Seine taken three times to show the effect of Time in the process which was made to occupy 1, 4, and 16 min. as well as I recollect. In the first the whole thing was sketched but the lights imperfect in the second it was fully brought out & in the third the lights were being lost by the long action of faint lights in the dark places but the outlines and the faintest objects were very clearly defined the general effect however was spoiled. Arago repeated several times Herschel's remark on seeing them — "Nous ne sommes que de barbouilleurs. On n'aurait pas pû s'en former une

idée. C'est admirable. C'est un miracle."
Forbes returned to the topic of Daguerre's
photographs four days later, in a letter to his sister
written in Lyons on May 20, 1839:

> Of all my Paris recollections by far the most
> interesting is having seen Daguerre's pictures,
> which is now a matter of some difficulty, but
> Arago kindly arranged it for a party of us the day
> before I left Paris. I went certainly prepared for a
> disappointment, yet certainly [cancelled] resolved
> not to be satisfied with anything which was not
> superior to what I almost believed possible. Yet I
> have no hesitation in saying that I was pleased
> beyond my most sanguine expectations; in short
> it baffles belief:- in promptitude & minuteness
> one can *conceive* it even if they cannot *believe* it
> upon report, but in beauty, and the perfect
> representation of nature it must be seen to be
> understood; all sort of objects were represented;
> objects of furniture plaster casts curtains &c all
> fixed by the camera obscura. Open air views at
> different hours of the day fixed in 3 or 4 minutes
> including the most exquisitely delicate objects, &
> fixing the shadows proper to the time of day in a
> way no artist can do.

Forbes concluded this rhapsodic description of
Daguerre's photographs with the uncharitable
sentence, "As to Messrs. Talbot & Co. they had better
shut shop at once."

The day after he saw Daguerre's photographs,
Forbes met Isidore Niépce, whom he described as "a
most gentlemanly person." Forbes indicates that he
was "recommended" to Niépce by a Mr. Bauer of
Kew, who had shown him the week before "the first
specimens of the Daguerre process as discovered
by...[Nicéphore] Niépce."[4] In the entry in his journal
for May 17, Forbes mentions that Isidore Niépce
explained "the thing" to him "circumstantially
and...no doubt correctly" and goes on to give a
detailed record of this history:

> A good many years ago Mr Niépce discovered a
> process of fixing views by light on Metal Paper
> Glass or other substances and even of etching
> from these. This process he modified & improved
> & being himself a man of retired habits & living
> generally in a provincial town, he in 1829
> associated himself with Daguerre whom he
> described as a clever, active pushing man of the
> world (of which he has the appearance). This
> contract still exists. In 1833 Mr Niépce senior
> died and subsequently to that, Daguerre
> discovered a new process or modification of the
> former one, which Mr N. does not attempt to
> deny to be a most important one, so important

that he, Mr N. agreed to give up all claim to the
title of the invention under his father's name in
order to share the profits of the discovery. This
new bargain was made, & the practical difference
is this that whereas the original process required
5 or 6 hours & the lights consequently changed or
were lost; the new one producing the same effect
in 5 minutes. Mr N. is at present associated with
M. Daguerre as regards any profit &c arising from
the concern. He shewed me specimens of his
father's art — both on silver plates & on glass. It
could be applied to Paper which he says
Daguerre's certainly could not. Daguerre has
possessed his secret in considerable perfection for
3 years at least; I saw one of his pictures of that
date he has certainly improved upon it since. He
has also improved the Camera Obscura. In
Niépce's landscape the details were very
imperfect except in the centre. Some of Niépce's
(all by the old process) of still life [illegible] were
very good. M. Niépce thinks it unlikely that
either process should be discovered — but
especially Daguerre's which judging also from
what Arago said is a very curious one.

Forbes goes on to record his own observations
regarding Niépce's photographs:

> I examined the pictures very minutely. The
> substance is acknowledged to be silver plated on
> copper — Arago hinted that the metal produced
> some galvanic effect — but evidently the surface
> has most to do with it — perhaps the
> indestructibility. The etching process is peculiar
> to Niépce's old process & his son possesses it.
> Both Niépce's and Daguerre's drawings have this
> very singular peculiarity that the parts which are
> dark & therefore unaltered *have a simply metallic
> aspect* and in those on glass the glass appears
> wholly uncoated. Therefore either the substance
> when applied is wholly transparent like varnish
> & whitens somewhat like *chilled* varnish on
> exposure to light, or what is more probable, the
> unchanged parts of the composition have been
> subsequently chemically removed — perhaps it is
> this process which destroys paper. The
> consequence of this is that if you look *along* any of
> these plates so as to get a *specular* reflection the
> picture is reversed, the lights being dark as in
> Talbot's process. I am inclined to think that the
> composition which remains is easily soluble at
> least in Niépce's process for he shewed me a blot
> made by a touch of the finger where a bunch of
> flowers should have been.[5]

Five years later, Forbes attended the meeting of the
British Association for the Advancement of Science

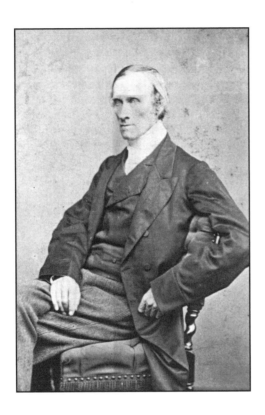

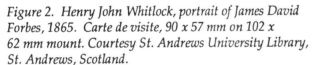

Figure 2. Henry John Whitlock, portrait of James David Forbes, 1865. Carte de visite, 90 x 57 mm on 102 x 62 mm mount. Courtesy St. Andrews University Library, St. Andrews, Scotland.

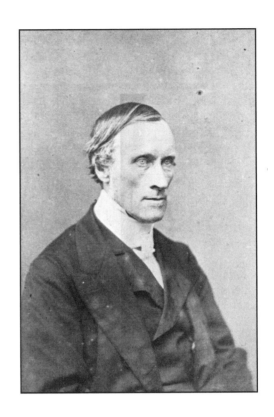

Figure 3. Henry John Whitlock, portrait of James David Forbes, 1865. Carte de visite, 93 x 59 mm on 102 x 62 mm mount. Courtesy St. Andrews University Library, St. Andrews, Scotland.

held in York in September 1844. The gathering was much excited by photographic issues, but Forbes had matters of a different kind on his mind. He had a new wife and a persistent cold, and he had his paper on glaciers to read.[6] In any case, there is no evidence that Forbes and Talbot met at the York meeting. Nor did Forbes attend David Octavius Hill and Robert Adamson's temporary studio in York.[7]

Forbes's involvement with photography revived during his principalship at the University of St. Andrews, however. Dr. John Adamson, the brother of Robert Adamson and himself one of the earliest photographers to use Talbot's process successfully in Scotland, was a colleague of Forbes, and photographed him at least once. Thomas Rodger, who established a photographic studio in St. Andrews in 1849 on Adamson's recommendation, also photographed Forbes's gaunt features and "tall, thin, but lathy frame" on several occasions.[8]

In September 1865, three years before his death, Forbes attended the British Association meeting at York where he sat for two *carte-de-visite* portraits by Henry John Whitlock [Figures 2 and 3].[9] Forbes found "a large preponderance of new faces" at the meeting and evidently already viewed himself as "a sort of resuscitated antediluvian, or one of the stone people come to partial life."[10] Something of these feelings of isolation, brought on by age and illness, is manifest in Whitlock's photographs.

REFERENCES

1. Brief biographies of Forbes are included in *The Dictionary of National Biography*, ed. by L. Stephen, vol. 19 (London: Smith, Elder & Co., 1889), pp. 398-400; and *Dictionary of Scientific Biography*, ed. by C. C. Gillispie, vol. 5 (New York: Charles Scribner's Sons, 1972), pp. 68-69. However, the fundamental study remains that by J. C. Shairp, P. G. Tait, and A. Adams-Reilly, *Life and Letters of James David Forbes, F.R.S.* (London: Macmillan and Co., 1873). The quotation regarding Forbes's prowess as a lecturer is from the latter publication, p. 99. The journal and letters that I quote from in this article are preserved in the University Library, St. Andrews, Scotland. Forbes's correspondence and papers are cataloged in *An Index to the Correspondence and Papers of James David Forbes (1809-1868)*, University Library, St. Andrews (1968). The portraits of Forbes reproduced here are also preserved in St. Andrews University Library. I am grateful to Robert N. Smart, Keeper of Manuscripts and University Muniments, for giving me access to the Forbes papers and for allowing me to publish the photographs.

2. Quoted in Larry Schaaf, "Herschel, Talbot and Photography: Spring 1831 and Spring 1839," *History of Photography*, vol. 4, no. 3 (July 1980), p. 197. For further notes on the terms "photograph," "photography," and "photographic," see the letters by H. M. Gosser and Larry Schaaf in *History of Photography*, vol. 5, no. 4 (October 1981), pp. 269-270.

3. Forbes's own copy of this letter is preserved in St. Andrews University Library.

4. No doubt this was Francis Bauer, the botanical draughtsman at the Royal Botanical Gardens, who befriended Niépce when the latter visited England in 1827 and persuaded him to address a memoir entitled "Notice sur l'heliographie" to the Royal Society. When Niépce returned to France in January 1828, he presented Bauer with this manuscript, a photographic view from nature, and three heliographic reproductions of engravings (see Helmut Gernsheim, *The Origins of Photography* (New York: Thames and Hudson, 1982), pp. 34-37, with further references). It must have been those photographs that Forbes saw before leaving for France early in May 1839.

5. This passage is quoted in part in Shairp, Tait, and Adams-Reilly, *Forbes*, pp. 242-243. The transcription is inaccurate in many respects, however.

6. See Shairp, Tait, and Adams-Reilly, *Forbes*, pp. 164-165.

7. On Hill and Adamson's activity at York, see K. Michaelson, "The First Photographic Record of a Scientific Conference," in *One Hundred Years of Photographic History: Essays in Honor of Beaumont Newhall*, ed. by Van Deren Coke (Albuquerque: University of New Mexico Press, 1975), pp. 109-116.

8. On Forbes and Rodger, see Graham Smith, "James David Forbes and Thomas Rodger," *The Bulletin of the Scottish Society for the History of Photography* (Autumn 1987). The description of Forbes is quoted from Shairp, Tait, and Adams-Reilly, *Forbes*, p. 136.

9. The following text is printed on the verso of the cards: PHOTOGRAPHED BY/H. J. Whitlock/11, NEW STREET/BIRMINGHAM. A Henry John Whitlock was the sole licensee for the daguerreotype in Warwickshire and opened a studio in Birmingham about 1842 (see Gernsheim, *Origins of Photography*, p. 145).

10. Quoted from Shairp, Tait, and Adams-Reilly, *Forbes*, p. 432.

Fox Talbot's Original Iron Copper Press

Robert E. Lassam

It is now thirteen years since the National Trust converted a sixteenth-century barn on the Lacock estate into the Fox Talbot Museum of Photography. Not long after the opening in June 1976, officiated by Her Royal Highness Princess Alexandra, we had a visit from Professor Heinz Henisch and Mrs. Henisch. He was then a professor at Reading University and was about to move to the United States. I realized then what an interesting man he was, and later I learned that he had thought of creating a special journal dealing with the history of photography. I am happy that this prestigious publication, *History of Photography*, came into being and has continued to be published. It was a great honor for me to be asked to be on the international advisory board.

In the early days of *History of Photography*, it was interesting to read the articles gathered for the journal. Many of them were about early photography in Eastern Europe, which we in the West were not aware existed. When Fox Talbot announced his negative/positive process, it was inevitable that it would be taken up by like-minded people in Europe. Through the activities of Heinz Henisch, who came from Czechoslovakia, and those of his Eastern European contacts, we were able to see just how quickly and how far interest in this new invention spread around the world. Of course, as far as calotype photography is concerned, these early pioneers never took out a Talbot patent for the process and their work was unknown to Fox Talbot.

In appreciation of Heinz Henisch, I think he would like to know that this year, after following up some rumors, I have been able to trace Fox Talbot's original iron copper engraving press, with the help of Mr. Gray, a lecturer at Bath College of High Education. I was inspired to trace this press because I had seen mention in the Talbot archives in an 1856 catalog that he had bought this press to use in the abbey for his photo-engraving experiments. We believe the press was purchased by Fox Talbot in 1852. I have included an illustration of this press [Figure 1], which is now housed in the museum, and which we are delighted to have acquired.

Research indicates that Miss Matilda Talbot, CBE, the last private owner of the Lacock Estate, gave the press to Lord Paul Methuen of Corsham Court, who was a governor of Bath Academy of Art. The press was housed in Bath, but during the war the property was damaged and the academy moved to the grounds of Corsham Court.

For several years the press was used at the academy, and was sold to King Edwards Senior School in Bath. It has been continually in use by the head of the Art Department, Mr. S. Williams, in teaching printing and engraving to the pupils. The school agreed to transfer the engraving press to the Fox Talbot Museum. The National Trust, through the Marsden Bequest, purchased a new engraving press from Harry F. Rochat Ltd. of Barnet in exchange for this nineteenth-century equipment.

In 1989, the 150th anniversary of the first announcement of photography, which is being celebrated all over the world, we will be able to make some photo-engravings from restored Fox Talbot original plates as part of our museum's contributions to these commemorations.

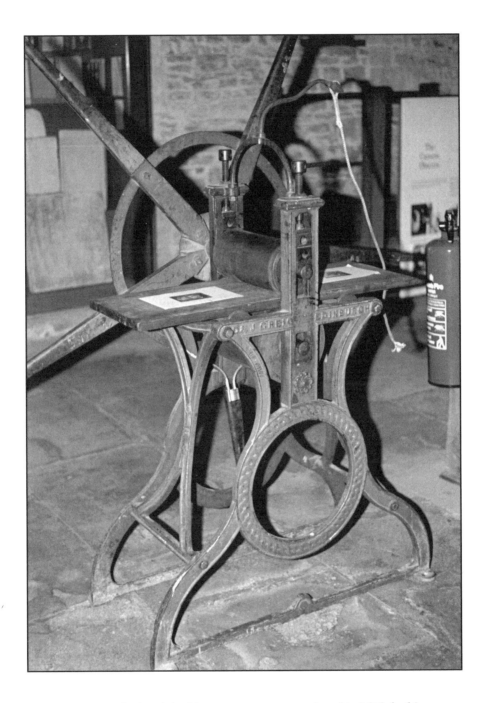

Figure 1. Fox Talbot's original iron copper press, purchased in 1852 for his photoengraving experiments, now housed at the Fox Talbot Museum, Lacock Abbey, Chippenham, Wilts, England.

Iván Szabó: A Hungarian Photographer in Scotland

Julie Lawson

Nineteenth-century Scottish photographers pop up in the most unlikely places, from Canada to the Crimea, from St. Peter's to St. Petersburg. Though it is somewhat unusual for people to migrate to Scotland to seek their fortune, it serves to redress the balance that one of the most lauded photographic talents of the 1850s in Scotland should have been a Hungarian. Iván Szabó was "by birth a Hungarian gentleman who had served in the War of Independence under Görgy, with the rank of captain."[1] After the war, and presumably for political reasons, he came to Scotland. It was in St. Andrews, Fife — the cradle of Scottish photography, birthplace of John and Robert Adamson and home of Sir David Brewster — that Szabó settled. He supported himself by teaching languages for a while, before learning the art of photography. His instructor was probably Thomas Rodger, one of the leading Scottish practitioners, who had in turn been the protégé of the pioneer photographer Dr. John Adamson.

In August 1856, Szabó was nominated a member of the Photographic Society of Scotland. He responded to the news of his election with modesty, saying, "I do not know how I deserved such a distinction."[2] That year, Szabó moved to Edinburgh where he set up a studio at Salisbury Place, Newington. "His fine artistic taste, combined with his skill as a manipulator, soon brought him into notice in his new profession; and he rapidly acquired a large business."[3] Although the few known examples of Szabó's work may not immediately strike us as the product of unusual genius, it is interesting to consider the critical response of his contemporaries.

Szabó showed several portraits at the 1856-1857 exhibition of the Photographic Society of Scotland. One reviewer wrote, "The gain is ours that he [Szabó] has exchanged arms for art, the sword for the camera....Mr. Szabó is particularly happy in the natural and pleasing pose of his figures, his works being worthy of admiration equally as pictures and as likenesses."[4] In the same exhibition was a portrait of Iván Szabó by Thomas Rodger. Comparison of the work of the two men was inevitable. The reviewer of the *Caledonian Mercury* opined that while "nothing can exceed Mr. Rodger's power of catching a characteristic expression or attitude, and the tints are soft and delicate, though sufficiently decided," yet, "some portraits of Iván Szabó...a pupil if we remember rightly, of Mr. Rodger's, are in many respects equal to those exhibited by his instructor, and are decidedly superior to any others in the exhibition."[5] This opinion was shared by the critic of the *Scotsman*, who said, "There is a peculiar delicacy and softness in all Mr. Rodger's productions, and his style is particularly graceful and attractive. We think that his portraits of ladies are, with Mr. Iván Szabó's, the most pleasing we have ever seen." He added, with evident satisfaction, "Scotland can produce, we affirm, a style of portrait superior to anything that has yet been executed on the other side of the border."[6]

Fig. 1: Portrait of Sarah Watson, the sister of David Octavius Hill, by Iván Szabó. Salt print from collodion negative. Courtesy Scottish National Portrait Gallery, Edinburgh.

Figure 2. Portrait of unknown man, by Iván Szabó. Salt print from collodion negative. Courtesy Scottish National Portrait Gallery, Edinburgh.

It was not only in Scotland that Szabó's talents were recognised. In 1857 he was awarded a medal at the Brussels exhibition, for a portrait of "Mrs. Findlay." He again exhibited in Edinburgh with the Photographic Society of Scotland, and the response was, if anything, more favourable than that in the previous year. The critic of the *Edinburgh Evening Courant* declared that "among our own portrait artists, we give the first place to Mr. Szabó....[His portraits] are as successful as the art seems capable of, and quite equal to some of Mr. Rodger's of St. Andrews, whose style Mr. Szabó adopts, we will not say imitates."[7]

In April 1858 Szabó took photographs of William Henry Fox Talbot's wife, Constance, and their children.[8] He was also associated with Scotland's most famous early photographer. In June 1857, David Octavius Hill requested Szabó to make a calotype of a

painting. Szabó's response gives a small insight into his meticulous approach to photography. He said, "firstly I want a peculiar light for painting," and "I must observe a certain degree of exactitude in placing the picture at right angles," adding that the wind (the painting would have to be photographed out of doors) "puts me to great uneasiness."[9] This sounds like the anxiety of a perfectionist.

Given all this promise and talent, and the hope and encouragement of the photographic and artistic community, it is tragic that the *Scotsman* of 17 July 1858 should have announced: "Sudden Death:—Mr. Szabó, the able and well-known calotypist was, we regret to say, found dead in his bedroom on Thursday morning, although in perfect health during the previous evening. Mr. Szabó, who was a Hungarian, was held in very high respect, both for personal and professional qualities."[10] The cause of death was

Fig. 3: Portrait of unknown woman, by Iván Szabó. Salt print from collodion negative. Courtesy Scottish National Portrait Gallery, Edinburgh

Fig. 4: Portrait of unknown man, by Iván Szabó. Salt print from collodion negative. Courtesy Scottish National Portrait Gallery, Edinburgh.

given as apoplexy. At his funeral a few days later, "the number of gentlemen assembled, representatives of so many classes and professions, among them some of the most eminent members of the Royal Scottish Academy[11] bore testimony to the high esteem which Mr. Szabó had won for himself during his brief and promising career in this city, no less as an artist than as a man. He was one, indeed, whom to know was to love."[12]

Szabó's studio, cameras and photographic equipment were sold by his executors to the miniature painter, Kenneth McLeay.[13] His camera is now in the collection of the National Museum of Scotland.

POSTSCRIPT

In the sale of 25 April 1974 at Christie's, lot 226 was described as "Rogue's Gallery: American album compiled by Samuel G. Szabó, ca. 1860-70, 214 oval portraits of criminals sold with album of letters to Szabó from friends and scrap album." According to *Art and Antiques*, 13 April 1974, the photographs were all taken "by the Hungarian émigré" Samuel Szabó. It would seem likely that there is a connection between these two Hungarian émigrés called Szabó who were taking photographs in the second half of the nineteenth century.

APPENDIX

Both manuscript letters quoted below are in Lacock Abbey.

Letter from William Henry Fox Talbot to Amelina Talbot (LA58-51)

London
April 22 1858
[Athenaeum Club Notepaper]
…I am glad Ivan Szabo has made the portraits. If unsuccessful they should not be preserved, as it is easy to try again with some other photographer. Szabo should let us have the *negative* as well as the positive copies as we do not wish other copies to be made except for ourselves.…

Letter from Constance Talbot to William Henry Fox Talbo (LA58-37)

April 1858
Athole Crescent [Edinburgh]
Wednesday night
…Szabo's portraits I understand are to be 23/- each - making £6.50 if we are *all* taken, and the girls seem really anxious to have *my* picture done as well as their own. - if you wish for a second copy this will be a addition of 7/- for each copy. Ela & Charles were taken on Monday - but we could not see the likenesses then. Mr Szabo gave 2 sittings to each, with the intention of offering me the choice of the 2 portraits but he said himself that Charles's second sitting produced a bad result & was not worth copying and that the first would certainly give me satisfaction. I must admit that he spared no pains in placing them, pushing about their hands and legs till he got everything in focus - and arranging Ela's gown in graceful folds of drapery. He seemed to consider everything, and particularly to get the attitudes natural & free from stiffness. I am to go with [? Ros.d] & Matilda on Monday - and then we shall see the results of Charles & Ela's sittings.…

The undated letter from Constance telling Talbot how much copies would cost (they were not inexpensive) must be a response to that written by Talbot on 22 April. Talbot requests in his letter:

…Ask Constance to buy me 6 or 8 photographic portraits of people (no matter who) with *pleasing* expression of countenance, or at any rate artistically good and expressive - and with *dress* well expressed and developed. They should not be larger than half a sheet of paper, but may be smaller to any extent. They should not be mounted, but on common paper and semitransparent. They are for specimens on which to try my Engraving process, but this should not be mentioned to the person who sells them as he might object.…

Constance says, at the beginning of her letter:

…Charles will tell you how he and I hunted up & down Edinburgh for photographs today with very indifferent success. I shall wait for further instructions but we think all that we saw today were too large or too small - and none can be had unmounted.…

REFERENCES

1. *Journal of the Photographic Society*, 22 November 1858, p. 73.

2. Record Office, Edinburgh: papers GD356(i).

3. *Journal of the Photographic Society*, 22 November 1858, p. 73.

4. "W.S.," in *Edinburgh Evening Courant*, 17 January 1857.

5. *The Caledonian Mercury*, 29 December 1856.

6. *The Daily Scotsman*, 4 February 1857.

7. *Edinburgh Evening Courant*, 12 January 1858.

8. At Lacock Abbey there is a note that reads,

 From I. Szabó, 4 Salisbury Place, Newington,
 Edinburgh, June 1858.
 1 calotype Portrait of Miss Talbot, first impr. £1.3.
 1 Miss A. Talbot 1.3.
 1 Miss B. Talbot 1.3.
 1 copy of Miss B. Talbot 7
 1 calotype portrait of Mr Talbot first 1.3
 1 copy 7
 1 copy of Sir D. Brewster 7
 To Mr Talbot £5.13

 The term "calotype" is used of Szabó's photographs, which were salt prints from collodion negatives. See Appendix.

9. MS letters from I. Szabó to D. O. Hill, 20 and 26 June 1857, in the Royal Scottish Academy, Edinburgh.

10. *The Daily Scotsman*, 17 July 1858.

11. Szabó had exhibited a portrait of Sir George Harvey, President of the Royal Scottish Academy, at the Photographic Society of Scotland exhibition of 1857-1858.

12. *The Daily Scotsman*, 21 July 1858.

13. J. Lawson, "Bankruptcy Through the Lens: the Case of Kenneth MacLeay," *Bulletin of the Scottish Society for the History of Photography*, Spring 1986.

An Early Picture Narrative by D. O. Hill and Robert Adamson

Ralph L. Harley, Jr.

Picture narrative that began to appear in the popular press during the last two decades of the nineteenth century is generally considered to be the precursor of the modern photo-essay and cinema.[1] This consists of a series of pictures devoted to a single theme that, when presented in an established order, tells a story.

Sometime between 3 July 1843 and 1 October 1845, D. O. Hill and Robert Adamson produced two calotype photographs that they placed on successive pages in the Clarkson Stanfield presentation album.[2] Their purposeful arrangement in an album established them as picture narrative, perhaps the first produced by means of photography.

The two photographs in question, "Oyster Dredgers" [Figure 1] and "An Oyster Boat" [Figure 2], tell the story of the Newhaven fisherman's centuries-old activity of harvesting the Edinburgh scalps. They occupy a place near the center of a group of thirty-nine album images illustrative of the life and economy of the village.

Their identification as picture narrative places them within the tradition of serial imagery introduced into British painting and drawing by William Hogarth during the second quarter of the eighteenth century[3] and theatrical applications originating with Philip de Loutherbourg during the third quarter.[4] Related developments were the panorama and the diorama and their animated versions.

Clarkson Stanfield was a leading designer of the moving diorama between 1823 and 1839.[5] He was also a noted painter of seascapes. In fact, it seems hardly accidental that the partners' first picture narrative in calotype should not only be concerned with life at sea but require a mechanical agent as activator. In the moving diorama this was a crew of men; here it is the viewer turning the page. Hill must have been apprised of moving diorama imagery because the second presentation album was given to Stanfield's associate and rival in Drury Lane, David Roberts.[6]

Common subject matter includes an oyster boat, fishermen and boy, and — the main narrative element — an oyster dredge. Closer inspection indicates that the same boat was used for both photographs. A brace holding the hull in an upright position [Figure 4] shows that the boat was resting on the beach. The necessity of taking the pictures on land reflects the impracticality of photography at sea because of the slowness of the medium. A blurred sail suggests both were made from timed exposures.

Because of the boat's stationary position, it is possible to precisely analyze changes in camera position that took place between exposures. These reveal part of the photographers' conceptual approach to narration.

For the first exposure [Figure 1], the camera was placed almost directly astern of the boat, level with the horizon, creating an impression that the boat is

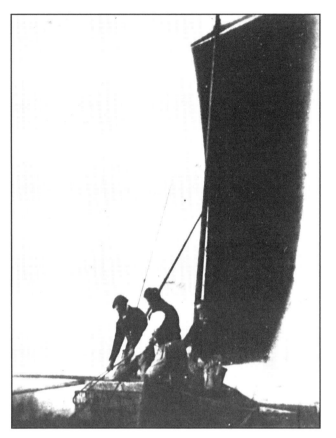

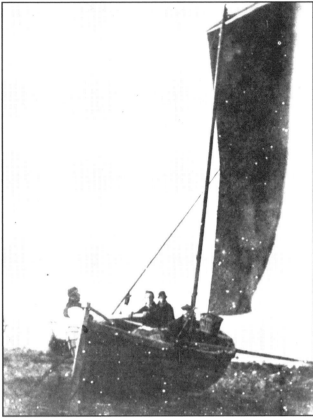

Figure 1. D. O. Hill and Robert Adamson, "Oyster Dredgers," 1843/45, calotype, 8 x 6 inches. Plate 73 in "100 Calotypes by D. O. Hill, R.S.A., and R. Adamson. Edinburgh, 1845." Courtesy Gernsheim Collection, Harry Ransom Humanities Research Center, The University of Texas at Austin.

Figure 2. D. O. Hill and Robert Adamson, "An Oyster Boat," 1843/45, calotype, 8 x 6 inches. Plate 74 in "100 Calotypes...." Courtesy Gernsheim Collection, Harry Ransom Humanities Research Center, The University of Texas at Austin.

gently drifting sideways with the tide. Before the second exposure [Figure 2], the camera was relocated further back and to the right. From there, the long, sleek line of the hull came into view. By tipping the camera to the left, the photographers were also able to suggest the force of wind against the sail, which leans to the right. This gives rise to the sensation that the boat is moving forward, propelled by the action of wind and oar.

An enlarged detail from the first picture [Figure 3] reveals an intimate psychological drama in the manner of those produced after 1800 by Sir David Wilkie,[7] whom Hill greatly admired.[8] It also shows the kind of fisherman's activities depicted in

Stanfield's diploma picture, "On Scheldt, near Leiskenshoeck — Squally Day," exhibited in 1837.[9]

Attention of the Newhaven fishermen is concentrated on the dredge as it is hauled from the sea. This idea is conveyed through a compositional device; namely, an arrow-like arrangement, established by the men's outstretched arms and a rope supporting the mast, to which it points.

The second picture in general is also reminiscent of an earlier sea piece by Stanfield, "Homeward Bound," that was engraved for W. Miller's *Heath's Picturesque Annual*, published in 1833.[10] An enlarged detail [Figure 4] reveals that between exposures the dredge was hauled into the boat and stowed while the men

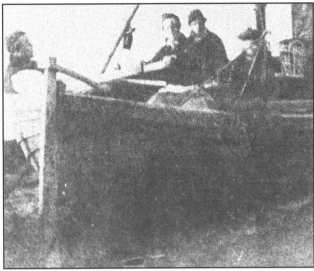

Figure 4. Detail from "An Oyster Boat."

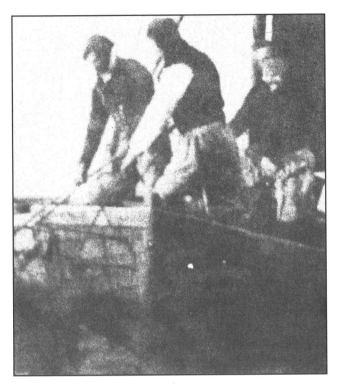

Figure 3. Detail from "Oyster Dredgers."

were repositioned at the tiller and oar, the changes suggesting the boat is underway.

What primarily establishes "Oyster Dredgers" and "An Oyster Boat" as narrative is the oyster dredge. In the detail from the first picture, it is being drawn up over the gunwale; in the second, it is inside the stern.

The narrative effect created by its movement from one place to another between exposures and made plain by the sequential order of the images in the album is similar to some of the imagery found in Stanfield's moving diorama. For example, in a working model [Figures 5a and 5b], based on "Mr. Stanfield's Diorama of Venice" (1831),[11] the silhouette of a moving gondola is used to create a secondary effect as an enhancement to one of the main scenes.[12]

Within a year or two of producing the narrative on the Newhaven fishermen, Hill and Adamson produced a second one featuring the Village's fishwife whose time-honored task was to market the oysters. This pair, which focused attention on the activity of the hands opening an oyster, was placed on successive pages of the Royal Academy presentation album.[13] It differs from the first pair in

that the time interval between activities has been significantly shortened.[14]

This shortening of time interval suggests that the partners may have begun experimenting with dissimilar paired imagery conceived for the purpose of animation. Such experimentation would belong to the general development toward animation that preoccupied many individuals during the middle decades of the nineteenth century. For example, Sir David Brewster introduced the lenticular stereoscope in 1849[15] and, seven years later, noted production of dissimilar paired imagery for animation.[16] This was achieved by a rapid alternate viewing of each of the paired pictures in this device.[17]

Experimentation of this kind was a prelude to Muybridge' famous motion study of the horse and rider produced in the 1870s. In this study, actual time was recorded and intervals reduced to mere fractions of a second. Twelve of these were projected from a disk in 1880 in his Zoopraxiscope, an instrument designed to create a sustained form of animation. Sixteen years later, the Lumière brothers projected a much more numerous group of dissimilar images

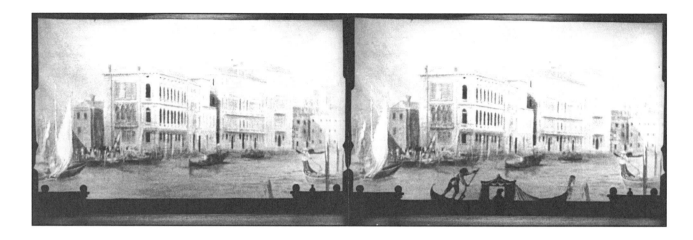

Figures 5a and 5b. Two details from working model of "Mr. Stanfield's Grand Diorama of Venice," Scene 15 (out of 20), no. 1, "The Grand Canal," as it may have appeared in the pantomime, "Harlequin and Little Thumb," at Drury Lane, 26 December 1831. Reconstruction of the original based on secondary materials for exhibition of the work of Clarkson Stanfield, organized by the Tyne and Wear County Council Museums, Sunderland, England, in collaboration with the Rheinisches Landesmuseum, Bonn, West Germany. Photographed by author at the Sunderland Museum and Art Gallery, 1979.

from flexible film in *The Train* and the modern form of motion picture was born.

In the context of the Stanfield album, "Oyster Dredgers" and "An Oyster Boat" would seem to belong to the late phases of earlier types of picture narrative. At the same time, they anticipate the in-camera art that began to appear in the mid-1850s and which led to modern cinema.

REFERENCES

1. On "photo-interview" and "picture-play," see Beaumont Newhall, *History of Photography*, 5th edition (New York: Museum of Modern Art, 1982), p. 252 ff. See also the illustration on p. 254: Paul Nadar, "The Art of Living a Hundred Years; Three Interviews with M. Chevreul...On the Eve of his 101st Year," from *Le Journal Illustré*, 5 September 1886. See also p. 255: Alexander Black, "Three Scenes from the Capital Picture-Play 'Miss Jerry'," from *Scribner's*, 18 (1895).

2. Plates 73 and 74, respectively. The title page of the album reads, "100 Calotypes by D. O. Hill, R.S.A., and R. Adamson. Edinburgh, 1845." On the first of the preceding pages is the penned inscription: "Clarkson Stanfield, Mornington Place - Octr 1st 1845." The album was acquired by Helmut Gernsheim shortly after World War II and is now preserved in the Gernsheim Collection at the Harry Ransom Humanities Research Center at the University of Texas, Austin.

3. Hogarth introduced this type of picture narration in such works as *Marriage à la Mode* (1743-1745).

4. On de Loutherbourg's "Eidophusikon" ("same-as-nature-machine"), see Francis D. Klingender, *Art and the Industrial Revolution* (London: Noel Carrington, 1947), pp. 78-79.

5. On Stanfield and the diorama, see *The Spectacular Career of Clarkson Stanfield, 1793-1867: Seaman, Scene-painter, Royal Academician*, catalogue of exhibition with essay by Pieter van der Merwe (Southerland, England: Tyne and Wear County Museums, 1979).

6. "A Series of Calotypes by D. O. Hill, R.S.A., and Robert Adamson 'and others' [added in pencil]. Edinburgh, 1846." This album was "presented by Hill

to David Roberts [R.A.], thence to his son-in-law Henry Bicknell, thence by family inheritance to the present owner....The album owned by David Roberts is referred to in a letter from Hill to David Roberts 14 Jan[uary] 1852." Katherine Michaelson, *A Centenary Exhibition of the Work of David Octavius Hill 1802-1870 and Robert Adamson 1821-1848* (Edinburgh: Scottish Arts Council, April 1970), pp. 79-80. It is presently on loan at the Scottish National Portrait Gallery, Edinburgh.

Stanfield's biographer, van der Merwe, does not believe "Stanfield and Hill were more than professional acquaintances — friendly certainly, but not intimate or in close contact." Correspondence, P. T. van der Merwe to R. Harley, Jr., 16 October 1979. There is evidence of a closer relationship between Roberts and Hill through correspondence and the fact that he was photographed by the partners at Greyfriars Churchyard, Edinburgh. See Sara Stevenson, *David Octavius Hill and Robert Adamson* (Edinburgh: National Galleries of Scotland, 1981), p. 101, col. 1, pl. 2, "David Roberts."

7. On Wilkie, see *Romantic Art in Britain: Paintings and Drawings 1760-1860,* catalogue of exhibition, with Frederick Cummings, et al. (Detroit, Michigan: The Detroit Institute of Arts, 1968), pp. 214-223; and *Tribute to Wilkie,* catalogue of exhibition with essay by Lindsay Errington (Edinburgh: National Galleries of Scotland, 1985).

8. See Ralph L. Harley, Jr., "The Partnership Motive of D. O. Hill and Robert Adamson," *History of Photography,* vol. 10, no. 4 (October-December 1986), pp. 309-310.

9. See *The Spectacular Career of Clarkson Stanfield,* p. 113, illustration 177.

10. *The Spectacular Career of Clarkson Stanfield,* p. 122, illustration 193.

11. *The Spectacular Career of Clarkson Stanfield,* pp. 91-92 and illustrations 127 and 128.

12. The author studied and photographed this working model while it was on exhibition at the Tyne and Wear County Council Museum, Sunderland, England, in 1979.

13. The title page to the third volume in which the subject images appear as plates 16 and 17 reads, "Calotypes by David Octavius Hill R.S.A. and Robert Adamson. Vol. 3. Newhaven Fishermen, Landscapes, Buildings, Etc. Etc. Etc., Edinburgh, MDCCCXLIII to MDCCCXLVIII." The dedication page in the first volume, inscribed to Hill, is dated 26 July 1846. The album was completed and presented by Hill to the Royal Academy of London in 1848. See *An Early Victorian Album,* edited by Colin Ford (New York: Alfred A. Knopf, American edition, 1976), pp. 40-41.

14. See Ralph L. Harley, Jr., "The Cultural and Aesthetic Significance of the Newhaven (Scotland) Fisherfolk Photographs by D. O. Hill and Robert Adamson," Ph.D. dissertation, University of New Mexico, Albuquerque, 1984, pp. 194-195, 252-258. The shortened time interval between exposures is only by implication because this slow medium would have required previsualizing the positioning of the hands.

15. David Brewster, "Description of Several New and Simple Stereoscopes for Exhibiting, as Solids, One or More representations of Them on a Plane," *Transactions of the Royal Scottish Society of Arts,* 3 (1849/1850), pp. 247-251 and plate 20, figure 2.

16. David Brewster, *The Stereoscope; its history, theory and construction* (London: John Murray, 1856), p. 154.

17. This procedure was based on Peter Mark Roget's theory of the persistence of vision published in 1824. The eye's inability to immediately give up the picture it had last seen is at the heart of this theory. See P. M. Roget, "Explanation of an Optical Deception in the Appearance of the Spokes of a Wheel Seen Through Vertical Apertures," read 9 December 1824, *Philosophical Transactions of the Royal Society of London,* 115 (1825), part 1, pp. 131-140 and plate 11.

The Enigma of Dougan 105

Ray McKenzie

Among the varied riches of Glasgow University's Dougan Collection, one of the most brilliant of its minor gems is a small folio of calotypes depicting monuments in Egypt. To anybody viewing these works for the first time, two features will immediately stand out as conspicuous: first, they are strikingly accomplished examples of photographic art; and second, they offer almost no factual information as to when they were made, for what purpose, or by whom. Practically everything that is known for certain about them is contained in the cryptic lines of the shelf catalogue entry under "Dougan 105," in which we read that the folio contains fifty paper negatives and forty-six positive prints, and that included with them are six further views of Paris and Rouen. Otherwise not so much as a faded pencil monogram provides us with a clue to the identity of their authors, and with few exceptions even their subjects are unidentified.

To be confronted with a body of unsigned, undated but unquestionably significant work is an experience no doubt familiar to every *habitué* of picture archives. In this case the paucity of contextual information is so frustratingly complete that despite the enthusiasm the folio has generated among local and visiting scholars in recent years, it has never, to my knowledge, been referred to in the literature of early Egyptian photography, nor has a single image from it been reproduced. I must declare at once, however, that it is not my purpose here to try to rectify this situation in

any more ambitious way than to simply draw attention to the fact that it exists. The solution to the problem of its authorship — the problem around which all other relevant issues revolve — is beyond the scope of this present study, and must await more prolonged research. Nevertheless it may be useful at this stage to record some of the tentative attributions that have been suggested in the past, and to offer some personal thoughts on how the collection might relate to the known pattern of early photographic activity in Egypt.

Generally speaking there have been two lines of speculation as to the possible identity of our calotypist, who for convenience will be referred to simply as Dougan 105. The first is based on the assumption that the presence of the work in a Scottish collection implies that the photographer himself must be a Scot. From here the trail of conjecture leads swiftly to the Edinburgh Calotype Club, a group of passionately dedicated amateurs who functioned as a loose association between 1841 and 1855, and who counted Fox Talbot and Sir David Brewster among their technical advisors.[1] Several members of the group are worth considering as possible candidates. Sheriff George Moir and John Muir Wood, for example, are both known to have worked in northern France.[2] Admittedly this does not take us very close to Egypt, but the group of six views of Paris and Rouen included in the folio are stylistically similar to the work of both, and could therefore represent a link.

A third member, Sir James Dunlop, travelled a little further afield, reaching at least as far south as Malta, and very possibly teaching Robert MacPherson how to use a camera in Rome on the way. Here, too, there are stylistic similarities between his studies of classical monuments, such as the Temple of Neptune at Paestum,[3] and the Egyptian works. The problem in all three cases, of course, is that all the evidence is what Sheriff Moir would object to as being "circumstantial"; it establishes little more than the vague possibility that any one of them may have been to Egypt at some otherwise undocumented point in their career. Also it should be added that the attribution to either Wood or Moir is further weakened by the likelihood that the French and Egyptian works in the folio, which differ significantly in size and manner, are not in fact by the same photographer. One further local possibility is thrown up by the case of P. Hinckes Bird, a calotypist not connected with the Edinburgh group but who is known to have exhibited Egyptian calotypes in Glasgow in the 1850s.[4] Unfortunately this is more or less all we do know about him, so that this attribution too must remain conjectural. Overall, the search for a Scottish identity for Dougan 105 leaves us in the uncomfortable position of having a body of work with no photographer, a photographer with no body of work, and much hazarding of guesses in between.

The alternative line of speculation has been to dispense with the assumption of a Scottish connection altogether, and to base the attribution of stylistic similarities with the work of known photographers whose activities are better documented. The most plausible, and most frequently cited candidate here is the precocious Franco-American archaeologist J. B. Greene, who made several expeditions to Egypt in the early 1850s, and whose highly distinguished work is represented in three albums in the Institut de France.[5] This attribution, however, is no less fraught with problems. As with Wood and Moir, the presence of the French calotypes in the Glasgow folio has been regarded as a crucial link, so that the doubts about their authorship already noted apply equally here. Problematic also is the fact that Greene regularly signed and numbered his negatives, which would make the complete absence of any identifying mark on the Glasgow works difficult to explain if they were by him. Finally there is the question of size. All the Glasgow negatives are within a few millimeters of a uniform 20 x 25 cm. format, and these dimensions do not appear to correspond with any negative size employed by Greene. Obviously none of these factors is conclusive in itself, but taken together the evidence seems to weigh against this attribution, and for the

moment Greene must be regarded as having no greater claim to being Dougan 105 than Bird or his Edinburgh contemporaries.

Having noted all this, however, the introduction of Greene into the discussion at this point does at least have the merit of providing us with a context for pictorial analysis, and thus an opportunity to determine something of the photographic personality of Dougan 105, even if for the moment his identity must remain unknown. In terms of their approach to the medium, and how they used it to express their response to the Egyptian environment, there are in fact some striking similarities. Like Greene, Dougan 105 appears to have understood his own calotype practice as operating within a very precisely defined conceptual framework, which required that it satisfy two very different sets of demands simultaneously. Greene in particular, as an archaeologist, was very much committed to the functional aspects of the medium, and the fact that he sought patronage from the Academie des Inscriptions et Belles-Lettres indicates the degree of confidence he had in its capacity for reliable documentation.[6] At the same time the often compelling lyricism that distinguishes the pictorial end product suggests equally that a more aesthetic imperative was at work as well, and that his understanding of the representational efficiency of the camera was qualified by a more intuitive perception of its power to evoke — through light, space, texture, and so on — the experience of being in one of the strangest places in the world. The essential dualism of Greene's position is well expressed by his practice of distinguishing between different classes of images with a system of coded letters: P for landscapes (i.e., *paysages*), M for monuments, and so on.[7] It is the frequency and skill with which he succeeded in reconciling the disparate terms of this dualism that makes Greene's work a paradigm achievement of its kind.

Though with Dougan 105 there is no such systematic designation of images, the underlying sense of two sets of pictorial criteria vying and interacting with each other is no less pronounced. By far the largest number of works in the folio are representations of individual buildings, presenting them, whenever possible, as structures which are complete in themselves, and from an angle seemingly contrived to yield a maximum of factual information about their appearance. Rarely, however, does this imply the pedestrian literalness of mere documentation. Even in the most straightforward examples there is a subtly understated concern for pictorial effect.

Figure 1. Minarets at Jirjā. Salt print from waxed paper negative, 20 x 25 cm. Glasgow University Library.

Not surprisingly, a much wider range of pictorial devices is to be found in works that are less concerned with buildings themselves, and more with the environment in which they are located, works which Greene would doubtless have designated as *paysages*. In some cases the interpretation depends heavily, and perhaps a little predictably, on the familiar European landscape convention of the Picturesque. A good example of this is shown in Figure 1 , where the varied elements of architecture and vegetation, as well as the rhythmic structure of the underlying geology are marshalled into a satisfying visual whole. But there are others which demonstrate a much more distinctive approach to composition. A typical motif is the presentation of a complex of ruined buildings as a single pictorial mass, stretched frieze-like across the entire width of the picture and framed by agoraphobic expanses of empty space above and below. In one particularly memorable variation on this idea [Figure 2], the impressionistic eloquence of the image is greatly enhanced by the natural graininess of the calotype process, creating an extraordinary anticipation of the late nineteenth-century pictorialism. The blurred mass of vegetation in the foreground brings to mind nothing if not George Davison's "Onion Field" of 1890.

It must be said, however, that this approach was not without its limitations, and that not all the "impressionistic" landscapes in the folio are as successful as this. In the "Approach to the Island of Philae" [Figure 3], a general feeling of the rocky environment certainly prevails. But it is not until we examine it closely that we notice that the Temple of Isis is featured as part of the subject as well. Not only do the buildings occupy the merest fraction of the picture's surface area, but the failure of the calotype process to resolve adequately what little detail there is renders them almost invisible. It is difficult to resist making a comparison with Francis Frith's account of the same subject, in which a more carefully organized composition combines with the crystalline brilliance of the wet collodion process to enable the buildings to tell effectively in their context.[8] They belong to a landscape that dominates but does not overwhelm them.

At the same time we must be careful not to exaggerate the shortcomings of Dougan 105 on the basis of a comparison with Francis Frith. Though we cannot date them with any precision, the Glasgow calotypes are clearly a product of the first pioneering wave of photographic activity in Egypt, which was already a virtually closed episode when Frith published his first series of views in 1858. The very choice of the calotype medium, which had largely

fallen out of favor by this time, suggests as much. But above all it is the fact that the work itself is replete with an unmistakable sense of visual exploration that confirms its early date. By and large, Egyptian photography of the early 1850s is characterized by an ambition to establish a repertoire of convincing views in an environment which was not only unfamiliar in itself, but for which there were few ready-made pictorial solutions to serve as models. Indeed, one of the reasons the work retains its fascination for us today is because it bears all the hallmarks of an artistic and technical struggle. For the slightly later generation of professionals like Frith, who preferred the more commercially viable collodion process, the task was essentially one of consolidating that repertoire into something resembling a tradition.[9] Up to a point, the confidence and artistic control displayed in Frith's "Approach to Philae" are predicated on the more tentative efforts of calotypists such as Dougan 105.

In fact the more carefully we examine this body of work, the more evidence we will find of a genuinely experimental approach. That the photographer was prepared to exploit the wide variety of chromatic and textural effects allowed by the calotype process is demonstrated by several examples in which prints with an entirely different aesthetic impact have been made from a common negative. The remarkable uniformity of the collection generally is sufficient to show that such occasional deviations were not the product of chance, but of calculated technical manipulation. Conversely, there are a number of cases in which more than one negative has been made of a single subject, the differences in the composition often being so slight as to suggest the sort of self-critical indecisiveness we would tend to associate with a creative as opposed to a mechanically documentary approach.

A particularly telling example of this is the "Temple of Wardy Kardassy" [Figures 4 and 5], in which the two versions differ noticeably in the position from which the building is viewed, but still manage to retain an identical interpretation of its structure. In both cases one pair of outer columns has been aligned in such a way that the more forward of the two has obscured its rear companion, while the opposite pair are both visible in perspective; the change of position merely reverses the effect. The photographer clearly had a very firm idea of how the building should read as a formal configuration, regardless of what other factors may be at work, and his manipulation of the effect of parallax to achieve this is so controlled that the pair might almost be regarded as a visual palindrome. At the same time it is interesting to

Figure 2. Temple of Thutmose II, Medinet Habu. Salt print from waxed paper negative, 20 x 25 cm. Glasgow University Library.

Figure 3. Approach to the Island of Philae. Salt print from waxed paper negative, 20 x 25 cm. Glasgow University Library.

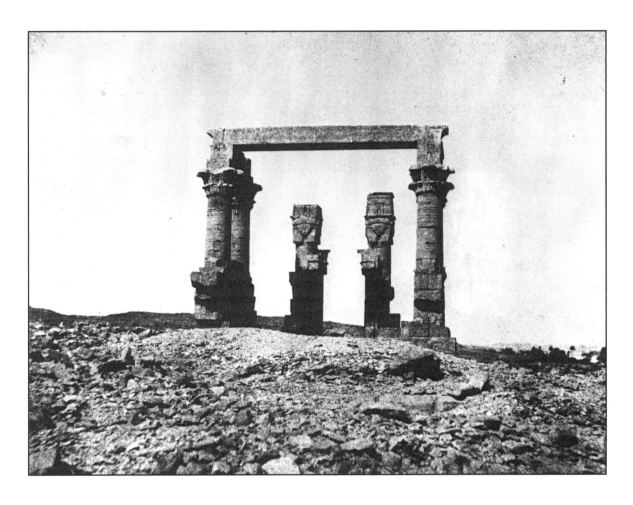

Figure 4. Temple of Wardy Kardassy, Nubia. Salt print from waxed paper negative, 20 x 25 cm. Glasgow University Library.

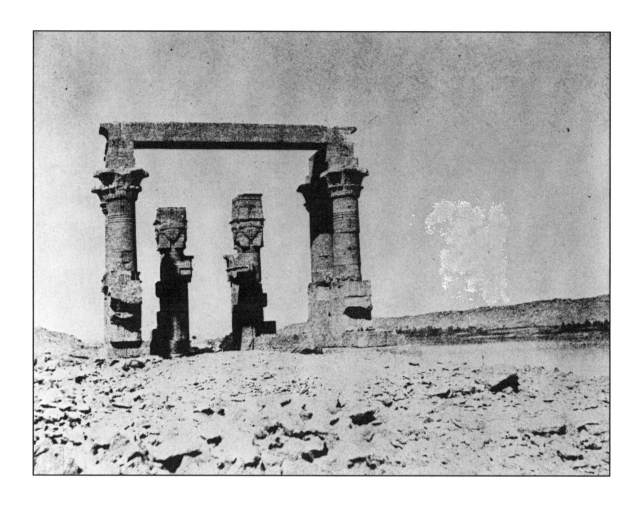

Figure 5. *Temple of Wardy Kardassy, Nubia. Salt print from waxed paper negative, 20 x 25 cm. Glasgow University Library.*

notice that although the image of the building has been preserved in this way, the shift of viewpoint has brought about a significant alteration in its relationship with the surrounding landscape. In the view from the left [Figure 4] the kiosk is placed in the center of the visual field, with very little landscape visible beyond the hill on which it stands, and featuring a heavily accented shadow in the foreground. In the second view [Figure 5] the balance of elements has changed. The swell of the hill beneath the temple is less pronounced, revealing a much larger expanse of both the river and the prospect beyond, while at the same time removing the foreground shadow to a less obtrusive position. So subtle are the changes of emphasis here that one is tempted to wonder whether the photographer regarded one view as more successful than the other — whether, indeed, the second was made specifically to rectify what he felt was an aesthetic flaw in the first. Plainly such speculation would be idle if carried too far, but it may be relevant to record that in the four separate proofs of Figure 5 that survive in the folio, none of them is technically perfect; they all suffer from a light under-printing which has bleached out the lighter tones and caused some of the details in the rocks to be lost. Figure 4, by contrast, is printed only twice, but with the full range

of tones visible. There is reason to believe Dougan 105 regarded the latter as definitive.

Doubtless there are some readers who will object that this discussion is excessively formalistic, and attaches far too much importance to what are after all very minor details of composition. As a line of analysis, however, I feel that it can and must be defended, if only on the grounds that the ability to exercise such rigorous control over the nuances of pictorial structure was clearly important to our calotypist, whose evident willingness to take pains over such matters should at least command our respect. It is, futhermore, precisely through an examination of this kind that we are able to make sense of the work as the product of a particular aesthetic motivation. Given the otherwise paralyzing lack of documentation, this surely provides us with an important tool — perhaps the only reliable one we have — in the task of locating it historically and evaluating it as a contribution to early Egyptian photography as a whole.

What I feel must be conceded, however, is that our discussion has arrived now at a curiously paradoxical point. Detailed examination of the work appears to have disclosed something very real about the personality of its creator, but without bringing us any closer to determining his identity than we were at the start. Perhaps we should not be altogether surprised by this. As a collection, the Glasgow folio is in fact bewilderingly contradictory and incomplete, and there are many aspects of it, the details of which cannot be gone into here, which suggest that it may originally have formed part of a more comprehensive achievement now either lost or buried in an archive elsewhere. As it is, what it presents us with is a *potpourri* of suggestive fragments through which we can sense, but not quite define, the outline of a larger whole. If, as Roland Barthes and the semiologists have argued, photographs are to be thought of essentially as signs for which we ourselves have to supply a code, then the task of making sense of this particular set surely resembles nothing if not the efforts of the early archaeologists to decipher hieroglyphics. Though it will require a far more diligent excavation than has been possible here, I have every confidence that the appropriate code will one day come to light. For the time being, we must be content to leave Dougan 105 as we found him: a small, anonymous figure in a very large landscape.

REFERENCES

1. The main source for the Calotype Club is an album containing over one hundred works in Edinburgh Central Library, which also contains an unpublished essay by C. S. Minto. See also *British Journal of Photography* (November 1874), p. 384.

2. See Jan Coppens, "Scottish Calotypists in Belgium," *The Photographic Collector*, vol. 5, no. 3 (1985), p. 320; and Allison D. Morrison-Low, "John Muir Wood, Calotypist," *Scottish Photography Bulletin* (Spring 1987), p. 14.

3. Edinburgh Calotype Club album, plate 66.

4. *Catalogue of Photographs Exhibited at the Meeting in Glasgow*, British Association, September 1955. I am grateful to Julie Lawson for drawing my attention to this.

5. Bruno Jammes, "J. B. Greene, an American Calotypist," *History of Photography*, vol. 5, no. 4 (October 1981), pp. 305-324.

6. Bruno Jammes, "J. B. Greene, an American Calotypist," p. 307.

7. Bruno Jammes, "J. B. Greene, an American Calotypist," p. 309.

8. Francis Frith, *Egypt and Palestine Photographed and Described* (London, 1858-60), vol. 2, plate 10.

9. For a fuller discussion of this issue, see Gerry Badger's introduction to "Early Egyptian Photography," *Creative Camera* (December 1979), p. 429.

Hans Thøger Winther: A Norwegian Pioneer in Photography

Robert Meyer

Little is known internationally about the Scandinavian history of photography, because few photohistorians have done research in this field and Scandinavian publishers have not found the field to be a research area worthy of their investment. Thus the Norwegian inventor of photography, Hans Thøger Winther, is hardly known outside of Scandinavia. Photohistorians Beaumont Newhall and Helmut Gernsheim do mention my research on Winther in their histories.[1] The only other international presentation of Hans Thøger Winther is due to Wolfgang Baier,[2] who relied in large part on the earlier research of the former archivist at the Technical Museum in Oslo, the late Rolf A. Strøm, who wrote an interesting article on Winther in 1958.[3]

A BRIEF BIOGRAPHY

Hans Thøger Winther (1786-1851) was born in Thisted, Denmark, when Norway was still under Danish rule. At the age of fifteen, in 1801, he moved to Christiania (Oslo) with his parents. Here he was educated as a lawyer and by 1815 was appointed attorney-at-law for all of the Superior Courts of Norway. In 1814, Norway gained freedom from the four hundred years of Danish rule and entered the union with Sweden. As Winther had lived for so long in Christiania, had been educated in Norway, and had family and career there at the time of liberation, he naturally became a Norwegian citizen and looked

upon himself as entirely Norwegian. In 1822, he opened a bookshop with a music rental library, and early in 1823 he established the first lithographic press in Norway. Two years later, book printing was added to the enterprise. Music was his initial publishing interest, but he soon turned to pictures and smaller books. As the enterprise grew, one periodical after another came into being. In 1834, he started the first popular illustrated magazine in Norway, *Archiv for Læsning eller Norsk Penning-Magazine*, after the popular international model. Because he had his own lithographic press, he did not need to depend on the numerous xylographic illustrations offered in stereotype by the large circulated magazines, such as *The Penny-Magazine* and *Magazin Pittoresque*. He had the advantage of superior reproduction quality, and could use original pictures of Norwegian origin. During his active period as editor (1822-1847), he became one of the dominant publishers in Norway. With a serious interest in the diffusion of knowledge, and his love for the Norwegian culture and history, he devoted his production to his concerns with the development of science, industry, arts and handicrafts, in addition to mythology and legends, history, poetry, and easy reading. When Daguerre's invention of photography was announced in the daily newspapers in 1839, Winther immediately understood the importance of the new art, and chronicled in his own magazines the events as they developed.

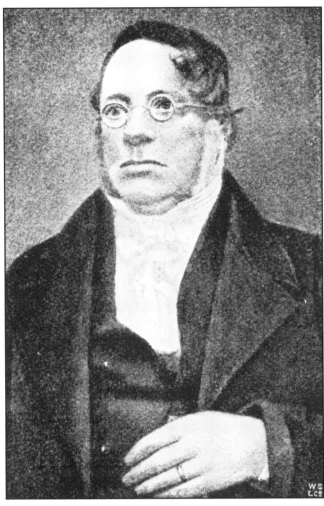

Figure 1. Hans Thøger Winther (believed to be a self portrait).

Without a doubt, Hans Thøger Winther was the first in Scandinavia to make photographs and to claim to have made independent inventions in photography. In July 1839, he had drafted a document — his testimony affirmed by witnesses — sealed it in an envelope, and deposited it in the custody of a third party.[4] Winther then awaited the publication of Daguerre's invention, as he truly believed that he had solved the secret of Daguerre's process. But the daguerreotype process turned out to be based on a different principle altogether.

Instead of publishing his own results at that point, Winther continued his experiments. In May-July 1842, he advertised a book about his discoveries, but received little response.[5] Because he discovered a new process at the end of July 1842, he decided to

postpone publication. He hoped to have the book out on the market before the Scandinavian Natural Scientific Meeting in Christiania in the summer of 1844, but he failed to meet that deadline. In the meantime, he published five of his own photographs to create more interest in his process of photography on paper. In 1844, he again advertised for book subscribers, and finally the book was released in May 1845.[6] The novelty had been lost, however. By that time, daguerreotypes were common, as the first daguerreotype studios had been open in Christiania for a couple of years.

WINTHER'S HANDBOOK

Hans Thøger Winther's 1845 book was the first handbook on photography on paper in Scandinavia. The book presents his own processes, which are entirely based upon his own research and inventions, and includes his own design for the construction of a photographic camera outfit with interchangeable lenses. The book's full title was *Anviisning til paa trende forskjellige Veie at frembringe og fastholde LYSBILLEDER paa Papir, som Portraiter af levende Personer, Prospecter efter naturen, Copier af Malerier, plastiske Gjenstande, Kobbere, Steentryk, Blade af Planter &c, deels ved at benytte Cameraobscura, deels et til Copiering indrettet Instrument. En Opfindelse af H. T. Winther. Overrets-Procurator (Christiania 1845)*. Simultaneously, a German edition was published: *Anweisung auf drei vershiedenen Wege Lichtbilder...auf Papir hervorzubringen und festzuhalten (Christiania 1845)*. Today, Winter's book is a rare and highly original work on the subject of photography, with sixty-four pages and one lithographic plate. In an introductory chapter, he recounts the brief history of photography, from Davy, Wedgwood, Niépce, Daguerre, and Talbot, to Kobbel and Steinheil, and includes his own story. In the first chapter, he explains the camera equipment and refers to the plate illustration. In the following chapters, he explains the three photographic processes he developed during the period 1839-1842: the direct positive process; the paper negative/positive process; and the reversal process. The book includes a separate appendix that provides the chemical formulas. Originally, the appendix was sealed in a separate envelope, and the book could not be returned for a refund if this envelope had been opened. The selling price was one Specie Daler. Daguerre's handbook had been translated and published earlier, in October 1839 in Denmark,[7] and in Sweden three months later, in December 1839, in the form of a small booklet.[8]

Figure 2. Title page of the Norwegian edition of Winther's Handbook, 1845.

WINTHER'S FIRST PROCESS

To understand Winther's contributions to the history of the medium, we need to see him in relation to other inventors of photography and compare his achievements with those that were written about in contemporary publications. Hans Thøger Winther was neither the sole nor even the first inventor of photography, but he did discover several original solutions to the basic problem of preserving the elusive image of the camera obscura.

Winther's first method of making photographs was a direct positive process on paper, which through his writing in 1839 can be dated to June 1839. At this time, he could hardly have had knowledge of other

inventors in the field. In 1839, both Jean Louis Lassaigne in France and Andrew Fyfe in Scotland discovered the same direct positive method and made their processes publicly known. In 1840, Sir John Herschel in England, and François Vérignon and Hippolyte Bayard in France, published similar processes. Later, even Dr. Alexander Petzhold (Dresden, Germany), Karl Emil Schafhäutl (Munich, Germany), Sir William Robert Grove (England), Alphonse Louis Poitevin (France) and others were doing the same. Winther had probably experimented further with Talbot's fixing agent of March 1839, described in "An Account of the Process Employed in Photogenic Drawing."[9] Here Talbot described the use of potassium iodide as a fixer. It seems as if Talbot himself had not yet observed the light-sensitive properties that the iodide fixer contributed through bleaching. The fixing method was due to an excess of silver iodide (or any other silver halide), which deprived the silver chloride of its light sensitivity. The iodide solution also functioned as a light-sensitive bleaching agent. The method was as simple as preparing a "photogenic" (sensitized) paper and exposing it to sun or daylight until it darkened with a blue-violet hue. It was then soaked in a weak solution of potassium iodide. When moist, the sensitized paper was quite light-sensitive, and would record even the faint image of the camera obscura of Talbot's day. Although Talbot's invention is best known to us today, several other people shared in the discovery of this principle, as we have seen, and most direct positive processes published resemble each other, even though Talbot included the method in his patent number 8842 (1841). From this we can assume that Winther not only followed the latest developments of the daguerreotype process but was aware of publications of other photographic processes as well.

Winther took the process somewhat further than his competitors, however. Because the process depends on the liberation of iodine during the exposure to light, the starch that was found in most papers was discolored to blue, and this is actually used today as a test for the presence of starch. This discoloration attacked only the light areas of the image, and so discoloration destroyed the quality of the visual image, as white areas became dark blue. Rather than accept this shortcoming, Winther looked for a method of removing or reversing the effect. He found that magnesia alba (magnesium oxide) achieved the desired effect so that the iodine was removed, the starch regained its whiteness, and the image was cleared of the blue cast.

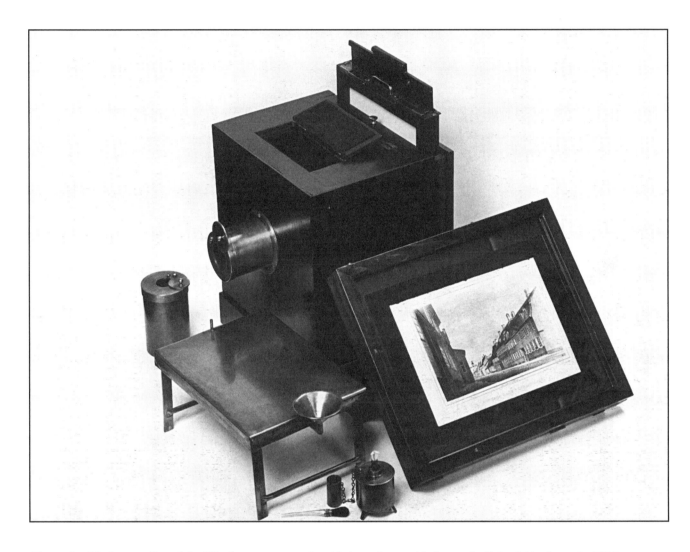

Figure 3. Modern replica of the Winther camera outfit with interchangeable lenses, built by I. Dyrhaug in 1976. The Robert Meyer Collection.

WINTHER'S SECOND PROCESS

Winther's second invention, the negative/positive process, resembles Talbot's calotype process, except that Winther did not use gallic acid. Instead, he found another, even stronger developer in the extracts of sumac. We should not be too eager to credit Talbot with the discovery of using organic reducing agents as developers. During the autumn of 1839, the chemist and medical doctor Alexander Petzhold of Dresden wrote that organic acids like gallic acid, tannin, and others actually reduced silver salts in a photogenic paper. His publication, "Über Daguerreotypie," is dated August 6, 1839.[10] Another article, "Petzhold's Methode Lichtzeichnungen Darzustellen," was published November 15, 1839, and referred to the same findings.[11] There are reasons to believe that these papers were widely read in European scientific circles.

WINTHER'S THIRD PROCESS

The third process is the most interesting, as Winther was the sole discoverer of this peculiar reversal photographic process on paper. The method was developed late in June 1842, and the light sensitive material was potassium dichromate. After exposure, Winther reversed the image and developed a positive representation using silver chloride, thus bringing out the lights and shadows with a purple-bluish hue on the surface of the paper. The pictures were different from other photographs on paper, where the light areas are due to the white base of the paper. In Winther's images, the white areas are developed chemically. An anonymous person was shown the first results of the process early in August 1842 in Winther's bookshop. That witness wrote an article in a newspaper about his encounter: "The principle for one of these methods, the one he [Winther] just recently discovered, and in which he finds pleasure, is founded on a *so far unknown chemical factum*. The specimens of this process, which are on view, are all successfully done....If Winther had lived in London, in Paris, or one of the major German cities, he would have had great success with his discovery."[12]

The use of potassium dichromate was not new. The first photographic use of the chromium salt was proposed by the vice president of the Scottish Society of Arts, Mongo Ponton.[13] The French scientist Edmond Becquerel published another process, also based on Ponton's discovery.[14] Becquerel utilized the discoloration of starch by the iodine, ending up with a blue positive image. Robert Hunt, the eminent English chemist, published a process he named

"Chromatype," though his process employed a different use of the chromium salt. Hunt's process was officially announced during the Cork Meeting of The British Association in August 1843,[15] and described in his manual, *Researches on Light* (1844).[16] Robert Hunt's "Chromatype" process was not published in Norway until 1845.[17]

Winther's only problem with this third process was the low sensitivity of the potassium dichromate. Accordingly, he wrote letters to the most notable scientists of his time in Scandinavia, including Professor Jøns Jacob Berzelis (Stockholm, 1779-1848), and Professor Hans Christian Ørsted (Copenhagen, 1777-1851), and to Professor Ludwig Ferdinand Moser (1805-1880) in Königsberg. In some of the letters, which have been preserved, he explained that he was looking for an agent or chemical compound that could increase the light sensitivity of the potassium dichromate. In his first letter to Berzelius, he wrote, "With the potassium dichromate I have developed especially beautiful renderings, and if it could be made sensitive enough for the camera obscura, one could make positive pictures on paper, that would not be inferior to the daguerreotype, that would be less expensive, and could be used with greater safety of operation, and that would have the peculiarity of producing pictures in many beautiful shades of colors, and thus a lot would be won for the Arts and Sciences."[18]

Winther postponed the publication of his book, so that he could improve his third process to make it a more workable photographic method, based on the same principles. None of the scientists with whom he corresponded seemed to have been of much help. At last, and many years too late, he finally printed the handbook. It was first advertised on May 4, 1845, in Christiania, and in other Scandinavian capitals, as well as in southern Germany.

WINTHER'S PHOTOGRAPHS

In 1826, Winther had built a camera obscura. His intention was to make a series of views for the lithographic press, though nothing came out of that project. Later, however, several series of Norwegian lithographic views were issued, by Winther and others. The camera obscura would give him an opportunity to get true representations of the views. During the summer of 1826, Winther recounts in his handbook (p. 7) that one of his children left in the camera obscura a small piece of paper impregnated with the juice of berries. During a three-month exposure with bright sunlight, the faint image of his white garden house became visible on the paper, due

Figure 4. Hans Thøger Winther. "Prospect af Bankbygningen i Christiania" ("View of the Bank Building in Christiania"), "Norsk Penning-Magazin, "Christiania (September 1842), plate 9, 12.4 x 18.2 cm. The Robert Meyer Collection.

Figure 5. Hans Thøger Winther. "Kongens Gade i Christiania - Efter Lysbillede af Winther" ("The Kings Street in Christiania - From a Photograph by Winther"), "Ny Hermoder," Christiania, vol. 5/18 (May 10, 1843), Winthers Steentryk, Nissen lith, 12.6 x 20.2 cm. The Robert Meyer Collection.

SLOTTET VED CHRISTIANIA.

Figure 6. Hans Thøger Winther. "Slottet ved Christiania - Efter Lysbillede af Winther" ("The Royal Castle Near Christiania - From a Photograph by Winther"), "Ny Hermoder," Christiania, vol. 5/21 (June 1, 1843), Winthers Steentryk, Nissen lith, 13.9 x 20.2 cm. The Robert Meyer Collection.

to bleaching. When he learned about Daguerre's invention in February 1839, he remembered the incident of 1826, and in the hope of solving Daguerre's secret he began his own experimentation with the juices of fruits, extracts of litmus, and silver salts. Most of his experiments employed contact prints in the traditional way, with leaves and pieces of lace. As he managed to control and improve the process, he acquired better equipment. In his letters to Berzelius, he also refers to his "Voigtlanderske" instrument, which probably refers to the optics. Because he needed a camera with special functions for moist paper photography, he constructed his own practical wooden camera. But he probably bought the best lenses he could find, lenses with the largest lens opening and the highest definition that he knew of: Voigtlander. I believe that all his known camera images were taken with these lenses; the formats do not change. While experimenting and researching the photographic processes, Hans Thøger Winther exhibited the results in the book store, for everybody to see. He also advertised these exhibitions in the newspapers. From 1842 on, he published some of the photographs in his own magazines, using hand-worked lithographs for reproductions. The five different views that were issued are all we have left of Winther's own camera photographs, as far as I know. The motifs are street scenes and new buildings in Christiania of the day (1842):

1) *"Prospekt af Bankbygningen i Christiania"* ("View of the Bank Building in Christiania"), published September 1, 1842;

2) *"Frimurerlogen i Christiania"* ("The Freemasonry Temple in Christiania"), published February 21, 1843;

3) *"Grunnings Løkke ved Christiania"* ("Grunning's Garden near Christiania"), published April 8, 1843;

4) *"Kongens Gade i Christiania"* ("The Kings Street in Christiania"), published May 10, 1843;

5) *"Slottet ved Christiania"* ("The Royal Castle near Christiania"), published June 1, 1843 .

The choice of topics fits perfectly his original idea of publishing typical Norwegian views, so we can easily place the interest in photography in the same context as the production of views. In his subscription notice for the book, he stated, "I am convinced that my invention and method will be useful for Art and Science....The travelling scientist can, without prior knowledge of drawing, enrich his portfolio with views, monuments of the past, objects of natural history, etc. The landscape painter may, in a couple of minutes, record the view he wants to paint, with all its details, and with an absolute correctness of perspective, and avoid the troublesome drawing,

especially of many unnecessary objects that, nevertheless, are of importance and give the painting greater truth."[19]

AFTER 1845

Hans Thøger Winther's photographic endeavors did not bring much advancement to photography in Scandinavia. The processes were never used for professional purposes, as far as I know, though he did encourage amateur photography in 1845. A young farmer's son, Amund Larsen Gulden, from Hadeland, a Norwegian land-district, became interested in Winther's photography on paper and worked with his processes for some time during 1845-1846. He even bought a cheap model of the Winther camera, made of cardboard by one of the bookbinders in Christiania.[20] Winther himself quit photography and continued to pursue other inventions. In 1846, he invented eyedrops that enabled people to see better in the dark winter evenings, candles that gave more light, and a new sort of black ink, that could be seen immediately as it was used for handwriting.[21] All of these invention came out of pure necessity, as the sixty-one-year-old Hans Thøger Winther probably was losing his eyesight. In 1847, Winther let others take over his printing press and workshop, and he retired from publishing. There is nothing left from Winther's photographic activity, apart from the published materials and his letters. After his death in 1851, the family seems to have gotten rid of everything. The same year, they held a book auction, and Winther's rich holdings of books, including much of his private library, were sold. Winther's last traces were swept away when his daughter and son-in-law tore down his old house and built a grand new house on the same property.

REFERENCES

1. Beaumont Newhall, *The History of Photography from 1839 to the Present* (New York, 1982), p. 25; Helmut Gernsheim, *The Origins of Photography* (London, 1982), pp. 235-237, and note 5, p. 272; Helmut Gernsheim, *Le Origina della Fotografia* (Milano, 1981), pp. 219-221, and note 5, p 252; Helmut Gernsheim, *Geschichte der Photographie: Die Ersten Hundert Jahre* (Frankfurt am Main, 1983), p. 188, and note 4, p. 744.

2. Wolfgang Baier, *Quellendartellung zur Geschichte der Fotografie* (Leipsig, 1966), pp. 110ff, 114, 335.

3. Rolf A. Strøm, "Hans Thøger Winther," *Volund* 1958, Norsk Teknisk Museum (Olso, 1958), pp. 138-158.

4. Hans Thøger Winther, *Anviisning til paa trende forskjellige Veie at Frembringe og fastholde LYSBILLEDER paa Papir* (Christiania, 1845), p. 12.

5. *Morgenbladet* (Christiania, May 30, 1842) no. 150, p. 2; Hans Thøger Winther, "Kunsten at fastholde Lysbilleder," *Norsk Penning-Magazin* (Christiania, 1842), vol. 9, no. 7, pp. 219-222.

6. *Morgenbladet* (Christiania, May 30, 1842) no. 154, p. 3.

7. Jacques Louis Daguerre, "Praktisk Beskrivelse af Fremgangsmaaden med Daguerreotypen og Dioramaet af Daguerre," *Nyt Magazin for Kunstnere og Haandvere* (Copenhagen, 1839), no. 15 (October 31, 1839), pp. 126-128, and nos. 16-17 (November 7, 1839), pp. 129-148. The publication included one lithographic illustration. A fascimile reprint was published in *Norsk Fotohistorisk Journal* (Oslo), vol. 1, no. 4 (1976), pp. 69-96.

8. *Aftonbladet* (Stockholm, December 23, 1839).

9. "An Account of the Process Employed in Photogenic Drawing," in a letter to Samuel Christie, Esq., Sec.R.S., from H.F. Talbot, Esq., F.R.S., *London and Edinburgh Philosophical Magazine and Journal of Science* (March 1839), pp. 209-211 (read before the Royal Society on February 21, 1839).

10. Dr. Alexander Petzhold, "Über Daguerreotypie" (dated August 6, 1839), *Journal für Praktische Chemie, von Erdmann und Marchand* (Leipzig), vol. 18, nos. 1-2 (1839), pp. 111-112.

11. "Petzhold's Methode Lichzeichnungen Darzustelen," *Dinglers Polytechnisches Journal* (Stuttgart), vol. 74, no. 4 (published November 15, 1839), p. 316. This article refers to Erdmann and Marchand's journal in the preceding reference.

12. Anonymous, "Kunsten at fastholds de i camera obscura dannede Lysbilleder paa Papiir," *Den Constitutionelle*, no. 219 (August 7, 1842), p. 3.

13. Mungo Ponton, "Notice of a Cheap and Simple Method of Preparing Paper for Photogenic Drawing, in Which the Use of Any Salt of Silver is Dispenced With," *The New Edinburgh Philosophical Journal*, Edinburgh (July 1839), pp. 169-171.

14. Edmond Becquerel, "Note sur un Papier Impressionnable à la Lumière, Destiné à Reproduire les Dessins et les Gravures," *Comptes Rendus des Séances de l'Académie des Sciences* (Paris), Monday, March 16, 1840, p. 469-471. See also Edmond Becquerel, "Über ein für das Licht Empfindliches Papier zum Copiren von Zeichnungen und Kupferstichen," *Dinglers Polytechnisches Journal* (Stuttgart), vol. 76, no. 4 (1840), pp. 301-303.

15. Robert Hunt, "On Chromatype, a New Photographic Process," *Notices and Abstracts of Communications to the British Association for the Advancement of Sciences at the Cork Meeting* (August 1843), pp. 34-35.

16. Robert Hunt, *Researches on Light* (London, 1844), pp. 150-151.

17. Anonymous, "Papier til Lysbilleder," *Skilling-Magazin*, no. 20 (May 17, 1845), p. 160.

18. Hans T. Winther's letter to Jøns Jacob Berzelius, November 26, 1843 (The Royal Library, Stockholm).

19. Hans T. Winther, "Kunsten at Fastholde Lysbilleder," *Norsk Penning-Magazin*, vol. 9, no. 7 (Christiania, September 1842), p. 221.

20. Robert Meyer, "Amund Larsen Gulden: Norges Første Amatørfotograf," *Hadeland* (May 30, 1981), p. 5.

21. Hans T. Winther, "Godt og Paalideligt Sort Blaek," *Morgenbladet*, no. 87 (March 28, 1846), pp. 1-2; Anonymous, "Hr. Overretsprokurator H.T. Winthers sort-af-penn-flydende Blaek," *Morgenbladet*, no. 12 (April 21, 1846), pp. 2-3.

"A Truth that Art Cannot Achieve"
The Scientific Environment in Venice
and the First Inquiries into Photography (1839-1846)

Paolo Costantini

I. In line with the enthusiasm and the tendency of society in the "positivist century" to reach out completely for that "modern progress," idealized by Cattaneo in the pages of the *Politecnico*, the years immediately following the news that spread about the invention of photography (in 1839) saw in Venice the assertion of scientific curiosity towards this new medium. People emblematic of this reality in transformation (physicists, chemists, astronomers, mechanic-opticians, naturalists, and botanists) crystallized this "curiosity" in a series of pioneering initiatives to spread the principles, to investigate details and scientific implications, to search for possible applications and developments for that process that "requires the most accurate and scrupulous exactness." The Venetian scientific environment (Venice and Padua, principally, but also Verona and Vicenza) appears in this period, on the Italian scene, among the most active centers for going deeper into theory and doing the first practical experiments in photography.

Conjecture, research, observation and experiments multiply in Venice as soon as the incomplete news about the invention comes from Paris. Apart from the many Venetian reports—after Milan, the Italian cultural center which follows the events most closely—timely communications come from the newspapers of Verona, Trieste and Rovereto.[1] Originality and usefulness to the arts, the speed with which it can be carried out, and the valid help that the

sciences find in photography, are the aspects which characterize the way in which the news of Daguerre's "marvelous discovery" also spreads in Venice. Here, the attention to the precise and mechanical registration of natural things, also found in the intentions underlying the landscape-painting genre, is reaffirmed in a surprising way, to be finally found in a concrete and ultimate achievement in a process that radically modifies "the field of techno-scientific research, but also directly that of artistic production, and perhaps even of aesthetics."[2]

The innovative importance of the new means, destined to upset the traditional ways in representing the real, is clearly and immediately recognized in the first reports of the invention that appear in Venice on Friday, January 18, 1839, in the general columns on the fourth page of the only daily newspaper the *Gazzetta Privilegiata di Venezia*. This article reports, with a delay of three days, the news of the "important discovery" which had appeared for the first time in Italy in the columns of the newspaper that is published in the new Italian cultural capital, the *Gazzetta Privilegiata di Milano*:

> Any kind of scene, of landscape,
> a portrait which can be done in a few
> minutes without the intervention of
> the artist, and with a truth (less the
> color) that art cannot achieve, this is
> the most perfect picture. . . . This is a
> complete revolution in the art of

painting and engraving; nature itself
can be reproduced in the wink of an eye,
without the cooperation of man. Today
we are only describing the marvelous
discovery of Mr. Daguerre.[3]

The subjects that, from this moment on, marked by a characteristic alternation of the work's appraisal with the value of help from a technical standpoint, accompany all the discussions on photography are highlighted in the very first reports: the astonishing precision even in the most minute detail; the speed with which it is carried out; the fidelity—"less the color"— and the precision of the reproduction of nature, which are in fact elements wholly alien to traditional artistic creation (with which new relations are now conjectured which seem to be able to exclude the arbitrary intervention of man). The photographic *event* literally upsets the means of referring to reality in the nineteenth century. The subject, projecting itself somewhere else, frenetically tends towards an idealized future, towards a yearned-for modernity. The daguerreotype proposes the possibility of reaching the prodigious "demiurge-like" achievement of the eighteenth-century dream of fixing the ephemeral image of nature through the action of light. The mechanical reproduction and the divine prodigy of the image produced by the daguerreotype are both present in the attempt to explain this "admirable painting," in which, as the first French comments affirm, "vous assistez, à proprement dire, à une création veritable, c'est un monde qui sorte du chaos."[4]

Impressions and information on the first "views" which went round Paris, spread through Venice with notable speed, indicative of the importance as a social phenomenon, of the curiosity aroused at this event: "But the astonishment was even greater when these pictures, examined with powerful lenses and microscopes, revealed everything, even the smallest details of the original, which, reproduced in miniature, are not visible to the naked eye."[5] Photography is proposed in this period, established and spread later on, through the opinions and the experimental research of the scientists who are the first to understand the potentiality of the possibility of its uses, as a magnifier of the *imperfect* organ of sight used to penetrate into the many obscure parts of reality:

> And so photography becomes the
> indispensable collaborator for every
> science founded on observation; and
> not only due to the ease with which
> it can multiply infinitely the copies
> of all man's manifestations and the

phenomena of nature which can be
given a form; but also, and more so,
because in the acquired sensitivity
this finds a way of making up for the
imperfection of our senses, and to
show us the invisible; it is this which
gives it a true value and a powerful
method for scientific analysis."[6]

In this period there is a progressive identification of photography as an "instrument" understood as an extension of man's senses, in order to understand nature completely. "The daguerreotype...should spread throughout every class of scientist, and even among people who know nothing of physics," affirmed the physicist Macedonio Melloni, presenting his *Relazione intorno al Dagherrotipo (Report on the Daguerreotype)* to the Royal Academy of Sciences in Naples, on November 12, 1839, a text which was to be immediately successful, constantly discussed in Venetian scientific circles. Melloni repeats and emphasizes what has already been stated in France, and shows the Italian scientists how "the ingenious discovery of Daguerre will become extremely useful to Science, not only to render easier and more precise the pictures of the bodies belonging to the three reigns of nature, but also to give the physicists a new means to measure the chemical irradiation of light and investigate its unknown properties." [7]

The discovery of infrared and ultraviolet light and the light-wave revolution caused a sensation at the beginning of the nineteenth century, even if "no one revealed the crisis which had been reached in the concept of light which the physicists had at that time."[8] The introduction of new instruments to study and measure light, and in particular the affirmation of the photographic process, however, make those physicists increase their experimental investigations in little-known fields.[9]

II. "There are many different reasons for loving, for admiring the brilliant invention of photography, which will be the honour of our century," writes Louis Figuier under "Photography" in the volume entitled *A History and Exegesis of the Principal Modern Scientific Discoveries*, of which the first Italian version, based on the third Parisian edition of 1853, was printed by the Venetian printer Grimaldo in 1855, emphasizing above all "the luminous testimony of the potency and importance of physical science in our age."[10]

Without a doubt at its first impact and for a long time after, photography above all in Italy was placed under the protection of the promoters of scientific, technical, and economic progress. It is possible to

read the connection between the bourgeois modernity which Carlo Cattaneo dreamed of—impatient with the Italian delay in "modern progress" — in the pages of *Il Politecnico* ("a monthly inventory of studies applied to social prosperity and culture" which came out in Milan in 1839), and the news on the light-graphic process by Daguerre which appears in that year in the same newspaper, which, as a note in the index of each six-monthly issue reminds us, "concerns <u>Art</u> in its widest and most complete sense of applying human knowledge to the habits of the most cultured society. Therefore it covers not only the application of physical and mathematical science, but also the economy and other social studies, education, linguistics and other disciplines which promote the development of the intellectual faculties, and finally the art of the word and all the *imitative* arts." However, the defense of photography "as a means of expression richer in technical resources and so superior to any manufactured article," which can be seen in 1839, reveals a tradition-based culture and becomes, as Bollati states, "a precious document on the encounter between aesthetic aristotelianism and the new positivism, an encounter of this kind only possible in Italy."[11]

While the first Italian experiments begin, which, in the last months of 1839, occur in rapid succession (in Florence, Turin, then Milan, Naples and Trieste) "photographic science" begins to be discussed, still unknown to the scientists: "In front of such an original series of operations and linked to connections wholly alien to whatever methodic induction, science remained for a while astonished and silent," says Melloni; "the best physicists, however, confess that the daguerreotype process cannot even be explained satisfactorily; which makes it even more interesting to the professors," echoes *Il Politecnico*.

Giovanni Minotto in the *Gazzetta Privilegiata di Venezia* in August 1840 writes, "We would not like somebody to think that Venice remained a slothful admirer of the work of others," in relation to "some scientific work recently done in Venice."[12] A professor of physics and mechanics, Minotto mentions the studies of Francesco Zantedeschi on dynamic induction, and of Pietro Magrini on the "mathematics," and also alludes to the *Supplimento* to the *Nuovo Dizionario Universale Tecnologico o di Arti e Mestieri* (the *Supplement* to the *Universal Technological Dictionary of the Arts and Professions*), ["a compilation of the best scientific and artistic works published recently . . . and extended to what concerns Italy in particular"] which was published in the first Italian translation by the Venetian editor Giuseppe Antonelli, "only for this do we believe to be extremely

valid." In the sixty-ninth issue of that publication ["produced by a group of experts, with the addition of an explanation of all the entries on the Italian arts and profession, of many corrections, discoveries and inventions taken from the best works recently published on these subjects...works interesting to every class of person..."], the same Minotto had written an extremely long essay under the entry *Photography*, one of the first and most thorough Italian comments on the new invention, that the same author had contributed in spreading during the year in a series of important articles in the *Gazzetta Privilegiata di Venezia*.[13] Minotto describes in detail Daguerre's method "extracting the details in this from the many articles on this subject," and comparing it with that of Talbot from England, he recognizes "fully" the priority of the Frenchman. Confessing that "Regarding the many articles I come across which have some points which are not emphasized enough and which leave some uncertainty," and above all that "Daguerre's pictures," could not be seen, Minotto has to limit himself to "simple conjecture," mentioning, at the end of his essay, "some imperfect endeavors which we had occasion to see here in Venice," which have disappeared.

The long entry on photography—"the name of a wholly new art whose aim, as shown by its etymological origin (from the Greek words for *light* and *to describe*) is to obtain pictures or images formed by light"—is now recalled to underline the Venetian attention to the progress of the century: " . . . for example, Daguerre's methods referred to the article *Photography*, at the end of last year, first published by him, indicating the various practices known then with some of our observations of these. Not long after, as if the minds had been relieved of all worry, when Zantedeschi obtained a daguerreotype, we all wished to fix the transient images produced by light, and extremely beautiful copies were taken of the Palazzo of Casa Pesaro, the Rialto Bridge, and other of the many majestic monuments, honourable witnesses to the ancestral greatness of Venice. In doing these experiments, it was observed that, already noticed by others, yellow rays did nothing, and also that some bronze objects projected a colour onto the plate analogous to their natural colours, while images of other red objects projected a rosy colour...."[14]

So Minotto identifies in Francesco Zantedeschi one of the very first experimenters of the daguerreotype in Venice. He is a scientist studying physical and electromagnetic phenomena to which he dedicates continuous research and a high number of memoirs, a fellow through correspondence of the principal European scientific societies and member of the

Istituto Veneto from its founding on, then teacher of physics at the Liceo S. Caterina in Venice and after, at the re-opening of the universities after the period of 1848, professor of physics at the University of Padua. Zantedeschi shows an interest in photography— revealed also through what Minotto says—principally in investigating the chemical action of light, which the daguerreotype stimulates among the scientists.[15] "There is still a lot to learn about the effect of light and heat in chemical actions....Let us continue to experiment, communicate to one another our results, give one another a hand, uplift one another when mistakes are made, and progress will be more ready and sure. May this new era for scientists and scholars arise!" states Zantedeschi in a memoir of 1845.[16]

Proceeding to examine other "scientific works," Minotto concludes by observing that "this long enumeration, albeit rapid, shows that in the pathways of Science, Venice is not inferior to other cities, and that its future promises more prosperous results, as the sovereign munificence wished to grant the I. R. Institute to maintain and inspire it on the road to progress." On July 26, 1840, sessions in the Venetian Institute of Science, Letters and Arts started, the Institute becoming immediately a center for scientific debates, but above all cultural in a more general sense, of the "lagoon metropolis." Among its members, personalities such as Angelo Zendrini, studying lagoon matters, Giusto Bellavitis, a well-known mathematician, Pietro Paleocapa, hydraulic engineer and politician of the first rank (he was the minister of Home Affairs under the Republic of Manin), the same Giovanni Minotto (physicist and vice-president of the assembly, again with Manin), Giuseppe Japelli, architect, and correspondents such as Emanuele Cicogna, among the most learned Venetians, the Romantic poet Luigi Carrer, and Nicolò Tommaseo. Giovanni Minotto, who collaborates right from the beginning of the Institute —introducing photographic subjects immediately — takes advantage of this important cultural event to remind the people, not without rhetoric, of the scientific-productive activity which was spreading through Venice: from the manufactures to the arts, from the technical schools to the museums, from the commercial societies to communications (now notably increased due to the construction of the railways), initiatives which reveal, for Minotto, the activities of the city in a "tacit but undisputable refutation of those foreign writers who call it decadent."

In 1840, a series of experiments were conducted on this "new art," in the Venetian area. It is still Minotto who continues to inform the Venetian readers of the most interesting results obtained: among all of them,

those obtained by the mathematics teacher at the Veronese secondary school, Giacinto Toblini, who in October of that year succeeded in fixing "the portrait of some people with incomparable clarity of outline, and a marvelous precision in the colours."[17] Meanwhile, In Padua, Gaetano Sorgato had published in June, on the occasion of the wedding of a local noblewoman, a brief outline of the new process which "by now there is no one who has not heard of its name and fame." Sorgato refers to the "many and lovely tests" that the professor of physics and natural history Abbot Tommaso Zannini carried out in Padua, of which "whoever saw them deemed them to be really marvelous."[18]

The year after saw the publication of an important scientific analysis of photography by Ambrogio Fusinieri, physicist in Vicenza and Fellow of the Istituto Veneto. In the *Annals of Science in the Lombard-Venetian Kingdom*, in the essay "On photographic pictures, and the chemical actions of light," he re-proposes the subjects which had caught the attention of the scientists.[19] "The chemical actions of light were very little known before these inventions," states Fusinieri, "so that scholars were right to wonder at such an interesting and unexpected effect, occurring by chance, at first difficult to explain using well-known scientific principles....The first study, the most important for science, to investigate the chemical actions of light....resulted in a great number of new facts; but these for the most part seem unconnected, perhaps due to a lack of knowledge of the causes. Such facts are very variable according to the circumstances; and precise principles are few." Even if "a series of precise experiences are missing," still Fusinieri proposes a "simple and clear explanation which results from the daguerreotype effect:" observing directly the phenomenon and rejecting some hypotheses, he perceives "that the light-dark effect of the daguerreotype pictures depends on the different grades of amalgamation of the molecules of silver, in the iodide decomposed by the light."

The first intervention by Minotto is in August 1841, when he presents, in one of the first meetings of the Istituto Veneto, "a sealed envelope containing the description of a new method to produce photographic images, and of a method to reduce to the state of engraved sheets adapted to be printed chalcographically."[20] On this occasion, Minotto shows that he is in direct contact with experiments abroad on the new invention, referring to the method of Josef Berres, professor of anatomy at the University of Vienna, who, in 1840, obtained a microphotograph of a section of a plant which was then reproduced with a printing process using daguerreotype plates of

his own invention. Later, he was to analyze those "curious and interesting phenomena" observed in 1842 by the physicist Ludwig Ferdinand Moser, professor of physics in Königsberg, relative to the so-called *latent* images.[21] Recalling the different explanations that Minotto's images provoked among the European physicists, Minotto rejects the conclusions to which those scientists had arrived. It is interesting to note the embarrassed resistance to the easy enthusiasm and the generalizations the new instruments like photography could provoke in the international scientific community. Minotto concluded, "We are unfortunately convinced of the imperfection of science in relation to the knowledge of the properties of all the bodies, and we would not be surprised in the least if other new ones were to be discovered, now not even thought of. But we regretfully note that too often and easily new properties are introduced to explain those phenomena that at first sight cannot be reconciled with the known properties of the substances." The "revolution" provoked by photography led the scientists to ask questions about the method used before asking those about the efficacy of their instruments. "Acting differently it is easy to relapse into those questions of abstract theory and deceptive sophism, which delayed the progress of science for such a long time. It would be better to accumulate facts, and explain them as far as their importance allows. If there were unknown and influential properties these would arise, not just from one circumstance or phenomenon but from many, and connecting together, would not leave any doubt on the existence of the new propriety which would then be admitted by everyone, and usefully applied to explain the phenomena which depend on this, and perhaps even to discover new ones or not yet observed ones."

The invitation by Minotto to intensify and compare the research seems to be accepted. The year after, astronomers, physicists and chemists prepare to gather together a series of observations relative to the total eclipse of the sun on the morning of July 8, 1842. The Italian scientists prepared for observations "regarding the total swooning of the sun," using, among other means, the new daguerreotype instrument. Professor Majocchi, making a list of a series of phenomena that during the imminent eclipse were to be a subject for research, had already requested the experiment to see if the light of the silver ring around the moon exerted an action on the chemical papers sensitive to ordinary light beams.[22] In Venice, Francesco Zantedeschi observes the changes that have resulted in exposing silver

hydrochloride to the light, finding in this phenomenon the confirmation of a fact noted by Daguerre to which Melloni had turned his attention.[23] Giuseppe Dembsher, an "Auditor of the First Class" at the Venetian Administration of Public Construction, refers to the experiences during the eclipse, Giacinto Toblini makes some observations with the daguerreotype in Verona,[24] and the Paduan professor of physics, Lorenzo Casari at the secondary school of Vicenza, who had arranged to place various instruments (telescopes, thermometers, thermometrographs, photometers), including "at the third window a daguerreotype."[25] "The daguerreotype was placed in such a way that the image of the sun fell on the plate covered in iodide, before and after the total eclipse. It was open at 6.7', closed at 6.9'29"; re-opened later at 6.14'9" and closed at 6.31'9". Traces left by the luminous crescent could be seen on the plate that subsequently changed position...." The results of the new instrument are not excellent, and the instrument needs to be perfected in order to fix those observations whose importance is understood:

> The image of the sun on the plate was too small to obtain the effects which served to judge the intensity or the duration of the phenomenon. I believe, however, that a large plate exposed to sunlight coming through a hole, opened slightly before the total eclipse, would offer more space for useful and interesting observations. And other plates, placed at a distance with different holes, each destined to receive a particular impression, would be suitable to deduce perhaps with some foundation the subsequent intensity of the sunlight, the form of the ring, and to calculate the duration of the eclipse, as well as other phenomena, taking into account the precise time of the opening and closing of holes.

These and other observations on the "results obtained as regards the intensity of light, heat, electricity, the hygrometric state of the atmosphere, and certain luminous appearances that presented the phenomenon," were to be discussed and analyzed during the Fourth Meeting of Italian Scientists held in Padua in September, 1842, and discussed again in the subsequent meeting in Lucca.[26]

III. If, therefore, "the physicist studies as hard as he can to make the senses more exquisite and

penetrating with artificial devices and equipment," as Zantedeschi wrote in an 1864 memoir, photography seems to impose itself in an ever more relevant way, for its unrelinquishable capacity to *record* the different pieces of information that experience is not able to grasp during the observation of the phenomenon. The tendency to "automatic observation" (affirmed in 1868 by Luigi Borlinetto) and the memorization of data—elements that are fundamental in the procedures of modern scientific knowledge—had been established in Venice, as in Verona, Vicenza and Milan, during the experiments prepared and carried out during the solar eclipse on July 8, 1842. In scientific and technical circles, there was the conviction that photography—"the objective method made instrument," as Massimo Tortelli in 1896 was to define it in the *Nuova Antologia (New Anthology)*[27] — could offer indisputable guarantees of *veracity*. Such a conviction is supported by the needs of the new positivist method that requires definite data, which means limiting the intervention of man which cannot be checked, in the reproduction of the observed phenomena. Photography "is not only useful for the reproduction of natural objects, but can be used in many circumstances, especially in the sciences of observation, a means that can be automatic and rigorous, supplying extremely interesting information without any human error," Luigi Borlinetto wrote in the *General Treatise on Photography*, published in Padua in 1868. The tendency to think in illusory terms of absolute documentation is commonly found in the Venetian scientific circles, such as the Ateneo Veneto (Giovanni Minotto was made president in 1843, already secretary of sciences) and the Istituto Veneto, which on various occasions takes on a starting point some communication (from Zantedeschi, or Carlini, Minotto or Bellavitis) on photography—where the intrinsic *productive* element of photography is understood and established: its often overrated capacity to reveal every secret and to make visible—to raise some heated arguments on the ends of scientific research and the best and most correct means.

The tendency to find an indisputable "truth" — Minotto had talked about "extremely exact copies of images produced in the dark room," where Daguerre had managed "to fix those images in all their truth:" "Using only the influence of light [Daguerre was able] to form pictures where objects mathematically retain their form in the most minute detail," wrote Sorgato in 1840, demonstrating that the photographic means go very well with the methods of physics and the natural sciences in the nineteenth century. Both look for the perfect duplication of the reality of the

physical world, and photography was shown to be that reality that can *make one see*,[28] albeit following often wrong ideas of representation in terms of offering a reproduction of what there is and trusting in its extraordinary persuasive force.

Making visible the infinitely small —"even the parts that are invisible to the naked eye"— and the infinitely far away stimulated the imagination of the scientists. In 1845, Francesco Malacarne, head engineer at the Public Constructions in Venice and an esteemed scientist, wrote in the *Annals of Science in the Lombard-Venetian Kingdom* about "daguerreotypical Curiosities," proposing some of his best productions to the "daguerreotyical optical camera."[29] "Similar curiosities with the aid of Science, and the cooperation of good optical mechanics to bring the results to ultimate perfection, will never become useless, not only with the progress of the still wonderful discovery of the daguerreotype, but also in pleasantly helping the vision of minute objects enlarged, without having to load the eye with other prodigious means supplied by optics." Malacarne is recognised by the most important French periodical of that period, *La Lumière* as the first experimenter with the daguerreotype in Venice—it mentions that in 1839 Malacarne presented "some very interesting tests" to the Venetian Academy—and was one of the first to be able to obtain an enlargement of the picture. The same periodical in 1854 published some of his important ideas on microscopic photography and the "successful" reproduction of a lunar eclipse.[30]

So, if photography rightfully enters, in these difficult years of experimentation, the academic debates of the Venetian and Italian scientific institutes, it would be wrong, however, to separate completely the scientific from the artistic applications of photography. Above all, in the phases of the research in photography as an instrument of scientific observation, its meaning and potential, "in a climate of acclaimed positivism, art is an ambiguous and unstable term, whereas science is a strong term, armed with a strong magnetic field. The endeavors to separate neatly—which will soon begin in a confused and violent way—to redefine art as autonomous and defend it to the end, are symptomatic of the abusive excessive power of science as the dominant culture of the bourgeoisie; and confirm that the borderline is harshly disputed exactly because it is uncertain objectively."[31]

The uncertainty of such distinctions motivates research done around 1856-57, both in the University experimental circles by Zantedeschi and his assistant Luigi Borlinetto—perhaps the most emblematic character of the period, which begins halfway

through the century—and also their commitment to find improvements and spread them as a means of expression (in one of their memoirs in 1856 they express their pleasure in having been the "master of photographic art in colloid" for the Venetian provinces). "Photography finally becomes friend and helper of the fine arts, at the same time that society accepts this application with the utmost wonder and satisfaction," wrote Antonio Pazienti, a pupil of Zantedeschi at the Venetian secondary school, in the dissertation of his degree delivered in 1846 at the University of Padua, recalling the "useful applications" of which the chemical action of light "was in these times predominant."[32]

The diffusion of positivism supplies a conception of photography—as information and not as language—as an immediate instrument of artistic knowledge, and also easier. It does not seem a coincidence that precisely in Venice, in 1846, the first Italian translation of *Cosmos* by Alexander von Humboldt was published, a work that suggests that the European bourgeoisie should learn from the natural sciences.[33] Describing the "means to stimulate the study of nature," Humboldt exalts the cognitive function of the aesthetic print in order to be able to understand nature exactly and fully, a necessary point of departure for the experimental recognition of the environment, and inserts photography as the last and perhaps decisive stage in the "history of the physical vision of the world."

REFERENCES

1. On the spreading of the news relative to the invention, cf. the chapter, "One thousand eight hundred and thirty-nine," which contains a full anthological collection of material and list, in chronological order, of the articles that appeared in the Italian periodicals during 1839, in I. Zannier and P.Costantini, *Cultura fotografica in Italia. Antologia di testi Sulla fotografia 1839-1949* (Milan: Angeli, 1985), p. 33 and subsequent pages. I refer to this volume also for further bio-bibliographical information on the authors and the events dealt with in the present article.

2. F. Negri Arnoldi, *Tecnica e scienza, in Storia dell'arte italiana*, 4 (Turin: Einaudi, 1980), p. 221. On the "cultural" character of the daguerreotype, cf. P. Costantini and I. Zannier, editors, *I dagherrotipi della collezione Ruskin*, (Venice and Florence: Arsenale-Alinari, 1986). As to the (in some ways) unique example of Venice, cf. also P. Costantini, "Dall'immagine elusiva all'immagine critica. La raccolta Ellis e la costruzione dell'immagine fotografica di Venezia," in *Fotologia*, 3

(1985), pp. 12-19; and P. Costantini and I. Zannier, *Venezia nella fotografia dell'Ottocento* (Venice: Arsenale-Böhm, 1986). The first trace of the event of photography in the Veneto is in the works of A. Prandi, in *Fotografia italiana dell'Ottocento* (Florence and Milan, Alinari-Electra, 1979), pp. 123-126. For a fuller account, cf. I Zannier, *Storia della fotografia italiana* (Bari: Laterza, 1986).

3. "Grande scoperta," *Gazzetta Privilegiata di Venezia*, 15 (January 18, 1839), p. 60.

4. J. Janin, "Le Daguerrotype," in *L'Artiste*, 2 (1839), pp. 145-148, reported in H. Buddemeier, *Panorama, Diorama, Photographies. Enstehung und Wirkung neuer Medien im 19. Jahrhundert* (Munich: Fink, 1970).

5. "La camera ottica di Daguerre," in *Gazzetta Privilegiata di Venezia*, 28 (February 4, 1839), pp. 109-110.

6. Cf. M. Tortelli, "La fotografia e le sue applicazioni," in *Nuova Antologia*, no. 4, vol. 62 (1896), p. 343.

7. M. Melloni, "Relazione intorno al Dagherrotipo. Letta alla R. Accademia delle scienze di Napoli nella tornata del 12 novembre 1839." I quote from the edition printed in Rome of the *Giornale arcadio di scienze, lettere ed arti*, 82 (1840), p. 31.

8. On these subjects, cf. V. Ronchi, *Storia della luce* (Bari: Laterza, 1983), p. 300.

9. For a deeper treatment of the relation between the physics of light and the history of photography, cf. the fundamental J. M. Eder, *History of Photography* (4th edition, 1932; English translation, 1945. New York: Dover reprint, 1978).

10. L. Figuier, "Fotografia," in *Sposizione e storia delle principali scoperte scientifiche moderne*, vol. 2 (Venice: Grimaldo, 1855) p. 7.

11. G. Bollati, "Il modo di vedere italiano (note su fotografia e storia), in *L'Italiano* (Turin: Einaudi, 1983), pp. 134-135, which quotes the text at the beginning of the volume by C. Bertelli and G. Bollati, *L'immagine fotografica 1845-1945*, second of the *Annali* from the *Storia d'Italia* (Turin: Einaudi, 1979).

12. G. Minotto, "Di alcuni scientifici lavori fattisi recentemente in Venezia," in *Gazzetta Privilegiata di Venezia*, 195 (August 27, 1840), p. 780.

13. Cf. G. Minotto, "Fotografia," in *Supplimento al Nuovo Dizionario Universale Tecnologico o di Arti e Mestieri...*vol. 23, no. 69 (Venice: Antonelli, 1839), pp. 403-428. See also the entries, "Fissazione," "Impressionabile," "Luce," and "Negativa."

14. G. Minotto, "Di alcuni scientifici lavori" (op. cit.).

15. On these subjects, cf. the chapter "'Le ignote proprietá della luce' e le prime indagini sulla fotografia," in I. Zannier and P. Costantini, *Cultura fotografica in Italia*, p. 87 and subsequent pages.

16. "Lettera del Prof. Zantedeschi al Sig. M. F. Preisser, Membro della Reale Accademia di Scienze, Lettere ed Arti di Rouen," in *Annali delle Scienze del Regno Lombardo-Veneto*, 14 (1845), printed by Tremeschin (Vicenza), 1845, p. 22.

17. "Miglioramenti alla daguerrotipia," in *Gazzetta Privilegiata di Venezia*, 249 (October 30, 1840), p. 993 (from the *Foglio di Verona* of October 26, 1840). Cf. also G. Minotto, *Prospettive e ritratti fotografici del Professore Giacinto Toblini*, 260 (November 12, 1840).

18. G. Sorgato, "Cenni sul daguerreotipo," in *Per le felicissime nozze del nobile signor Domenico Carminati colla nobile signora Marietta Molin* (Padua, 1840).

19. A. Fusinieri, "Sopra i disegni fotografici, e le azioni chimiche della luce," in *Annali delle Scienze del Regno Lombardo-Veneto*, 11 (1841) (Venice: Tremeschin, 1841), pp. 92-100.

20. Cf. G. Minotto, "Di un nuovo metodo per produrre le imagini fotografiche e renderle atte a calcograficamente incidersi," in *Atti dell'I.R. Istituto Veneto*, vol. 1, no. 1 (1840-41), pp. 206-209. It was the first intervention on photography in the acts of this institute that was to receive many more important interventions on the application of the camera to the telescope, on the use of photography for astronomical observation, and in the philosophical terms raised by Zantedeschi, on the "photographs of the prototypes in the external world or of the images printed on the eye's retina."

21. G. Minotto, *Sulla causa delle imagini di Moser*, vol. 7, no. 1 (1847-48), pp. 66-77.

22. G. A. Majocchi, "Istruzione per osservare l'eclisse che accadrà il giorno 8 luglio 1842 esposta dal prof. Majocchi," in *Annali di fisica, chimica e matematiche...*, 16 (Milan, 1842).

23. F. Zantedeschi, *Relazione dei principali fenomeni osservati in Venezia nell'eclisse solare dell'8 luglio 1842* (Venice, 1842).

24. Dembsher [G. Dembscher], "Cenni preliminari intorno alle osservazioni fatte col daguerrotipo durante l'eclissi dello 8 di luglio dal chiarissimo professore Giacinto Toblini," in *Gazzetta Privilegiata di Venezia*, 176 (August 6, 1842), pp. 701-702.

25. L. Casari, *Sopra le osservazioni fatte all'I. R. Liceo di Vicenza nell'eclissi solare del giorno 8 luglio 1842* (Vicenza, 1842).

26. Cf. *Atti della Quarta Riunione degli Scienziati Italiani tenuta in Padova del settembre del 1842* (Padua, 1843), p. 432; and *Atti della Quinta Riunione degli Scienziati Italiani tenuta in Lucca nel settembre del 1843* (Lucca: Giusti, 1844) pp. 459-461.

27. M. Tortelli, "La fotografia e le sue applicazioni," loc. cit.

28. On these problems, cf. M. Cacciari, "Il 'fotografico' e il problema della rappresentazione," interview edited by P. Costantini, in *Fotologia*, 5 (1986).

29. F. Malacarne, "Curiosità daguerreotipiche (Immagini degli insetti; Immagini ingrandite d'oggetti discosti)," in *Annali delle Scienze del Regno Lombardo-Veneta*, 14 (1845) (Vicenza: Tremeschin, 1845), pp. 25-28.

30. Cf. *La Lumière*, 1854, pp. 24, 32, 36, 50; 1857, p. 74 (Files on the nineteenth-century photographer, Paris, Bibliothèque Nationale).

31. G. Bollati, "Il modo di vedere italiano," op. cit., p. 132.

32. A. Pazienti, *Dell'azione chimica della luce, del calorico, dell'elettrico e del magnetico sopra i corpi inorganici. Dissertazione di Antonio Pazienti per ottenere la laurea in chimica* (Padua: Crescini, 1846).

33. A. von Humboldt, *Cosmos. Saggio d'una descrizione fisica del mondo*. First Italian version by Giulio Vallini (Venice: Gattei, 1846).

Lerebours' *Excursions Daguerriennes*
and an Early Picture of a Daguerreotypist at Work

Nachum Tim Gidal

Students of the history of photography consider Daguerre's picture of the Boulevard du Temple, taken in 1838, as the first one showing a human being, probably a man having his shoes polished, photographed in a documentary way in open air and natural surroundings.[1] The reason for this was the fact that the lens constructed by Noel Marie Paymal Lerebours and Charles Chevalier for Daguerre achieved a sharp image only if closed down to about f/17. This meant very long exposures, the hub of many jokes and caricatures by Daumier and others. The exposure time on a sunny day was, according to Helmut Gernsheim's *The Origins of Photography* (London, 1982), about fifteen minutes.

But a great step forward was made in 1840 by the Viennese Joseph Max Petzval, who designed a lens giving a sharp image at an opening of f/3.6. This meant an exposure of about fifteen times less than the Chevalier-Lerebours lens, with which the photographers using the Daguerre-Lerebours camera worked in 1839-1841.

In 1839, Lerebours started his great project of showing famous sites the world over in 114 "Daguerreotypes," chosen from about 1,300. He sent daguerreotypists to places in Europe, to Egypt, Palestine, Nubia, Syria. [Figure 1] From other daguerreotypists he received pictures taken in Moscow, at Niagara Falls, and other places. The daguerreotypes, whose physical support was copper (plated with silver), were traced and transferred to

other copper plates, mostly by the aquatint process. Lerebours published the pictures in two albums, between 1840 and 1842-43: *Excursions Daguerriennes, Vues et Monuments les Plus Remarquables du Globe.* But as Lerebours soon realized, there was a hurdle to success. Slow exposure time ruled out daguerreotypes with people moving around. Those people who did move during an exposure disappeared completely by the very act of moving. Lerebours realized that, despite the novelty, not enough buyers would be willing to pay for pictures that were very similar to the thousands of other engravings in fashion at the time, which showed all these places and included people as well.

Perhaps Lerebours took a cue from a book that was published in Paris in 1840 by Charles Philippon, *Paris et ses Environs, Reproduits par le Daguerreotype.* Philippon had transferred daguerreotypes to the lithographic stone and had added figures in the realistic style of Gavarni and Daumier.[2] Lerebours also enlivened his views. "Figures and traffic," in Lerebours' albums, notes Beaumont Newhall, "imaginatively drawn in the romantic style, were added in an attempt to please the public, who deplored the depopulated aspect of the first daguerreotypes."[3]

In contrast to Philippon, Lerebours appealed to the conservative taste of the majority of the prospective buyers of his albums, the wealthy upper classes. And indeed it was mostly upper-class people, riding,

Figure 1. Detail from "Maison Carrée à Nîmes," from Lerebours' "Excursions Daguerriennes," plate 10.
Full picture is 20 x 15 cm.

Figure 2. "Vue Prise de la Piazetta à Venise," from Lerebours' "Excursions Daguerriennes," plate 89, 20.2 x 14.8 cm. Martens, sc.

Figure 3. Detail from "Vue Prise de la Piazetta à Venise."

Figure 4. Detail from "Portail de Notre Dame de Paris," from Lerebours' "Excursions Daguerriennes," plate 43, engraved by Huerliman. Full picture is 26 x 20.5 cm. This may be the earliest image of a daguerreotypist at work.

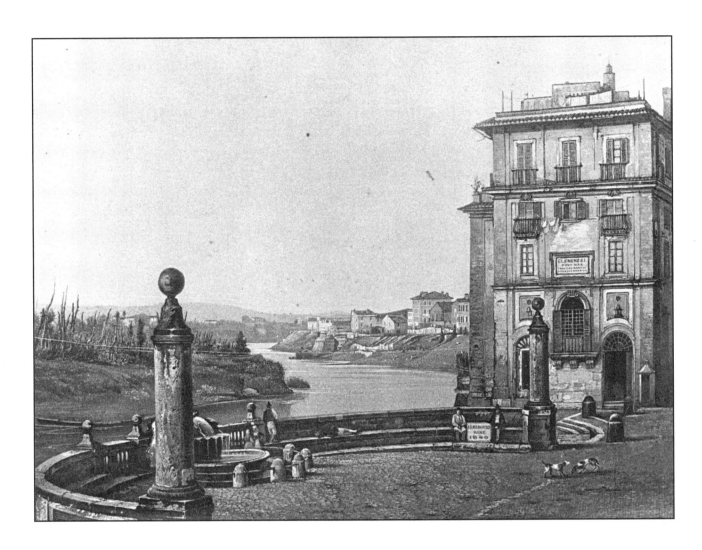

Figure 5. "Port Ripetta à Rome," from Lerebours' "Excursions Daguerriennes," plate 83, "Himely sculp." 14.5 x 25 cm.

Figure 6. Detail from "Port Ripetta à Rome," showing stiffly posed figures.

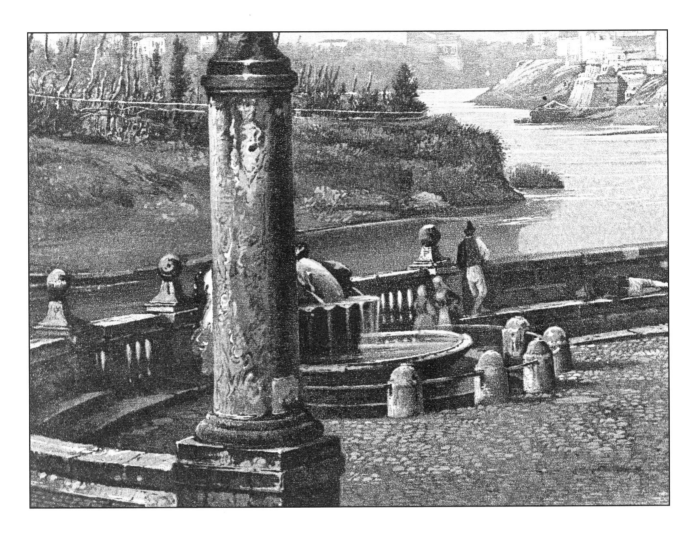

Figure 7. Detail from "Port Ripetta à Rome," showing figures in candid poses and two female figures (out of perspective) added by engraver.

taking in the sights in foreign lands, taking a walk, with a few romantic-looking natives, which are shown in many of these 114 pictures. Demoiselles and cavaliers promenading in the Tuileries of Paris or looking, as tourists, at the famous sites in foreign lands, or a native rider galloping happily past the column of Pompeius in the Egyptian desert. On the "Vue Prise de la Piazetta à Venise," tourists are seen walking about. [Figures 2 and 3] A gondolier talks to a charming young lady, while a group of others pose gracefully near their gondolas. In front of the "Portail de Notre Dame de Paris," a daguerreotypist stands patiently next to his camera during a seemingly long

exposure, taking a picture of a man leaning against a decorated part of the portal. [Figure 4]. He stands there, in fine repose, kept in a position of lengthy duration by leaning his body against the stone wall. It looks as if the photographer were taking a full-size portrait in the open, quite unusual for this early period of photography. It is perhaps one of the earliest, if not the earliest, picture of a daguerreotypist at work.

Lerebours took some of the pictures for his albums himself, including a river landscape near Bas-Medon. In the text to this picture the name of the artist is given, no less than the famous landscape painter

Charles François Daubigny (1817-78), an important precursor of the French Impressionists.[4]

In sharp contrast to these romantic pictures in imitation of the idyllic genre and landscape paintings and drawings of the 18th century, we find one purely photographically seen picture in the Lerebours albums. [Figure 5] It is called "Port Ripetta à Rome." The caption might as well read, "Photographed at the Port Ripetta in Rome." At least the foreground, especially the people in it, could have been photographed this way in these natural, albeit posed attitudes. They do not look as if they had been added by an artist later. They look as if they had been posed by the daguerreotypist for his purpose of documenting the fact of his having taken the picture for Lerebours in 1840. And, in contrast to all the people in all the other plates of the Excursions Daguerriennes, the people in this picture look clumsily posed, with the expression of having been told by the photographer, "Hold it!"

There are the two men left and right of the poster with the inscription "Lerebours Rome 1840." [Figure 6] They lean against the stone bench in a position that clearly indicates that it was chosen so that they could sit still for a certain length of time, perhaps even for a few minutes. Their faces and part of their clothes look as if they had been retouched, because they came out a little blurred on the daguerreotype. Of the other eight or nine people in the picture, three or four stand with their backs to the camera. One is lying down. [Figure 7] The reason for this attitude, unnatural for so many persons in one picture, seems obvious. They all lean heavily on the stone railing of the small plaza. Four are clearly discernible, a fifth is almost completely hidden by a column; only part of what seems to be a flowing robe is visible. What makes the full picture look even more like a genuine photograph (or rather, a daguerreotype) is the fact that two women, talking to each other, do look as if they had been added later by hand, and in an unusually incorrect perspective: they are made to look smaller instead of taller than the people further away. The two dogs and the group in the shade on the right side were, of course, added later. According to Gernsheim, the exposure time in the open was, until June 1841, fifteen to thirty minutes for half-plate cameras.[5] A strong support was certainly needed to keep one's position for such a long period without appreciable movements of body and face. This may account for the faces of the two men sitting as if they were heavily retouched original photographs or daguerreotypes.

All the original daguerreotypes taken for Lerebours' *Excursions Daguerriennes* are presumed to have been lost, perhaps having been discarded after they were copied (traced) for the aquatint prints. For this reason, unless a lucky photohistorian finds them in some hidden corner, our theory must remain just that: a theory. However, theories are often the basis for discoveries.

REFERENCES

1. This picture was published by Beaumont Newhall (in *The History of Photography*, Museum of Modern Art, New York, 1964, p. 20), Helmut Gernsheim, and others, as the first picture (daguerreotype) showing a human being in natural pose in open air. In the latest edition of Newhall's *The History of Photography* (1982), Newhall adds a hitherto unpublished daguerreotype of the same scene, but without the human figure (pp. 16-17). Apparently, Daguerre took a number of pictures of this boulevard, and of the man standing there. The American inventor and photographer Samuel F. B. Morse seems to refer to a third version in a letter to his brother, which he wrote after a visit to Daguerre on March 7, 1839: "Objects moving are not impressed. The boulevard, so constantly filled with a moving throng of pedestrians and carriages are perfectly solitary, except an individual who was having his boots brushed. His feet were compelled, of course, to be stationary for some time, one being on the box of the boot black, and the other on the ground. Consequently his boots and legs were well-defined, *but he is without body or head*, because these were in motion." [Italics mine.]

2. The title page and two examples are reproduced in Raymond Lécuyer, *Histoire de la Photographie* (Paris, 1945), p. 3.

3. Beaumont Newhall, *The History of Photography* (New York: Museum of Modern Art, 1982), p. 27.

4. Wolfgang Baier, *Geschichte der Fotografie* (Leipzig, 1977), p. 478. The picture is reproduced on page 568.

5. Helmut Gernsheim, *The Origins of Photography* (London, 1982).

Ford's Fancy

This rhymed advertisement, now in the collection of S. F. Spira, appeared in the *Daily Alta California* of San Francisco, on Saturday morning, January 1, 1853.

FORD'S DAGUERREAN GALLERY

D on't you remember "The Old Folks at Home,"
A nd the young ones—the wives and the fair ones so dear?
G rey hairs, rosy cheeks, deep sighs and the tear,
U nhidden that fell when you left far to roam?
E ach kind word that they spoke, and each uplifted prayer,
R evoked for thy safety and final success,
R eprinted kisses! the hands gentle press!
E ach long, loving look! the last words of the fair!
O h! yes, you remember; then do not forget
T o procure a memento, to please young and old,
Y ou know they expect it from the land of gold.
P er express or by post, neither seldom do fail,
E xpress is the surest, but cheaper by mail.

M ementos are numerous, from which to select,
I ntrinsic their value, may dazzle the eye,
N or do they lack richness, may've been drawn as a prize
I n a raffle or lott'ry, and not a defect.
A ll different opinions, we give them a place,
T ho' in our opinion, and we think we are right,
U ndoubtedly best is a DAGUERREOTYPE:
R emember, FORD'S Gallery's by odds the best place,
E ver there, ever ready, he invites you, come and see,
S outh side of Clay street, 202 and 3.

N.B. Don't forget the place, 202 and 203 Clay street.
Entrance first door below the new Post Office.

Contributed by Ann Wilsher

Art and the American Daguerreotype

Floyd and Marion Rinhart

Art became intertwined with photography after the introduction in 1839 of the daguerreotype — an exact image reflected on a silvered sheet of copper, produced through the medium of the camera obscura. The new photographic process was the result of lengthy experiments by the Frenchmen Nicéphore Niépce and Louis M. Daguerre. The techniques were brought to a workable photographic process by Daguerre, artist and co-inventor of the popular diorama.

The details of Daguerre's process were given to the world on August 19, 1839, when the eminent French scientist Arago lectured to a large crowd at the French Academy of Science, in Paris, outlining the history and development of the daguerreotype. Many newspaper reporters from other countries attended the event, and within days the details of the lecture would appear in print.

American experimenters began their intensive search for an improved daguerreotype process immediately after the details of Daguerre's invention arrived in New York City, in September 1839. Among the first of the experimenters to improve the process, so that portraits from life could be taken, was Samuel F. B. Morse, artist and inventor, who earlier in the year, in March 1839, had exchanged visits with Daguerre in Paris. Morse had traveled there to examine Daguerre's specimens on silvered plates of copper and to show Daguerre his telegraphic apparatus.[1] Morse, who had patiently awaited the details of the process, immediately began his experiments and succeeded in taking a daguerreotype

scene that drew the attention of the *New York Journal of Commerce*. On September 28 the newspaper announced, "Professor Morse showed us yesterday the first fruits of Daguerre's invention....It was a perfect view, on a small scale, of the new Unitarian Church, and the buildings in the vicinity..." Morse quickly denied the honor of being the first to produce a daguerreotype in America, and gave credit to a Mr. D. W. Seager, a resident of New York City.[2]

Morse was the first American to realize the potential of an interaction with the daguerreotype and painting, and some of his thoughts about the use of the new art to painters were revealed in a letter to his old friend, Washington Allston, a popular and romantic painter during the first half of the nineteenth century:

You have heard of the Daguerreotype. I have the instruments on the point of completion, and if it be possible I will yet bring them with me to Boston and show you the beautiful results of this brilliant discovery. Art is to be wonderfully enriched by this discovery. How narrow and foolish the idea which some express that it will be the ruin of art, or rather artists, for every one will be his own painter. One effect, I think, will undoubtedly be to banish the sketchy slovenly daubs that pass for spirited and learned; those works which possess mere general effect without detail, because forsooth detail destroys the general effect. Nature, in the results of Daguerre's process, has taken the pencil into her own

Figure 1. Samuel Broadbent, portrait of William J. Dunwoody, ca. 1846. Half-plate daguerreotype. Courtesy John Jones Collection, University of Georgia Libraries, Athens, Georgia. Broadbent visited Athens, Georgia, as a miniature painter in 1840. In the winter season of 1843 he daguerreotyped in Savannah. Following the tradition of artists who traveled in the south during the winter months, he advertised as a daguerreian artist in both Athens and Macon, Georgia, during the winter of 1845. Later Broadbent became a prominent photographer in Philadelphia.

hands, and she shows that the minutest detail disturbs not the general repose. Artists will learn how to paint, and amateurs, or rather connoisseurs, how to criticize, how to look at Nature, and therefore how to estimate the value of true art. Our studies will now be enriched with sketches from Nature which we can store up during the summer, as the bee gathers her sweets for winter, and we shall thus have rich materials for composition, and an exhaustless store for the imagination to feed upon.[3]

The daguerreotype was introduced into America during a period of great expansion in which the arts — literature, native painting, architecture, and music — would reach the masses. America was creating a character of its own, developing its own art forms.[4] While there was some European influence on American painters, and not a few went abroad to study, native art reflected the mood of the country and the great interest in nature abroad the land in mid-nineteenth century.

The many problems inherent in the early daguerreotype process were quickly resolved within a very few months after reaching America. Exposure time had been cut from minutes to seconds, cameras and lenses had been improved, and by the spring of 1840 studio galleries were being opened to the public, who responded warmly to having their portraits taken. Thus, the nuclei of daguerreotypists began to spread from the larger cities to the smaller communities of America. By 1845, a network of daguerreotypists had spread throughout the country.

During the first years of photography in America, many portrait, landscape, miniature painters, lithographers, and engravers entered the new art of daguerreotyping, beginning with Samuel Morse and his assistant Samuel Broadbent, a miniature painter from Weatherfield, Connecticut, who helped Morse in his daguerreotype studio until August 1841[5] [Figure 1]. The influx of artists to photography continued during the years of the daguerreotype and beyond when other forms of photography became popular.

Most successful daguerreotypists followed traditional art precepts in their lighting techniques, using in their portrait photography three qualities of light: diffused, direct, and reflected. The master daguerreians brought out the "beautiful eye" to perfection, and in their expertise, in the shading of the portrait, they often revealed the elusive character of the sitter. Also by a judicious use of light, the daguerreotypist suppressed unimportant details of drapery or background, an effect that brought the sitter into bold relief.

The background of the portrait was considered very carefully in its relation to the total composition. Most daguerreotypists preferred a plain dark or neutral background to bring out the sitter effectively. Sometimes a painted mural or landscape background was used that gave to the portrait an illusion of space and the effect of a painting or mezzotint.[6] From 1849 on, new background techniques were developed and patented, which gradually blended the subject into the background giving a bust effect.[7] These daguerreotypes were called "crayon portraits," and the images stood out boldly with the effect of a crayon drawing [Figure 2].

From the earliest days of the art, accessories in the studio were important to the daguerreotype portrait. The tablecloth was effective to the total composition; its many designs and graceful drapery often gave interest to an otherwise plain portrait. Objects on the table, such as books or a simple vase of flowers, were popular studio accessories throughout the daguerreian era.

In the posing of patrons, most daguerreotypists preferred to use the pyramidal composition, an influence stemming from the early Italian masters of painting.[8] The flowing lines of mother holding child is an example of this pose. In full-length and three-quarter-length poses, a horizontal or vertical line was often introduced — an example of this technique would be the use of a column or pedestal as an accessory. Symbolic objects held in the hand, a tradition used by painters — a book, flowers, toys, or riding whip — often produced the correct mood for the portrait [Figure 3].

Only one ingredient was missing for an art daguerreotype to compete with portrait painting: color. From 1841 until the close of the daguerreian era, various hand-color and chemical methods were employed and their effectiveness depended upon the talent of the daguerreotypist or artist employed in the daguerreian gallery. [9] [Figure 4].

A fine daguerreotype portrait has a beautiful blending of light and shadow and color, and its "breath of life" quality at times transcends the realistic. The daguerreian artist had his own stylistic portrayal of his subject according to the creative use of his camera, manipulations, and chemical treatment of his silvered plates. His techniques of lighting, color, posing, backgrounds, and drapery were influenced by many traditional schools of painting, classicism, and native American art.

A visit to art galleries with displays of American paintings or miniatures or a perusal of art books illustrated with American or European paintings will show that the daguerreotype was influenced by — and influenced — traditional art.

Figure 2. Southworth and Hawes, portrait of James H. and William E. Bowditch, ca. 1853. Half-plate daguerreotype. Courtesy Floyd & Marion Rinhart Collection, The Ohio State University, Library of Communication and Graphic Arts. A crayon-style portrait, a masterpiece of pose and lighting. On the daguerreotype plate, the mercury process used to develop the image casts a halo of rainbow tints around the portrait.

Figure 3. Unknown artist, portrait of Isaac Van Amburgh, ca. 1850. Half-plate daguerreotype. Courtesy Floyd & Marion Rinhart Collection, The Ohio State University, Library of Communication and Graphic Arts. Allegorical themes in daguerreotypes were pioneered in the mid-1840s. Many daguerreotypists entered allegorical daguerreotypes in exhibitions, including the Crystal Palace Exhibition in London, 1851, and the New York Crystal Palace Exhibition, 1853-1854. Van Amburgh was a popular stage performer with his "cats" both at home and abroad.

REFERENCES

1. Beaumont Newhall, *The Daguerreotype in America* (New York: Duell, Sloan and Pearce, 1961), p. 15.

2. Beaumont Newhall, *The Daguerreotype in America*, p. 22.

3. Samuel Irenaeus Prime, *The Life of Samuel F.B. Morris* (New York: D. Appleton and Company, 1875), p. 405.

4. Floyd and Marion Rinhart, *America's Affluent Age* (South Brunswick and New York: A.S. Barnes and Company, 1971), pp. 159-180.

5. Carleton Mabee, *The American Leonardo: A Life of Samuel F.B. Morse* (New York: Alfred A. Knopf, 1943), p. 242.

6. Floyd and Marion Rinhart, *American Daguerreian Art* (New York: Clarkson N. Potter, Inc., 1967), pp. 115-127.

7. Floyd and Marion Rinhart, *American Daguerreian Art*, pp. 5-6.

8. Floyd and Marion Rinhart, *The American Daguerreotype*, (Athens: University of Georgia Press, 1981), p. 286.

9. Floyd and Marion Rinhart, *The American Daguerreotype*, pp. 208-212.

Figure 4. Lorenzo Chase, "The Golden Portrait," ca. 1847. Sixth-plate daguerreotype. Courtesy Floyd & Marion Rinhart Collection, The Ohio State University, Library of Communication and Graphic Arts. Chase, a Boston artist and daguerreotypist, probably used some form of electrolysis to create the beautiful golden tone on the original daguerreotype. The additional ripple finish provided an artistic overlay not unlike a miniature painting.

Political Emigration and the Photographic Profession

Juliusz Garztecki

We Poles are justly famous for our ability to start disastrous revolutions and national uprisings against foreign oppression. Such were the anti-Czarist uprisings of 1794 and 1830-1831, the revolution of 1846 in the token "Republic of Cracow" against Austria and Russia, the 1863-1864 uprising against Russia in the Russian-administered part of partitioned Poland and finally, the anti-Nazi Warsaw Uprising of 1944. Each one of them, including the 1939 defeat in the war campaign against Germany, had as a direct effect a wave of political emigration, mainly to Western Europe and particularly to France. Even the 1905-1906 revolution in Poland, to some degree coordinated with anti-Czarist revolutions in Russia and Finland, though not, technically speaking, quenched by military force, had its effects nullified by the subsequent "Stolypin's reaction" from 1908 onward. Practically the only successful national uprisings were the anti-German revolt of 1918 in the former Dukedom of Posnania, which returned to Poland the cradle of Polish statehood, and three uprisings in Silesia, in 1920 and 1921, which resulted in the return to the motherland of the major part of the coal basin in Upper Silesia.

It is interesting that every one of the above-mentioned emigration waves produced quite a number of professional photographers plus a handful of well-known amateurs. Even the 1939 September war campaign had as a result the foundation of the Society of Polish Art Photographers in Great Britain,

with a membership of around thirty, and quite an impressive record of activity for over a quarter of a century. Its presidents were, among others, the famous colorist and professor at the Ealing School of Arts, the late Wladyslaw Marynowicz for two terms, and the London photojournalist of renown, Jorge Lewinski (now a historian of photography) for one term.

For the purposes of our study, the most interesting wave of emigration occurred in 1831 and was called in Polish history "The Great Emigration," not because of its numerical strength (slightly over 8,500 people) but because the greatest Polish artists and intellectuals, including the poet Mickiewicz, the composer and virtuoso Chopin, and the historian Lelewel were among the refugees. France received the Great Emigration with warmth and applause and accorded to each one of the refugees a pension corresponding to their military grades, fixed at the rate of half of the pay that rank would earn in the French Army.

But in the years to come a political rapprochement ensued between France and Russia; former Polish heroes began to be frowned upon, and their pensions were gradually cut and finally cancelled. Poles were forced to seek professional occupations, and just at this moment providentially occurred the advent of photography, both in the daguerreotype and talbotype forms. It is estimated that about thirty to forty Poles began professional careers in France at

that time, and thereafter some of them migrated further, and were among the earliest pioneers of photography in several countries.

It must be said here that too little is known about the majority of them. Studies in the history of Polish photography were amateurishly begun in the late 1930s, and now we have only half a dozen historians of photography with academic credentials in Poland. Due to the economic conditions in Poland, funding for research abroad is scarce and short-term. Nevertheless, some interesting information has been unearthed.

Among the leading portraitists in France in the 1850s and 1860s was the famous Count Stanislaw Ostrorog, scion of one of the oldest aristocratic families of Poland, who claimed direct descendance from extinct dukes of Western Pomerania because of his identical coat of arms, "Griffin marchant." Ostrorog's estates in Poland were confiscated by Russian administration. Therefore, he turned to photography and opened a studio in Paris at No. 9 rue des Londres. With only a brief interruption during the Crimean War, in which he participated as colonel of cavalry of the Turkish Army, he operated under the trade name "Walery" for many years, opened branches of his studio in Marseilles, Nice, and Istanbul, and eventually made a fortune, allowing him to buy a sumptuous estate at Côte d'Azur. In his time, Ostrorog was considered in Paris as Disdéri's equal. But Disdéri invented the *carte de visite* and led a colorful life. Ostrorog only invented — possibly merely promoted — a special varnish or enamel for prints that insulated them from noxious atmospheric elements. Thus, he is now completely overshadowed by his French rival. Nevertheless, Ostrorog's enamel proved to be so effective that prints from his photographs are still in mint condition after 130 years.

About Stanislaw Ostrorog information is fairly complete. Quite the opposite is the case with a certain Justyn Kozlowski. He was an enlisted man in the Polish Army in 1830-1831, then fled to France, and finally appeared in the 1850s at Port Said as the official photographer of the Canal-de-Suez Company. Some years ago twenty prints were discovered in a private collection in Poland. They were 24 x 30 and mounted on cardboard with "Canal Maritime de Suez" imprinted as a heading on each, along with Kozlowski's name, and the date and time of exposure, accurate to hours and minutes, scratched on the negative emulsion of each. The contents of the photographs proved that Kozlowski was documenting the construction of the Suez Canal from the beginning of work to the festive opening. But nothing more is known of this photographer, and

Polish historians of photography will find it difficult to make a trip to Port Said for field research to pursue this subject.

Much is known of the photographic career of Jozef Feliks Zielinski, known under his *nom de plume* "Izet Bey" as a traveler, writer, author of some studies on the art of military fortifications, and man of many and varied accomplishments. He was one of the first professional daguerreotypists in France between 1842 and 1850 and owned daguerreian parlors at Nantes and Angers, the first establishments in those cities.

Of forty-some Polish names in the history of photography, we know only that much, and sometimes only the family name. These include Maciej Bobinski; Adam Jozef Pilinski, inventor of one of the methods of photolithography; Michal Szweycer, murdered by Versailles troops during the Paris Commune; A. Pietkiewicz, full Christian name unknown; E. Koziell, secretary of the French Photographic Society, first name unknown; "Antony," of whom we know only this trade name; Druchlinski of Paris and Ostroga of Menton, first names unknown; and so on.

Some of them migrated further. Mr. and Mrs. Hulanicki were daguerreotypists and photographers in Switzerland, but details of their activity are unknown. A certain Jozef Benda opened the first photographic atelier in Kandia, Crete, then under Turkish rule. It is known that among the first daguerreotypists in Brussels was a Pole, but his name is still uncertain. A Polish daguerreotypist named Popowic or Popowicz was active in Edinburgh, according to details in the Public Records of Scotland, which no Polish historian has been able to investigate. If Polish daguerreotypists went from France to the United States, this information has yet to be uncovered.

Of the political emigrants who left after the disaster of the 1863-1864 uprising, two are notable. Ludwik Szacinski went first to Stockholm and then to Christiania (now Oslo) and was in his epoch considered as the best photographer in Scandinavia. He was appointed photographer to the Royal Court of Sweden and Norway, which were united at this time. He brought about the Norwegian Photographic Society, was considered a Norwegian national, and is represented in the collections of Oslo University. The only detail that remains a mystery is whether or not he was, in addition to his photographic pursuits, trainer of the royal pack of hounds during his stay in Stockholm, as suggested in the archives of the Royal Court of Sweden.

A certain Aleksander Ken, of the same wave of emigrants, is known only by the fact that in 1864 he

was granted by H. M. the King of Italy (or, rather, of Savoy) the Order of Sts. Maurizius and Lazarus for his book under the lengthy title, *Dissertations historiques, artistiques et scientifiques sur la photographie,* which was published the same year in Paris, where Aleksander Ken opened a photographic atelier. Press sources contemporary to this event say that he was formerly a photographer in Warsaw, but no further information has been found. During World War II, Polish archives, public records, libraries, and museums were methodically destroyed by the Nazis during their occupation of Poland.

Jan Strozecki, first secretary general of the Polish Socialist Party in the nineteenth century, presents an interesting case. He was arrested after only two years of this activity and sentenced to deportation to the Kolyma region, called "Siberia of Siberia." He made his living there first by taking photographs of the local population, the Yakouts, and later as photographer to some Russian paleontological expeditions in this region. It must be remembered that unlike those who were sentenced to forced labor and kept in chains working underground in mines, deportees were encouraged to undertake trades and professions. It is estimated that about twenty photographic ateliers were run by deportees all over Siberia, but only three names had been found until recently. A standard trade-name for their ateliers was "Warsaw Photography." Only recently Soviet historians discovered a fourth name, that of Michal Cejzyk, pharmacist, who in the 1850s owned the first camera in Orenburg, Kazachstan, and was the first photographer there. When and why he was sentenced to deportation remains unknown.

I cite these cases not merely to complain about the deplorable state of knowledge of Polish photographic history and the difficulties of research in this country, but to raise a larger question. Economic emigration from poor countries to those that offered greater opportunity has been studied thoroughly enough. We know, for example, that there were more Irish people in the United States at one point than in Ireland. Chicago, Illinois, was second only to Warsaw in its Polish population. There are several famous cases of emigration to free countries for ideological reasons as well. Edward Muggeridge thought that his human rights were restricted in Great Britain and felt that only in the United States could he be Eadweard Muybridge, Welshman, to cite one well-known case. But Poland is not a unique country in terms of political emigration. The whole Balkan Peninsula, from Greece to Rumania, struggled with Turkish oppression for centuries and only in the early twentieth century did they have some success.

Hungarians were oppressed for decades by the Austrian Empire and Czechoslovakia for centuries. In the 1930s, because of their Jewish origins, political creeds or religion, thousands of people were forced to flee from Nazi Germany and from countries that Germany invaded.

I believe that a comparative international study that investigates the relationship between political emigration and the photographic (and photographic science) professions would yield interesting results. The Polish chemist, Professor Witold Romer, the inventor of posterization, went to England after the 1939 campaign, where he worked in the photographic research laboratory of the Royal Air Force. Through his own research efforts, he discovered that the well-known Leon Warnerke was a Polish political emigrant whose true name is Count Wladyslaw Malachowski. Other important photohistorical findings could be expected as well from a concerted effort to track down photographers and inventors who began as political emigrants.

Russell Sedgfield: His Modus Operandi

Hardwicke Knight

When Russell Sedgfield set out on that short journey from Devizes to Lacock Abbey, he was a boy setting out on a new adventure, with an unexplored world of science before him, as Darwin was when he set out in the *Beagle*. Sedgfield had no idea that for the next sixty years his life was going to evolve, step by step, with the new science and art of photography. It was a birthday that was to last him the rest of his life.

Sedgfield never paid the license fee that Fox Talbot exacted and practiced calotypy as an enthusiastic amateur.[1] He turned to the collodion process immediately after Scott Archer described it and then took advantage of each major advance by selecting what was useful to him in the production of fine photographs.

William Russell Sedgfield (1826-1902) was one of five sons of a family of modest means. His father ran a grocery business at Devizes, a market town in Wiltshire, England.[2] In 1842, at the age of sixteen, Sedgfield recalled that his first experiments in photography were with bichromate of potash, that he practiced calotypy and that, although he was sent to London to train as an engraver, he remained true to his first love of photography. In 1854 his fine portfolio appeared, *Photographic Delineations of the Scenery, Architecture and Antiquities of Great Britain and Ireland*.[3]

He married in 1857 and became a professional portrait photographer, but managed also to produce some of his finest view photographs. In the early 1860s he took a partner, Francis G. Eliot, in order to free himself from studio work and enable him to travel. The 1870s and 1880s were his most productive years. He retired in the 1890s but continued to take family groups and local scenes. No other outstanding photographer was active during six successive decades from the pioneer years of the 1840s. Biographical research and a study of his photographs reveal information on his working methods.

CAMERAS

Sedgfield's calotype prints were from paper negatives, 4 x 3 inches and 7 x 5 inches. His early albumen prints showing plate edges suggest that prior to 1861 he was using cameras 10 x 8 inches, both whole-plate and half-plate. Seen in a photograph of his garden is a whole-plate camera by George Hare of the box-within-a-box-type, with what looks like a Grubb lens. A note on a stereograph says, "Taken on Dancer." By the 1870s he was travelling with a 12 x 10 inch folding camera by P. Meagher, a whole-plate camera of the tail-board type, a 7.5 x 5 inch portable bellows camera for wet and dry plates by George Hare of Calthorpe Street, London, and a stereo camera. Photographs of the same subject showing slightly different angles and arrangements of people suggest that he sometimes had three cameras standing side by side and that he exposed them one

Figure 1. Russell Sedgfield, The Crypt, Canterbury. Albumen print, 7.5 x 9 in. 1852. Hardwicke Knight Collection.

EXPOSURES

Neither negatives nor record books have survived. When Sedgfield retired, his son had left England and he moved to a smaller house. All he left to posterity was a file collection of his prints. A photograph of the interior of a great hall carries the information that the exposure was for 3/4 of an hour with the lens stopped down. There was no direct sunlight. Another interior, of a church near Kingsbridge, shows remarkable absence of halation around the stained glass east window, but there is sunlight casting shadows of the pew ends on the aisle which suggests an exposure of perhaps half an hour. Definition in Sedgfield's landscape and architectural photographs extends into the extreme corners of 12 x 10 inch plates, suggesting full stopping down. Views of the 1870s, however, which include people and children playing on beaches, are remarkable for the absence of the usual ghost images, and in one such photograph the movement of the top of the mast of a sailing ship shows that the exposure was not instantaneous.

after anther. After 1890 he appears to have used only a half-plate hand camera. Unlike some early photographers, Sedgfield only rarely left photographic gear showing in his pictures.

LENSES

In the 1850s he was using a Grubb aplanatic lens of two meniscus elements. Later he occasionally records information about the lens used on the negative plate or print. An Andrew Ross double combination lens is mentioned. Doublet lenses were introduced in the 1860s. Thomas Ross introduced one which was popular for many years especially for landscapes. Sedgfield favored an extended hood before the lens to cut out stray light. His frequent use of the rising front may account for his arching the top corners of prints to eliminate vignetting. A view of Criccieth has a note written on the edge of the whole plate that it was taken with the back element of a 7-inch lens. Another note scratched on a plate says, "Used Ross No 1 Triplet on 1/2 plate camera."

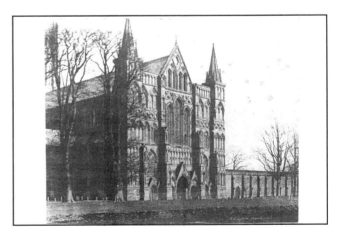

Figure 2. Russell Sedgfield, West facade, Salisbury Cathedral. Dated on negative March 1853. Hardwicke Knight Collection.

Figure 3. Russell Sedgfield, printing frames in the garden at Hemel Hempstead. Albumen print, 1857. Hardwicke Knight Collection.

DEVELOPMENT

The only clues to the developers he used are from notes scratched on plates or pencilled on the backs of prints. A half-plate is inscribed, "Wratten developer," and on a print is a reference to the use of "Alkaline developer." In 1862, Major C. Russell communicated to the *British Journal of Photography* (15 November) that adding ammonia to the pyro instead of acetic acid shortened the development time.

PLATES

That Sedgfield managed to photograph beach scenes with short exposures was no doubt due to the favorable light. From an early date he used the Norris Extra Quick Dry Plates, which were introduced in 1860. A.J. Melhuish and Francis Bedford also used these plates. He used a range of sizes from 4.5 x 3.5 to 12 x 10 inches. He followed J. E. Mayall's theory that "it is only by means of a long exposure (a landscape lens stopped down and an exposure of 15 seconds) that you can thoroughly get at the quality of your emulsions." A print of the 1870s has been inscribed on the verso, "Swan plate — alkaline developer."

PAPERS

For his early albumen prints, Sedgfield used Canson's paper, a French-manufactured product that gave good black tones. He favored Rives for his later albumen prints. This paper was originally made at Rives, Isère, France. He also used Saxe paper, which was manufactured at Saxe in Germany. The Marion mark is on a print from a half-plate of Ludlow Castle possible made in about 1866. In 1856, in a communication to the *Journal of the Photographic Society* of 21 January 1856 (page 291), Sedgfield states that he found albumenized paper could give poor results from an insufficient amount of silver in the emulsion to decompose the whole of the chloride and leave free nitrate on the surface of the paper. He recommended his own practice of using 80 grains of nitrate of silver to the ounce. This view was vigorously expressed by the portrait photographer Payne Jennings when interviewed by Baden Pritchard.[4] Sedgfield found that the fine details that he wished to record were better shown with a slight gloss on the paper. His experiments at that early date led him to assume a confidence in the excellence of his prints and this is confirmed by the lasting quality of the file collection and his published pictures of 1854.[3]

TONING

Sedgfield wrote, in a communication to the *Photographic News* of 18 February 1859 (page 287) that three or four years previously he had toned prints in bichloride of platinum in place of gold, but had found it slower and a larger quantity of chemical was required, which equalized the cost, and he did not continue it. He toned his albumen prints by adding gold chloride to the hypo bath. He would not use perchloride of iron because it led to rapid fading such as he had noted in some stereos on the market. He claimed that none of his own had "faded in the proper sense of the word." Even as early as this, 1859, he had the confidence to say "an ordinary positive print, toned with gold by any of the recent processes, and carefully washed, may be considered quite permanent." His prints show no sign of fading 120 years later.

WASHING

No doubt the practice of sufficient washing played a part in the permanence Sedgfield achieved. His close association with Francis Bedford, whose prints have also largely stood the test of time, and who stated that he washed prints for 24 hours with at first considerable agitation, may explain Sedgfield's frequent mention of lengthy washing as essential.

STUDIOS

Sedgfield's first studio, in the 1840s, was the garden at Devizes. At Canonbury, North London, in the early 1850s, he may only have had a printing room for his interest was mainly in taking view photographs. At Hemel Hempstead, in 1857, he had a large second-floor studio with a vertical north light window as well as a glass-roofed and fronted veranda on the ground floor garden entrance; nevertheless, many portraits were taken in the garden. At Kingston-upon-Thames, in 1860, he had a glass house after the style described by Margaret Cameron in her *Annals of My Glass House* and by J. E. Mayall when he was commanded at forty-eight hours' notice to photograph the wedding of the Prince and Princess of Wales at Windsor, and purchased in the Euston Road, London, a glass house on condition that it be set up at Windor by ten the following morning. Sedgfield's glass house had a brick wall twelve courses high with glass walls above and a glass roof. His darkroom was then in the house. After about 1870, he became so fully occupied with

Figure 4. Russell Sedgfield, residence at Kingston-upon-Thames and glass house. Half-plate albumen print, 1860. Hardwicke Knight Collection.

Figure 5. Russell Sedgfield, photograph taken inside the Great Exhibition building, 1862. Hardwicke Knight Collection.

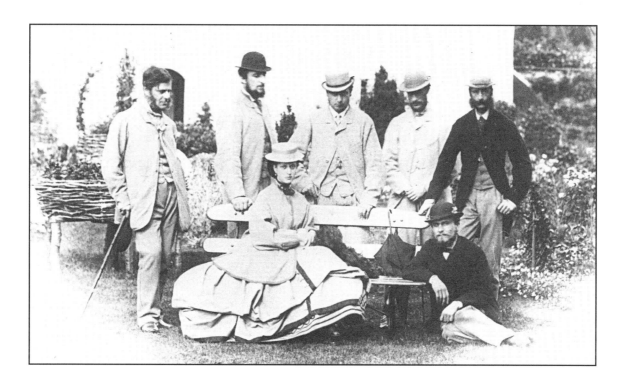

Figure 6. Russell Sedgfield, The Prince and Princess of Wales. Albumen print, 1864. Hardwicke Knight Collection.

Figure 7. Russell Sedgfield, Staithes. Albumen print, 6.5 x 9 inches, 1870. Hardwicke Knight Collection.

view photographs, travelling widely in both summer and winter, that he was only concerned with having processing facilities in the house. In the field, Sedgfield used a dark tent and, during the wet-plate period, had or had use of a dark van and experimented with the problem of keeping processing dishes level in one. He often took photographs of family and friends in living rooms, and after his retirement did not have a studio.

ILLUSTRATION OF BOOKS

In an advertisement in the *Athenaeum* of 20 April 1867, Sedgfield called attention "to the great facilities which he has for producing book illustrations." Some of the books Sedgfield illustrated are listed in my 1977 essay.[2] In 1855 Samuel Highley published Dr. Unger's *Ideal Views of the Primitive World*, illustrated by fourteen photographic plates. Highley explained that the photographic illustrations "are albumenized paper positives printed by Mr. Russell Sedgfield from collodion reproductions of Professor Unger's great work. In this respect, the present volume presents one of the first instances in this country of the practical application of Photography to Illustrated Literature." The second edition was printed by Taylor & Francis in 1863 with seventeen prints by Sedgfield, which were also offered as lantern slides. One of the better known books with Sedgfield's photographs is William and Mary Howitt's *Ruined Abbeys and Castles of Great Britain: the Photographic Illustrations by Bedford, Sedgfield,Wilson, Fenton, and others*, published by A. W. Bennett, Bishopsgate Without, London, 1862. S. Thompson, writing in the *British Journal of Photography* (1 March 1862) says that they are all too beautiful but he preferred those by Bedford and Sedgfield, and considered Sedgfield's Bolton Priory a gem. The total number of books illustrated by Sedgfield has not been ascertained, nor has it been possible to calculate the number of prints involved. Photographs of Sedgfield's garden at Hemel Hempstead and at Kingston show a considerable array of printing frames set up on easels sufficient to print at least 150 whole-plates simultaneously. His *Photographic Delineations* of 1854 is a very rare work and may not have been a large printing.[3] The photographs show a fine sense of mass, balance, texture, and light and shade. The portfolio is austere; there are no human figures. Long exposures make trees and water ephemeral and the architecture appear eternal. The prints in the Cambridge University Library copy are a good deep color. Sedgfield's views are usually taken from

sufficient distance to show the setting, such as Worcester Cathedral from across the river, and Salisbury rising out of the flat meadows. Western facades of cathedrals are only lit by oblique afternoon sun, too contrasty for the recording of detail, so that Sedgfield had to wait for bright but overcast conditions. His exercise of extraordinary patience in choosing the right time of day and angle of light is evident in all his work. He was travelling expressly for the one purpose of obtaining the most perfect photographs possible.

MICROSCOPY

Sedgfield took a photograph of his Smith & Beck compound microscope, a very fine instrument. The *British Journal of Photography* (1 August 1862) observed that "we are pleased to find so able a photographer as Mr. W. Russell Sedgfield making an attempt to introduce among the general public a series of photographs of microscopic objects." His photographic reproductions of Dr. Maddox's photomicrographs, which formed the frontispiece to the third and fourth editions of Dr. Lionel S. Beale's *How to Work with the Microscope* (Pall Mall, London: Harrison, 1864 and 1867) was a major commission, requiring thousands of prints for tipping in the editions. In addition to photomicrography, Sedgfield took macrophotographs of frost on glass and on bushes, of coral, shells, coins, and other subjects.

STEREOSCOPY

The introduction of photographic stereoscopy created an insatiable demand as evidenced in a review of Sedgfield's stereographs in 1860.[4] The reviewer makes the interesting observation that it is evident from a photograph of Margate that Sedgfield "employs a single lens camera, for three vessels out at sea, visible in both pictures of the pair, have slightly shifted their positions between the times of the two exposures." He may also have used a J. B. Dancer camera, but whether this was the 1853 prototype or the improved model patented in 1856 is not known. It is surprising to find that the halves of stereographs of purely family content that he preserved in his private collection have turned up in the United States and elsewhere as stereographs he had commercially marketed. Less surprising is a study of chess players, a stereograph showing his brothers, Sydney and Henry Sedgfield, with a chess board between them, and seated on an armchair and a music stool familiar in other portraits taken at Devizes. However,

Figure 8. Russell Sedgfield, beach scene. Albumen print, 1870. Hardwicke Knight Collection.

Figure 9. Russell Sedgfield. Worcester Cathedral from across the river. Albumen print, 1875. Hardwicke Knight Collection.

Sedgfield took many photographs specially for the stereo market and his skill was favorably noticed. A reviewer was impressed by such details as "a group of little girls sitting on the beach with their wooden spades, and the wet portion of the shingle exposed to its influence contrasts well with the dry crispness of the heaped-up water-worn pebbles under the blazing sunshine." Sedgfield issued many stereos as series, such as an English Series, a Welsh Series, a Farming Series. These often have printed labels with a wavy line border; others are embossed. A collection of over fifty prints contacted directly from stereo negatives show cropping marks, and level markers at the two outer margins so that, after the two views had been separated, the markers could be brought together and aligned at the center.

REDUCTIONS

There is no evidence that Sedgfield made use of an enlarger. There is, however, evidence of his making reductions. Two images of different sizes from the same negative frequently occur, the smaller clearly a reduction. He made reduced portraits for lockets. He also made contact prints, *carte-de-visite* size, from portions of larger plates.

PRICES

In the 1870s, for a 10 x 8 inch view photograph, Sedgfield charged £2.2s; for 12 cartes, 15s; and for 6 cabinets, £1.1s. In 1884 he advertised his Salisbury Series [5] numbered 1 through 57 (including numbers 40 through 48 of Stonehenge) and charged for 9 x 7 inch prints at 1s.6d; 7.5 x 4 inch prints cost 10d. Prints Nos. 55 and 56 showed twelve views on one sheet, size 7.5 x 4. Sedgfield was in competition with other photographers' series of Salisbury. Wormolds Series size 20x 24 inches were 14s; Frith's 10.5 x 6.5 inch prints were 2s. and 8.5 x 6.5 were 1s.6d; G. W. Wilson's 10 x 7 inch prints were 1s.6d. and Carl Norman's series size 12 x 10 inch prints were 3s. What Sedgfield received for the thousands of prints he produced for book illustration is not known. According to his will, when he died in 1902, he did not leave a large estate, but he lived for many years in retirement with his daughter Ada, and in comfort, so there can be little doubt he prospered in his profession.

REFERENCES

1. When Sedgfield asked Robert Hunt about the calotype process, he was told that Talbot threatened with an injunction any person who used it, even for amusement, without a license. On application to Talbot, Sedgfield received a reply from his solicitor with an agreement that prohibited even giving away prints to friends, and required a payment of £20.

2. Hardwicke Knight, "Russell Sedgfield," *History of Photography*, vol. 1, no. 4 (October 1977), pp. 301-312.

3. Russell Sedgfield, *Photographic Delineations of the Scenery, Architecture and Antiquities of Great Britain and Ireland*, folio, parts 1-4 (London: Highley, 1854-1855).

4. H. Baden Pritchard, *The Photographic Studios of Europe*, 2nd edition (London: Piper & Carter, 1883).

5. *Brown's Illustrated Guide to Salisbury Cathedral* (Salisbury: Brown & Co., 1884).

Nineteenth-Century Women Photographers

William Culp Darrah

The commercialization of photography that followed the introduction of the glass-negative paper-print processes, 1850-1865, provided employment for thousands of women in the manufacture of mounted images. The jobs included laboratory assistants, print cutters and mounters, colorists and retouchers, and clerks and receptionists. Editors of professional periodicals enthusiastically commented upon the opportunities for women in the photographic business.[1]

More remarkable, and as yet largely unappreciated, was the opportunity for women to enter the profession as photographers, especially as independent studio proprietors. Literally hundreds of women became studio photographers in the United States and in western Europe.

Photography was a new scientific technology, a new art, and a new business. There were no traditions, no requirements, no guilds or controlling organizations. It was an open profession, open to anyone with an interest and a very modest capital. There were no bars against women. Certainly in the history of the liberation of women the role of photography was profound.

How many women photographers were there? No one knows, although fairly reliable records indicate that there were more than a thousand in the United States.

This paper considers six aspects of the participation of women in studio photography: 1) Sources of information and data; 2) Entering the profession; 3) The numbers of women photographers; 4) Their geographic distribution; 5) Their work and workmanship; 6) European women photographers.

SOURCES OF INFORMATION

There are many contemporary records that provide the names and locations of photographers and their studios. Business directories, newspapers, tax lists, mention in professional periodicals, and U.S. Census records are most helpful. Nevertheless, all of these are incomplete and contain errors.[2]

Within the past twenty years, numerous directories of nineteenth-century photographers have been published for various states (Illinois, Connecticut, Colorado, Maryland, et al.) and cities (Chicago, Boston, St. Louis, et al.). Furthermore, many state historical societies are compiling information for such directories.[3]

In 1954, I began a project to document the existence of as many American photographers as possible, limiting names to those found on imprinted images that I have personally examined: *cartes de visite*, cabinet cards, and stereographs. All data used in this study have been derived from imprinted images. No names have been taken from published directories or lists, although whenever possible imprinted names have been compared with published sources.

It is a remarkable fact that the vast majority of nineteenth-century paper-print images (1854-1900) are imprinted. These imprints are an indispensable

tool in understanding the studio business. The typical imprint gives the name and address of the photographer. Usually, some form of advertisement is included, such as copying and enlarging services, specialties, awards received, and so forth.

As the index of photographers increased from 1,000 to 4,500 names, it became evident that about three of every two hundred "new" photographers were female, a ratio that has remained consistent. The file, as of January 1989, includes 22,315 names, of which slightly more than 18,200 are *carte-de-visite* photographers, and of these, 272 are women.

ENTERING THE PROFESSION

The three most common ways to enter photography were formal instruction, apprenticeship, and family association. Photographers frequently advertised for students or simply included in their imprints, "photography taught." There were schools of photography in England and the United States, some in existence for more than ten years. Generally the student paid for the instruction.

Learning under an established photographer was often informal, the student gradually becoming familiar with and proficient in the art. The most frequent approach by young men was apprenticeship, to work as a helper or an assistant for an agreed period of time. This might be as little as six months or a year, seldom more. Usually, the apprentice received free room and board. There are also instances of aspirants volunteering to work without pay until they were able to be independent.

Family associations were important centers of learning: husbands taught their wives, fathers taught their children, who in turn taught their children, uncles taught their nephews and nieces. Among the better-known families of photographers were Abbott, Barraud, Bennett, Dunshee, Freeman, Lochman, Mumper, and Weaver.

Many photographers began their employment as laboratory assistants or colorists, learned camera operation and studio management, and became operators in branch galleries, ultimately establishing independent businesses.

There were many skillful amateurs and other self-taught individuals who entered the business of photography, as well. We seldom know where or how a photographer learned his or her skill, although a little research will usually provide an answer.

THE NUMBERS OF WOMEN PHOTOGRAPHERS

The list of American (U.S.A. and Canada) photographers given at the end of this paper includes 272 names, with locations and approximate dates of operation. Of these, 156 operated as "Mrs."; 80 operated as "Miss"; and 36 operated as "Mr. & Mrs." Eleven widows continued to operate studios as "Mrs." following the death of the husband. These are not counted in the "Mrs." figures above.

The question has been raised about the possibility that some women concealed their sex by using initials instead of given names in their imprints. If any did so, the number would be trifling, there being little reason to do so.

No "art" photographers (unless they operated commercial studios) or amateurs have been considered in our survey here.

The ratio of 272 women to 18,200 *carte-de-visite* photographers is only 1.5%, a figure that is too low for estimating the probable total number of women studio operators.

The coverage of my collection is approximately 33% complete for the 1860s, 20% for the 1870s, barely 10% for the 1880s, and less than 1% for the 1890s. Women entered photography in increasing numbers between 1890 and 1905, a period in which the *carte-de-visite* virtually disappeared. Calculating only the period 1860-1880, the ratio is 1.8%.

Coincidentally, John Craig, who is compiling a directory of American daguerreotypists, informs me that he has approximately one hundred women among six thousand names, "less than 2%."[4] This is a striking discovery, showing how rapidly women entered photography.

Assuming that my list represents 15% of the photographers operating in the United States between 1860 and 1900, the probable total numbers would be 110,000 ±10,000, with at least 1,600 women.

GEOGRAPHIC DISTRIBUTION

There are several remarkable regional differences in the distribution of women photographers. The ten states with the greatest numbers of women photographers (and the ratio of male to female photographers) are:

Illinois	67 of 1,402	1:21
New York	26 of 2,173	1:83
Iowa	23 of 655	1:28
Wisconsin	13 of 485	1:37
Michigan	12 of 558	1:46
Pennsylvania	11 of 2,020	1:184
Kansas	10 of 320	1:33

Massachusetts	10 of 1,228	1:123
California	9 of 457	1:51
Minnesota	7 of 257	1:37

Grouping these states by regions, these 267 women photographers are distributed as follows:

Midwest	154
Middle Atlantic	53
New England	28
Far West	25
South (including Texas)	7

Six of the ten states with the most photographers are in the Midwest. During the post-Civil War population movement to the Midwest and Far West, where every new resident was an asset and every skill was needed, women were more readily accepted as business and professional associates.

In contrast, the unexpectedly low numbers in Pennsylvania, New York, and Massachusetts indicate a reluctance of women to enter the profession. My file of photographers is approximately 90% complete for Pennsylvania, 80% for New York, and 90% for Massachusetts for the period 1860-1890, indicating that the ratios given above are reliable.

The great majority of women operated studios in small towns and villages. Working in such communities meant a limited volume of business. Their images were not widely distributed, factors that account for the relative rarity of their images.

The studio photographer in a community smaller than 1,000 to 1,200 inhabitants had little opportunity to specialize. Instead, she had to perform any photographic service called for. All work was custom trade, not commercial or publishing. Portraiture was the mainstay of the business and of that 75% to 80% was *carte de visite* and most of the balance cabinet cards. Copying and enlarging in the1860s and 1870s was an important part of the business. Daguerreotypes and ambrotypes, one-of-a-kind images, were copied in *carte* format so that the likeness could be distributed among distant relatives and descendants. Copying of building plans, sketches, and documents was also a profitable service.

Generally the studio had a small display area showing albums, stereoscopes, other optical instruments, and various commercially published photographs to increase income.[5]

The importance of the photographer's imprint has already been mentioned. As a vehicle for advertising the studio business, its potential was unlimited, subject only to the ingenuity and daring of the photographer.

The following services, in order of frequency, are offered in the imprints:
1) inviting reorders by negative numbers;
2) copying and enlarging old pictures;
3) copying documents, plans and sketches;
4) framing photographs and selling frames;
5) selling *cartes de visite*, stereographs, albums, and optical instruments;
6) outdoor photography;
7) publishing photographs, usually stereographs;
8) teaching photography.

Of these services, only the first five appear in the imprints of women photographers. Only 21 of the 272 women photographers listed included anything other than name and location of their studios, occasionally embellished with a vignette or ornamental design.

Mrs. R. Maynard of Victoria, British Columbia, stands alone as an entrepreneur, calling herself "Photographic Artist and Dealer in All Kinds of Photographic Materials." Her imprints sometimes mention stereographs she has published.

The 21 imprints advertising services include the following:

10	copying and enlarging;
3	albums, frames, stereoscopes and views;
2	children and copying;
1	dealer in photographic materials and publishing;
1	portraits finished in oils, crayon or pencil;
1	photographs, ambrotypes, and gems (tintypes);
1	gems and copying;
1	Meinerth Mezzotint License;
1	hair jewelry made to order.

Four women used the logo of the National Photographic Association in their imprints: L. C. Gillett of Saline, Michigan [Figure 1]; Mrs. W. A. Reed, Quincy, Illinois [Figure 2]; Mrs. L. A. Watts, Altoona, Pennsylvania; and Mrs. R. Thorp Woodworth, Geneva, Ohio. The association, organized in 1869, was, to its credit, open to all professional photographers. Gillett and Reed were among the early members of the society.

The imprint of Ada Brown, Memphis, Tennessee, contains a curious error. She states, as required, permission to use the Mezzotint process, U.S. Patent 66726, License no. 175. She credits Oscar Bill (Brooklyn, NewYork), but the patent belongs to Carl Meinerth (Newburyport, Massachusetts). Oscar Bill has no connection with the patent or licensing.[6]

Figure 1. L. C. Gillett (Saline, Michigan), verso of albumen carte-de-visite portrait of unidentified child, 4" x 2 3/8" (mount). William Culp Darrah Collection, The Pennsylvania State University Libraries.

Figure 2. Mrs. W. A. Reed (Quincy, Illinois), verso of albumen carte-de-visite portrait of unidentified woman, showing National Photographic Association logo, 2 1/2" x 4 1/8" (mount). William Culp Darrah Collection, The Pennsylvania State University Libraries.

Photographer:		Male	Female
Subjects	Massachusetts	Nationwide	Nationwide
adult males	37.1%	35.5%	35.7%
adult females	34.5	37.6	34.0
children	12.6	8.8	13.4
infants	7.0	6.2	6.5
husband and wife	2.5	4.1	3.6
mother and child	2.8	2.6	3.6
groups	2.2	2.8	2.4
miscellaneous	less than 1.0	less than 1.0	less than 1.0

Table 1

The most conspicuous difference between the imprints by men and women involves publishing images. The term refers to the commercial publication for public sale. The images in stereograph, *carte-de-visite*, and larger formats generally pictured outdoor subjects. Although more than 30% of male photographs between 1854 and 1880 published views, only one imprint by a woman (Mrs. R. Maynard) advertised publishing. It is probable that Mrs. Rainheld, who advertised selling stereographs, published her own [Figure 3]. I know of only eight American women stereographers and only seven European. There is no explanation for the failure of women to pursue publication of their images.

WORK AND WORKMANSHIP

No American woman studio photographer achieved fame or national recognition, nor did the great majority of male photographers. There is no evidence that suggests specialization by women. Operating largely in small communities, their business was of a varied general nature.

In order to understand the nature of that business, 525 images by 226 women photographers were tabulated by subject. Only four non-portraits were found.

Adult males	188	35.7%
Adult females	179	34.0
Children	71	13.4
Infants	34	6.5
Husband and wife	18	3.6
Mother and child	18	3.6
Groups	13	2.4
Miscellaneous	4	less than 1.0

(Miscellaneous included a baby carriage, a dog, calla lilies, and a funeral wreath.)

Figure 3. Mrs. H. E. Rainheld (Fort Atkinson, Wisconsin), verso of albumen carte-de-visite portrait of unidentified woman, 4 1/8" x 2 1/2" (mount). William Culp Darrah Collection, The Pennsylvania State University Libraries.

Figure 4. Mr. & Mrs. C. D. Cornell (Waterloo, New York), verso of albumen carte-de-visite portrait of unidentified young man, 2 3/8" x 4" (mount). William Culp Darrah Collection, The Pennsylvania State University Libraries.

To compare the work of male photographers, two samplings were taken, 525 images by 225 Massachusetts photographers and 525 images by 225 photographers in twenty other states. Images were picked randomly in groups of twenty-five, with no selection of subjects. The categories are shown in Table 1.

There is striking conformity. While there are slightly higher percentages of images of children and mothers with children, these are statistically insignificant.

The figures for adults may be slightly skewed because youths over sixteen have been counted as adults. Boys commonly left school at fourteen to work, and girls of sixteen and seventeen married.

QUALITY OF WORK

The small number of images available for sampling makes any evaluation open to criticism. Subjective criteria may be misleading with inadequate numbers of images resulting in unjust judgments. One approach is to consider all images as a unity, and simply to generalize on the totality of 615 images by female photographers, using as criteria posing, characterization, lighting, print quality, and overall attractiveness. Accordingly, in my judgment:

3%	are very fine to superb;
6%	are very good to excellent;
25%	are good, pleasing;
50%	are adequate, acceptable, conventional, average;
10%	are poor;
5%	are very poor, including four that are pathetic attempts to produce a portrait.

It is more difficult to judge fairly the work of a photographer on the basis of one, two, or three images, all in one format, the *carte de visite*. Here again, relative rarity of images by women photographers is an obstacle. For example, of the 272 women photographers considered in this study, only thirteen are represented by more than five images:

Mrs. W. A. Reed	24	
Mrs. E. C. Frissell	20	
Mr. & Mrs. Rainheld	16	
Mr. & Mrs. Fields	15	
Mrs. J. C. Lesher	12	
Mr. & Mrs. Cornell	10	[Figure 4]
Mrs. M. A. Cutler	10	
Miss L. A. Gillett	10	
Mrs. H. P. Harvey	8	[Figure 5]
Mrs. W. B. Andruss	7	
Miss C. Smith	7	
Mrs. M. A. Van Housen	7	
Mrs. Stuart	6	[Figure 6]

Figure 5. Mrs. H. P. Harvey (Maquoketa, Iowa), verso of albumen carte -de-visite portrait of unidentified man, 4 1/8" x 2 1/2" (mount). William Culp Darrah Collection, The Pennsylvania State University Libraries.

The Rainhelds operated in four towns over a period of eighteen years: Fort Atkinson, Wisconsin; Clinton, Iowa; Marshalltown, Iowa; and Galva, Illinois.

For fifty-seven photographers, I have a single image each; for ninety-two there are two images; and for seventy-four there are three. These groups comprise 72% of the images and 70% of the photographers.

The outstanding photographers, listed alphabetically, include Mrs. J. F. Bauer, Brooklyn; Belle Bybee, Harper, Kansas; Miss L. A. Gillett, Saline, Michigan; Miss E. A. Hart, Whitewater, Wisconsin; Mrs. W. A. Reed, Quincy, Illinois; Mrs. R. A. Smith, Carlisle, Pennsylvania; Mrs. Stuart, Boston; and Mrs. Thompson, Ottawa, Illinois. Mrs. Hattie Clark, not included in this list, produced charming portraits of infants.

EUROPEAN WOMEN PHOTOGRAPHERS

Although this study is concerned primarily with American photographers, comparisons show that women in Europe entered the profession much as in the United States. There were daguerreotypists and later studio photographers in nearly all, if not all countries of Europe. I have images produced by ninety-eight photographers. The ratios between women and men operators show some remarkable differences.

Sweden	51 of 158	1:3
Norway	7 of 103	1:15
Austria	4 of 149	1:35
Switzerland	2 of 94	1:47
Denmark	1 of 68	1:68
Germany	8 of 860	1:108
Great Britain	11 of 1680	1:151
France	2 of 307	1:153

Women photographers worked in Belgium, Finland, Spain, and Russia, including present-day Poland, Czechoslovakia, and Lithuania. The numbers of images by women in those countries are too small to establish ratios.

Two recent exemplary studies of English photographers show many parallels between British and American studio photography. Pritchard compiled a list of 2,535 London photographers who operated between 1841 and 1908, relying heavily upon the London Post Office Directories, a most reliable and continuously maintained record of names and locations. The list includes 115 women, of whom 53% operated between 1890 and 1908.[7]

The second study, specifically dealing with women studio operators between 1841 and 1855 by B. V. and P. F. Heathcote, provides information about twenty-two women, some of whom had remarkable careers.

Figure 6. Mrs. Stuart (Boston, Massachusetts), verso of albumen carte-de-visite portrait of unidentified woman, 4" x 2 3/8" mount). William C. Darrah Collection, The Pennsylvania State University Libraries.

Figure 7. Miss M. A. Clegg (Darlington, Wisconsin), verso of albumen carte-de-visite portrait of unidentified child, 4 1/8" x 2 1/2" (mount). William Culp Darrah Collection, The Pennsylvania State University Libraries.

The authors mention that the names of "some 750 individuals," have been compiled, thus giving a ratio of approximately 3%.[8]

Among European countries, Sweden seems to have offered the greatest opportunities for women photographers. The ratio between female and male photographers in Sweden was 1:3. Active in the 1860s and 1870s, probably earlier, their numbers increased rapidly after 1890, with almost 65% operating between 1890 and 1910. No other country accepted women photographers so freely. In the United States, Illinois has the highest female-to-male ratio (1:21), comparable to Norway (1:15), yet does not come close to Sweden's representation.

Swedish women produced some of the finest portraits ever made in the *carte-de-visite* format. However, most of these beautiful images were produced between 1900 and 1910, a period in which

the *carte* had virtually disappeared in the United States and Great Britain.

SUMMARY

We may conclude from these data that

1) The profession of photography, especially the opportunity for proprietorship, was open, without hindrance to women in the United States, Canada, and Europe.

2) Their geographic spread covered nearly every one of the forty-eight contiguous states (in the nineteenth and early twentieth centuries, some were territories).

3) Studios were operated by married women, unmarried women, husband and wife teams, and widows, many of whom continued in business after the death of the husband.

Figure 8. Myra B. Rush (Olney, Illinois), verso of albumen carte-de-visite portrait of unidentified man, 4 1/8 x 2 1/2" (mount). William Culp Darrah Collection, The Pennsylvania State University Libraries.

Figure 9. Mrs. M. A. Russ (Salem, Oregon), verso of albumen carte-de-visite portrait of unidentified man, 4 1/8" x 2 1/2" (mount). William Culp Darrah Collection, The Pennsylvania State University Libraries.

4) The great majority of women established studios in small towns and villages, rather than in larger cities.

5) Women have constituted approximately 1.6% to 1.8% of American photographers, a ratio that appears to have been constant from the mid-1840s to 1890. Statistical extrapolation of these data suggests that at least 1,600 women photographers operated in the United States prior to 1900.

6) There are no appreciable differences between the kinds of images produced by women and men photographers, nor any qualitative differences.

7) In contrast, women photographers rarely published any of their images, whereas 30% of male photographers did. The kinds of images published commercially were generally scenery, cityscapes, public buildings, disasters, and so on, nearly all involving outdoor photography. Whether social taboos or avoidance of financial risk in publishing were deterrents is uncertain.

A checklist of American women photographers known through their imprinted images follows. Each name is accompanied by location of the studio and a numeral indicating the decades in which the images were produced. The notation "70s" indicates 1870s, "80s" indicates 1880s, and so on. If the photographer operated in more than one city, separate entries indicate this mobility. Variants in spelling are also given.

A CHECKLIST OF AMERICAN WOMEN PHOTOGRAPHERS

Aldridge, Mrs. J. E.	Chicago, Illinois	60s
Alford, Mrs. H. N. (also as Alfred)	Galesburg, Illinois	60s
Allen, Mrs. M. H. (as M.H. Allen & Lady)	Oswego, New York	70s
Allen, Mrs.	Norwalk, Ohio	60s
Allhands, Mrs. (as Mr. and Mrs. Allhands)	Jackson, Mississippi	70s
Anderson, Mrs. L. S.	Elgin, Illinois	60s
Andruss, Mrs. W. B. (also as Andrus)	Amboy, Illinois	60s, 70s, 80s
Archer, Mrs. D. J.	Columbus, Ohio	60s
Ashley, Mrs. Kate	Peoria, Illinois	80s
Atwood, Mrs. H. A.	Corvallis, Oregon	70s
Baird, Mrs. Melinda	Scottsville, Pennsylvania	60s
Barker, Mrs. J. K. (also as Baker)	Gardiner, Maine	70s, 80s
Barrett, Mrs. G. N.	Fort Dodge, Iowa	70s
Barrett, Mrs. G. N.	Del Norte, Colorado	70s
Bauer, Mrs. J. F.	Brooklyn, New York	70s
Bennett, Mrs. A.	Meadville, Pennsylvania	60s
Bennett, Orlanda O.	Abingdon, Illinois	60s
Bennett, Mrs. W. H. (also as Bennett)	Wilkes Barre, Pennsylvania	70s, 80s
Berglof, Mrs. H. M.	Concordia, Kansas	90s
Bissell, Mrs. E. M.	Tecumseh, Michigan	60s, 70s
Blodgett, Mrs. H. H.	Englewood, Illinois	80s
Brecht, Mrs. Emily (also as Gus and Emily Brecht)	St. Louis, Missouri	60s, 70s
Bridgeman, Mrs. C. P. (also C. T.)	Amboy, Illinois	60s
Bridgeman, Mrs. C. P. (also C. T.)	Oswego, Kansas	70s
Brown, Ada	Memphis, Tennessee	70s
Brown, Cornelia R.	Galesburg, Illinois	60s
Brown, Mrs. M. M. (also as Mr. and Mrs. Brown)	Hopewell, Missouri	70s
Buck, Ella A.	Fort Atkinson, Wisconsin	70s, 80s
Buck, Lydia	Franklin Grove, Illinois	60s
Butler, Mrs.	Buffalo, New York	70s
Bybee, Belle (also as Blybee)	Harper, Kansas	70s
Cady, Mrs. H. B. (also as Mr. and Mrs. Cady)	Waitsfield, Vermont	60s
Caldwell, Lydia (also as Cadwell)	Chicago, Illinois	70s, 80s
Call, Mary A.	location unknown	70s
Carpenter, Lucelia	Parkersburg, Iowa	80s
Carry, Hattie	Wilkes Barre, Pennsylvania	90s
Chapin, Mrs. J. A.	Fairfield, Iowa	60s
Clark, Mrs. Hattie	Mendota, Illinois	80s, 90s
Clark, Mrs. Robert A.	Black Hawk, Colorado	70s
Clegg, Mary A. [Figure 7]	Darlington, Wisconsin	70s
Collier, Mrs. M. A.	Circleville, Ohio	60s
Collier & Mix	Circleville, Ohio	60s
Cornell, Mrs. C. V. (as Mr. and Mrs. C. V. Cornell)	Waterloo, New York	70s, 80s
Cox, Mrs. J. R.	Sterling, Illinois	60s
Cox, Mrs. J. R.	St. Augustine, Illinois	60s
Craig, Mrs. M. A.	Urich, Missouri	70s, 80s
Cummins, Mrs. E. F. (as E. F. Cummins and Lady)	Watkins, New York	70s
Cutler, Mrs. M. A.	Galva, Illinois	60s, 70s
Cutler, Mrs. M. A.	Chariton, Iowa	70s
Darling, Mrs. F. B.	Streator, Illinois	70s
Denton, Mrs. B. R.	Newton, Kansas	70s
Dickey, Elizabeth	Delavan, Illinois	70s

Dikeman, Mrs.	Geneva, Ohio	60s
Douglas, Mrs.	Brooklyn, New York	60s, 70s
Drum, H.	Langton, Kansas	70s
Drum, Mrs.	Cerro Gordo, Illinois	60s
Drum & Ogle	Cerro Gordo, Illinois	60s
Durham, Mrs. Susan	Prairie City, Illinois	80s
Eames, Mrs. Elizabeth J.	Shasta, California	60s
Edmonds, Mrs. M. E.	Niles, Ohio	70s
Elliott, Mrs. L. E. (as Mr. and Mrs. L. E. Elliott)	Ottawa, Illinois	80s
Emery, H.	Bryan, Ohio	60s
Engle, Mrs. A.	Wilmington, Delaware	60s
Ersley, Mrs. (as Mr. and Mrs. Ersley)	Whitewater, Wisconsin	70s, 80s
Esterbrook, Mrs. Harriet	Peterborough, Ontario	70s
Evans, Mrs. O. B.	Fredonia, Pennsylvania	70s
Faunce	Franklin Grove, Illinois	70s
Fields, Mrs. (as Mr. and Mrs. Fields)	Lyons, Iowa	70s, 80s
Fitzgibbon, Mrs. J. H.	St. Louis, Missouri	70s
Fleming, Jenny	Council Bluffs, Iowa	60s
Folsom, Mrs. J. H.	Danbury, Connecticut	80s
Foote, Mrs. F.	Lake Mills, Wisconsin	70s
Foy, Mrs.	location (?), Canada	70s
French, Mrs. M. B.	Hudson, Michigan	60s
Frissell, Mrs. E. C.	Jefferson, Wisconsin	60s
Frissell, Mrs. E. C.	Fort Atkinson, Wisconsin	70s, 80s
Gage, Mrs. M. D.	San Francisco, California	70s
Gail, Addie	Lake City, Iowa	60s
Gaisford, Mrs. M.	Great Bend, Kansas	70s, 80s
Gantt, J.	Lockport, New York	60s
Garland, Lizzie	New Market, New Hampshire	70s
Gendron, A. M.	Watch Hill, Rhode Island	70s
Gendron, A. M.	Westerly, Rhode Island	70s, 80s
Gibson, Mrs. A.	Cedar Falls, Ohio	70s
Giles, Mrs. M. A. (also as Mr. and Mrs. Wm. Giles)	West Aurora, Illinois	60s, 70s
Gillett, Mrs. E. H.	LeRoy, New York	60s
Gillette, L. A. (also as Gillett)	Saine (Salina), Michigan	60s, 70s
Glover, Mrs.	Syracuse, New York	60s
Goodwin, Mrs. R. A.	St. Johnsbury, Vermont	70s
Graves, Mrs. (also as Mr. and Mrs. Graves)	Lockport, New York	60s
Gray, Helen	Blossville, New York	70s
Guernsey, Mrs. B. H.	Colorado Springs, Colorado	80s
Haley, Mrs. M. K.	Metropolis, Illinois	60s
Hanson, Mrs. Anetta	Menasha, Wisconsin	80s
Hart, E. A.	Whitewater, Wisconsin	70s
Harvey, Mrs. H. P.	Maquoketa, Iowa	70s
Hauser, Mrs. E. F. (also as Houser)	Sterling, Illinois	70s, 80s
Hawes, Mrs. Jennie (also as Haws)	Decatur, Illinois	80s
Hebard, Drusilla	Marshall, Missouri	70s, 80s
Hemptz, Mrs. Eugenia (also as Mrs. P. Edward Hemptz; and Hemtz)	Boston, Massachusetts	80s
Henley, Mollie	Dongola, Illinois	60s
Henry, Mrs. P. A.	Bowmansville, Ontario	60s
Hicks, Mrs. L. A.	Brooklyn, New York	60s
Hillbrand, Clara	Gowrie, Iowa	80s
Hinman, Mrs.	Holliston, Massachusetts	60s

Hissick, Mrs. C. J. T.	Marengo, Illinois	70s
Hitchcock, Mrs. Dr. J.	Canton, New York	60s, 70s
Hitchcock, Mrs. James		
(also as Mr. and Mrs. James Hitchcock)	Mt. Vernon, Illinois	70s
Hogan, Mrs. J. J.	The Dalles, Oregon	70s
Houser, see Hauser		
Howard, Mrs. E. M.	Alstead, New Hampshire	60s
Howe, Mrs. M. F.	Jamestown, New York	60s
Hoyt, Mrs. Fannie	Salt Lake City, Utah	80s
Ingalls, Sue C.	Cortland, New York	70s
Jacobs, Mrs. E. C.	Willimantic, Connecticut	60s
Jaixen, Mrs. Dora	Chicago, Illinois	80s
James, Mrs. A.	Lockport, New York.	60s
Jenkins, Ella I. (also as Mrs. O. A.)	Whitesville, New York	60s
Johnson, Adelaide	Adams, New York	80s
Jones, Mrs. D. W.	Greenville, South Carolina	60s, 70s
Jorns, Mrs. J. A.	Auburn, Illinois	80s
Kellett, Mrs. T. A.	LaPorte City, Iowa	70s
Kinston, Mrs. M. E.	Danville, Illinois	60s, 70s
Knox, Cornelia	Lake View, Oregon	90s
Labb, Emily	St. Anne, Illinois	60s
Lake, Mrs. E. C.	Detroit Lake, Minnesota	80s
Larabee, Mrs. F. H.		
(also as Mr. and Mrs. C. M. Larabee)	Hillsborough, Illinois	80s
Larimer, Mrs.	Humboldt, Kansas	70s
Lawton, Mrs. A. J.	Willimantic, Connecticut	60s
Leigh, Mrs. M. E.	Ionia, Michigan	70s
Lesher, Mrs. J. C.	Shippensburg, Pennsylvania	60s, 70s
Lewis, Mrs. A. T. (as Mr. and Mrs. A. T. Lewis)	Sioux Falls, South Dakota	80s
Louis, Jaline	Madison, New York	60s
Lewis, Mrs. J. B.	New York, New York	70s
Lewis, Mrs. J. B.	Greenwich, Connecticut	70s
Lockwood, A.	Ottawa, Ontario	60s, 70s
Lockwood, Mrs. E. M.		
(also as Mrs. Wm. Lockwood; Mr.		
and Mrs. Wm. Lockwood)	Ripon, Wisconsin	70s
Lockwood, M. L.	Lisbon, North Dakota	70s, 80s
Loomis, Mrs. (as F. F. Loomis and Lady)	Watkins, New York	70s
McCafferty, T. B.	Columbus, Wisconsin	70s
McClare, Miss (see Spence and McClare)	Buckley, Illinois	70s
McKean, Mrs.	Streator, Illinois	60s, 70s
McPhee, Mrs. James	Minneapolis, Minnesota	70s
Madden, Mrs. M.	Shelby, Ohio	60s
Madden and Robinson, Misses	Columbus, Ohio	70s
Madsall, Millie	Belvidere, Illinois	60s
Maine, M. Leslie (with W. Blanch Ward;		
as The Union View Co's Pavilion)	traveling; location ?	70s
Martin, Mrs.	Austin, Texas	60s
Mason, Anna	Keokuk, Iowa	60s
Mason, Mrs. H. (also as Mr. and Mrs. Wm. H. Mason)	Salem, Illinois	80s
Mason, Mrs. P. G.	Falls City, Nebraska	70s
Masters, Mrs. G. H. (also as Mrs. E. A. Masters)	Fort Collins, Colorado	70s
Matson, Fannie and May (also as Matson Sisters)	San Francisco, California	90s
Maxwell, Mrs. M. A.	Boulder, Colorado	60s

Maxwell, Mrs. M. A.	Denver, Colorado	70s
May, Mrs. J. A.	Xenia, Illinois	80s
Maynard, Mrs. R.	Victoria, British Columbia	70s
Miller, Mrs.	St. Catherine, Ontario	60s
Mitchell, Mrs. M. G.	Boston, Massachusetts	70s
Mohr, Carrie	Streator, Illinois	90s
Monroe, Mrs. A. L.	Thorpe, Wisconsin	80s
Moore, Mrs.	New York, New York	60s, 70s
Morris, Mrs.	Santa Cruz, California	80s
Naracon, Mrs. Wm.	Clyde, New York	60s
Nelson, Etta	Oakland, California	70s, 80s, 90s
Newdick, Mrs. M. A.	Rockford, Illinois	70s
Nichols, Mrs. C. A.	Rochester, New York	60s
Nikodem, Mrs. Annie M.	Chicago, Illinois	80s, 90s
Nillson, Mrs. Pauline	Cambridge, Illinois	70s, 80s
O'Donaghue, Mrs.	Frankford, Kentucky	60s, 70s
Oleson, Mrs. John H.	Minneapolis, Minnesota	80s
Paeszler,Clara P.	Ada, Ohio	90s
Palmer, Mrs. (as Mr. and Mrs. Palmer)	Tomah, Wisconsin	70s, 80s
Parsons, Mrs. J. H.	Ypsilanti, Michigan	70s
Peirce, Anna H.	Springville, N.Y.	70s, 80s
Pomeroy, Mrs. G. E.	Independence, California	60s, 70s
Pyles, Mrs. A. B.	Mount Ayr, Iowa	70s
Raimheld, Mrs. H. E.	Fort Atkinson, Wisconsin	70s
Raimheld, Mrs. (also as Rainheld)	Marshalltown, Iowa	70s
Rainheld, Mrs.	Clinton, Iowa	70s
Rainheld, Mrs. (as Mr. and Mrs. Rainheld)	Morristown, Illinois	80s
Randall, Mrs. Charlotte	Clyde, Ohio	60s, 70s
Rathbun, Mrs. G. W.	Roklan, Rhode Island	60s
Redman, Mrs. A. C. (also as Redmond)	Washington, D.C.	50s, 60s
Reed, Mrs. Julia A. (also as Read)	Morris, Illinois	80s
Reed, Mrs. W. A. (also as Mrs. M. A. Reed)	Quincy, Illinois	60s, 70s, 80s
Rheems, Mrs.	Bellevue, (state ?)	60s
Rhodes, Mrs. A. A.	Rockford, Illinois	60s
Rich, Mrs. S. A.	Zanesville, Ohio	70s
Ringgold, Mrs. F. G.	Quincy, Illinois	80s
Roberts, Miss	Coburg, Ontario	60s
Robinson, Mrs. Jane A.	Peoria, Illinois	70s
Robinson, Mrs.	Perrysburg, Ohio	60s
Robi(n)son, Mrs. N. A.	Hillsboro, Illinois	70s
Rochford, Rose	Osborne, Kansas	80s, 90s
Rogers, Mrs. I. L.	Springfield, Massachusetts	70s
Royce, Mrs. H.	Willimantic, Connecticut	60s
Royce, Mrs. H.	Stafford Springs, Connecticut	70s
Rudolph, Mrs. J. F.	Sacramento, California	60s
Rush, Myra B. [Figure 8]	Olney, Illinois	70s, 80s
Russ, Mrs. M. A. [Figure 9]	Salem, Oregon	70s, 80s
Rust, Mrs. M. J.	Hastings, Minnesota	60s
Sanderson, Lizzie	Oakland, Illnois	90s
Schellhaus, Mrs. L. W.	Ada, Michigan	70s
Schoeffer Sisters (also as Sheffer)	Clarion, Iowa	80s, 90s
Schooley, Mrs. L. A.	Indianapolis, Indiana	80s
Schooley, Mrs. N. A.	Indianola, Iowa	70s
Schultz, Mrs. (as Mr. and Mrs. Schultz)	Belvidere, Illinois	80s

Schwartz, Mrs. H. A.	Cincinnati, Ohio	70s
Sears, Mrs. D.	Camden, New York	60s
Seiger, Mrs. F.	Chicago, Illinois	70s
Severn, Mrs. M. E.	Chicago, Illinois	70s
Sharp, Mrs. (as Mr. and Mrs. Sharp)	Rensselear, Indiana	70s
Sippill, Mr. R. H.	Providence, Rhode Island	60s
Smith, Miss C.	Lowell, Massachusetts	70s
Smith, Mrs. C. A. N.	New York, New York	60s
Smith, Flora	Wells River, Vermont	60s
Smith, Mrs. J. A.	Xenia, Illinois	80s
Smith, Lizzie	location unknown	90s
Smith, Lula	St. Petersburg, Florida	90s, 1900s
Smith, Mrs. P. H.	Jasper, Oregon	80s
Smith, Mrs. R. A.	Carlisle, Pennsylvania	60s, 70s
Spalsberg, Mrs. B. B.	Morrison, Illinois	80s
Speechley, S. T.	Manchester, Michigan	60s
Spence, Susan	Paw Paw Grove, Illinois	80s
Spence and McClare, Misses	Buckley, Illinois	70s
Sprake, B. R.	Red Wing, Minnesota	70s
Stebbins, Mrs. S. L.	Corry, Pennsylvania	60s, 70s
Steele, Mrs. (as Mr. and Mrs. Steele)	Red Jacket, Michigan	80s
Stevenson, Mrs. (as Mr. and Mrs. Stevenson)	El Dorado, Kansas	70s
Stirling, Mrs. H. N.	Niles, Michigan	70s
Stoll, Miss Lottie M.	Leadville, Colorado	70s
Stone, Mrs. T. P.	Woodhull, New York	60s
Strong, Mrs. C. (also as Mrs. J. C. Strong)	Jerseyville, Illinois	70s
Stryker, Mrs. C. M.	Corvallis, Oregon	70s
Stuart, Mrs.	Boston, Massachusetts	60s
Sunderlin, Mary	Flemington, New Jersey	80s
Ten Eyck, Mrs.	Milwaukee, Wisconsin	60s
Thayer, Ida	Cresco, Iowa	70s, 80s
Thompson, Mrs. Catherine	Waukeegan, Illinois	80s
Thompson, Mrs.	Ottawa, Illinois	70s
Thornton, Mrs. M. A.	Perrysburg, Ohio	70s
Thorp, R. M.	Geneva, Ohio	60s
Thurston, Mrs. E. Q.	Waukegan, Illinois	60s
Towne (as Towne and Whitney, Lady Photographers)	Gardner, Massachusetts	90s
Townsend, Mrs. A. P.	Conneautville, Pennsylvania	80s, 90s
Tyler, Mrs. M. E.	Portland, Oregon	90s
Van Housen, Mrs. M. E.	Hammondsport, New York	60s
Van Housen, Mrs. M. E.	Bath, New York	70s
Wadsworth, Mrs. Wm. B.	Franklin, New Hampshire	70s
Waldack, Mrs. Charles	Cincinnati, Ohio	70s, 80s, 90s
Ward, W. Blanch (as Union View Co., with M. Leslie Maine)	travelling, location unknown	70s
Watts, Mrs. L. A.	Altoona, Pennsylvania	70s
Weary, Mrs. (as Mr. and Mrs. Weary)	Lanark, Illinois	70s
Weed, Mrs.	Neponset, Illinois	60s
Weigle, Mary	Dyersville, Iowa	80s
Wells, Mrs. T. M. (as Mr. and Mrs. T. M. Wells)	Decatur, Illinois	80s
Whitcomb, Mrs.	Brownton, Minnesota	80s, 90s
Whitney (as Towne and Whitney, Lady Photographers)	Gardner, Massachusetts	90s
Wilmarth, Mrs. H. H.	Chicago, Illinois	70s

Wilson, Alice, M.	Winters, California	90s
Wimermark, Pauline	Cambridge, Illinois	70s, 80s
Withington, Mrs. E. W.	Amador County, California	60s
Withron, Mrs. A. J.	Salem, Iowa	60s
Woodbury, Dora	Rochester, Minnesota	60s
Woods, Miss M.	location unknown	70s
Woodworth, Mrs. B. Thorp	Geneva, Ohio	70s
Worsfold, Misses	Waukeegan, Illinois	70s
Worth, Mrs. S. A.	Harper, Iowa	60s
Worthing, Hannah, A. (also as Anna H. Worthing; also as H. A. Worthley and A. H. Worthley)	New Bedford, Massachusetts	60s, 70s
Wynder, Mary A.	Baltimore, Maryland	80s
Wyatt, Mrs. A. A. (also as Mrs. Mary J. Wyatt and Mr. and Mrs. A. A. Wyatt)	Roseville, Illinois	70s, 80s
Wyatt, Mrs. Mary J.	Phelps Center, Nebraska	80s, 90s
Wyatt, Mrs. Mary J.	Wilcox, Nebraska	90s
Young, Mrs. S. J.	Fayetteville, Arkansas	70s

Henry Deeks generously loaned me his gathering of *cartes de visite* by women photographers. Approximately fifteen names in the list are based on Deeks' specimens.

REFERENCES

Author's Note: Throughout this essay, I deliberately use the first person singular to make it clear that I assume full responsibility for all facts and statements for which no other documentation is available. Some of my findings and conclusions may be shown by future research to be premature, incomplete, or erroneous. My sole purpose here is to present a "present status" report, to encourage others to investigate the role of women in the history of photography.

1. *Philadelphia Photographer*, vol. 1 (May 1864), p. 12.

2. William C. Darrah, *The World of Stereographs* (1977), p. 237.

3. There are many directories of nineteenth-century photographers compiled from published records and business directories. Among the more useful is Marie Czach's *A Directory of Early Illinois Photographers* (1977), which lists approximately 2,500 photographers, excluding Chicago. Women constitute 4%, of whom 20% operated earlier than 1860 and 15% after 1890. See also Sue E. Fuller, "Checklists of Connecticut Photographers, 1839–1889," *Connecticut Historical Society Bulletin*, vol. 47, no. 4, pp. 117-163, which gives 667 names, including eight women. T.M. Mangan's *Colorado on Glass* (1975) gives a list originally compiled and revised by Opal Harber, with additions by Mangan, including about one thousand names, of which fifty-one are women. Of these, thirty-four (55%) operated between 1890 and 1910. Peter Palmquist published a list of 112 nineteenth-century California women photographers (*Photographic Collector*, vol. 1, no. 3 [1980], pp. 18-21). Six names have no data; forty-five operated in the 1890s, thirty-five in the 1880s, leaving only twenty-six operating between 1860 and 1880.

4. John C. Craig, personal communication, August 6, 1986.

5. William C. Darrah, *Cartes de Visites in Nineteenth Century Photography* (1981), p. 12.

6. William C. Darrah, *Cartes de Visites*, p. 29. See also William C. Darrah, "Carl Meinerth, Photographer," *Photographic Collector*, vol. 1, no. 4 (1981), pp. 6-9.

7. M. Pritchard, *A Directory of London Photographers, 1841-1908* (1986).

8. B. V. Heathcote and P. F. Heathcote, "The Feminine Influence: Aspects of the Role of Women in the Evolution of Photography in the British Isles," *History of Photography*, vol. 12, no. 3 (1988), pp. 259-273.

Sons of Vulcan: An Iron Workers Album

Ronald Filippelli and Sandra Stelts

I am brown with the soot of my furnace;
I drip with the sweats of toil;
My fingers throttle the savage wastes,
And tear the curse from the soil.

Hymn of Pittsburgh, by Richard Realf.

In the midst of Pittsburgh's rise to dominance as the nation's iron and steel center, even as the Union armies fought the Civil War with the products of her furnaces and mills, the management of the iron rolling mill of Lyon, Shorb and Company commissioned a photographer to compile a complete record of the firm's personnel in a photographic album.[1] Thirty officials of the company, which had its headquarters in St. Louis, apparently submitted images taken by photographers of their own choosing, including one by Mathew Brady. The contract for the workers' photographs, however, went to R. M. Cargo, a Pittsburgh photographer.

Cargo's photographic rooms were at 21 Fifth Street, on the "Brewer's Block" near the Post Office, in the heart of Pittsburgh's thriving commercial photography district.[2] No doubt the nearly 260 *carte-de-visite* photographs of the Lyon, Shorb workers were taken in Cargo's studio because of the requirement in the wet collodion process that camera and darkroom be close to each other. It is unlikely that Cargo carried his bulky camera and tripod, not to mention processing equipment and chemicals, to the

Lyon, Shorb mill for the project.

The iconography of occupations and industries was highly regarded in the United States, symbolizing as it did work, prosperity, and progress. Normally, large-scale industries employing many workers were photographed while in operation. *Carte-de-visite* images portrayed workers busy at their tasks, often posed with either the tools or products of their labor, or in traditional costume.[3] These images of America's robust industrial youth remain highly desirable as collectibles today.[4]

Although taken in the studio, the *cartes de visite* produced by R. M. Cargo are securely in this tradition. Certainly the bustling firm of Lyon, Shorb and Company, even in the midst of a terrible civil war, symbolized the confidence of the young republic. What activity represented the sinews of American industrial might more than the making of iron? When the company decided to commission a photographic record of their work force, there were at least 25 iron and steel mills in Pittsburgh and vicinity, employing over 2,500 workers. With some 260 workers and 15 puddling furnaces, Lyon, Shorb and Company must have been among the largest.[5]

Most of the photos made by Cargo portray the workers in their work clothes. Many wear the characteristic leather aprons of the nineteenth century. They are posed in the traditional stilted fashion of studio photography, standing beside props meant to represent the work done at the mill. Piled

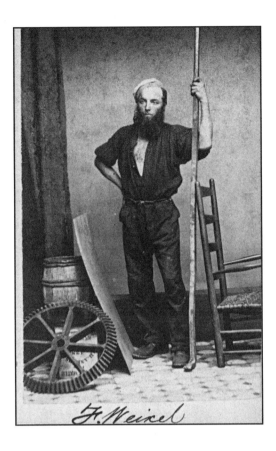

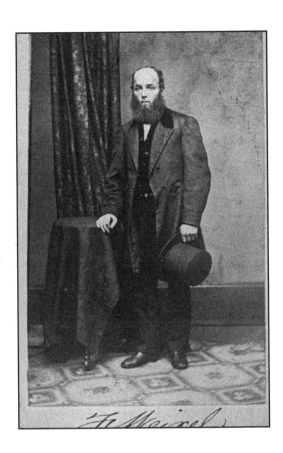

Figure 1. R. M. Cargo, Pittsburgh, Pennsylvania, photographer. Lyon, Shorb and Company iron worker F. Weixel, in work clothes and holding his long iron rabble, ca. 1864. Carte de visite, 4 x 2.5 in. Courtesy of the Centre County Library and Historical Museum, Bellefonte, Pennsylvania.

Figure 2. R. M. Cargo, Pittsburgh, Pennsylvania. Lyon, Shorb and Company iron worker F. Weixel, in dress clothes, ca. 1864. Carte de visite, 4 x 2.5in. Courtesy of the Centre County Library and Historical Museum, Bellefonte, Pennsylvania.

up beside the subjects are an assortment of iron rods, gear wheels, sheet iron, a small nail cask, and other miscellaneous items. Often the workers are holding a tool of the trade. In many cases the tool clearly identifies the job, but although an iron rolling mill was a complex operation, there were few implements that were characteristic of a particular trade. Many of the jobs in the rolling process required the use of a common implement. In the album, workers are frequently portrayed holding a set of iron tongs, or perhaps a long iron rod, both of which were used to do various tasks. Only the lordly puddlers, with their long iron rods called "rabbles," are easily identifiable [Figure 1]. The many other skilled craftsmen such as painters, bricklayers, carpenters, masons, and millwrights who were necessary, but ancillary, to the

puddling, heating, and rolling process, are easier to identify, with their brushes, saws, and trowels. Finally, a number of photographs portray the common laborers who were employed by the day or hour to carry materials about, shovel ore, clean up, stack and load goods for shipment, and perform other types of gang labor.

There is little indication from the photographs of the workers in their work clothes of the rigid hierarchy of the mill. But fortunately a number of the workers were also photographed in dress clothes [Figures 1 and 2]. While not all of the workers photographed in this fashion were skilled workers, most seem to have been. In these formal photographs the skilled workers are indistinguishable from the bankers, businessmen, merchants, and lawyers of

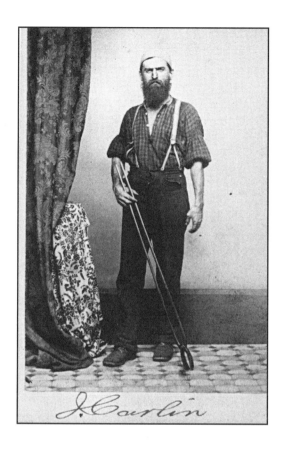

Figure 3. R. M. Cargo, Pittsburgh, Pennsylvania. Lyon, Shorb and Company iron worker James Carlin, heater, 8-inch roll train, ca. 1864. Carte de visite, 4 x 2.5 in. Courtesy of the Centre County Library and Historical Museum, Bellefonte, Pennsylvania.

their day. There is no hint from their somber yet elegant clothes and their confident manner that these men spent their days in the heat and noise of a rolling mill performing labors so severe that they had "to stop, now and then, . . . take off their boots, and pour the perspiration out of them."[6]

From the vantage point of the late twentieth century, it is difficult for us to comprehend the lofty status of the skilled worker in mid-nineteenth-century America. Pittsburgh was an industrial city, and the skilled men who manned her mills were the backbone of her citizenry, respected and envied as the elite of the working class. The aristocrats of the iron mills were the rollers, puddlers, heaters, and nailers. After pig iron from the Juniata forges was melted in the hearth of a furnace, the puddler (called a "boiler" at

Lyon, Shorb) stirred it with his rabble to keep the spikes of pure iron, which rose to the top of the froth, moving to the bottom and to knead them there into a pasty mass that slowly "came to nature." After the slag had been poured off, the puddler then shaped the spongy mass into 200-pound balls that were subsequently rolled into flat sections known as "muck bar." The heaters [Figure 3] then took over, heating the muck bar in gas-fired soaking pits and sending it on to the rolling mills where a team of workers, under the direction of the roller, used large tongs to force the iron through the rolls a dozen or more times to fashion rail, nail, bar, and plate iron. Finally, the nailers ("shearman" at Lyon, Shorb) and their helpers who tended the shearing machines and stamping hammers cut and pounded the iron to its final form [Figure 4].[7]

The workers in all four crafts enjoyed broad autonomy in the control of their own work and that of their helpers. Not only did they direct a highly coordinated team effort, but they customarily hired and promoted their helpers, negotiated a "price" per ton with their employers, and divided up the money among themselves according to the skills involved in each job. This occurred whether or not they were unionized, although by the 1860s most of the skilled workers at Lyon, Shorb and Company no doubt belonged either to the Sons of Vulcan (the puddlers union); the Associated Brotherhood of Iron and Steel Heaters, Rollers and Roughers; or the Rollers, Roughers, Catchers or Hookers Union.[8]

Although there was no apprenticeship in the iron trades, workers acquired their knowledge of the highly variable qualities of molten iron by assisting experienced craftsmen. Not surprisingly, the helpers whom the skilled workers hired, and thus put into position to learn the crafts, were often their relatives. The presence of nepotism in the mill is graphically depicted in the album. Appropriately placed at the back of the album are the photographs of twenty-eight boys, many of whom have the same surnames as older skilled workers [Figure 5]. Among the helpers, straighteners, rougher ups, and rougher downs, catchers, drag downs, drag outs, and a score of other job categories, certain family names appear often.[9] For example, three Weixels, who appear to be brothers in the photographs, were all puddlers. One can speculate that they learned the coveted trade as their father's helpers, because as late as the 1890s the rights to puddling furnaces were often passed from father to son.

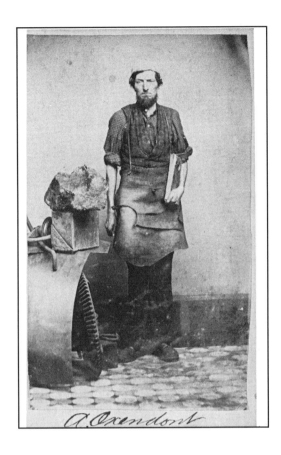

Figure 4. R. M. Cargo, Pittsburgh, Pennsylvania. Lyon, Shorb and Company iron worker A. Oxendont, shearman, ca. 1864. Carte de visite, 4 x 2.5 in. Courtesy of the Centre County Library and Historical Museum, Bellefonte, Pennsylvania.

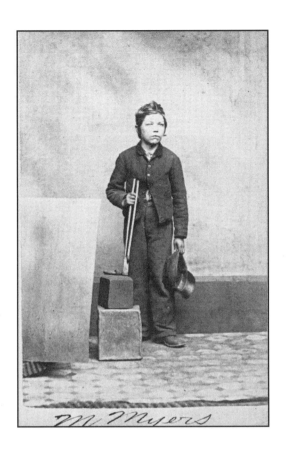

Figure 5. R. M. Cargo, Pittsburgh, Pennsylvania. Lyon, Shorb and Company helper (probably on a rolling crew), M. Myers, ca. 1864. Carte de visite, 4 x 2.5 in. Courtesy

The Lyon, Shorb album also stands as a graphic record of an industrial era that was soon to pass away. The fatal weakness of wrought iron manufacture was its resistance to mechanization. The procedures were entirely manual, which accounted for the functional autonomy of the skilled workers. By the end of the century, however, mechanization in the rolling process had eliminated eight of the thirteen-man crew. As early as 1875 the introduction of the Bessemer process for the making of steel from pig iron doomed the puddler. By 1892 steel production had surpassed that of iron.[10] Not surprisingly, that was the same year in which Andrew Carnegie crushed the union of the skilled workers during the epic Homestead Strike.

It might seem an exaggeration to place R. M.

Cargo's ironworkers album in the same tradition as acknowledged masters of the photography of industrial workers. Cargo clearly did not view the workers who trooped to his studio as social "types" who represented the working class in the existing social order, as the German photographer August Sander later did in his monumental project, *Citizens of the Twentieth Century*.[11] Nor did he portray his subjects as heroic figures, emphasizing their power, grace, skill, and control as Lewis Hine was to do in his "work portraits."[12] Yet, perhaps unconsciously, the obscure Pittsburgh photographer achieved the same results as his illustrious successors. The *carte-de-visite* photos in the Lyon, Shorb album are a remarkable collective portrait of the mid-nineteenth-century industrial working class. What comes through

strongly in these portraits is the pride and dignity of "noble sons of labor" who, in the words of an old Sons of Vulcan poem, "with bone, and brain, and fibre, make the nation's wealth," and "in the name of truth and justice . . . our land from ruin save."[13] It is our great good fortune that R. M. Cargo's treasure survives.

REFERENCES

1. The album was found in the attic of a descendant of the Lyon family and donated to the Centre County Library and Historical Museum, Bellefonte, Pennsylvania, in 1982. The Historical Society of Western Pennsylvania, Pittsburgh, Pennsylvania, acquired the album in 1988. Accompanying the album is a holograph list of the names and job titles of the workers pictured. It is difficult to date the album with precision. Cargo's imprint on the back of the *cartes de visite* lists his Fifth Street address. We know from city directories that Cargo moved his studio across the Allegheny River to Federal Street in Allegheny City sometime in 1863 or 1864. The album in which the photographs appear has a patent date of April 1864. It is reasonable to assume that Cargo presented the finished project to the Lyon, Shorb management in the album. The two facts indicate that the photographs were taken no later than 1864.

2. *City Directory of Pittsburgh and Allegheny Cities,* George H. Thurston, n.p. (1861-1865). On Fifth Street near Cargo's studio one could also find Boyd's Ambrotype Gallery, where clients were assured that the pictures compared "with any in the world"; the Chronicle Premium Gallery, winner of "two silver medals and three diplomas"; C. Wertz's Pittsburgh Daguerreotype Rooms; J. N. Glogger, a "photographic painter"; and several other photographers. Just around the corner on Wood Street more practitioners could be found. Not surprisingly, with such a concentration of business, the Brewer's Block also housed three photographic goods houses, including that of C. C. Kelsey, who sold apparatuses, plates, cases, glass, frames, chemicals and "every description of daguerreotype, ambrotype and photographic materials" to the trade.

3. William C. Darrah, *Cartes de Visite in Nineteenth Century Photography* (Gettysburg, Pennsylvania: W. C. Darrah, publisher, 1981), p. 150.

4. William C. Darrah, pp. 140, 141, 150.

5. G. H. Thurston, *Pittsburgh As It Is* (Pittsburgh, Pennsylvania: W. S. Haven, Book and Job Printer, 1857), pp. 111-112.

6. J. Parton, "Pittsburgh," *Atlantic Monthly,* vol. 21 (January 1868), p. 33.

7. For the best description of the work processes of an iron rolling mill see D. Montgomery, *The Fall of the House of Labor* (New York: Cambridge University Press, 1987), pp. 9-24; also see D. Brody, *Steelworkers in America: The Non-Union Era* (Cambridge, Massachusetts: Harvard University Press, 1960), pp. 26-49.

8. D. Montgomery, pp. 9-11.

9. At Lyon, Shorb and Company certain surnames, such as Young, Myers, Brokaw, and Petticord, among others, appear frequently.

10. D. Brody, pp. 8-9.

11. Gunther Sander, ed., *August Sander: Citizens of the Twentieth Century; Portrait Photographs, 1892-1952* (Cambridge, Massachusetts: The MIT Press, 1980). It is interesting to note that August Sander (1876-1964) grew up in a coal-mining family and was apprenticed in 1889 to an iron-miner.

12. Lewis W. Hine, *Men at Work: Photographic Studies of Modern Men and Machines* (New York: The Macmillan Company, 1932; Dover Publications reprint, 1977); and J. L. Doherty, ed., *Women at Work: 153 Photographs by Lewis W. Hine* (New York: Dover Publications, 1981).

13. *National Labor Tribune,* vol. 6 (March 30, 1878). The poem is reproduced in D. Montgomery, p. 23.

The Lady Is For Turning

This remarkable structure was photographed at Laxey, on the east coast of the Isle of Man, by Valentine and Sons of Dundee. It was used from 1854 onwards to pump water from the local lead mines, and was affectionately known as "The Lady Isabella."[1] Valentine and Sons came to be one of the great postcard publishing firms of the wet collodion age, rivalling Joseph Cundall of London, Francis Frith of Reigate and George Washington Wilson of Aberdeen. James Valentine had gone to Paris in the late 1840s to learn the daguerreotype process, but changed his ways soon after his return. In the early 1850s, he was operating a portrait studio, specializing in *cartes de visite*.[2]

Figure 1. Valentine and Sons, of Dundee, Scotland. "The Lady Isabella," water wheel on the Isle of Man, ca. 1854. Albumen print. Private collection

Gernsheim mentions that Valentine and Sons employed forty workers in the 1870s, turning out some 18,000 albumen prints weekly.[3] This photograph was probably taken soon after the big wheel's construction. Heavily retouched to cope with the intrusively bright sky and delicate silhouettes, it was later distributed in the form of an enlarged (16 x 22 cm) gravure print, glued to a sheet of glass (as here), a tribute to the growing interest in man-made landscapes, and a thoroughly unselfconscious forerunner of the Neue Sachlichkeit.[4]

Benjamin Spear

REFERENCES

1. Sara Stevenson, Personal Communication.
2. J. Hannavy, *A Moment in Time: Scottish Contributions to Photography, 1840-1920.* (Third Eye Centre, Glasgow, and Interbook Media Services Ltd., Scotland, 1983).
3. H. & A. Gernsheim, *The History of Photography* (New York: McGraw–Hill, 1969).
4. This reference serves no bibliographical purpose but is dedicated to HKH, on the occasion of his 68th birthday, and to all who share his famous fondness for footnotes.

Photographic Felonies

Ann Wilsher

Self-congratulation is supportive, and so easy to sustain; the problem is to persuade others to join in the applause. Early photographers loved to present themselves as champions of the truth, but all too often found their missionary work rejected by a hostile public. "Let There Be Light" was the motto on the banner unfurled by every studio and yet, after the pleasant dreams and proud claims of being servant, partner, even, in moments of special complacency, master of the sun, it was disconcerting for the standard-bearer himself to discover that he was thought of by large sections of society as the agent of the Prince of Darkness. The only comfort in this sorry state of affairs was that in this one point at least the photographer attained what he had most longed for: equality in the eyes of the world with the traditional artist. Whether armed with a lens or a brush, each was viewed on occasion as a shady character up to no good who, when not stealing secrets, was off stealing souls.

Anyone who does unexpected things in out of the way places is liable to fall under suspicion. Artists have an unfortunate tendency to poke about in strange territory in search of the picturesque. Dr. Richard Pococke agitated the authorities in Alexandria during 1737 by hiring a boat and sketching the ruins submerged in the calm waters round Pharos. He was thrilled by traces of a long-lost world, but the watchers on the shore thought he was noting down the details of present-day fortifications.

The same problem surfaced a few years later, in 1810, when Edward Dodwell annoyed yet another group of Turkish officials by taking a view of the remains of Tiryns with his camera obscura.[1]

Misunderstandings and misadventures have dogged the intrepid down the centuries, and so it comes as no surprise to learn that Dr. Claudius Galen Wheelhouse was once arrested as a spy while making calotypes of Cádiz during 1848. Marched to the Guard House, Wheelhouse tried to explain what he had been up to, only to find his shreds of Spanish embarrassingly insufficient for the task. The British Consul was summoned to the rescue, but as that official had never heard of photography the affair might have taken a very nasty turn had it not been for the lucky chance that, once face to face, he and Wheelhouse recognized each other as fellow school-mates.[2]

Suspicions slide smoothly into minds with grooves made ready to receive them. Official opposition to even such innocent expeditions as these was not entirely groundless. It was a custom hallowed by long tradition for armies to use artists to sketch both weak and strong points in an enemy's position. When a photographer like James Robertson made panoramas of Sebastopol during the Crimean War he was following in the footsteps of a long line of military men trained to create the same kind of detailed overview with a pencil. Throughout the eighteenth century, classes in draughtsmanship had a

111

*Figure 1. "Devil-in-the-Box." Trade emblem on the back of
a carte de visite issued by the Garrett Studio, 828 Arch Street,
Philadelphia, Pennsylvania, in the mid-1870s. Crabtree
Collection, Rare Books Room, Pattee Library, The
Pennsylvania State University.*

place in the curriculum at the Royal Military Academy at Woolwich, and Paul Sandby, the noted landscape painter, earned his bread and butter, if not his jam, by teaching a steady stream of cadets there one day a week, from 1768 to 1796.[3]

Authority smiled while artists and photographers ran tame and did what they were told, with no questions asked. Trouble began when they wandered off on their own, to dig up details best left buried. That new figure, the war correspondent, who caught the public imagination in the last decades of the nineteenth century, proved a perpetual irritant to the military establishment. When William Simpson, working for the *Illustrated London News*, wanted to sketch Napoleon III's travelling carriage at Metz, during the Franco-Prussian War of 1870, an enraged

commandant turned down the request point-blank, and summoned the whole corps of correspondents to hear the bellowed grounds for his refusal: "Carriages forsooth!—it may be a carriage today, but it will be sketching the fortifications tomorrow."[4]

In the face of such hostility it was inevitable that a trace of iron began to show up in the illustrator's soul, and "determination and duplicity" became his watchword. René Bull brought back many pictures of the Armenian Massacres in Turkey during 1895-1896, and was praised for resourcefulness by his paper, *Black and White*: "Despite extreme difficulties, for a camera is strictly prohibited, Mr. Bull by the exercise of great ingenuity has taken some excellent photographs, nor has his pencil been idle."[5]

The editorial is maddeningly discreet about Bull's

methods; perhaps he simply managed to disguise his camera. A caricature of "A War Artist at the Front," which appeared in *The Regiment* on 27 January 1900, shows a Kodak camera in the foreground, with the Red Cross emblem boldly blazoned on its side.[6]

If only all those in authority had taken the trouble to read *The Filibuster,* an 1862 novel by Albany Fonblanque, they might have slept more soundly in their beds. The war correspondent in that story was not nearly so interested in particular details as the generals suspected. As he explained to an admirer: "Between you and me, I was only one day and night in the Filibuster's camp; but there was an old ruin, a village and a forest near at hand, so I took 20 views of each from different points, and one or the other did very well for every place mentioned in the news. No one in New York knows the difference. It was much the safest way of doing business and saved travelling expenses."[7]

To steal a soul is a considerably more serious matter than to steal a secret. Here again, the same cloud of suspicion shadowed photographer and artist alike. The very phrases, "to make a likeness" and "to catch a likeness" have about them disturbing suggestions of magic and of theft.

Travelling artists were always getting into trouble. Holman Hunt on his expedition to the Middle East was accused, as he made portraits, of collecting souls to sell to the Devil, and Edward Lear was denounced as Satan incarnate while sketching in Albania.[8] Travelling photographers ran into just the same problems. An 1869 essay in the Warsaw magazine, *Kłosy,* described the fear and hostility which greeted the camera in the Polish countryside: "The first photographers were considered by the peasants as instruments of the Evil One. The apparatus, the mysterious preparations, aroused alarm and the suspicion that evil spirits and the Devil himself must be concealed in the machine with the long tube, and that it is he who 'paints' so well, on orders of the one who sold him his soul"[9] [Figure 1].

Loss of a soul meant the loss of a life, and this is the black thread which runs through story after story. Lady Macartney, wife of the British Representative in Chinese Turkestan at the turn of the century, mentions one such episode in her memoirs: "One day we wanted to photograph a particularly attractive little child, and were just getting the camera ready when the mother rushed out and snatched the child away, declaring that the evil eye was in the camera, and if it was turned on her child it would die."[10]

Bluff reassurance and well-timed bribes could sometimes smooth away suspicion. The American artist James Freeman, who worked in Rome for many years in mid-century, managed to paint Checca, a charming little girl, despite her mother's fears that the child would die as soon as the portrait had been made: "It was not the first time I had encountered this superstition and had vanquished it; the offer of one *paul* an hour conquered it now, and pretty Checca was to be my model." Freeman got his way, but the story had an ending that could only have confirmed the mother's distrust. In a passing reference to "the cemetery of the indigent Aricciaroli," the artist mentions, without comment, that "there, a year after she was with us, was laid the pretty Checca."[11]

The same complex tissue of religious and social taboos underlay many of the fears with which people faced the sketch-pad and the lens, but it may be that the photographer seemed a special threat in the eyes of the victim. The very nature of the early photograph was peculiarly disturbing, an uncanny mixture of the life-like and the lifeless, because both colour and movement had been drained away. As Thomas Sutton remarked when congratulating G. W. Wilson on his first instantaneous view of Edinburgh, the street scene thus captured was far more appealing than those "cities of the dead with which we have previously had to content ourselves."[12]

Even the photographer's equipment put him at a disadvantage. The artist's pen and pencil were unobtrusive, and in some form or another were familiar to most societies, but a suggestion of menace clung to black cloths and chemicals. In 1840, at the very beginning of the photographic era, customs officials in Spain thought Gautier's camera was a new kind of bomb: "They approached it with the greatest precautions, like people who are afraid of being blown up."[13] Towards the end of the century, Colonel Gale, a Founder Member of the Linked Ring, stirred the same kind of apprehension in a Highlander on one of the Western Isles when he set up his camera and tripod: "From his earnest inquiries as to the nature of the projectile and explosives used in the machine, it was evident that his bold demeanour was but the cloak to a most penetrating terror."[14]

Enough. For the loyal partisan it is a relief to cut short this catalogue of calumny and near-disaster, and end with an anecdote which sets the record straight. While visiting the Aran Islands in 1895, Edith Somerville found that the inhabitants, fearing the Evil Eye, melted away the moment she pulled out a sketchbook, but lined up with cheerful confidence to face her Kodak.[15]

* * * * * * *

This essay is offered with affection, and a touch of trepidation, to Heinz Henisch, the editor with an indulgent heart but an eagle eye.

REFERENCES

1. Rose Macaulay, *Pleasure of Ruins* (London: Thames and Hudson, 1953), pp. 110, 228-229.

2. Gail Buckland, *Reality Recorded* (Greenwich, Connecticut: New York Graphic Society, 1974), p. 41.

3. Leslie Parris, *Landscape in Britain, ca. 1750-1850* (London: The Tate Gallery, 1973), p. 47.

4. George Augustus Sala, *The Life and Adventures of G. A. Sala* (New York: Charles Scribner's Sons, 1895), p. 165.

5. Quoted in Pat Hodgson, *The War Illustrators* (New York: Macmillan Publishing Co., Inc., 1977), p. 148.

6. Pat Hodgson, *The War Illustrators,* p. 130.

7. Albany Fonblanque, Jr., *The Filibuster* (London: Ward and Lock, 1862), chapter 8, p. 55.

8. *The Orientalists: Delacroix to Matisse.* Exhibition catalogue (Washington, D. C.: The National Gallery of Art, 1984), p. 27.

9. Quoted in Julius Garztecki, "Early Photography in Poland," in *History of Photography,* vol. 1, no. 1 (January 1977), p. 49.

10. Lady Macartney, *An English Lady in Chinese Turkestan* (Oxford University Press, 1931), p. 126.

11. James E. Freeman, *Gatherings from an Artist's Portfolio* (New York: D. Appleton and Co., 1877), pp. 262, 280.

12. Quoted in John Hannavy, *A Moment in Time: Scottish Contributions to Photography, 1840-1920* (Glasgow: Third Eye Centre and The Scottish Arts Council, 1983), p. 79.

13. Théophile Gautier, *Wanderings in Spain* (London: Ingram, Cooke and Co., 1853), chapter 3, p. 21.

14. "Colonel Joseph Gale," in *Sun Artists* (London: Kegan Paul), issue no. 1 (1889), p. 7.

15. Gifford Lewis, *Somerville and Ross: The World of the Irish R.M.* (New York: Viking Press, 1986), p. 93.

The Custodial Photograph

Bernard V. and Pauline F. Heathcote

What must surely have been one of the earliest uses of the photographic process in the detection of crime took place in France towards the latter end of 1841, when the police authorities adopted the idea of taking a daguerreotype likeness of any important criminal whom they had apprehended. The portrait was then copied and circulated to other police departments so that, in the event of an escape, the accused man would, if charged with another felony elsewhere in the country, be easily recognized as a previous offender. A contemporary report of this practice wryly concluded with the observation that "Mons. Daguerre never contemplated such an application of his 'type.'"[1]

It is of interest to note, however, that the use of the silver-coated copper plate within the arena of custodial detention was not confined exclusively to France. It is known, for instance, that during the 1840s there were occasions when Irish political prisoners in Dublin faced the camera. One individual who was photographed was Kevin Izod O'Doherty. He was visited in Richmond Bridewell by J. Tully, the proprietor of the Photographic Institution at 31 Great Brunswick Street, Dublin. Tully later arranged for a lithograph to be made from the portrait and distributed this likeness on both a wholesale and retail basis.[2] Copies of the original daguerreotype, mounted in brooches, lockets, and other forms, could be purchased by O'Doherty's political supporters.

In 1849, Martin Laroche took daguerreotype images of Frederick George Manning and his wife, Maria, at their preliminary appearance at Southwark Police Court, London, where they were charged with the murder of Patrick O'Connor.[3] The subsequent trial of the Mannings at the Central Criminal Court and their public hanging on 13 November 1849 attracted widespread interest. Laroche, aware of the financial gain which could be derived from the prevailing Victorian passion for sensationalism, sold lithographs of his portraits of the couple:

> …india proofs 1s.0d., each; plain 9d., to be obtained of all the principal print sellers in London. Country dealers supplied.[4]

In April 1850, there occurred a particularly brutal murder of a poor elderly woman named Jane Lewis, near Newport in South Wales. Two young men in their early twenties, Patrick Sullivan and Maurice Murphy, were charged with the crime and sent for trial at the Monmouthshire Summer Assizes. But before they were transferred to Monmouth Jail, the local Police Superintendent requested that they should be photographed so that copies of their portraits could be sent to the Irish authorities in order to verify details of their previous life and conduct. The task was undertaken by a Frenchman, Joseph Jacquier, who had been working as a daguerreotype artist at a studio in Commercial Street, Newport, since the previous autumn.[5] He was allowed a quarter of an hour in which to take the likenesses in an enclosed

Figure 1. Portraits of Patrick Sullivan (left) and Maurice Murphy (right), from a daguerreotype by Joseph Jacquier. "Monmouthshire Merlin," Newport, England, 31 August 1850. British Library.

yard at the Union Workhouse and "having his apparatus ready, and several plates prepared," he took a number of group photographs showing the handcuffed prisoners seated between police officers. A single portrait was also taken of Murphy, "who, with Sullivan, laughed heartily during the process."

The death of Jane Lewis aroused an unprecedented feeling of outrage in Newport and local inhabitants took advantage of the opportunity to closely examine the features of the men accused of her murder:

> Copies of the groups of portraits, taken by Mons. Jacquier have since been exhibited to the public, who have flocked to the windows of the photographic establishment, and of Mr. Whitehall, watch and clock maker, where they have been placed on view.[6]

Sullivan and Murphy were later executed and a few days afterwards an illustration of the two men, based on one of Jacquier's daguerreotypes, was published in the local newspaper [Figure 1].

By the early 1860s it had become standard routine at many British jails to photograph the inmates. This reliable method of identification was, however, regarded with open hostility by the prisoners, some of whom tried to disrupt the proceedings by suddenly moving their heads or contorting their features at the moment of exposure. The authorities were therefore forced to adopt a ruse which was specifically designed to overcome this lack of cooperation:

> Every preparation being made the sitter is placed in his chair, and asked to sit still. If he be tractable a portrait is secured without further trouble. If on the other hand, he attempts to defeat the object of his sitting by movement, he is told that

he had better take a seat elsewhere for a short time, so that he may overcome his nervousness, and be able to sit still, and that in the meantime another portrait will be proceeded with. Another sitter takes his place, and he takes the seat indicated for rest. There he watches with deep interest the operations of his fellow, and whilst thus engaged he sits motionless and interested, another camera peeping through a convenient aperture, has its eye upon him and registers on the faithful tablet the true presentment and natural expression of the unconscious victim, who is exulting in having thus baulked the authorities and rejoicing in the anticipation of a similar piece of management on the part of his "pal."[7]

Some twenty years afterwards, according to H. Baden Pritchard, it would appear that, apart from a few isolated instances, the photographing of prisoners was no longer a particularly troublesome or difficult task. Indeed, Pritchard's description of a working session in the studio at Pentonville Penitentiary, London, conveys the impression of a perfectly straightforward undertaking:

Six convicts file into the studio attended by a warder. They remove their caps, and sit down in a row on a form; in grey jackets and knickerbockers, with shaven faces and cropped hair, they look like big school boys. One of them takes up a narrow black board, some six inches wide, and proceeds to write very neatly in chalk the number and name of the first sitter, the board being then placed above the man's head when his picture is taken. He sits on a high-backed chair, and with no head-rest remains perfectly still for the seven seconds the exposure lasts. "Look at those bottles in the corner," says the photographer, briefly, so that the man may turn his head a bit; and then the lens is uncapped. A double carte plate is used; but the men are so steady that rarely is a second negative taken; another convict takes the seat, and the narrow black board above the head is reversed, the back bearing the second man's name and number.

While the double plate is being developed, and another put into the slide, there is time to clean the black board and put upon it two other names. There is no speaking; the convict simply pulls out of his jacket pocket a wooden tablet bearing name and number, and this is copied.[8]

A century has elapsed since Pritchard concluded the report of his visit to Pentonville with the comment that

Every criminal is aware that a picture has beentaken of him, and he never knows how much this may be the means of bringing him to justice if he relapses once more into evil ways. He is apt to over-estimate rather than under-estimate the power of photography, and it forms, at any rate, one reason the more why he shouldrefrain from crime hereafter when he is again a free man.

REFERENCES

1. *Bath & Cheltenham Gazette*, Bath (30 November 1841), p. 2b.

2. *Evening Packet & Correspondent*, Dublin (20 January 1849), p. 2a.

3. Martin Laroche was the professional name used by William Henry Silvester.

4. *The Times*, London (19 October 1849), p. 2d.

5. *Monmouthshire Merlin*, Newport (29 September 1849), p. 2a. By July 1850 Joseph Jacquier had moved to Cardiff.

6. *Monmouthshire Merlin*, Newport (20 April 1850), p. 3c.

7. Anonymous, "Portraits of Prisoners," *Photographic News*, vol. 6 (3 January 1862), p. 12.

8. H. Baden Pritchard, *The Photographic Studios of Europe* Piper & Carter, 1882. Reprint edition: Arno Press, 1973), p. 121.

Photographs from the Queen

S. F. Spira

The enthusiasm of Queen Victoria and Prince Albert for the young art and science of photography is well known. They had a darkroom installed in Windsor Castle, collected thousands of photographs in albums, commissioned photographic portraits, gave financial support to photographic projects, and supported the Royal Photographic Society.[1]

The Queen often sent photographs as state gifts and mementoes for less formal occasions. The letter reproduced here [Figure 1] accompanied four inscribed photographs sent to Sir George Cornewall Lewis (1806-1863), who had expressed interest in their deer-hunting trophies after visiting the Queen and Prince Consort in Scotland. Sir George held numerous government posts, was a man of letters, and Home Secretary under Lord Palmerston at the time he received these photographs.
"Remembering the interest Sir G. Lewis took in the *Stags* during his short stay in *our dear* Highlands, the Queen thinks he may not dislike receiving these photographs of the best *Heads* of the Deer killed in our forest this year — and therefore send him these impressions. We saw nine of these antlers [on a] very large one killed the day Sir G. Lewis left Balmoral. The Queen has written the date at the back."

The inscriptions on the four albumen prints reveal the hunting skills of the Royal Family: "Stag shot by the Prince Consort on Feilhost. Oct: 5.1859. Horn measured 24 inches in width & 35 in. length." "Stag shot by the Prince Consort on Carrop Hill Oct: 1-1859." "Stag shot by the Prince Consort on Little Craigliadh Oct 3-1859" [Figures 2 and 3]. "2 Stags shot by the Prince of Wales — Sept. 30 1859 — Balmoral" [Figures 4 and 5].

REFERENCE

1. Naomi Rosenblum, *A World History of Photography* (New York: Abbeville Press, 1984), p. 64.

119

Figure 1. Letter from Queen Victoria to Sir George Cornewall Lewis, October 22, 1859. S. F. Spira Collection.

Figure 2. "Stag shot by the Prince Consort on Little Craigliadh. Oct 3 - 1859." Albumen print, 5 1/4" x 4" oval. S. F. Spira Collection

Figure 3. Inscription on Figure 2.

Figure 4. "2 Stags shot by the Prince of Wales — Sept. 30, 1859 — Balmoral." Albumen print, 4 1/2" x 6". S. F. Spira Collection.

Figure 5. Inscription on Figure 4.

Fugitive Slaves in Canada: Photographic Frontispiece

Kathleen Collins

In 1859, the Colonial Church and School Society's *Mission to the Fugitive Slaves in Canada* was published in London.[1] The report's frontispiece [Figure 1] was a pasted-in albumen photograph of former slave children who had escaped through the "underground railroad" to Montreal. A white woman, Miss J. Williams, and six black and mulatto children are grouped in one photograph. The booklet's table of contents refers to "Photographic Portraits of Colored School Children."

The sixty-four-page booklet included information about the Society's anti-slavery activities in England, Wales, the Channel Islands, Scotland, and Ireland, with reports from Toronto, "Vancouver's Island," and elsewhere in Canada. It also printed letters from workers in the field, a list of officers, cash accounts, acknowledgements of gifts of clothing, and other information. The main text discussed slavery topics: "Colored Population of the Western Hemisphere," "Slave Mart," "Slavery, the Extinguisher of Parental Feelings," the "Great Slave Auction," and the "Market Value of Slaves."

The Colonial Church and School Society, under the leadership of its president, The Right Honorable Earl of Shaftesbury, operated under the heavy load of the "white man's burden," and expressed its ambivalence toward "the colored races" and the institution of slavery throughout this publication. "The funds of the Mission are expended entirely for spiritual purposes," they assured their readers.

"The Committee deem mere temporal relief altogether alien from their special work. . . ." Because they offered primarily spiritual comfort, the organizers believed that "subscribers will thus have the assurance that their kind co-operation cannot be interpreted . . . into an enticement of slaves to run away from their masters."

Among charitable organizations, high administrative costs are not solely a late twentieth-century complaint. Cash accounts for the Society indicated that from April 1, 1858, to March 31, 1859, the organization had given out £1,362.0.5, of which a mere £75 went for clothing, books, and printing costs. Much of the remainder went for agent salaries, passage and expense money, and shipping and postage costs. Donations to the cause averaged about £2 with the largest being £75. Subscribers sent Bible tracts, book-markers, book bags, books, some clothing, and "cheap maps of Palestine," for the edification of these youngsters.

The pamphlet reported an estimated 10,395,000 slaves in the U.S., Brazil, and West Indies, among whom 2,695,000 were free slaves; 60,000 of those slaves lived in Canada. Experience with such large numbers led to "scientific" observations by one Rev. T. Hughes: "In all our efforts for the instruction of the colored children, we have to contend with the natural instability of the negro character....we have not yet been permitted to experience the joy...of witnessing many outward results of our labors." Later the

Figure 1. "Photographic Portrait of Colored School Children," albumen photograph, 2 7/8" x 4 1/4" pasted-in as frontispiece on 7 1/4" x 4 3/4" page. From "Mission to Fugitive Slaves in Canada...," 1859. Library of Congress, Rare Book Division.

Figure 2. Title page from "Mission to Fugitive Slaves in Canada...," 1859. Library of Congress, Rare Book Division.

organizers report that "Great allowances must be made for them. When they were in slavery everything was provided for them, and habits of self-dependance are not soon formed." To remedy this problem, 1,500 of the rescued slaves were put to work (for pay, presumably) on the Grand Trunk Railway construction project.

More observations were made regarding the children's skin coloring, and photography provided the perfect medium with which to document these variations. Miss J. Williams wrote, "With this I send you the portrait mentioned in my last, and a short description of each [child]. My object in having so many taken together was to show the varieties of color between the genuine African and the nearest approximation of Anglo-Saxon." James S., standing at Miss Williams' right, is the darkest, with John P., on James's right, "No. 4" in shade. Alice G., on Miss Williams' left, is "No. 3 shade" and "little Lizzie L....No. 2 shade," also on Miss Williams' left. "The mulatto, William L.," is shade "No. 5."

James S.'s mother was shown her son's portrait. Her response was reported by Miss Williams: "Wall, raly I thought our Jim was a better lookin fellow than that; but 'deed, Misses Williams, I shouldn't a knowed you no how, you looks reel weel." Miss Williams added, "Of course I could appreciate the doubtful compliment."

For the editors of this report, vivid verbal descriptions were not sufficient, even enhanced by a wood engraving of an enchained slave [Figure 2]. To ensure that the philanthropic audience understood the effect of slavery on those enslaved, the tender vulnerability of the rescued children, and the possibilities for rehabilitation, a photograph was needed. Posed though it was, against a hastily hung backdrop, with well-groomed children wearing the clothing of their white benefactors and standing ramrod straight against hidden metal waist- and headrests — perhaps to counteract "the natural instability of the negro character" — their wariness and weariness nevertheless are apparent to the perceptive reader.

REFERENCE

1. *Mission to Fugitive Slaves in Canada: Being a Branch of the Operations of the Colonial Church and School Society. Report for the Year 1858-9.* Printed by Macintosh, Great New Street, London. 1859. The Society's Offices were listed at 9, Serjeants'-Inn, Fleet Street, London. The price of the 64-page pamphlet was twopence. The pamphlet itself measures 7 1/4" x 4 3/4". The *National Union Catalog Pre-1956 Imprints Supplement* lists a booklet of the same title, 80 pages in length, published in London in 1860 (see p. 437). The booklet described here is in the Rare Book Division of the Library of Congress, Washington, D.C.

Sixty-nine Istanbul Photographers, 1887-1914

William Allen

The history of photography in the Ottoman Empire remains sketchy in spite of the fact that we know a good deal about the handful of photographers who worked in the realm. The best-known worked in and out of places such as Cairo, Damascus, and Beirut. Ironically, we know more about the history of photography and photographers at the periphery of the Empire than we do of photography and photographers at the center of it, in Istanbul.

In the waning days of the Ottoman Empire, there was more energy and seemingly more inventiveness at the edge than at the center and this state of affairs no doubt affected photography just as it did everything else. And yet photography in Istanbul has about it something of the fascination and the attraction that the city more generally possessed, even in its imperial sunset years. It was, after all, Istanbul or, as the Europeans insisted upon calling it, Constantinople.

A few Istanbul photographers' names are fairly well known, chief among them the Abdullah Frères, a photographic partnership of two (or perhaps three) Armenian brothers. They are said to have taken over an establishment inaugurated by a German chemist, Rabach, perhaps as early as 1856, and sold to the Abdullah Frères in 1858. The Abdullahs, seemingly the first "Photographers to His Majesty the Sultan," dominated Istanbul commercial photography until the end of the century.[1] It is said that at that point they sold the firm to the second really well-known Istanbul commercial photographic firm, that of Sébah and Joaillier, partners who had earlier established themselves with distinction in Cairo.[2]

A few other individual or firm names appear often enough in negative signatures that the observer of nineteenth- and early twentieth-century Istanbul photography is aware of them: Berggren, Phoebus, Caracache Frères or the Gulmez Frères. Beyond these, the world of commercial photography in Istanbul has been chiefly known by a scattering of images with unfamiliar names signed in corners of negatives. Some of the names can be tracked down in tourist guides of the nineteenth-century, but the most promising compendium of names is that contained in the various volumes of the *Annuaire Oriental du Commerce*, published in Istanbul from 1880 until well into the twentieth century.[3] "Promising" because the commercial directory does indeed list many photographers, giving their addresses year after year and displaying the advertisements of many, but unfortunately copies of the annuals are now extremely rare. The commercial annual shares with photographs the unfortunate quality of seeming to be so ubiquitous and so ordinary that history has neglected to properly preserve them. I have so far tracked down only seven volumes, those for the years 1887, 1892/93, 1903, 1905, 1910, 1912, 1914. Scattered though the years may be, they do give us some very particular information for each of those years and give us some sense of the dynamic of the Istanbul

photographic profession for a quarter-century.

To begin with, the *Annuaire* documents sixty-nine names. These are listed below in the appendix along with each firm's address and the years of inclusion in the directory. For the firms not known by the owners' names (Phoebus, Simon, or Iris, for example) the directory supplies the proprietors' names. As firms change locations (or expand to more than one location) the directory dutifully records the changes.

It would certainly be misleading to suppose that the directory lists all the photographers of the city, but it must have listed all of the major firms. And while the disappearance of a name from the list does not automatically tell us that the photographer had left the profession, such is likely the case. The numbers of photographers for each given year, while not necessarily inclusive, are suggestive of the overall level of commercial photographic activity in the city. Note, for example, that the number of firms doubled in the years 1887-1905. It was an increasingly competitive profession.

That competitiveness is probably reflected in the fact that almost half of the entries appeared only once in the surveyed volumes. The clustering of a good many of these names around the years 1892, 1903, and 1905 suggests that the expanding world of commercial photography at the turn of the century was a short-lived venture for many.

The advertisements bought by photographic firms in the directory also suggests a rising level of competition, especially among the reasonably well-established firms. The Gulmez Frères advertised in four languages: French, Turkish, Armenian, and Greek [Figure 1]. Berggren boasted of his official appointment to the King of Sweden and Norway [Figure 2] and Sébah and Joaillier of theirs to the court of Prussia [Figure 3]. Most of them tell the reader that they make portraits and sell views, including views from beyond the environs of the imperial capital. The Caracache Frères also sold supplies for the new amateur cameras and graphically substantiated that fact in their ad [Figure 4].

The directory also attests to something of a photographic district in Istanbul. More than a quarter of the firms were located within a five-block stretch of the Grande Rue de Péra and many of these within a two-block expanse. The Grande Rue de Péra was the most fashionable street of the European quarter of the city. C. J. Fettel [Figures 4 and 5], whose address in the directory is clearly (and repeatedly) on the exotic-sounding Rue Derviche, tries to claim a seemingly more prestigious Grande Rue de Péra address (it appears that his building fronted on the wrong street, from his point of view).

The directory clarifies the evolution of some firms. It was Sébah before it was Sébah et Joaillier. R. Caracachian's 677 Grande Rue firm (1877) became the Caracache Frères (by 1892) [Figure 6]. The Abdullah name was attached to more than the premier firm. Cosmi Abdullah had a business as did Abdullah Fils. A curious disclaimer, contained in the advertisement for Abdullah Frères Fils [Figure 7], makes it clear that the firm had no connection with the veteran Abdullah Frères. (Could it be that the ancient house had developed so bad a reputation late in life that one couldn't afford to be mistakenly identified with it?)

We find some sharing of space as in Kurkdjian and Hazarossian in 1914 and probably Servanis and Servianis in 1903 at Kadikeuy. Some addresses were committed to photography, but experienced considerable turnover in renters. Take, for example, 305 Grande Rue de Péra: in 1887 it housed the very successful Gulmez establishment and then passed on to three others whose longevity in the photography trade was far less- Sapienza (1910), Scagliola (1912), and Bolian (1914). A similar succession occurred at the Galata Ismirlioglou Han 21 between Triphonidis (1903) and Vehbi (1905). Among the short-lived firms successively occupying the same site, it seems prudent to be alert for evidence of wholesale transfer of both business and archive.

Busy and competitive, the niche for some and the bane of others, commercial photography in Istanbul produced its artists and its hacks, its giants and its failures. Photography did so wherever it went. Knowing the names of Istanbul photographers is probably no more pressing than it is for any other great city. And yet it is important, for they did more than merely make studio portraits. They were part of the society and scene that the photographer M. Iranian, among many other operators, documented with his camera [Figure 8].

On the occasion of this volume of essays dedicated to his labors in this field, I should like to acknowledge Dr. Heinz K. Henisch's own scholarly contributions to the history of photography in Istanbul, and to thank him for encouraging others to explore that history.

Figure 1. Double-page advertisement by Gulmez Frères from the 1887 directory, industrial review section, pages 24-25. Library of Congress.

Figure 2. Advertisement for G. Berggren from the 1892-93 directory, advertising section, page 32. Library of Congress.

Figure 3. Sébah & Joaillier advertisement from the 1892/93 directory, advertising section, page 47. Sigmund Weinburg was a major supplier of photographic equipment and materials. Library of Congress.

Figure 6. Advertisement for R. Caracachian from the 1887 directory, industrial review section, page 32B. Library of Congress.

Figure 7. Full-page advertisement for Abdullah Frères Fils from the 1903 directory, advertising section, page 297. Library of Congress.

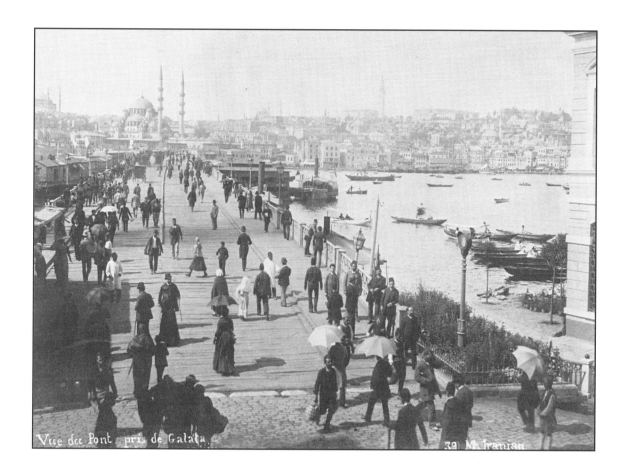

Figure 8. M. Iranian. Galata Bridge, taken from Galata. Library of Congress.

LIST OF PHOTOGRAPHERS DOCUMENTED IN THE
ANNUAIRE ORIENTAL DU COMMERCE, 1887-1914

(Note: reference to the combined volume 1892/93 is indicated by 1892 date.)

NAME	ADDRESS	DATES
Abdullah, Cosmi	Rue Tarla Bachi 52	1887
Abdullah Fils (Léon)	Rue Bouyoukdéré 21	1912, 1914
Abdullah Frères	Grand Rue de Péra 452	1887, 1892, 1903, 1905
Abdullah Frères Fils	Grand Rue de Péra 417	1903, 1905
Abel	Passage Alléon 3	1910
Alevridis, J.	Rue Bab-i-Ali Djaddessi 25	1912, 1914
Amiraian, K.	Rue Okdjilar Bachi 99	1903
Andriomenos, Nicolas	Rue Sulta Bayazid KieuktchilarBachi 99	1892
	Grande Rue de Péra 281 and Okdjilar Bachi 99	1903
	Grande Rue de Péra 162 and Okdjilar Bachi 99	1910, 1912, 1914
Andriomenos, S.	Rue Bouyoukdéré 49	1903, 1905
Arslan, M.	Rue Bab-i-Ali Djaddessi 10	1905
Assimacopoulos, C.	Rue Bouyoukdéré 93	1912
	Grande Rue de Péra 133	1914
Bahdassarian, G.	Rue Keokdjiler 25	1887
Balts, Joseph	Rue Madjiar	1887
Behaeddin, Rahmi Zadé	Rue Djelaloglou Yocouchou 59	1912, 1914
Bella, Georges	Rue Kaya 40	1912
Berggren, G.	Grande Rue de Péra 414	1887, 1892, 1903, 1905
	Rue Vénédik 2	1910
	Rue Asmali Mesdjid 9	1912, 1914
Bochenakian, Vahan H. (firm's name: Simon)	Grande Rue de Péra 412	1910, 1914
Bolian, Sirak	Grande Rue de Péra 305	1914
Boulmann, Joseph	Rue Keklik 1	1892
Caracache Frères	Grande Rue de Péra 677	1892
	Grande Rue de Péra 675-677	1903, 1905
	Grade Rue de Péra 474	1910, 1912 1914
Caracache, Y.	Rue Idjadie 39	1905
Caracachian, R.	Grande Rue de Péra 677	1887
Constantinidès, S.	Rue Helvadji 11	1903, 1905, 1910, 1912, 1914
Coritsopoulos, Const.	Ismirlioglou Han 22	1910, 1912 1914
Derarsène, Ant.	Rue Hodja Zade 1	1912
Derarsène, Grégoire (firm's name: Parnasse)	Grande Rue de Péra 288	1903, 1905 1910, 1912,

		1914
Edelstein, A.	Rue Yuksek Calderim 52 bis	1892
Ferdinand, M.	Rue Bab-i-Ali Djaddessi 24	1905, 1910
		1912
Fettel, C. J.	Rue Dervich 1	1887, 1892
Frery, Emilie	Rue Ermeni Kilissé 17	1905
Goldenfan, E.	Rue Yuksek Calderim,	
	Oriental Han 2	1914
Goldenfan Frères	Rue Yuksek Calderim 27	1892
Gulistan Hafiz Achir	Rue Hamidié Djaddessi 18	1912
Fulmez Frères	Grande Rue de Péra 305	1887
	Grande Rue de Péra 397	1892
	Grande Rue de Péra 337	1903, 1905
	Grande Rue de Péra 397	1910, 1912
		1914
Hazarossian, Léon	Grande Rue de Péra 431	1910, 1912
		1914
Iranian, M.	Impasse Ottoni 7	1892
Iris (see Mitaraki, M.)		
Jacobi, Ch. H.	Rue Ebekissi	1887
Joseph, D.	Rue Esadji 2	1903, 1905
Kargopoulo Frères	Grande Rue de Péra,	
	Place du Tunnel 6	1887
Kargopoulo, B.	Place du Tunnel 6	1892
Kasparian, Edouard	Rue Leilak 4	1892
Khendamian, Raph	Kadikeuy	1892
Kurkdjian, Puzant	Grande Rue de Péra 46	1910, 1912
	Grande Rue de Péra 431	1914
Machanovitch, Stefo	Rue Bab-i-Ali Djaddessi 28	1912
	Rue Bab-i-Ali Djaddessi 25	1914
Mavraki, Cl.	Rue Okdjilar Bachi 45	1910, 1912,
		1914
Mavraki, G.	Rue Okdkilar Bachi 45	1903, 1905
Mirat, F.	Rue Bab-i-Ali Djaddessi 28	1903
Mitaraki, M.	Rue Bouyoukdéré 87	1903
(firm's name: Iris)		
Nicolaïdès, Alcibiade	Rue Bab-i-Ali Djaddessi and	
	Rue Eski Zaptié 74	1903
	Missirlioglou Han	1905, 1910
	Ferouh Bey Han 25	1912, 1914
Pappadopoulos & Théophilidis	Manoukoglou Han 71905	
Parnasse (see Dararsène, G.)		
Phébus (see Tarkoul, P.)		
Sapienza, Victor	Grande Rue de Péra 305	1910
	Grande Rue de Péra 346	1912
Scagliola, Giuseppe	Grande Rue de Péra 305	1910
Sébah	Grande Rue de Péra 439	1887
Sébah et Joaillier	Grande Rue de Péra 439	1892, 1903,
		1905, 1910
		1912, 1914
Servanis, Th.	Kadikeuy	1903
	Rue Mertebany 23	1912
Servianis, Ch.	Grande Rue de Modà à Kadikeuy	1903, 1905,
		1910

Simon (see Bochenakian, V. H.)		
Sofiano, C.	Au Phanar	1892
	Rue de Quais	1905
Stylianidis, A. (see Theophilidis et Stylianidis)		
Syngros, Jean	Rue Mavi 9	1912
Tarkoul, Paul		
(firm's name: Phébus)	Grande Rue de Péra 301	1892
	Grande Rue de Péra 367	1903, 1905
	Grande Rue de Péra 359	1910, 1912
		1914
Tatarian, Nichan	Rue Tarla Bachi 78	1912
Tchobanian Frères	Ismirlioglou Han 20	1887, 1892
Théophilidis, Ph.	Manoukoglou Han 7	1910, 1912
(also see Pappadopoulos & Théophilidis, 1905)		
Théophilidis, Photis	Grande Rue de Galata 17	1910
Théophilidis et Stylianidis	Yuksek Kalderim 92	1914
Triphonidis, Nic.	Ismirlioglou Han 21	1903
Vafiadis, Kostaki	Rue Hamidié 2	1903
(cf. Vaphiadis, Costaki)		
Vafiadis, Théodore	Rue Soouk Tchechmé 1	1903, 1905
Vaphiadis, Costaki	Rue Hamidié Djaddessi 2	1905, 1910,
		1912, 1914
Vehbi, Ahmed	Ismirlioglou Han 21	1905
Yannios, J.	Grande Rue de Galata 97	1903

REFERENCES

1. Engin Çizgen, *Photography in Turkey, 1842-1936* (Istanbul, 1981), identifies the three brothers as Wichen, Kevork, and Hovsep. Hovsep's role in the firm is shadowy; one usually hears only of Wichen (or Vichen) and Kevork. The Sultan Abdülaziz appointed the brothers as official photographers and the designation was continued under Abdulhamid II. Perihan Kuturman, in "Pioneers of Turkish Photography 1858-1920" (*Camera*, June 1966, p. 6), notes that the original appointment was made in 1862.

2. According to Çizgen, the Abdullahs had opened a studio in Cairo in 1886. This was bought by Sébah et Joaillier in 1895 and the purchase of the Istanbul studio followed shortly thereafter in 1899. As we shall see, a studio continued to operate under the Abdullah Frères name until at least 1905.

3. *Annuaire Oriental de Commerce de l'industrie, de l'administration et de la magistrature*, Constantinople, various dates. Its title page in later years says that the annual was founded in 1880 and also notes that it was privately published in Istanbul under authorization from the Ministry of Public Information.

Nadar, Kodak, and the Importance of Being Modest

Rolf H. Krauss

The first copy of a new photographic journal appeared in France on 25 April 1891. It bore the title, *Paris Photographe*, and the subtitle, *Revue mensuelle illustré de la Photographie et des applications aux Arts, aux Sciences et à l'Industrie* (A monthly journal of photography and its applications to the Arts, Sciences and Industry). The responsibility for this publication was taken by Paul Nadar, son of the great Nadar, who was named as "directeur." The publishers were the "Office Général de Photographie."

The journal originated as the result of an attempt by the young Nadar to free himself from his father. The father had, for some years, been living in the countryside and viewed his son's activities with suspicion. As there had been a decline in the standard type of business due to an increase in the number of studios and the budding amateur market, Nadar junior had, for example, taken to selling photographic appliances, film materials, and accessories and had become general agent for the American firm Eastman Kodak.

These two points are clearly visible on the extravagantly designed front and back cover of the journal. The heraldic design on the back cover [Figure 1] presents, in addition to the name Nadar, the information, "Représentant général de la Cie Eastman, France-Colonies" (General agent of the firm Eastman for France and the colonies). The banner fluttering over the left-hand side of the emblem bears the inscription, "Express Detective," the name of a

travel camera retailed under the name of Nadar. At the top, in the center, the "Nadar Lamp" (a magnesium lamp invented by Paul Nadar) is depicted. The banner on the right-hand side once again makes reference to "Kodak Eastman."

The front cover of the first edition [Figure 2] shows a host of details. A beautiful, scantily clad young girl with a burning-glass in her right hand is pushing away the clouds with her left. In the distance, the "Nadar Balloon" is clearly recognizable. The names of the inventors of photography, "Niépce," "Daguerre," and "Talbot," are inscribed in the socle of a tripod elevating some sort of globe. These names, significantly, correspond to the (larger and bolder) original printed characters of "Nadar," which are, in turn, positioned very close to the title of the journal *Paris Photographe*. The address, "Paris, Office Général de Photographie, 53 Rue de Mathurins," adds one of the finishing touches. The other, not to be overlooked, is provided by the illustration of a mass of appliances, among which are conspicuously included the lamp previously mention — distinctly designated "magnesium" — and the various parts of a Nadar Detective camera outfit.

If one studies the illustration very carefully one discovers an important accessory. Very close to the lens that is to be found immediately above the writing (unfortunately illegible) in the bottom left-hand corner of the illustration, there is a roll-film adaptor leaning against a bag that evidently belongs to it. It is

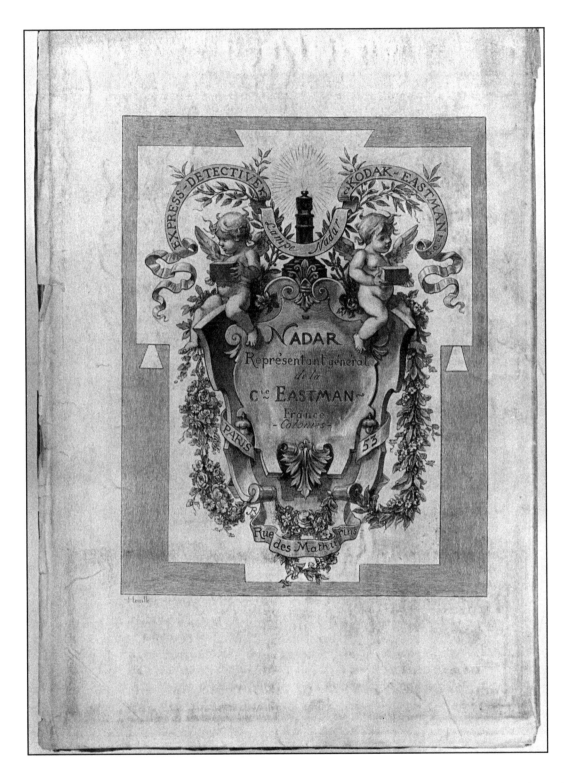

*Figure 1. Back cover of "Paris Photographe." First year of publication (issue number 1, 25 April 1891),
27.3 x 18.5 cm.*

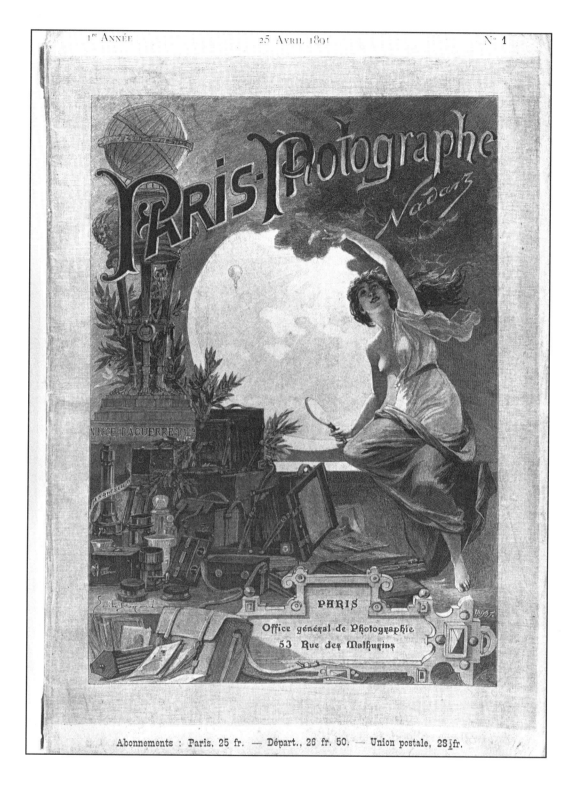

Figure 2. Front cover of "Paris Photographe." First year of publication (issue number 1, 25 April 1891). 27.3 x 18.5 cm.

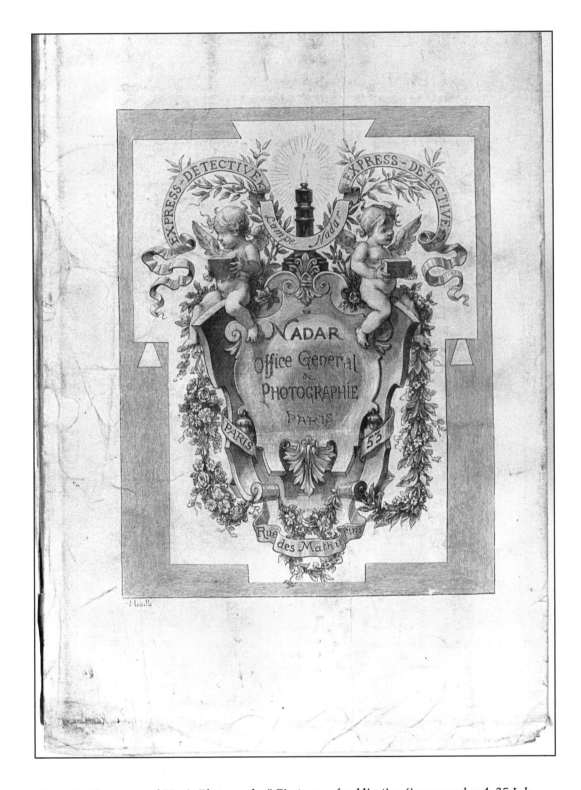

Figure 3. Back cover of "Paris Photographe." First year of publication (issue number 4, 25 July 1891). 27.3 x 18.5 cm.

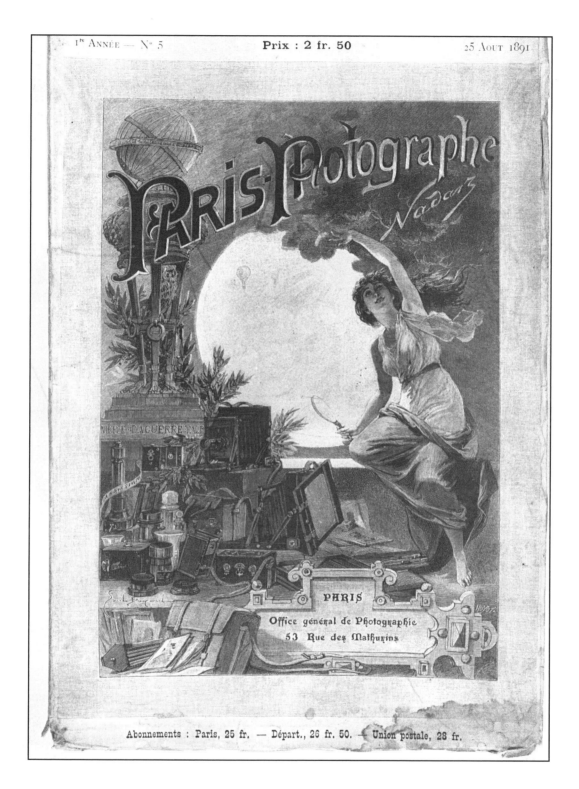

Figure 4. Front cover of "Paris Photographe." First year of publication (issue number 5, 15 August 1891). 27.3 x 18.5 cm.

easy to identify as such because it has the two characteristic knobs that help to transport the film from one spool to the other. In the first instance one is taken aback and asks oneself whether in the year 1891, so short a time after the introduction of roll-film, this type of device already existed. A glance at the relevant literature informs one better.[1] Even if such a device had only recently appeared on the market, a firm calling itself general agent for the inventor of this type of light-sensitive material, roll-film, had to offer its customers such an accessory in conjunction with its own camera system.

Only three months later, however, the collaboration with the firm Kodak appears to have been ended. The back cover of the fourth edition of *Paris Photographe* (25 July 1891) has, in effect, decidedly changed [Figure 3]. The "Représentant Général de la Cie. Eastman" has vanished and has made room for an "Office Général de Photographie, Paris." Moreover, "Kodak Eastman" no longer appears on the right-hand banner but has been replaced by "Express-Detective," the same as on the left-hand banner. Had father Nadar got his own way as a result of his seemingly negative attitude toward the American firm? Had Paul Nadar realized that the Kodak's programme did not fit in with his own? Or had the Eastman firm, themselves, for whatever reasons, terminated the cooperation? I must admit that I have done insufficient research to be able to answer these questions.

If, however, the firm Nadar no longer sold Kodak's programme, then the roll-film adaptor in question no longer had a reason to appear on the front cover. This point also seems to have been noticed in the firm Nadar, although only after a certain time had elapsed. Issue number four, the back cover of which had been altered, still appeared with the same front cover as that shown in Figure 2. Not until issue number five (25 August 1891) was a correction made [Figure 4]. The roll-film adaptor has been transformed into a plate-magazine and the accompanying bag had also been altered. Thus order was restored once again.

On this occasion, however, order was also restored in quite a different sphere. I must admit that I was, in the beginning, only interested in this last detail and the whole Kodak story was simply a by-product of a discovery and careful investigation of a totally different set of circumstances, namely that of the baring or covering of a female breast. For many years I have had in my private collection a series of copies of this extremely rare journal, *Paris Photographe*. Recently I had the possibility of acquiring some copies missing from my series and amongst these were the first journals from the first year of

publication. I was delighted and seized the opportunity to acquire them. As I was examining, classifying, and cataloging the new acquisitions, I noticed that the "cloud-pushing" young girl on the front cover only had her right breast bared on the first four editions of the journal. From issue number five on, her breast is modestly covered and remains so up to issue number twelve of the fourth year of publication (1894). I presume that 1894 was the last year of publication; in any case, I do not know of any later editions.

One can now enter the realms of speculation. In any case, I can well imagine what happened in those summer days of the year 1891 in the Nadar home in Paris. There had probably been complaints from this reader or that reader about the all-too frank "immodest" portrayal of the female depicted on the cover. Perhaps there had been scruples from the outset in the firm Nadar about the daring and, for a photographic journal, unusual cover design. In short, as alterations had now, in any case, to be made, the graphic designer was merely given instructions to pull up the thin cloth of the flimsy shift somewhat higher. Thus the firm Kodak unintentionally become the custodian and upholder of modesty. A great name from the nineteenth century, together with an institution from the twentieth century, became the protectors of virtue. And photography brought about all of this.

REFERENCES

1. Raymond Lécuyer, in his *Histoire de la Photographie* (Paris, 1945), dates this equipment to 1892 (p. 50).

The Claudets of British Columbia

David Mattison

The improvements of Antoine François Jean Claudet (1797-1867) to the photographic process perfected to commercial practicability by L. J. M. Daguerre and Claudet's pioneering work in the field of stereo photography are well documented.[1] Claudet's stature as an early photographic giant was recognized in a posthumous tribute by Joseph Ellis:

> When at first chemistry had to be called in aid, he was a chemist (as testifies François Arago). When, later, optics had to be appealed to, he was a mathematician; when mechanical science was to be invoked — he was an ingenious mechanician; when art was required, he was a artist of consummate taste....[2]

Unlike his older brother Henri (Henry), Francis George Claudet (1837-1906), the youngest son, did not follow in his father's footsteps as a professional photographer. Instead, Francis [Figure 1] emulated another older brother, Frederic Just Claudet (1826-1906) and spent most of his life as an assayer, first in British Columbia, and in his twilight years with his brother Frederic.

British Columbia, situated in territory formerly controlled by the Hudson's Bay Company as a vast fur preserve, was organized as a crown colony in the fall of 1858 following a gold rush, largely by Americans, to the Fraser River. A government-controlled assay office and a mint were established with Francis Claudet recommended as assayer by the home government's Royal Mint. Francis was twenty-three years old.[3]

Francis left England for British Columbia on 17 December 1859 and reached Victoria, Vancouver Island, on 10 February 1860. Francis did not expect to see his family in England for at least two and a half years, the initial term of his appointment. Letters to Frederic and Frederic's wife Mary, who followed Francis as far as San Francisco on separate business, reveal a range of emotions, but mostly his disillusionment, frustration, impatience and anger over bureaucratic ineptitude. He gradually tempered his outbursts and settled into the quiet rhythms of colonial life.

One of Francis's greatest disappointments was his inability to practice photography from the day he landed at the New Westminster wharf [Figure 2]. He could not bring any photographic apparatus with him for two reasons, because his one-way travel allowance of £100 had to include all baggage charges and because mail packets could not transport chemicals. In one of his notebooks he recorded what he intended to purchase in England for use in British Columbia:

Photographic Apparatus
Camera 12 x 10 £7 20% off
Stand folding & string [?] £2.2.0 / 15% off
1 d[itt]o for paper negatives / [£]1.13.6 20% off
2 frames printing £2.15.0 20% off
Levelling stand 7/5 15% off[4]

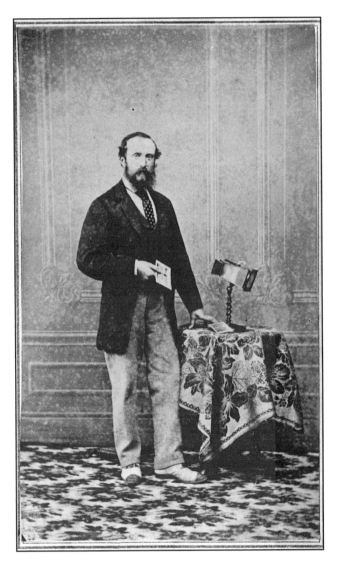

Figure 1. Francis George Claudet, ca. March 1870. Photographed in David Withrow's New Westminster studio, Francis's props remind us of his connection with one of the fathers of stereoscopic photography. Provincial Archives of British Columbia, no. 2481.

Claudet's reaction to the British Columbia landscape was typical for someone of his background. In a letter to his brother he sketched his observations of his new home [Figure 2] in photographic or artistic terms:

> Imagine to yourself a bank of the river as steep as the steepest part of Primrose hill, with deep ravines running at right angles to the river, densely wooded with immense Pines, maples, cedars, Firs &c. and upon this bank a few acres of land, where the trees instead of being upright are lying on the ground, half rotten, half burnt, with huge stumps and roots some 10 or 11 ft. in diameter thickly scattered among the few wooden houses which have sprung up since about a year. This is New Westminster — a perfect Chaos. The country around is wild and picturesque. The [Fraser] river is wide & imposing, lined for hundreds of miles with dark pines & firs, above which you see the snowy peaks of the various mountains forming a remarkable contrast with the dark forest below. It is grand but monotonous.[5]

Claudet's first recorded effort at photography occurred in mid-June 1860 on a visit to Nanaimo aboard *HMS Satellite:*

> I also made the acquaintance of an old bachelor Dr. [Alfred Robson] Benson who is an amateur photographer. He would insist on my trying views, but I did not succeed, all his apparatus & chemicals were in an awful state, I just managed to get a passable one of the town, (Nanaimo), but I have not yet got a copy of it.[6]

Less than two months later, Francis wrote to his brother Frederic from New Westminster. The assay office was finally open. Referring to one of the coastal packets that provided communications between Victoria and San Francisco, Francis wrote with relief:

> I am glad to hear the *Robertson* has made her appearance, as we are in want of several little things which are in her. I shall not be sorry to have my photographic apparatus. I intend to make an interesting collection of views & groups of Indians to send home.[7]

This passage can be interpreted to mean that either Francis's photographic supplies and camera were being sent up by his brother, or that Francis was annoyed at his inability to produce photographs for his family back home.

Francis photographed the assay office at least three times. There were three components to this building [Figure 3, left half]: the treasury department on the left with the porch, the balance room of the assay office in the middle, and the melting room on the

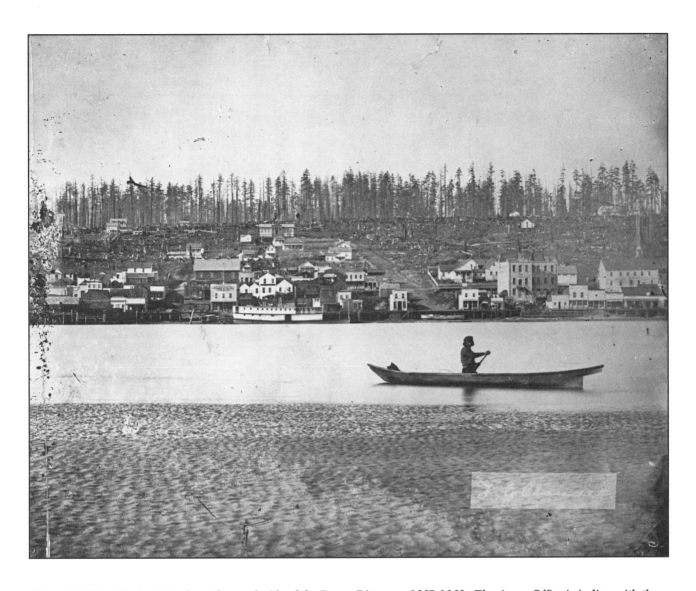

Figure 2. New Westminster from the south side of the Fraser River, ca. 1867-1868. The Assay Office is in line with the Indian's head. The wooden bell tower for Holy Trinity Church is at the right edge. University of British Columbia, no. BC784.

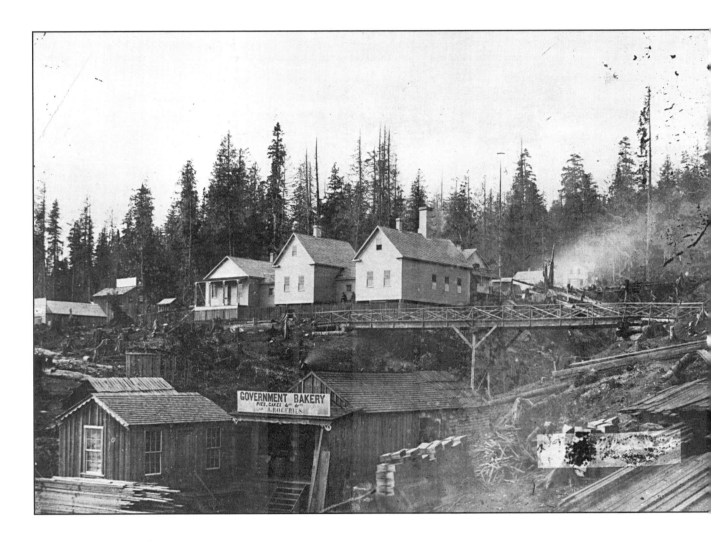

Figure 3. (left and right) Two-part panorama with the Assay Office on the left and Holy Trinity Church on the right, 1861. Columbia Street bridges the two ravines. None of the buildings are still standing. University of British Columbia, no. BC789 (left) and BC783 (right).

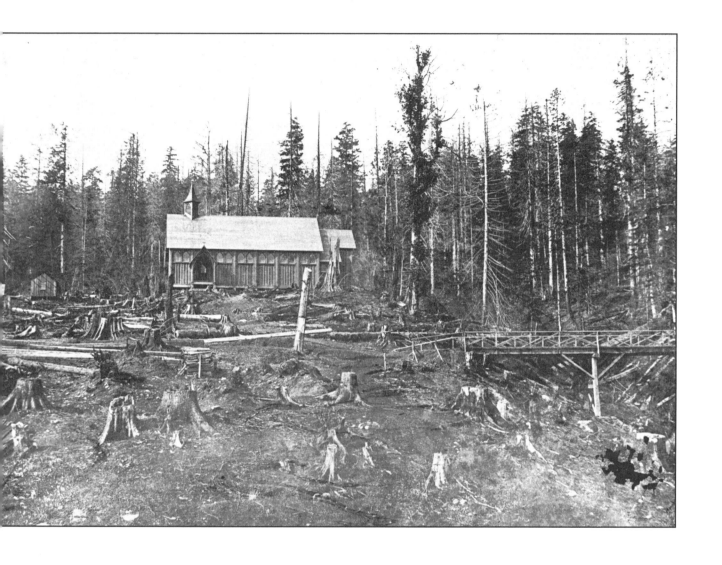

Figure 4. Interior of the second Holy Trinity Church, New Westminster, ca. 1868-70. The first church (1860-65) was destroyed by fire except for the partially completed bell tower seen in figure 2. Provincial Archives of British Columbia, no. 95387.

right with the two chimneys. A tiny log hut, visible at the left edge of the right half of Figure 3, is the first rectory of Holy Trinity Church.

Figure 3 (left half) was reproduced as an engraving in an early emigrant guide. The engraver added a number of workers to the lower right corner and reduced to one standing figure the two seated figures between the balance room and melting room.[8]

At the same time Claudet shifted his camera to produce a portrait of the first Holy Trinity [Anglican] Church [Figure 3, right half]. One witness to the cornerstone laying on 22 May 1860 described the site as "a very beautiful one in Victoria Gardens…two deep ravines are on either side, around it are large stumps of trees, and the ground is entirely unlevelled."[9]

Two exterior views of this church taken in late 1860 or early 1861 were reproduced as engravings and both photographs appear as halftones in the Rev. John Sheepshanks's biography. The engraving of Figure 3 (right half) was published in R. C. Mayne's *Four Years in British Columbia and Vancouver Island* (London: John Murray, 1862). The engraver was faithful to the photograph and did not introduce any imaginative details, nor eliminate any of the picturesque clutter. A second engraving of Holy Trinity, based on an earlier and different photograph, is in the *Third Report of the Columbia Mission* (London: Rivingtons, 1861). W. Dickes, the engraver of this view, dispensed with much of the foreground, cleared away the slash and added a grasslike appearance to the ground. He retained a ladder propped up against the church porch, as well as some lumber stacked on the porch, an indication the photograph was taken shortly before the consecration.

Claudet's photographs of the first Holy Trinity Church and its replacement are especially significant since both buildings were destroyed by fire, the first in 1865, the second in 1898. Claudet's photograph of the interior of the second Holy Trinity Church is the only known interior photograph by him [Figure 4].

By early April 1861, Francis was utilizing his own camera equipment. He confidently announced to his brother, "I have been preparing my photographic things, and I have already done a very good view of the [Royal Engineers] camp — first rate. When I have done a few more I will send you some."[10] A few years later he photographed the Royal Engineers Camp in the middle of a winter freeze-up of the Fraser River.

Francis also told his brother that he was planning a trip up the Fraser River to photograph Hope and Yale, two Hudson's Bay Company posts a dozen miles apart on the Fraser River. He reported on his trip to Hope in early May 1861:

I went up to Hope with my camera and took a good view of the place, but as I went up without leave I was not able to be away more than a couple of days and as most of the time was taken up with the journey I had no time to visit the silver lead [mine].[11]

Francis's colleagues in the colonial service could not help but notice his photographic efforts.[12] Francis volunteered his services to an organizing committee for the London International Exhibition of 1862. The committee published a prospective catalogue and under the heading "Photographs of the Towns and other interesting places — Mr. Claudet," was the following:

The Colony is fortunate in being promised the services of the son of the accomplished "Father of Photography" [sic] for this task, should Mr. Claudet's official duties admit of his making a tour. Persons can greatly aid Mr. C. and save him from much loss of time by selecting points of view prior to his arrival, escorting him to them and assisting in the transport of his instruments, chemicals, &c[13]

Knowledgeable visitors to the London International Exhibition were surprised to come across not one, but two sets of photographic views of the twin British colonies on the Northwest Coast of North America. George Robinson Fardon (1807-1886) exhibited a dozen portraits and scenes around Victoria, including a panorama of the city which the *Illustrated London News* reproduced in its 10 January 1863 issue. Possibly an equal number of photographs by Francis Claudet were also on display.

Among the photographs taken during this period was a classic view of Yale, the head of steam navigation on the Fraser River. This photograph, and a later one of the newly constructed Alexandra Bridge on the Fraser River near Spuzzum, were faithfully rendered as engravings in the *Illustrated London News* (12 May 1866, p. 465).[14] By the time of its publication the photograph of Yale had evolved into an important visual record. The *News* reported that not only had the original Hudson's Bay Company post close to the river been demolished, but several houses gutted by fire "not long before the time when Mr. Claudet obtained this view, have likewise been replaced by newer structures."[15]

On 15 September 1861, Francis travelled to Point Roberts aboard *HMS Grappler*, "to see Cap. Gosset who was encamped there superintending the works for the erection of an obelisk to mark the 49th parallel, or boundary between the American States & British territory. Arrived there & camped with Gosset, having landed my things, photographic apparatus included."[16]

A day of rain after his arrival prevented any photography, but Francis hiked up the hill upon which the obelisk was placed. On 17 September Francis tersely recorded "Took a view of camp, dined on board [*Grappler*]." He returned to New Westminster by canoe, but did not state in his notebook whether he packed his camera and portable darkroom.

Francis also left a small but important legacy of photographic portraits. Once he commented somewhat caustically upon his father's occupation, "Poor dear mammy hopes I am putting by a *deal of money* & making a good little business of my own taking portraits."[17] Various references in Francis's diaries and those of a son, Frederick G. Claudet, indicate that Francis photographed friends and acquaintances between 1860 or 1861 and 1870. One example, dated to 1860, depicts the Rev. John Sheepshanks (later Bishop of Norwich) in the pose of a frontier minister, a hewer of wood and healer of souls.[18] On 14 March 1870 Francis spent "most of the day at Withrows taking the Pooley's photographs." On 3 December 1870 he tried unsuccessfully to take some photographs at Joseph Davis's studio.[19]

Some time in 1870, possibly in early December, Francis also produced two self-portraits in Withrow's studio, one in civilian dress [Figure 1] and the other in the uniform of an ensign in the New Westminster Rifle Volunteers of which he was a founding member.[20] A third photograph, probably taken around the same time, shows Francis with his two sons, Anthony Francis standing between his father's legs and holding a flag on a short pole, and Frederick George, seated on a cloth-draped table with his father's left arm steadying him for the camera.

Francis journeyed to San Francisco for the second time at government expense on 21 November 1861 where he arranged the purchase of coining equipment and the preparation of dies. Except for sample coins struck without official sanction, the mint equipment was never used. The matrices and dies prepared in San Francisco and some of the specimen coins struck there and in New Westminster are preserved by the Provincial Archives of British Columbia.

The brief existence, if it can be called that, of the British Columbia mint foreshadowed the fate of the assay office. An administrative shuffle dictated by the Colonial Secretary in London promoted Claudet to superintendent of the assay office in April 1866.[21] To supplement his income, Claudet took other minor positions, including agent for a savings bank (1869), justice of the peace (1870), assistant commissioner of Lands and Works (1871), registrar of voters for New Westminster city and district (1871), coroner (1871)

and stipendiary magistrate (1872). He was also involved in various charitable, cooperative and private business ventures such as the Royal Columbian Hospital, the New Westminster Public Library and the Colonial Bank of British Columbia.

Francis was given ample warning of the assay office's fate. He dryly noted in his diary on 21 December 1870, "Got letters from Col[onial] Sec[retar]y &c about being abolished."[22] Over two years passed, however, before Claudet received another letter from Victoria severing once and for all his provincial government civil service appointments. He was so incensed at his shabby treatment by his new political masters he moved back to England after thirteen years of honest devotion to the colony and province of British Columbia.

Following a public dinner in New Westminster for Francis, the Claudets departed the Royal City on a foggy Thursday morning in late March 1873 with a crowd cheering and waving from the steamer wharf. The Claudets lived in Victoria until 12 May 1873. Francis wrote letters to politician friends and visited with Lieutenant-Governor J. W. Trutch, his search for employment all in vain. He almost moved to Peru where Frederic had some connection with a silver mine, but at the last minute his brother sent a telegram "calling us home."[23] The Claudets sailed from Victoria for England on 12 May 1873.

Despite his family connections and exemplary civil service record, Francis was unable to secure permanent employment for one to three years. He freelanced as a geologist, examining various mining properties on the Continent for British and French capitalists. By 1876 he was managing the chemical works at Weston, Cheshire, a position he held until 1887 or 1888 when Frederic took him on as a partner or associate in his assaying business in London.

Francis appears not to have practiced photography in England, certainly not to the extent he had in New Westminster when time was not at a premium. The photographic negatives of life and friends in New Westminster brought back to England became a family treasure, which Francis's eldest son Frederick George[24] returned to time and again for fresh photographic prints, and which he freely distributed to all who asked.

REFERENCES

1. [Joseph Ellis], *A. Claudet, F.R.S.: A Memoir* (London: Basil Montagu Pickering, 1868). See the bibliography, pp. 25-32. Helmut and Alison Gernsheim, *The History of Photography: from the Camera Obscura to the Beginning of the Modern Era*, rev. ed. (London: Thames and Hudson, 1969), p. 147.

2. Ellis, *A. Claudet*, p. 5.

3. R. L. Reid, *The Assay Office and the Proposed Mint at New Westminster: A Chapter in the History of the Fraser River Mines*, Archives of British Columbia Memoir no. 7 (Victoria: King's Printer, 1926).

4. F. G. Claudet notebook (vol. 9), Claudet Papers, Provincial Archives of British Columbia (hereafter PABC).

5. F. G. Claudet to Frederic Claudet, 27 April 1860, Claudet Papers, PABC.

6. F. G. Claudet to Mary Claudet, 22 June 1860, Claudet Papers, PABC. Dr. Benson was a Hudson's Bay Company physician who arrived in British Columbia in 1849 and served at various posts. If he had his camera with him when he moved to Nanaimo in 1857, he would be the earliest land-based photographer north of the 49th parallel.

7. F. G. Claudet to Frederic Claudet, 4 August 1860, Claudet Papers, PABC.

8. *The Handbook of British Columbia, and Emigrant's Guide to the Gold Fields* (London: W. Oliver, ca. 1862), between pp. 6-7.

9. [George Hills], Bishop of Columbia, *A Tour in British Columbia* (London: R. Clay, Son, and Taylor, printers, 1861), p. 1. Victoria Gardens was one of several park reserves surveyed by the Royal Engineers in 1859.

10. F. G. Claudet to Frederic Claudet, 6 April 1861, Claudet Papers, PABC.

11. F. G. Claudet to Frederic Claudet, 4 May 1861, Claudet Papers, PABC.

12. Late in his British Columbia career Francis even offered to make "photographic copies of maps or plans...under my own impression" at lower cost and better quality than whatever photographer the Dept. of Lands and Works was using; F. G. Claudet to J. W. Trutch, 22 March 1870, Colonial Correspondence, PABC.

13. W. Driscoll Gosset and J. Vernon Seddall, *Industrial Exhibition: Circular Respectfully Addressed to the Inhabitants of British Columbia* (New Westminster: Printed at R. E. Camp by Corporal R. Wolfenden, April 1861), pp. 18-19.

14. For a detailed discussion of five images of Yale, including Claudet's, taken from the same vantage point, see Joan M. Schwartz and Lilly Koltun, "A Visual Cliché: Five Views of Yale," *BC Studies*, no. 52 (Winter 1981-82), pp. 113-128.

15. *Illustrated London News*, 12 May 1866, p. 470.

16. Mary Claudet notebook, 1860, Claudet Papers, PABC. This notebook belonged to Frederic's wife. Most of the notebook, however, contains jottings by Francis between 1861-67. The notebook also includes a sketch of the Point Roberts camp.

17. F. G. Claudet to Frederic Claudet, 27 January 1861, Claudet Papers, PABC.

18. Reproduced in D. Wallace Duthie, ed., *A Bishop in the Rough* (London: Smith, Elder & Co., 1909), frontispiece.

19. F. G. Claudet diary, 14 March and 3 December 1870, Claudet Papers, PABC. Joseph Davis (d. 1891), an ex-Royal Engineer who served as a carpenter, operated a photographic studio in New Westminster between 1869-90. Francis also knew one of the best colonial-period landscape photographers of British Columbia, Frederick Dally (1838-1914). Claudet viewed some of Dally's images in Victoria on 8 March 1870, and on 24 September 1870. Three weeks before Dally left British Columbia permanently, Francis "wrote to Henry [Claudet] for Dally." F. G. Claudet diary, 8 March and 24 September 1870, Claudet Papers, PABC.

20. David Withrow (d. 1905), the photographer, was also a member of this militia group. Claudet was elected 2nd Lieutenant at a meeting of the Rifle Volunteers on 14 September 1870; F. G. Claudet diary, 14 September 1870, Claudet Papers, PABC.

21. A. N. Birch to Francis G. Claudet, 16 April 1866, Frederick G. Claudet scrapbook, Claudet Papers, PABC.

22. F. G. Claudet diary, 21 December 1870, Claudet Papers, PABC. British Columbia joined the Confederation of Canada as the sixth province on 20 July 1871.

23. F. G. Claudet diary, 29 April 1873, Claudet Papers, PABC.

24. Francis G. Claudet married Frances (Fanny) Fleury in Victoria on 22 September 1863. The two were engaged before Francis left for British Columbia. Their eldest son, Frederick George (1866-1946), settled at Nanoose Bay, Vancouver Island, in 1907 following a return visit three years earlier. The PABC purchased Frederick's archives of family papers, photographs and heirlooms for $1,750 in February 1946. Frederick's diaries were presented to the PABC by his brother Henry Hayman (1874-1954) after Frederick's death. The glass negatives taken by Francis between 1860-72 are not mentioned in the correspondence between Frederick and the PABC, or in inventories prepared by Provincial Archivist Willard Ireland in 1946. The whereabouts of these negatives is for now a mystery.

Der Karlsbader Strudel

Albumen print, 3 7/8 x 5 1/4 inches, of Karlsbad's pulsating hot geyser, the foundation of the spa's fame and opulence. The water, renowned for its health-giving qualities, was (and is) in fact a concentrated solution of Glauber salt. In that sense, it did indeed make veritable sprinters out of the sick and the lame. No clients are here in sight, but in the late 1920s the celebrant of this volume was one of those tempted to "take the waters," with instructive and unforgettable consequences.

The present albumen print comes from a collection of postcard-size prints, published by Verlag K. Maloch of Prague, ca. 1890.

Hans Christian Adam

Three Gardner Assistants in Texas

W. R. Young, III

William J. Oliphant (1845-1930), a badly wounded Confederate veteran, entered the profession of photography shortly after returning to his home in Austin, Texas. In 1866, he "took up the study of photography in an art studio opened by two northern men in Austin, Texas."[1] These unidentified teachers were probably W. D. Stone and William T. Waggoner, who occupied a photo-gallery in a building owned by Oliphant's father. A photograph of William Reddish Pywell, dated October 31, 1867, on a *carte de visite* bearing Oliphant's imprint, suggests that Oliphant had now taken over the gallery. In any case, by February 1868 William J. Oliphant advertised *his* studio at their former address. But why was Pywell there? How did they meet? Was he now instructing Oliphant in the finer points of photographic science?

Later in 1868, apparently not satisfied with his mastery of wet-plate photography, Oliphant "went to Washington to study photography in Alexander Gardner's studio on Seventh Street"[2] [Figure 1]. Perhaps Pywell had persuaded Oliphant to return with him to Washington. During his stay in Washington, Oliphant lived with the Pywell family at their home on D Street. While studying at Gardner's studio, he met and became friends with another Gardner assistant, George Robertson. Although the precise dates are uncertain, Oliphant seems to have stayed in Washington during the middle to latter half of 1868 and returned to Austin in time to reopen his gallery by January 1869.

But he was not operating alone. Theodore Richey, a twenty-four-year-old (precisely Oliphant's age) Gardner ex-assistant, lived with him and worked for him during 1870. It must have been an interesting household: Oliphant's new bride, his aging father, Richey, and two servants.[3]

By mid-1872, George Robertson arrived to take Richey's place. The Austin newspaper described Robertson as "a gentleman of rare skill as an artist who was connected for a number of years with Gardner's celebrated gallery at Washington."[4] Robertson made two series of stereo cards for Oliphant, one on a buffalo hunt (1874) and another with the geologic survey of Texas. Within a few years of Robertson's departure, Oliphant left photography, probably because of physical limitations imposed by his war injuries.

REFERENCES

1. Walter Prescott Webb, "A Texas Buffalo Hunt with Original Photographs," *Holland's Magazine*, October 1927, p. 11.

2. Walter Prescott Webb, "A Texas Buffalo Hunt with Original Photographs," p. 11.

3. U.S. Census for 1870, enumerated in June, State of Texas, Travis County, City of Austin, p. 45.

4. *Tri-Weekly Statesman* [Austin, Texas], June 25, 1872, p. 3.

Figure 1. This carte de visite bears Oliphant's handwritten inscription: "Those celebrated photographers Messrs. W. J. Oliphant of Austin Texas and W. R. Pywell of Washington City D.C. Taken by Gardner, Washington, D.C., 511 7th Street. Taken in Sept. 1868." Oliphant is seated, William Pywell is standing. Collection of Lawrence T. Jones.

Major General James Waterhouse

G. Thomas

A man of untiring energy and versatile interests, Major General Waterhouse rode the crest of the waves in two continents and contributed to the technical progress of photography, in many of its applications.

Born on 24 July 1842 to J. W. Waterhouse, James grew up in Hurstmed, Eltham.[1] He studied in the University College School and then went on to King's College, London, and later joined Addiscombe.

His first posting as Lieutenant came on 10 June 1859, to the Royal (Bengal) Artillery in India. His promotions followed the usual army pattern. Thus he was promoted to Captain on 10 June 1871; to Major on 10 June 1879; to Lt. Colonel on 10 June 1889; and to Major General on 27 June 1898.

His interest in photography was the reason why he was singled out in 1868 to be posted to be the Assistant Surveyor General, in charge of photographic operations in the Surveyor General's Office at Calcutta and he continued there until 1897.

During his tenure in that office, he took part in the observations of the total eclipses in 1871 and 1875, as also in the observation of the Transit of Venus in 1874.[2] As Chief of Cartographic Service in Calcutta, he introduced Photozincography for the reproduction of maps, as well as the collotype process in the reproduction of pictures. He also introduced a waxed sand process. He discovered that Eosin was a green sensitizer for silver bromide collodion dry plates in 1870.[3]

He was one of the small band of photographers, along with Houghton and Tanner[4] to have contributed to the monumental collection of 465 photographs to be published by the India Museum in eight volumes. His coverage was mostly from Saugor, Delhi, and Allahabad.[5,6] He contributed many articles to the *Journal of Asiatic Society* on a variety of subjects, such as "Tidal Observations in the Gulf of Cutch";[7] "Notes on Survey Operations in Afghanistan, in Connection with the 1878-79 Operation";[8] "Photography in Connection with the Transit of Venus at Roorkee";[9] "The Application of Photography to the Reproduction of Maps and Plates by Photomechanical and Other Processes";[10] and "Some Observations on the Electrical Action of Light upon Silver and its Halide Compounds."[11]

He was elected president of the Asiatic Society of Bengal in 1888 for a two-year term. His interests were many and he was made a trustee of the Indian Museum, Calcutta, from 1875 to 1897. He was also the Secretary of the Zoological Garden, Calcutta, from 1894 to 1897.

He was elected president of the Photographic Society of India (Calcutta) for the term 1894-1897. It was during this period that he produced the first three-color photogravure print.[12]

His research into photo-optics and photographic chemistry earned for him the Progress Medal of the Royal Photographic Society in 1890, as well as the Voigtlander Medal of the Vienna Photographic

*Figure 1. Johnston & Hoffman, Portrait of James
Waterhouse, from a halftone reproduction in the "Journal of
the Photographic Society of India," vol. 7 (1894).*

Figure 2. James Waterhouse, "The Houghly Railway Bridge," from a halftone reproduction in the "Journal of the Photographic Society of India," vol. 4 (1891).

Figure 3. James Waterhouse, untitled landscape photograph, from a halftone reproduction in the "Journal of the Photographic Society of India," vol. 5 (1892).

Figure 4. James Waterhouse, "The I.R. Austro-Hungarian Corvette Saida at Calcutta," from a halftone reproduction in the "Journal of the Photographic Society of India," vol. 6 (1893).

Figure 5. James Waterhouse, "The Tanks, Aden," from a halftone reproduction in the "Journal of the Photographic Society of India," vol. 7 (1894).

Figure 6. James Waterhouse, "In the Zoological Garden, Calcutta," from a halftone reproduction in the "Journal of the Photographic Society of India," vol. 10 (1897).

Society. He was made an Honorary Member of the latter society.[13]

At the age of 55 (1897), he retired from the Survey of India and returned to Eltham, Kent, but he continued his researches in a number of projects in the following years.

He was Honorary Secretary of the Royal Photographic Society in 1899, when he had the honor of delivering the Traill Taylor Lecture on "Teachings of Daguerreotype."[14,15] In 1905 he was elected President of the Royal Photographic Society.[16] On assuming office as president, he delivered his presidential address on "The By-ways of Photography."[17] This learned lecture covered a wide range of topics concerning the present state of photographic technology. During that address he made reference to the varied opportunities he had had during his service in India. He said, "I have perhaps been specially favoured by opportunities and the varied training I acquired in this way by photographing Indian archaeological remains, native tribes, sun pictures and eclipses, and practically working out many of the principal photo-mechanical processes and orthochromatic and spectrum photography has been valuable educationally and has added very greatly to the interest and pleasure of my way through life."[18]

He remained a bachelor throughout his life, perhaps because he was so wedded to his work that he had no time to share it with a life partner. He died at the age of 79 on 28 September 1921 at Eltham, Kent.[19]

REFERENCES

1. *Who Was Who*, 1916-1928, p. 1097.

2. *Journal of the Photographic Society of India*, 37 (1922), p. 39.

3. *Focal Encyclopedia of Photography* (London: Focal Press, 1960), p. 1270.

4. G. Thomas, *History of Photography, India, 1840-1980* (Andhra Pradesh: Akademi of Photography, 1981), pp. 16-17.

5. G. Thomas, *History of Photography*.

6. R. Desmond, "India Office Library and Records Report," 1974, p. 11.

7. *Journal of Asiatic Society*, vol. 47, no. 2 (1878), pp. 21-25.

8. *Journal of Asiatic Society*, vol. 48, no. 2 (1879), pp. 146-172.

9. *Journal of Asiatic Society*, vol. 44, no. 2 (1875), pp. 64-82.

10. *Journal of Asiatic Society*, vol. 47, no. 2 (1878), pp. 53-124.

11. *Journal of Asiatic Society*, vol. 62, no. 2 (1893), pp. 10-29.

12. *Focal Encyclopedia of Photography*, p. 1270.

13. *Who Was Who*, 1916-1928, p. 1097.

14. *British Journal Almanac*, 1923, pp. 295-296.

15. *The Photographic Journal*, Royal Photographic Society, November 1922, pp. 487-488.

16. *The Photographic Journal*, March 1905, p. 114.

17. *The Photographic Journal*, November 1905, pp. 351-358.

18. *The Photographic Journal*, November 1905, p. 354.

19. *Who Was Who*, 1916-1928, p. 1097.

Félix, Adrien, and Roger Bonfils

Ritchie Thomas

During my first two years in the library of the American University of Beirut, I discovered a large wooden box, painted gray, about two feet wide, five feet long, and two feet deep, with a hinged lid. The box contained a large collection of nineteenth-century photographs of European and Middle Eastern landmarks. These photographs had been given to the university by relatives of E. W. Blatchford, vice-president of the American Board of Commissioners for Foreign Missions from 1895 to 1898, and had never been properly cataloged. The ABCFM was the organization responsible for the founding of the American University of Beirut in 1867. The photographs were acquired by Blatchford on his extensive travels and were referred to as the Blatchford Collection.

As I began to examine these photographs, I sorted them into subject categories. I found that most of the photographs were of the Middle East and that the majority of these were signed by Félix Bonfils [Figure 1]. Jibran Bikhazi was then the Assistant University Librarian and could remember Beirut during World War I and the hardship that the city had suffered as a part of the Ottoman Empire. I asked him what he knew of Félix Bonfils. He told me that Bonfils had lived in Beirut, described where the photographic studio had stood, and said that it had been demolished some years ago and replaced with a modern structure. Fouad Debbas, author of *Beirut: Our Memory* and noted collector of photographs of the

Middle East, told me in correspondence that the studio of Félix Bonfils was located at the corner of Rue Trablos and Rue Patriarche Hoyek in Beirut. I began my search for Bonfils in the Roman Catholic cemetery. I found no grave marker inscribed with "Bonfils," but did find a grave marker inscribed "Tancrède Dumas," with no other inscription on the stone. In a 22 January 1982 letter to the author, Fouad Debbas stated that Tancrède Dumas had six children, none of whom were named Tancrède. The Tancrède Dumas interred in the Roman Catholic cemetery of Beirut must have been the photographer who, like Fèlix Bonfils, was French, lived in Beirut, and was his contemporary. In another letter to the author, dated 3 February 1982, Fouad Debbas wrote, "They were both [Dumas and Bonfils] protestants and French." If so, how did Tancrède Dumas come to be buried in a Catholic cemetery? Debbas continues, "I have on two occasions found photos of Bonfils/Dumas with only the Bonfils serial number and an embossed stamp, 'Dumas et Fils, photographe,' on the picture. The fact that the picture had only the white serial number and no caption suggests that it was a special edition of Bonfils' glassplates destined for Dumas, or it was a current edition of Bonfils' photographs but the caption and *the signature* in the lower part has been cut. I am inclined to believe [the latter] is more probable. When Dumas would run out of stock of certain views, he would buy directly from Bonfils, cut away the signature and use his embossed signature.

Figure 1. Unknown photographer, portrait of Félix Bonfils, ca. 1880-1883. Courtesy of Roger Bonfils.

Figure 2. Unknown photographer, portrait of Adrien Bonfils, ca. 1910. Courtesy of Roger Bonfils.

He was then able to constitute a complete album for a customer."

One of my colleagues thought that Bonfils may have been Jewish. An inquiry at the synagogue in Beirut produced no record of the Jewish cemetery containing the remains of a Bonfils.

Bonfils was proving to be more elusive than I had at first imagined. I discussed my problem with John Carswell, then Professor of Fine Art at the American University of Beirut. He suggested that I place a classified advertisement in the French- and English-language local newspapers asking readers with knowledge of the family of Bonfils, photographers of Beirut, to contact me.

The day after the publication of the advertisement, Mr. Albert Kanaan, an engineer and graduate in the early 1930s of the American University of Beirut's College of Engineering and Architecture, called on me at the university library, in response to my advertisement in *Le Jour*.

Mr. Kanaan remembered that he once had occasion to spend the night in a hotel in the town of Royat,

while motoring through the Puy-de-Dôme district of central France. At the hotel, he remarked on the nineteenth-century photographs of Lebanon and the Middle East decorating the lobby and dining room and was told that the owner of the hotel was a descendant of Bonfils, the Middle East photographer. As he could not recall the name of the hotel, Mr. Kanaan suggested that I write to the Syndicate d'Initiative of Royat, France, requesting that my inquiry concerning the Bonfils family be forwarded to the proprietor of the hotel.

Almost by return mail I received a letter dated 20 February 1969, in which Roger Bonfils acknowledged that his grandfather was Félix Bonfils and his father Adrien Bonfils. [Figure 2] The biographical information appearing in "Bonfils & Son; Egypt, Greece, and the Levant; 1867-1894" (*History of Photography*, vol. 3, no. 1, January 1979) is entirely from this four-page letter. The photographs of Félix and Adrien Bonfils that illustrate this essay were made available by Roger Bonfils.

Francis Frith: The Enterprising Cameraman

Elizabeth Lindquist-Cock

It was an age of adventurous exploration, and photography was its prime explorer. It was an age of exacting science, and photography was its measure. It was an age of sentimental Christianity, and photography became its demi-god. It was, above all, an age of capitalist adventure, and photography was big business. In exploration, sentiment, and enterprise, the career of Francis Frith is the very model of photography in the Victorian age. Like his contemporary and compatriot, Charles Dickens, the genius of Francis Frith managed to produce art for the masses and art for the aristocracy simultaneously and profitably.

Frith was seventeen when the announcement of Daguerre's invention amazed Europe, shocking the academy artists so violently that the French painter, Paul Delaroche, proclaimed, "From today, painting is dead!"[1] Even more momentous was the negative-positive process of Sir William Henry Fox Talbot, but there was so much wrangling over the patents and rights to the paper processes that it was not until 1850 that Frith took up photography, founding at the same time a printing business in which photography may have played a part in creating such enormous success that he could sell his company in six years after amassing two hundred thousand pounds, a sum which royally financed his full-time pursuits with the camera in the coming adventurous years.

Adventures with photography had been enthusiastically encouraged by the famous scientist and explorer Baron von Humboldt, whose scientific treatise, *Cosmos*, had appeared in 1845, urging the use of photography as an aid to obtaining exact illustration for scientific reports and scientifically correct botanical details for paintings.[2] The continents of Africa and South America particularly beckoned scientists, artists, and photographers, while the half-forgotten treasures of Egypt and the Bible territories became prime targets for photographic investigation. The identification of "Truth" with "Beauty" and the Victorian passion for authenticity in detail would make it necessary for landscape painters, like the America landscape artist Frederick Church, to study the photographs of "Frith Brothers of London" before undertaking their own journeys to Palestine and the Near East.[3]

The fact that an English photography company would be well known to an American painter is not at all surprising when we consult the *Catalog of the Principal Series of Photo Pictures*, printed and published by F. Frith and Co. at Reigate, which states that the Frith Collection "is incomparably the largest and most complete extant" in the world. The catalog lists a stock of one million unmounted photographs, opalines (photographs mounted behind glass), medallions, morocco albums empty or mounted with "our" photographs, platinotypes, lantern slides, postcards for sale in over two thousand shops. The company advertised that it would supply photographs for "artists" and architects; develop,

retouch, and print the work of amateur photographers; provide photography lessons; take pictures of groups, estates, and houses; and supply newsworthy photographs, like that of a suffragette committing suicide by throwing herself under the hooves of King Edward's horse at Ascot.[4]

The firm listed photographs of the United Kingdom; a "Continental Series" representing Germany, Austria, and the Tyrol, Switzerland, Italy, the Italian Lakes, Spain, Portugal, Norway, Paris, the French cathedrals and the South of France; an "Eastern series" including Egypt, Palestine, Asia Minor, China, Japan, and India; and an "American series." Lantern slides were advertised as a "splendid selection, mounted and unmounted, of Newquay, and neighborhood, and Cornwall...."[5] In short, for Francis Frith and the company he founded, photography was big business indeed.

The firm itself would long survive the death of Francis Frith in 1893, continuing under the management of Frith's two sons, Eustace and Cyril, and then subsequently in different hands until liquidation in 1971. Some of the Frith Collection of negatives and prints was purchased by the National Maritime Museum in England. The rest of the collection was purchased by Messrs. Rothmans, a commercial company. In his biography of Frith, *Victorian Cameraman*, Bill Jay records that in 1971 the Frith Collection comprised sixty thousand original glass plates and two hundred and fifty thousand original albumen prints. There were apparently so many negatives, prints, cards, and other manufactures that employees back in the 1880s had thought nothing of using a large batch of glass plates to mix into concrete in the construction of the floor of an outhouse at Reigate. Bill Jay also noted in 1973 that Frith's four surviving grandsons, Francis E. Frith of Wotten-under-Edge, Jasper Frith of Penrith, Paul Crosfield of Broadway and Claude Frith of Fletching have preserved family photographs, diaries, manuscripts and books.

The originator of this phenomenal plethora of images, Francis Frith, managed to establish the world's largest photographic establishment not only because he was a canny businessman and had a remarkable talent for wet-plate photography, but because he was the right man at the right time. He began his photography business when the grand tour was *de rigeur* for every English family, not limited to the aristocracy, as had been the case in the 18th century. Frith catered to an omnivorous Victorian demand for the picturesque view at a time when the critic John Ruskin would enthuse about photography in *Modern Painters*:

My drawings are truth to the very letter — too literal perhaps; so says my father, so says not the daguerreotype, for it beats me grievously. I have allied myself with it; sith [since] it may no better be, and have brought away some precious records from Florence. It is certainly the most marvelous invention of the century; given us just in time to save some evidence from the great public of wreckers.[6]

It was a time when the Pre-Raphaelite painters like Dante Gabriel Rosetti were striving almost obsessively for absolute accuracy and photographic realism in their art:

If there are any stereoscopic pictures, either in the instrument or elsewhere, which represent general views of cities, would you send them, or anything of a fleet of ships. I want to use them in painting Troy at the back of my Helen.[7]

Frith's photographs satisfied the Victorian curiosity about the world at a time when railroads were making tourism more and more possible for the middle classes in England. He epitomized the Victorian interest in scientific discovery at the time when Henry Morton Stanley was searching for Dr. Livingston at the source of the Nile, and during France's great adventure with the Suez Canal, from 1859 to 1869. He was the very paradigm of colonial empire when he wrote,

It is an exciting thought that perhaps to England will eventually fall the task of governing this wonderful land [Egypt], and of reviving and Christianizing its mummified and paralyzed life.[8]

He was aided and abetted in all his achievements by the fact that the monarch of England, the ruler of dominions on which the sun never set, mighty Queen Victoria herself, was fanatically devoted to photography ever since she saw the first stereoscopic pictures at the Crystal Palace Exhibition of 1851. Shortly after Frith's third journey up the Nile in 1859, for example, a lady-in-waiting to Queen Victoria wrote,

I have been writing to all the fine ladies in London for their and their husband's photographs, for the Queen. I believe the Queen could be bought and sold for a photograph.[9]

Before the advent of the motion picture travelogue, it was the stereographic viewer that supplied entertainment and adventure for the arm-chair traveler. Based on Wheatstone's discoveries in 1838 of stereoscopic vision, the lenticular stereoscope, invented by Sir David Brewster in 1856, made it possible for millions to view these popular prints. In 1861, Oliver Wendell Holmes invented the hand-viewer, which was mass produced, and pirated in

England, making the stereo-mania even more prevalent and pronounced. In that year, Holmes wrote that he had personally seen one hundred thousand stereographs in the United States, and that the process was clearly a "leaf torn from the book of God's recording angel."[10]

Every Victorian household, including the Queen's, would have its stereographic viewer on the parlor table, with prints of the castles at Heidelberg, Interlaken, Niagara Falls, the Temples of Karnak and Luxor. Every Victorian home, including the Queen's palaces, would have its morocco albums with *carte-de-visite* prints or tintypes of friends and family. Travelers abroad were expected to bring back souvenir prints of their recent tours of Paris or the Swiss Alps. Stereographic prints were produced on every subject imaginable: soldiers in the Crimea, the war in China, factory workers at their machines, Blacks picking cotton in Alabama, camps of the Blackfoot Indians, the wonders of Yosemite Park, gold miners in the fields of California, earthquakes and floods, with these terrors softened by sentimental genre scenes of proposals, weddings, and domesticity that brought tears to the eyes of everyone from the kitchen maid to the Queen herself.

Francis Frith was quick to capitalize on this Victorian mania for photographs. His travel-minded audience, encouraged by traveling panoramas and other realistic theatrical displays, thrilled at such romantic and exotic subjects as the great pyramids of Gizeh, the statues of Abu Simbel and the Nile cataracts, and sighed with pious pleasure at all things Biblical.

This photographer whose name would become a household word in Victorian England was born in a small town, Chesterfield in Derbyshire, in 1822. Frith's father was a cooper, but a well-educated craftsman who could quote Shakespeare and the Bible. Like most Victorians, the young Frith was given a good religious education in a Quaker boarding school in Birmingham in the years 1834-38, and acquired Latin, Greek, some conversational French, mathematics, and natural philosophy. During his school years, he displayed a keen interest in poetry, travel, biography, and mechanical invention, designing a rotary steam engine which unfortunately turned out to be a financial disaster. After a five-year apprenticeship with a cutlery firm in Sheffield, he moved to Liverpool, where he started a wholesale grocery business. When this failed, he found a more appropriate enterprise, the printing trade, and began his life-long absorption with photography. At the age of thirty-four, having made his spectacular first business success, he was off to Africa and the Near East, pursuing the romantic piety of the Victorians and their craving for views of the Holy Lands. [Figure 1]

Between 1856 and 1860, Frith made three separate tours to the Near East, proving that, in his own way, he was every bit as colorful a figure as Richard Burton, the explorer of Lake Tanganyika and Victoria Nyanza, and Lord Gordon, the stalwart defender of Khartum. He recorded, in great detail, his perilous adventures. Here is a typical paragraph about entering the dangerous rapids and channels at the mouth of the Nile:

> Then about noon, we approach as we suppose the mouth of the river. We see nothing however but a wall of angry white breakers, stretching as far as the eye can reach. The sea is rising. Our high pressure boiler is nearly saturated with salt. The engineer has just told us it is useless to think of returning when a great wave strikes us and sweeps the foredeck....[11]

Frith describes living in a tomb at the foot of the great pyramids, fighting off a pack of wild dogs; he tells of bargaining with a mysterious priest for an eight-hundred-year-old copy of the Koran, meeting on the desert Arab princes who were "blazing with jewelled-hilted swords and gold-mounted firearms,"[12] trading for camels with desert sheikhs, defending himself against bands of Arab bandits from a stone fortress on the Mount of Olives. On his third expedition to the Near East in 1859, Frith travelled further up the Nile than any photographer before him, reaching the sixth cataract in a period before Stanley's famous search for Livingston:

> I had an exciting dromedary ride of thirty miles into the heart of the desert above the sixth cataract upon the tracks of a panther and an antelope...the spiral horns of the latter adorn my hall.[13]

It takes an act of imagination to realize that he was faced each day with the herculean task of transporting the heavy equipment needed for wet-plate photography in wild and desolate regions. He had already traveled around England by horse and wagon, photographing the country estates and mansions of upper and middle-class Victorian families. By the time of the Nile adventure, he was completely familiar with large studio cameras employing 8 x 10 inch or 16 x 20 inch glass plates, and he had already been successful making stereographic slides with a dual-lens camera. But, in Egypt, he had to transport these huge studio cameras and a portable darkroom by boat, mule, or camel. In the 1850s, wet-plate photography was a complicated process. A glass sheet would have to be cleaned, then coated

Figure 1. Francis Frith, Assouan Dam, 1857. 9 x 6 1/4 in., albumen print from wet collodion glass-plate negative. From the author's collection.

with a mixture of collodion (a solution of pyroxyl in equal parts of alcohol and ether), potassium iodide, and other light-sensitive salts. The photographer had to rock the plate until this mixture covered the plate evenly. With temperatures reaching perhaps 130°F in the desert, with flies buzzing around, with the photographer's face dripping with perspiration, this required great patience and skill. After the plate was coated with collodion, it had to be dipped into a sensitizing bath of silver nitrate and immediately loaded into a light-tight holder. The plate would then have to be exposed and developed at once because the collodion was useless once it dried. Thus the sweating photographer would have to rush into a suffocating darkroom tent to develop the plate with gallic acid. The image would be fixed with hypo or potassium cyanide, and rinsed with a bucket of water. After finishing a picture-taking session — one exposure for the stereographs, one for the 8 x 10's, and one for the 16 x 20's, each in a separate camera — the photographer would have to fold up his darkroom, pack it and the chemicals on a camel, and set off toward the next archaeological site. Often, Frith would attempt to develop his photonegatives in rock-cut tombs for the sake of their greater coolness.[14] However, he discovered that his negatives were often marred by the dust that permeated the tombs, leaving pin pricks of black on the final print. To avoid these problems, Frith had a photographic van made out of wicker sent over from England:

> This carriage of mine, being entirely overspread with a loose cover of white sailcloth to protect it from the sun, was a most conspicuous and mysterious looking vehicle, and excited amongst the Egyptian populace a vast amount of ingenious speculation as to its uses. The idea, however, which seemed the most reasonable…was that therein, with right laudable and jealous care, I transported from place to place — my harem. It was full of moon-faced beauties, my wives all — and great was the respect and consideration which this view of the case procured for me.[15]

The wet-plate collodion process was cumbersome, but its results were breathtaking. Frith's speed of forty seconds was adequate for the brilliant light of the desert, and many of the plates have the beautiful contrasts, sharp definitions, and range of tones admired by "zone system" enthusiasts today. Perhaps the real secret to the process lay in the use of albumen papers, which Frith employed in printing his plates when he returned to England. Most of his unmounted prints remain in a clear and mint-clean condition; only the mounted prints faded as a result

of chemicals contained in the glues. Robert Sobieszek has described the special qualities of these prints:

> Albumen printing's particular beauty was and still is directly related to its extremely smooth and hard surface, its slightly translucent and opalescent luminosity, and its soft and mellow tonal coloration. Its darkest areas…are warm and contain an almost unbelievable amount of shadow detail. The highlights are creamy, nearly the subtle hue of eggshell.…[16]

Even today, the clarity and detail of these views is undimmed.

Frith was not only an excellent craftsman but he had an artist's eye for compositions that were later simply expropriated by landscape painters. Even so, Frith was disappointed with many of his photographs:

> I think I will confess to a weakness for rapid production in all that I undertake…I regret, especially, that I was so grievously hurried whilst taking my views. Most undoubtedly I might have done more justice to my subjects — yet when I reflected upon the circumstances under which many of the photographs were taken, I marveled greatly that they turned out so well.…[17]

He was perhaps being overly modest. Frith's photographs of Ramses the Great, Abu Simbel, are taken from such unusual angles, with such feeling for contrast and texture, that they seem not to have been surpassed by even the most sophisticated photographic equipment of today.

In his "Approach to Philae," Frith demonstrates such a fascination for three-dimensional space as to inspire his audiences. The stereoscopic views, like those of the Temple of Luxor, Thebes, fit Oliver Wendell Holmes' description of looking through a stereoscope in 1859: "a surprise such as no painting ever produced.… The mind feels its way into the very depths of the picture…we have the same sense of infinite complexity which nature gives us.…"[18]

Frith's photographic expeditions made him instantly famous. After the return from his second journey to the Near East, he was given a standing ovation from the Photographic Society of London, and the *Times* wrote, "Frith's photographs carry us far beyond anything that is in the power of the most accomplished artist to transfer to his canvas."[19]

* * * * *

Frith's reputation as a great photographer rests primarily on the production of many handsome volumes, illustrated with mounted photographs taken on his travels. It is important to recall that Frith was

publishing his books in the period before the invention of the halftone technologies, well before the successful development of photogravure in the 1880s. Before then, the only means of illustrating books with photographs was to either glue them down on the pages of the text or to tip them in separately. In 1857, his 16 x 20 inch views were bound into a complete book entitled, *Cairo, Sinai, Jerusalem and the Pyramids of Egypt*, very probably the largest photographically illustrated book ever published, with text pages measuring 21 x 29 inches.[20] The smaller prints were bound into two volumes entitled *Egypt and Palestine,* handsomely published by James S. Virtue of London in 1858-59, and proved to be enormously popular.[21]

Typical, perhaps, of the format of Frith's works, is the set called *Sinai and Palestine,* available in the research library of the International Museum of Photography at George Eastman House. Each large photograph is accompanied by a page or two of explanatory historical or geographical information, with comments by the photographer concerning equipment employed, point of view, anecdotes, and descriptions of the natural beauty of particular sites. This information, for example, accompanies the prints entitled "Cedars of Lebanon":

> The tree now represented is, upon the whole, the noblest of the ten or twelve "venerables" now standing. It measures forty feet in circumference near the roots....The day which I spent at the Cedars was one of the most delightful that I ever enjoyed. The delicious and temperate air of this elevation, the songs of the nightingales which abound in the grove, the scent of the timber and fallen leaves, and above all, the "spiritus" of this half-hallowed place...combine to render the cedar grove of Lebanon, in the beginning of June, one of the most enchanting spots on earth.[22]

Other such travelogue "gush" was characteristic of both the man and the audience for whom he wrote so knowingly. Frith's stereoscopic prints were also published in book form, the most famous being *Egypt, Nubia and Ethiopia* of 1862. The book contained one hundred stereoscopic prints and small wood engravings by Joseph Bonomi.[23] The preface offered many comments illuminating the new standards for scientific accuracy being established by photography:

> Some of our English artists have also published beautiful volumes on the picturesque ruins in this land, most interesting for the draftsman; but we cannot but sometimes fancy that they have sacrificed somewhat of scientific accuracy to artistic effect. But when we look at photographic views, we are troubled by no such misgiving. Here we have all the truthfulness of nature, all the

reality of the objects themselves, and at the same time, artistic effects which leave us nothing to wish for.

A tag inserted in the front of the volume informs the public that stereoscopes especially adapted for use with Frith's work were available from "Messrs. Negretti and Zambra" for five shillings.

In the history of the printed book, Frith will be remembered for having produced the first Bible illustrated with photographs. Called the "Queen's Bible," and dedicated to his patron for his work, "Her Gracious Majesty Queen Victoria," it is a most impressive volume bound in red moroccan leather with brass mountings and clasps, almost too heavy and large to maneuver with any grace. Frith did his best to illustrate various passages of Biblical text: if there was mention of corn and food in the cities, Frith provided a photograph of the government corn stores at Luxor. Another passage, from Exodus, verses 2-3, which warns "I am the Lord thy God, which have brought thee out of the land of Egypt, out of the house of bondage. Thou shalt have no other Gods before me," was illustrated by an 8 x 10 inch plate of an Egyptian idol at Thebes. The Frith Bible was sold in a limited edition of one hundred and seventy copies in 1862, for a price of fifty guineas, and is now a most valued collector's item.[24] [Figure 2]

Frith's volumes roamed from the sublime to the gossipy, and two of his books were titled *The Gossiping Photographer at Hastings and The Gossiping Photographer on the Rhine.* These were chatty, written in light-hearted prose, illustrated with numerous topographical photographs. In the introduction to the Rhine volume, Frith states that his books are for the arm-chair traveler:

> The Rhine now-a-days is "at our doors." Everybody who can afford a guinea for my book has been, or might have been, up the Rhine....In the compass of this book, and through so costly a process as Photography, I do not pretend to have thoroughly illustrated or described the Rhine. I have given such pictures and observations as in the course of a rapid journey — embracing very few days of favorable weather — occurred respectively to my camera and to my mind.[25]

It is clear that Frith had no axe to grind, no social reform to pursue. Almost in spite of his own relaxed bourgeois attitudes, he did record and therefore reveal certain changing social conditions. The abandoned mines and lime kilns of Cornwall indicated the passing of a once-thriving industry. Decaying docks and abandoned ships standing in shallow water on the beaches were a silent testament to what once must have been a thriving coastal trade.

While Frith documented the bustling seaports and the industrial towns of Liverpool, Swansea, Grimsby and Hull, with their belching chimneys, their crowded harbors, he overlooked the hard life of the poverty-stricken villages where dehumanized creatures lived on stone-floored cottages without light, sanitation, or running water. Frith was far more interested in touching the heartstrings — and therefore the pursestrings — of his Victorian audience with picturesque views of pretty English towns, thatched roof cottages, old manor houses and country fairs.

Many of Frith's English views seem closer to the painted landscapes of a Gainsborough or a Wilson than to documentary photography. The grand master of English pictorial photography in Frith's day was, of course, Henry Peach Robinson, whose *Pictorial Effect in Photography* dominated the artistic ideals of both landscape and portrait photographers. Robinson, in true English aesthetic tradition, declared:

> It is an old canon of art, that every scene worth painting must have something of the sublime, the beautiful, or the picturesque. By its nature, photography can make no pretensions to represent the first, but beauty can be represented by its means, and picturesqueness has never had so perfect an interpreter.[26]

Frith's "picturesqueness" might have been described by William Gilpin in his essays on "Picturesque Travel," as his photographs often depicted a "scene broken into irregular and jutting forms, marked by rugged rocks, clothed with shaggy boskage, and enlivened by two figures and a ruined castle."[27]

This series of English views was enormously popular and sold by the thousands through newsagents, tobacco shops, stationery stores, mostly in the form of postcards printed from the originals and reduced in size. Frith undoubtedly took many of these views himself, but the volume of his business indicates that he must have employed an army of assistants, in the same way that the firm of Matthew Brady produced its astonishing multitudes. Frith directed the operation, but it is almost impossible to say, unless the prints are signed by him, which of the many thousands of images are by his own hand.

In addition to all this heady enterprise, Frith also illustrated Henry Wadsworth Longfellow's romance, *Hyperion*, spending six months in 1865 following the footsteps of Paul Flemming, the hero of Longfellow's tale, through Switzerland and the Tyrol, where he found "some of the most picturesque scenery of Europe."[28] Later he complained sadly about the severe limitations of photography in capturing the majestic scenery of the Alps or the beauties of ancient monuments:

And yet…even under the most favorable circumstances, how greatly the one-sided inflexibility of the camera mars the pleasure and probably success of such an undertaking.…The church of the Holy Rood, which contains the celebrated tomb of Maximilian and the twenty gigantic bronze statues of the House of Hapsburg, was alarmingly dim to our photographic version.[29]

Among other illustrations for books were thirty-eight romanticizing pictures for R. D. Blackmore's *Lorna Doone*, published in the photogravure process perfected by Karl Klič in 1879. Frith's energies seemed boundless, but his admiration for photography, his own or anyone else's, seemed to cool as he grew older.

* * * * *

Like John Ruskin, who had at first praised photography and later damned it, Francis Frith began by exploiting the camera's ability to record in abundant and specific detail. Later, rich beyond his earliest imaginings, with a prospering business at Reigate, he turned his prodigious energies from travel and photography to the writing of poetry and to landscape painting in the realist style. It was as if the pursuit of the fact had prevented his earlier use of his imagination, and it was this that he seemed to need to develop and enjoy in his last years. Yet, while his poems were amusing or philosophical, his paintings remained firmly within the photographic aesthetic. His picturesque views of the English countryside, or of the south of France where he lived in the last decade, were so realistic as to be indistinguishable from photographic reproduction, except that they were in color and photography had not yet achieved that miracle. The Victorian painters like Dante Gabriel Rosetti, William Holman Hunt, Sir John Millais, Abraham Solomon, James Tissot, and Alma-Tadema would have no greater ideal than the imitation of photographic sharp-focus and detail. Most landscape painters had been following Ruskin's precepts in *Modern Painters*:

> We hold that the primary object of art is to observe and record truth, whether of the visible universe or of emotion.…the greatest art includes the widest range, recording with equal fidelity, the aspirations of the human soul, and the humblest facts of physical nature.…[30]

In his critique of the Salon of 1859, Charles Baudelaire had despaired of the future of painting, seeing that the influence of photography would push artists into abandoning imagination:

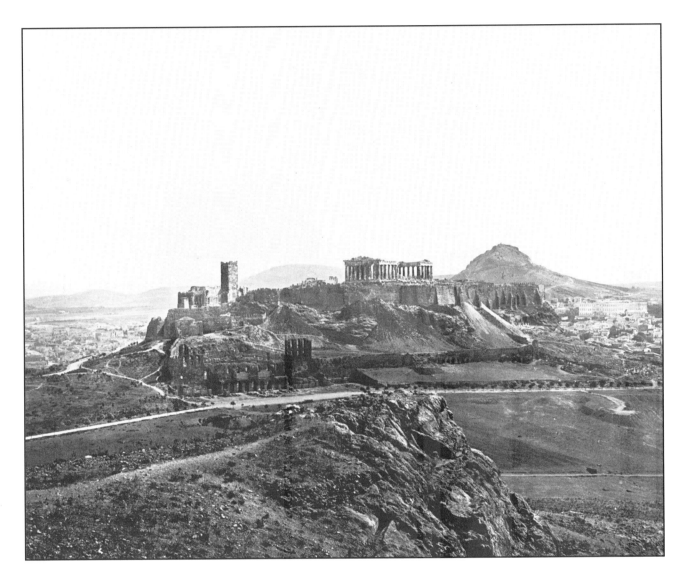

Figure 2. Francis Frith, The Acropolis, ca. 1962. 8 x 6 in., albumen print from wet collodion glass-plate negative. From the author's collection.

In matters of painting and sculpture, the current credo of rich and fashionable people, especially in France...is this: "I believe in Nature and I believe only in Nature....I believe that art is and cannot be anything but the exact reproduction of Nature....Thus, the industry which could give us a result identical to nature would be Art Absolute." A vengeful god has granted the prayers of this multitude. Daguerre has his Messiah. And so they say, "Since photography gives us all the desirable guarantees of exactitude (they believe that, the blockheads), art *is* photography.[31]

While painters were imitating photography, the photographers were attempting to raise the status of their art by imitating the romantic pictorialism of painting, posing models in ridiculous historical costumes in the manner of the Pre-Raphaelites and putting together composite pictures for elaborate allegorical tableaux like Oscar Rejlander's *The Two Ways of Life,* in imitation of Couture's painting, *The Romans of the Decadence.*

Rejlander had felt keenly that photography had serious limitations as a means of "artistic expression," and like him, Frith, the greatest landscape photographer of the Near East and a master of the intimate nooks of English scenery, would lament that he could never equal Turner:

> No man is so painfully conscious as he is that Nature's lights and shades are generally woefully patchy and ineffective compared with Turner's; and in short, that although his chemical knowledge be perfectly adequate and his manipulation faultless, it is a marvel, an accident, a chance in a thousand, when a picture turns out as artistic in every respect as his cultivated taste could wish.[32]

Today, when we study Frith's photograph of the pyramid of Dahshoor (1856), with its astonishing depth of field, recording the valley of the Nile four miles away as sharply as the sand dunes in the foreground, or his carefully composed views of Jerusalem from the Mount of Olives, with its long line of olive trees leading toward the Church of the Ascension in the background, we can only marvel at his meticulous craftsmanship and his artistry, so superior to the maudlin and ridiculously sentimental genre paintings which won the praise of academicians and the public.

Francis Frith may not have been a Turner of photography, but one can hope that he did not judge himself too harshly on that account. If he became dissatisfied with the limitations of the photographic techniques available to him in his own lifetime, he had, nevertheless, learned to make the most of these limitations. He had, in fact, taken the camera to places where it had never before been taken, including all the dangerous way up the Nile. He had, in fact, produced some of his period's most magnificently composed, detailed, articulate, and otherwise admirable photographs of record. He had, in fact, an impressive list of "firsts" to his name, not the least of which was the "Queen's Bible." His use of the printed book as a means of distributing his work was expert and intelligent. The fact that he made of photography a capital enterprise, that he became almost insufferably rich by the standards of today's compensation for photographic prints, that the crowds loved him and purchased his picture postcards by the thousands and thousands, should not be held against him. Even the most ordinary of his studio's productions, and certainly the work demonstrably by his own hand, had two elusive characteristics: "quality" and "good taste." He was, moreover, a typical man of the Age of Enterprise, when, thanks to the inventiveness of photographic scientists, an adventurous, energetic, dedicated individual like Frith could make the most of a new technology for the benefit of both himself and a enthusiastic public. He had a personal credo which he shared with his students, a philosophy which was always reflected in his own work:

> The rapidity of production of which the merely mechanical process of photographic picture making is capable, may easily become a source of great mischief. The student should bear in mind that what he has to aim at is not the production of a large number of good pictures, but if possible, of *one* that shall satisfy all the requirements of his judgement and taste. That one when produced will be, we need not say, of infinitely greater value to his feelings and reputation than a lane-full of merely good pictures.[33]

Better or more eternally useful advice to contemporary students can hardly be imagined.

REFERENCES

1. Helmut Gernsheim, *The History of Photography* (New York: McGraw-Hill, 1969), p. 70.

2. Baron von Humboldt, *Cosmos*, vol. 2 (London, 1849), p. 452.

3. The name, "Frith Brothers of London" was found on a page of Church's Diary dated 1868, now in the collection of the New-York Historical Society. The page contained miscellaneous information concerning the dimensions of the Tomb at Khasne in Jordan, the name of a hotel in Jaffe, and the name of Abram Samuels, a guide for Jerusalem. Church also employed a photographer, Mr. Berghem, to take panoramic photographs of Jerusalem as preparatory studies for his painting. See Elizabeth Lindquist-Cock, *The Influence of Photography on American Landscape Painting* (Garland Press, 1977), pp. 113-114.

4. *Catalog of the Principal Series of Photo Pictures*, printed and published by F. Frith and Co., Reigate, Surrey, 1892.

5. Bill Jay, *Victorian Cameraman; Francis Frith's Views of Rural England 1850-1898.* (Newton Abbott, David and Charles, 1973), p. 30.

6. John Ruskin, *Works,* ed. by E. T. Cook and A. Wedderburn (London, 1906), vol. 3, p. 210. Letter to W. H. Harrison, August 12, 1846.

7. Helmut Gernsheim, *Masterpieces of Victorian Photography* (London, 1951), p. 12.

8. Bill Jay, *Victorian Cameraman*, p. 20.

9. Helmut Gernsheim, *History of Photography*, p. 295. From the Hon. Eleanor Stanley, "Twenty Years at Court, 1842-1862," London, 1916.

10. Oliver Wendell Holmes, "Sun Painting and Sun Sculpture," *Atlantic Monthly*, 8 (1861), p. 14.

11. Bill Jay, *Victorian Cameraman*, p. 16.

12. Bill Jay, *Victorian Cameraman*, p. 17.

13. Bill Jay, *Victorian Cameraman*, p. 19.

14. Francis Frith, *Sinai and Palestine* (London: William MacKenzie, 1857). Text accompanying photograph of Absalom's tomb.

15. Francis Frith, *Egypt and Palestine*, 1858-9, vol. 11. Captions to photographs entitled, "Doum Palm and Ruined Mosque near Philae."

16. Robert Sobieszek, *British Masters of the Albumen Print* (University of Chicago Press, 1976). Quoted in the review by Aaron Scharf, "One Man's Fiche," *History of Photography*, October 1977, p. 353

17. Bill Jay, *Victorian Cameraman*, p. 25.

18. Oliver Wendell Holmes, "The Stereoscope and the Stereograph," *Atlantic Monthly*, 3 (1859), p. 21.

19. Bill Jay, *Victorian Cameraman*, p. 26.

20. This book seems to have been published under various titles. The George Eastman House has a copy bearing the title, *Egypt, Sinai and Jerusalem*, with descriptions by Mrs. Poole and Reginald S. Poole (London: MacKenzie, 1858). Gernsheim refers to *Egypt, Sinai and Palestine*, with descriptions by Mr. and Mrs. Poole, 1860, as the largest photographically illustrated book.

21. The George Eastman House owns several sets: *Upper Egypt and Ethiopia* (London: MacKenzie, 1857); *Egypt and Palestine* (London: James S. Virtue, 1857); *Lower Egypt, Thebes and the Pyramids* (London: MacKenzie, 1863); *Sinai and Palestine* (London: William MacKenzie, 1877).

22. Francis Frith, *Sinai and Palestine*, 1857. Text accompanying plate entitled, "Cedars of Lebanon."

23. Francis Frith, *Egypt, Nubia and Ethiopia*, illustrated by one hundred stereoscopic photographs taken by Francis Frith for Messrs. Negretti and Zambra with descriptions and numerous wood engravings by Joseph Bonomi, author of *Nineveh and its Palaces* (London: Smith and Elder, 1862).

24. *The Holy Bible*, containing the old and new testaments, translated out of the original tongues...illustrated with photographs by Frith (Glasgow, William MacKenzie, 1862). Dedicated to her most gracious majesty, Queen Victoria.

25. Francis Frith, *The Gossiping Photographer at Hastings* and *The Gossiping Photographer on the Rhine* (Reigate: Frith Brothers, 1864).

26. Henry Peach Robinson, *Pictorial Effect in Photography* (Pawlet, Vermont: Helios, 1971), reprint of first edition (1869), p. 15.

27. Walter John Hipple, *The Beautiful, the Sublime and the Picturesque* (Carbondale, Illinois: 1957), p. 195.

28. Henry W.Longfellow, *Hyperion, a Romance*, illustrated with twenty-nine photographs of the Rhine, Switzerland and the Tyrol by Francis Frith (London: Alfred William Bennett, 1865), p. iv.

29. Henry W. Longfellow, *Hyperion, a Romance*, pp. iv-v.

30. David Dickason, *The Daring Young Men*, (Ondiana, 1953), p. 75.

31. Charles Baudelaire, "Salon de 1859: le public moderne et la photographie," *Baudelaire, II, Critique* (Fribourg, 1944), p. 107.

32. *Art Journal*, 1859, pp. 71-72.

33. Gernsheim, *History of Photography*, p. 28.

Francis Frith: A Catalog of Photo-Pictures of Germany

Charles Mann

Francis Frith's (1822-1898) photo operations were on a grand scale. Bill Jay in 1971 came upon the firm's decimated archive which *still* contained 60,000 glass plates and 250,000 prints; this despite the breaking up of early plates for an outhouse floor, and the simple burial of thousands more in what is described as a ten-yard trench, two- to three-feet deep and wide, filled with glass plates with images yet perceptible but with emulsions sadly decayed. I wish to describe here a relic of the firm's vast enterprise, a catalogue issued ca. 1860-65, and titled *Frith's Photo-Pictures. Germany*. [Figure 1] The pamphlet in paper wrappers paginates [i-ii], [1]-29, 30-33, and lists about fifteen hundred views available for the most part in three sizes: panoramic (11 x 7 inches), cabinet (7 x 5 inches), or universal (9 x 7 inches). This last size curiously was available only for 43 views. There is a simple index, but no prices, aside from those advertised for pre-assembled albums, which were available in cloth, half-morocco, and morocco.

Photographs were also available unmounted, mounted in large mounts for framing, mounted on panels, and special orders could be made up for birthday, Christmas, and New Year's cards. All of these it is assumed were provided for buyers in quantity.

The firm's address was Reigate, Surrey, but sales were through the trade. The catalogue in hand has the printed label of George Philip & Son, Map, Chart, and Geographical Depot, 32 Fleet Street, London,

pasted over the Frith imprint on the cover-title. So the catalogue is strictly a business document issued without frills and with only a few puffs for the product.

However, other "Foreign Series" besides that for Germany are advertised, with some telling statistics. Photographs of Switzerland, a small country, and India, a very large country, were available in 1,500 views each; "France and Paris, etc." were represented by 1,000; 800 for Italy, 800 for Algiers, Egypt, and Palestine; 500 for China, Japan, and Ceylon. America seemed only of minor commercial interest with a mere 150 views. It was even outranked by Norway, which was represented by 250. Such figures reflect a market, of course, and Frith had long supplied the market with the products of his famous photographic expeditions to the Near East, and of his encyclopedic coverage of Europe, but all of these figures pale before the sheet mass the firm had available of English photographs for the home market, and the tourist trade. Over 15,850 photographs of the British Isles could be solicited. There were 1,500 in stock for Devonshire alone, and 3,000 of cathedrals, abbeys, and castles, plus 1,200 of the Lake district. England thus was the mainstay of his market.

The German series catalogue cannot be common as it does not turn up in the National Union Catalog, ARLIN, or the British Library Catalogue, nor for that matter do any of the other Frith catalogues. It is arranged by city and locale from ALF to ZELL, with

Figure 1. Cover-title and verso of rear wrapper of "Frith's Photo-Pictures. Germany "(London, n.d.). 7 1/8 x 11 inches. The Pennsylvania State University Libraries.

Frith's Photo-Pictures.—Germany. 21

HEIDELBERG—*continued.*

No.			
15584	The Castle, from Philosophenweg		
15585	" Entrance Gate		
15586	" Ruins in Courtyard		
15587	" Courtyard		
15588	" Old Window		
15589	" Octagon Tower		
15590	" " and Balcony		
15591	" Frederic's & Otto Henry's buildings		
11171	" Courtyard		
11172	" " and Roman Pillars		
11173	" Elizabeth's Gate		
11174	" Otto Henry's Buildings		
11175	" Frederic's		
11176	" Entrance to Otto Henry's Buildings		
11177	" "		
11178	" Blown-up Tower		
11179	" Bridge Tower		
11180	" Octagon "		
11181	" " from Balcony		
11182	" From Molkenkur		
11183	" and Hotel, from Molkenkur		
11184	Carlsplatz		
15592	Student's Prison, "Villa Trail"		
15593	" "Solitude"		
15595	" "Sans Souci"		
15596	" "Palais Royal"		
15597	" Entrance		
15598	Stifts-Kirche		
15599	Bridge Towers		
15600	Carlsthor		
15601	The Ritter		
11193	The Neckar, from near Wolfsbrunnen		
11194	Schleirbach		
11202	Neckargemünd		
11203	Neckarsteinach, Swallow's Nest,		
11204	" " and Dilsberg		
11205	" "		
11206	" " Dilsberg		
11207	" " from across River		
11195	" " below Dilsberg		
11196	" "		
11197	Speyer Cathedral		
11198	" Porch		

Frith's Photo-Pictures.—Germany.

WORMS.

No.			
11199	Cathedral, from North-East		
11200	" " South-West		
11201	" " South		
11202	" " East End		
11203	" Nave, looking East		
11204	" Choir, Altar		
11205	" Interior		
15569	" South Portal		
15570	" Interior Nave, East		
15571	" " The Choir		
15572	" " The Baptistry		
11206	Trinity Church		
11207	Luther's Monument (upright)		
11208	" "		
15568	" "		
11209	" Tree		
11210	Heilsche Haus		
11211	St. Martin's Church		
11213	Liebfrauenkirche		
15573	St. Paulus Kirche		
15574			

HEIDELBERG.

No.			
11165	Castle and Town, from Elizabeth's Terrace		
11166	" " from Elizabeth's Terrace, near		
11167	Castle, from Elizabeth's Terrace		
11168	The Neckar, from "		
11169	View from Castle Balcony		
11170	Old Bridge and Castle		
11185	" "		
11186	The Neckar, from near New Bridge		
11187	View from Heiligenberg		
11188	" " near		
11189	" Geisberg		
11190	" " nearer		
11191	" Castle Road		
11192	" Heiligenberg Road		
15575	The Castle, from the North		
15576	" "		
15577	" from the Terrace		
15578	" "		
15579	" from Schloss Hotel		
15580	" "		
15581	" from Molkenkur		
15582	" " near Hirschgasse		
15583	" " Philosophenweg		

Figure 2. Pages 20 and 21 from Frith's catalog. The Pennsylvania State University Libraries.

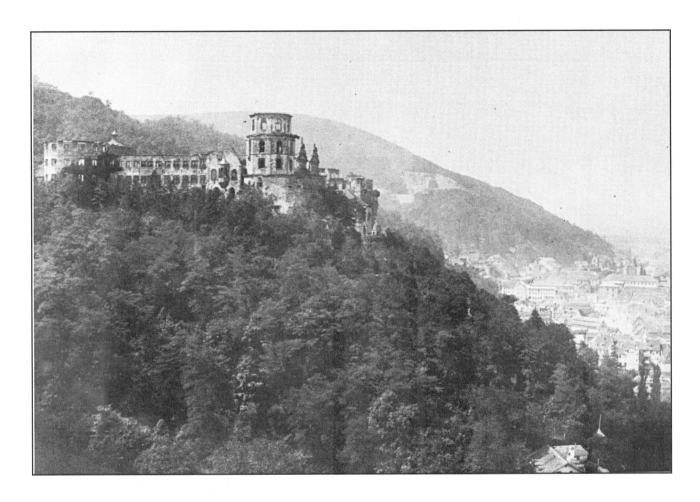

Figure 3. Francis Frith, "Heidelberg, From Elizabeth's Terrace." 4 3/4 x 6 5/8 inches. Albumen print from H.W. Longfellow, "Hyperion: A Romance "(1865). Frith provided twenty-four photographs of the Rhine, Switzerland, and the Tyrol for this work. Courtesy of The Pennsylvania State University Libraries.

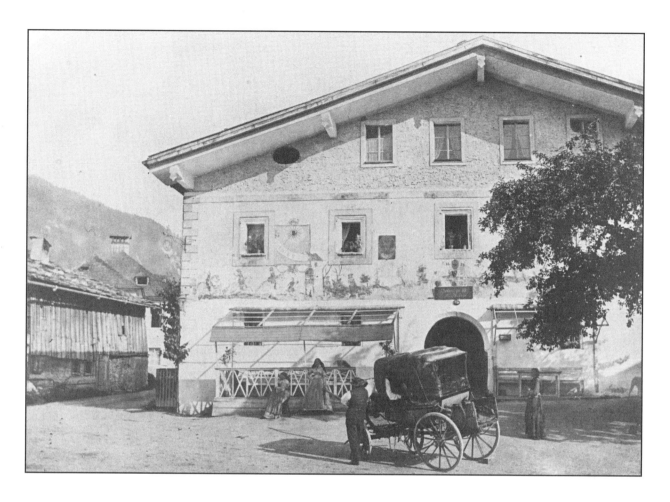

Figure 4. Francis Frith, "The Inn at St. Gilgen, with Portrait of the Widow Schöndorfer." 4 3/4" x 6 5/8". Albumen print from H. W. Longfellow, "Hyperion: A Romance "(1865).

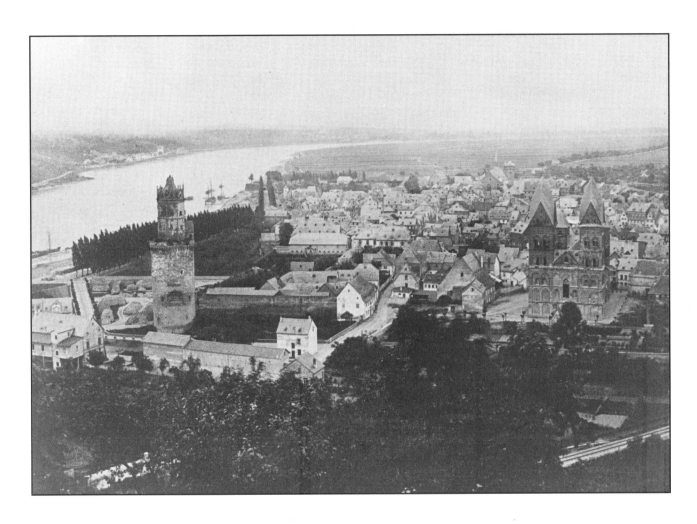

Figure 5. Francis Frith, "Andernach." 4 3/4 x 6 5/8 inches. Albumen print from H. W. Longfellow, "Hyperion: A Romance "(1865).

the larger selections given over to Berlin, the Rhine, the Moselle, Cologne, Baden-Baden and, moving south, Salzburg, Innsbruck, Strasbourg, and the Black Forest. [Figure 2] As though realizing the encroachment upon Swiss scenes, the listings end with an advertisement for the photo-pictures of Switzerland, listing the provinces and towns available in the Swiss group.

For such a voluminous listing, the titles are necessarily short: "Thiergarten, Goethe Monument," and "Brandenburger Gate and Parisen Platz." The Cologne Cathedral is represented by thirty views ranging from "The Cathedral (Peep of)" to "Nave East" in six versions. Characteristically, there are few detail shots or interiors, and no views of peasants in costume listed. Such human interest material was not part of the austere program of the company. They certainly took a lot of pictures, so many that quality did give way a bit to the mechanical nature of the medium but never entirely so. Frith had high standards, and in the end a quality product resulted. An advertisement in the catalogue states flatly, "Great care is exercised in the production of Frith's photographs so as to render them permanent." Many of them are, and we are fortunate to be able to see so much of the nineteenth century as Francis Frith saw it.

AFTERWORD

This short note owes what few biographical facts it contains to Bill Jay's *Victorian Cameraman, 1850-1898: Francis Frith's Views of Rural England* (Newton Abbot: David & Charles, 1973). What remained of the Frith plates and prints were purchased by Rothmans of Pall Mall, London.

NOTE ON THE ILLUSTRATIONS

The examples of Frith's work that illustrate this essay were taken from Henry Wadsworth Longfellow, *Hyperion: A Romance*, illustrated with twenty-four photographs of the Rhine, Switzerland, and the Tyrol (London: A. W. Bennett, 1865), courtesy of The Pennsylvania State University Libraries.

Henry Peach Robinson and the Great Hall Studio, Tunbridge Wells

Margaret F. Harker

The fame of the nineteenth-century photographer, Henry Peach Robinson, rests on his composite imagery, as evidenced in his masterpieces, such as "Sleep," and "Dawn and Sunset," and his photographic art theory, as published in *Pictorial Effect in Photography, Picture Making by Photography*, and his other books published between 1869 and 1896. What is not widely known is his reputation as a professional portrait photographer and the esteem in which he was held by other practising photographers of his day.

H. P. Robinson established an ideal portrait studio, with an ancillary suite of rooms and a display gallery, in a newly built major property on a prime site opposite the entrance to the railway station in Tunbridge Wells, a spa town in Kent, southeast England, in 1871 [Figure 1].[1] It was the realisation of a dream he had nurtured from the outset of his life as a professional photographer in 1857 in Leamington, Warwickshire, another spa town in England.

From a business point of view, Robinson was very shrewd. He had no independent means and was entirely reliant on income from his practice of photography to support himself and his family. Apart from expensive prime sites in the major cities such as Regent Street in London and St. Ann's Square, Manchester, the spa towns offered the best opportunities for business all year round, in the nineteenth century. At seaside resorts, business was affected by the seasons, high in summer but low in winter.

Many wealthy families lived within easy reach of Tunbridge Wells; a comparatively large element of upper-middle-class people were resident in the town, and visitors from the surrounding area and as far away as London flocked to the town by rail. Many of those who came to take the waters at the Pump Rooms would have seen Robinson's Great Hall Studio in the north wing of the Public Hall buildings as they emerged from the station, and would have crossed the road to make an appointment to have their photograph taken.

The Great Hall Studio's impressive entrance was on the ground floor. Facing the street were two large plate-glass windows behind which were displayed a few large portrait photographs and a frame of photo-enamels, a form of photographic imagery for which the Robinson studio was renowned. In one journalistic review of a visit to the studio it was said that "the enamels were executed by a process akin to that which has often been described in the journals; and, between you and me, I don't mind whispering that they were really first-rate....I do not know how to account for their very perfect character."[2] Another contributor was impressed by what he considered to be the unique feature in the window of "a display of medals—gold, silver and bronze—amounting to nearly fifty, obtained at various exhibitions in England, Scotland and Ireland, Continental Europe,

TUNBRIDGE WELLS.

THE GREAT HALL AND PUBLIC ROOMS.

A Company was formed some years since, with a capital of £10,000, for the purpose of erecting "a Public Hall for "Concerts, Public Meetings, Exhibitions, Horticultural Fêtes, "Sales of Property, with rooms suitable for a Club, Baths, "Lectures, Refreshments, or other purposes." A central site was procured in the Calverley Hotel grounds, opposite the South

The Great Hall and Public Rooms.

Eastern Railway Stations; and a building was erected which is an attraction, a convenience, and an ornament to the town. The large hall is 100ft. in length by 42ft. in width, and is 31ft. high in the centre. It is the most central building in the town, and where now the principal entertainments take place, and will seat from 600 to 700 people. Applications for hiring the hall should be made to the agent, Mr. R. Pelton, the Pantiles

Figure 1. "Tunbridge Wells. The Great Hall and Public Rooms."

India and America."[3] H. P. Robinson was a prolific exhibitor at photographic exhibitions all over the world, the publicity thereby generated having a beneficial effect on his business.

The Great Hall Studio was a model of good design, being a show-place for exhibiting his work as well as incorporating all the features needed to make possible the most efficient methods of production in the practice of photography. For years he had advised other photographers, both amateur and professional, on studio design, and professionals on studio

practice. In this as in many other photographic matters he had achieved a singular reputation. He was able to put all his ideas into practice in the Tunbridge Wells Studio.[4]

Passing through spacious reception rooms, the client entered a studio which was lit by a large, steep north skylight, as it was on the north-facing side of the building. No direct sun-rays entered this room. Beyond were dressing rooms, darkrooms, printing and toning rooms and an open air studio with access to Calverley Park at the rear of the building.

"Entering the happy compromise between office, shop, and picture gallery which constitutes the reception rooms, we find an unusual display of specimens all in spotless condition of neatness....Our attention is soon riveted on the fine display of pictorial compositions with which Mr. Robinson's skill as an artist has long been associated."[5] A corridor was at first arranged as a fernery but later used for picture display. This led into anther exhibition room in which was displayed "every style and size of portraiture, a fine collection of landscapes and combination pictures (familiar to exhibition goers) some of [which] have been converted into paintings (by H. P. Robinson) and pleasantly vary the display of effective coloured work to which one side of the room is devoted." Robinson, who continued to draw and paint throughout the latter part of his life in Tunbridge Wells, exhibited his paintings as well as his photographs, offering both for sale.

Like most other eminent photographers of his day who had good accommodations, Robinson was his own print seller. He and his partner prepared stocks of prints of all his appropriate exhibition photographs, in addition to the landscapes and scenic views taken in the country surrounding Tunbridge Wells, which were displayed in the galleries of the Great Hall Studio. In fact the numbers of people who came to view the pictures on display and make a purchase were, at times, greater than those whose purpose was to have a portrait taken!

The studio was so arranged that an invalid's chair could easily be wheeled into it. It was 36 feet long by 14 feet wide (11 x 4.25 meters). The eaves were low and the ridge at the apex of the glass roof was high—the former 5 feet 6 inches (1.70 meters) and the latter 14 feet (4.25 meters) from the ground. The north-facing side was of glass panels down to 2 feet from the ground. A complete system of blinds controlled the entry of light. The walls were a green-grey and the floor covered with linoleum of a Maltese cross pattern. "Hot water pipes maintained the whole establishment at a comfortable temperature," according to a contemporary description. At either end of the studio was a series of backgrounds with a canopy overhead and a stand to which a curtain could be attached. Chairs and other furniture gave "an air of elegance and comfort and afford as well great variety of effect in the pictures." In the studio and dressing rooms were children's toys of all kinds. In the open-air studio were "banks covered with growing wild flowers and natural rustic accessories in profusion." This was used for instantaneous groups, portraits of animals, equestrian photography and figure studies for combination printing with

landscapes. The prints were made in an enclosed glass structure like a very large cucumber frame at the rear of the premises.

On the two floors above the ground level were rooms devoted to printing on enamel surfaces, mounting, retouching, and finishing, and a painting room where "Mr. Robinson is engaged in painting in the moments he can snatch from the glass room [photography studio]."

Robinson received many visitors to his studio, apart from clients. Other photographers and journalists went away greatly impressed by what they had seen. One reported an interesting side-light on Robinsonian humour. When the guest accepted the offer of a thirst-quenching drink, Robinson opened up the back of a large studio camera and from the dark interior produced a tankard of beer![6]

Probably on account of the great interest taken in his studio, as well as his pride of achievement in managing a photographic business under ideal conditions for which he could honourably claim to be responsible, he decided to impart his knowledge to a wider audience through a book, *The Photographic Studio and What to Do in It.*[7] It was the summary of a lifetime of experience in such matters. Out of twenty-two chapters, ten are devoted to the "Management of the Sitter" and contain advice on the conventions practised by artists for hundred of years, adapted to the special requirements of photography.

The photography of people at its best requires the power of rapid analysis of personality, a summary of natural characteristics and an appreciation of what the medium can and cannot reveal. Robinson had developed these powers during his many years of practice. In *The Photographic Studio and What to Do in It*, he advised his readers to avoid difficult poses in the studio with nervous or awkward people, and to make the pose very simple. In order to accomplish an easy and relaxed pose, it was sometimes necessary to require the subject to walk about the studio and to stop at a point on which the camera lens was focused.

An article he wrote, which was published in the *Mirror* on 17 January 1874, "Heads I Have Taken Off," makes fascinating reading. In reminiscing about some of the sitters in front of his camera, he compared his role as a portrait photographer with that of an executioner, remarking, "I am often looked upon by my victims with almost as much horror as those grim personages....However . . . unwilling as they generally appear to be, they come by shoals, offering themselves of their own accord; and in the exercise of my profession I have taken off thousands of heads." He warned against the purchase of new clothes especially for a portrait session as being different

from garments worn in everyday life. "How am I to get a likeness of a person who does not look like herself?" he warned his readers.

In this same article, he commented on the range of sitters who went to his studio, saying that the most vain creatures of all were men, and quoted a number of stories to illustrate the point. He then described an elderly marchioness who was " . . . the favourite toast of sixty years ago, who was so dilapidated and limp that she had to be shaken occasionally by her attendant. She was so anxious to present a juvenile appearance, that to hide the sinking of her cheeks, natural to her years, she insisted on keeping a biscuit in her mouth while I exposed the plate." He continued with the descriptions of a number of types of female clients, favouring "...the average English young lady without any peculiarities, except those which distinguish her from her sisters of any other nation, and of which the country is proud, and who does all in her power to assist the photographer and save him trouble." He maintained that young ladies were the best models of all with the exception of young children. There is no doubt that Henry Peach Robinson was a "lady's man," as evidenced by his "Figures in Landscape" photographs taken during the 1880s on holidays in North Wales. The majority of these are peopled with young women. Clearly he enjoyed their company and they were at ease with him.

He wrote about his experiences of photographing children in the same article: "The most delightful sitters are children....A glow of happiness runs through me when I think of some of my little friends. I do not know a more charming occupation than photographing little girls, from the age of four to eight or none. After that age they lose their beauty for a time....I can call to mind many pleasant hours in trying to get the "counterfeit presentments" of little elves and fairies, who have at the same time driven me nearly mad by moving at the critical moment, or who would take a fancy to waltz when I required them to be immovable...yet I never tired of them. The result, when you do get one, is so exquisitely beautiful that it repays you for all your labour. The reason is that children cannot act—they must be natural or nothing."

It is most disappointing that so few examples of Robinson's studio portraits have survived. The usual "run of the mill" *cartes de visite* are to be found in victorian albums and private collections but the more distinctive and individualised portraits in large format size are seldom seen. A few examples of his delightful child studies, in the form of vignettes, can be viewed in the collection of the Royal Photographic Society. A journalist who reported on a visit to Robinson's Studio in 1880 commented, "Children's portraits are what Mr. Robinson delights in, and everywhere those laugh at you from the walls...."[8] A most significant feature of H. P. Robinson's portraiture is the facial expression of his sitters. He paid special attention to this. A careful study of his portraiture reveals animated and life-like expressions very different from the portraits of many contemporary photographers, in which instances the eyes have a glazed and far-away look and mouths are set in a firm and unsmiling line.

When Robinson opened a studio at 1, Grove Villas, Upper Grosvenor Road, Tunbridge Wells, in 1868, he took Nelson King Cherrill into partnership with him [Figure 2]. Due to business pressures and ill health, he had been forced into retirement from professional practice in 1864-1865 for four years and sold his former premises in Leamington Spa to Netterville Briggs. His wife, Selina, ever solicitous about her husband's well-being, insisted on his engagement of a photographer with whom to share the responsibilities of running the business. N. K. Cherrill was well regarded in photographic circles and had received a number of adulatory notices for his landscape photographs of the English Lake District in 1866.[9] He had also taken fine photographs of machinery. It is known that he trained as a civil engineer and had a good grasp of the sciences.

N. K. Cherrill also wrote for the photographic press. Most of his articles were of a technical nature concerned with photographic processes with which he had experimented. For instance, in February 1866 Cherrill made tests and was soon producing some excellent prints by means of the carbon tissue made available by Joseph Wilson Swan.[10] He made carbon prints of several of Robinson's former exhibition pictures, which were displayed in the Great Hall Studio galleries. The partners became expert at the transfer of carbon images to silk and to porcelain and enamel, the latter becoming one of the specialties in which the studio excelled.[11]

The partnership lasted from 1868 to 1875. Cherrill sailed to Australia in January 1876. It is not known why the partnership came to an end, neither is it recorded how the partners shared the work load of running a busy studio. This factor is further obscured by their practise of signing the work produced during this period, the usual form being "H. P. Robinson and N. K. Cherrill" signed on the mount or in the negative on the lower right corner. The only seeming exception being photographs of Robinson's young children taken in the surrounding countryside. Even the composite photographs taken at this time bear

Figure 2. "A Study by Henry Peach Robinson and N.K. Cherrill, 1873." Albumen print, 54 x 40.5 cm. Courtesy Tunbridge Wells Museum and Art Gallery. This head and shoulders portrait was one in a set of three photographs than won Crawshay prize for large-size portraits in 1873.

Figure 3. "H. P. Robinson in his study at home in Tunbridge Wells, 1890" by his son, Ralph Winwood Robinson. Courtesy Tunbridge Wells Museum and Art Gallery.

their joint signatures, notably, "Watching the Lark, Borrowdale."

Articles written by both photographers, independently, refer to the making of this photograph as combining a portrait of Robinson's second daughter, Maud, taken in his studio, with a Borrowdale landscape photograph by Cherrill.[12] Other than this, we can only surmise. It is a reasonable assumption that Robinson maintained control over studio production on most occasions and that Cherrill took over responsibility for the darkroom work and the printing.

After Cherrill's departure, Robinson continued to run the business on his own. Moreover, he produced

three of his major composite photographs between 1876 and 1888, when he retired from business. They were "When the Day's Work is Done," "Dawn and Sunset," and "Carolling."

One of his last commissions as a practising professional photographer was to photograph several of Tunbridge Wells's most celebrated townsmen. Five leather-bound volumes in the County Library, Tunbridge Wells, are inscribed "Tunbridge Wells in the Jubilee Year, portraits of some of the residents in 1887 by H. P. Robinson, Great Hall Studio, in platinotype." The first photograph is of the Chairman of the Town Council and the last is of H. P. Robinson himself.

188

Henry Peach Robinson's son, Ralph Winwood, took over the studio on his father's retirement in 1888 and later transferred the business to Redhill Surrey where he had acquired premises [Figure 3]. He named it the Rembrandt Studio and practised under the family name of H. P. Robinson and Son.

REFERENCES

This essay is based on *Henry Peach Robinson, Master of Photographic Art, 1830-1901*, by Margaret F. Harker (Oxford: Basil Blackwell Ltd, 1988.)

1. M. F. Harker, *Henry Peach Robinson, Master of Photographic Art, 1830-1901* (Oxford: Basil Blackwell Ltd., (1988), pp. 54-56.

2. "About a Studio at Tunbridge Wells by a Modest Contributor," *Photographic News*, 20 September 1872, p. 449.

3. "Noteworthy Studios: Messrs Robinson and Cherrill's Studio at Tunbridge Wells," *Photographic News*, 8 September 1875, pp. 427-428.

4. M. F. Harker, *Henry Peach Robinson*, p. 55.

5. "Noteworthy Studios . . .", pp. 427-428.

6. "About a Studio . . .", p. 449.

7. H. P. Robinson, *The Photographic Studio and What to Do in It* (Piper and Carter, 1885).

8. "Mr. H. P. Robinson at the Great Hall Studio, Tunbridge Wells," *Photographic News*, 11 June 1880, pp. 278-279.

9. "A Critical Notice, *Views of the English Lake Scenery* by Nelson K. Cherrill," *Photographic News*, 12 October 1866, p. 428.

10. "Experiments with Carbon Printing by Nelson K. Cherrill, Number 2," *Photographic News* (1866), pp. 459, 483-484, 532, 603; pp. 483-484 refers to his experiments with transfer to surfaces other than paper, especially silk.

11. N. K. Cherrill, "On Ceramic Enamels," *Photographic News*, January and February 1878; and "Mr. Robinson at the Great Hall Studio, Tunbridge Wells," *Photographic News*, 11 June 1880, p. 278.

12. *Journal of the Photographic Society*, November-December 1868; and *Photographic News*, 18 December 1868, p. 601.

Adolphe Braun: Art in the Age of Mechanical Reproduction

Naomi Rosenblum

In 1979, my article entitled "Adolphe Braun: A 19th Century Career in Photography" appeared in *History of Photography*.[1] Convinced that Braun was typical of entrepreneurs who took up the medium both for the livelihood it might offer and from the conviction that art and industry might find a common goal, I sought to make this connection clear. However, there were several aspects of Braun's activities that I did not adequately explore, and in view of the fact that Heinz Henisch, editor of *History of Photography*, was unfailingly supportive of my work on Braun, I am pleased to submit an updated addendum to a publication in his honor. One factor that has enabled me to proceed with my investigation was a fortunate purchase in a second-hand bookshop in Paris in 1976 of a group of letters written by Adolphe Braun and his sons Gaston and Henri to Paul de Saint-Victor.[2] Another is the fact that Braun himself has begun to interest historians in France, among them Pierre Tyl, whose 1982 Master's thesis on the photographer has been very helpful.[3]

The area that received the least attention in my article concerned the reproduction of works of high art, even though this was the enterprise that became the consuming interest of the Braun Company after 1866. In France, the reproduction of drawings, lithographs, engravings, paintings, sculpture, and architectural monuments was considered of paramount importance by publicists of photography during the 1850s and early 60s. For one thing, it

accorded with the judgment that, as a mechanical activity, photography was best employed as a pathway to accurate delineation; Baudelaire, in his well-known critique of the Salon of 1859, urged that photography "return to its rightful task, which is to be a servant to the sciences and the arts....."[4] In depicting actuality, the medium would allow both artists and public to gain a greater grasp of truth, without interfering with or usurping the role of the imagination in the arts.

As a consequence, photography became the channel by which masterworks of art in all media could be accurately and (relatively) inexpensively reproduced, and made available to large numbers of the bourgeoisie. The dissemination of replicas convinced middle-class owners that they had achieved a level of culture formerly obtainable only by the aristocracy.[5] An equally important goal was the improvement of taste, especially in the design and decoration of commodities produced by the industrial sector, such as textiles, wallpapers, and decorative objects for the home, which had become the basis for French expectations of industrial superiority over the British. Besides Braun, the photographers Baldus, Bingham, the Bisson brothers, and Marville were involved in producing such reproductions: their contributions and those of the well-known Alinari firm in Florence were highly praised by French critics when shown at Expositions.[6]

Nevertheless, art reproduction was a challenge. The inability of the collodion process to register all colors truthfully made certain drawings and nearly all paintings difficult to reproduce accurately, while the vagaries of printing on an albumen and silver salts emulsion created an unstable image, which in time might yellow or disappear. Furthermore, although still considerably less expensive to produce than an engraving, collodion photographs essentially were made by hand, their price beyond the means of large numbers of the middle classes. Indeed, this fact was recognized in 1850 by Louis-Désiré Blanquart-Evrard, sometimes called the "Gutenberg of photography," whose printing works at Lille pioneered in printing camera images in book format.[7] In his view, the definitive achievement of photographic printing would be to obtain a plate solely by the action of light that might be printed on an ordinary press using printer's ink.

Because the technology for this development — the half-tone plate — was not perfected until the final decades of the 19th century, various processes were advanced as a means of making permanent prints on a large scale. One, the carbon process, which appeared to solve the difficulties inherent in collodion/albumen, made possible the expansion of the Braun enterprise throughout the decade and on into the 1870s. This technology was based on discoveries by Mungo Ponton in 1839 concerning the insolubility of certain bichromates when exposed to light. Later work with this material by several French chemists, which opened up the possibility of adding color to the bichromate matter, intrigued Braun, who in fact worked on improving the procedures with two of the inventors. However, in 1866 he purchased a franchise for a more advanced process from British inventor Joseph Wilson Swan, and installed in his workshops at Dornach a steam engine that furnished power for his glazing and printing machinery. Along with the franchise, these improvements enabled him to manufacture carbon papers and make large numbers of prints at his enterprise in Dornach.

Braun's overriding interest in obtaining the rights to this procedure lay in its permanence and the coloristic possibilities; by adding granules of sepia, sanguine, and umber, for example, the process allowed him to work with more than a single color in reproducing the subtle and delicate tonalities of old-master drawings. Around 1870, the Braun Company added the more mechanized and consequently more productive Woodburytype process (known in France as *photoglyptie*), thus making use of two industrial photography technologies simultaneously.[8]

The art reproduction project started in 1866 with the drawings in the Louvre and drawings and paintings in the Basel Museum [Figure 1]. Eventually, reproductions included drawings, sculpture and paintings in museums in Dresden, Florence, Rome, Weimar, Vienna, Venice and Milan; after Braun's death in 1877, the stock expanded further to include objects in museums in England, Spain, Holland, Russia, and the United States. Catalogues detailing the objects reproduced began to appear in 1867 and were updated when new works were added.

Reproduction of works by contemporary artists was less common, but in 1868, following the death of Theodore Rousseau, the Braun firm began to reproduce his work, eventually issuing a catalogue with 120 examples, and a biographical text by Braun himself.

The impression one has of the activities of the Braun enterprise in the realm of art reproduction is of unceasing effort to preempt the field as well as to produce a quality product. That this goal necessitated intervention behind the art scene is apparent from an exchange of letters between the Brauns — Adolphe, Gaston, and Henri — and Paul de Saint Victor. The enterprise was made possible, it seems, because of a campaign, so-to-speak, waged by this eminent journalist.

Saint-Victor, initially art critic for *La Presse* and after 1868 for *La Liberté*, appears to have offered his services as consultant to the Braun firm sometime in 1867, for in letters to him late in that year and early in 1868 Adolphe accepts "with gratefulness the aid you offer," and thanks him "for the interest you bring to my work.…" The correspondence reveals that Saint-Victor's contributions included directives regarding what should be photographed, introductions to important personages, and publicity when the works were offered for sale to the public. Whether the Brauns were photographing in France or elsewhere, he advised also on itineraries.

For instance, writing to Saint-Victor in December 1869, Henri, who had been put in charge of the Italian operation, reminds the critic of his promise to outline how to organize the voyage to Italy, and asks for a sketch of a program for this second Italian venture. We may logically surmise that the inclusion of works in the Academy of Fine Arts in Venice, the Ambrosiana and Brera in Milan, the Michelangelo statuary and the frescoes of San Marco in Florence, photographed in 1868, and the Sistine frescoes and works in the Farnese Palace, and in the Vatican, undertaken the following year, resulted from the program set forth by Saint-Victor. As Henri noted, he would "be more than stupid" if he did not avail himself of the instruction promised by a

Figure 1. Adolphe Braun, "Le Christ Mort," facsimile photograph (carbon print, ca. 1868) of drawing by Hans Holbein in the collection of the Basel Museum. Société Française de Photographie, Paris.

knowledgeable critic whom the elder Braun had referred to as "gifted with a powerful pen."

Henri kept Saint-Victor informed of the problems faced by the Braun team. He described initial attempts to photograph in St. Peter's and the Sistine Chapel as "deplorable," and referred to the constant need "for a certain simple and costly gesture" to the officialdom. Other difficulties involved the number of holidays, the crowds in Saint Peter's, the rainy season, the insufficiency of light in the various rooms, the inconvenient scaffolding. The results of the labors in the Vatican were promised to Saint-Victor as soon as they had been processed at Dornach; that the journalist's comments were taken seriously is indicated by a directive from Adolphe to Henri, seemingly based on a comment by Saint-Victor, to take additional views of the ceiling in the *stanza* of Heliodorus in the Vatican Palace. The arrangement between critic/publicist and business establishment continued even after Henri assumed the directorship of the enterprise at Dornach, with the son asking Saint-Victor to continue in the future "the advice and benevolent support that you have so energetically maintained up until now."[9]

The art reproduction projects were interrupted by the Franco-Prussian war (during which Henri contracted the illness that resulted in his premature death in 1876), but in September 1871 Adolphe was able to write to Saint-Victor that "today my business has started up again," and to indicate that he had made progress in the reproduction of paintings (*tableaux*) as opposed to drawings. Naturally, the letters from the Brauns sometimes were accompanied by gifts, usually in the form of photographic reproductions, but also of more tangible value, as in a case of wine, made from grapes grown on Adolphe's property in Alsace.

The critic again proved to be an invaluable resource in the renewed efforts to enlarge the scale of the art reproduction business after the war. Because photographing in the galleries of the Louvre had been forbidden after 1866 under a decree of the Director of the Museum, Saint-Victor interceded in 1871 with the authorities to allow the Braun establishment to make a set of reproductions of the sculptures of the Louvre. Although not completely satisfied with the results — the camera operator did not always select the best vantage point, the light was uneven, and some of the marble was stained — Adolphe had the wit to send a set of plates to Félix Ravaisson-Mollien, Conservator of Antiquities at the Louvre; whether this was his own idea or suggested by Saint-Victor is not known. As Pierre Tyl observes, the issuance, despite the prohibition against photographing in the Louvre, of a catalogue of photographs of its sculptures, was a first step toward the goal that Braun had set — to reproduce the masterworks of painting in that institution.[10] [Figure 2]

Such ambitions required delicacy and timing, however, and we find Adolphe asking Saint-Victor to advise him on the proper moment to approach Charles Blanc, who had been named Director of Fine Arts in 1870. In that Gaston Braun had met Blanc when both were part of the group invited to Egypt for the ceremonies marking the opening of the Suez Canal, he was to present the case for photographing the paintings, but only, as the older Braun wrote, in the manner in which Saint-Victor would counsel.

Figure 2. Adolphe Braun, "Landscape by Primaticcio," in the Louvre. Facsimile photograph (carbon print), ca. 1868. Société Française de Photographie, Paris.

When Blanc finally agreed, Adolphe wrote Saint-Victor, thanking him for making it possible for an Alsatian to "reproduce the masterworks of a country from which he has been separated," and pledged himself to spare neither effort nor money in pursuit of this enterprise, which, he claimed, was to be his "masterwork."

The next project for which the advice of Saint-Victor was solicited involved photographing the work of living photographers in the Luxembourg Museum. With regard to this undertaking, to be started in the winter of 1874, Adolphe asked his mentor if he "would guide him in the steps necessary to take" which, he notes, "are much easier if I make them under your aegis." In the same year, Saint-Victor again was called upon to ease the way, by presenting Gaston to the director of an exhibition of works in private collections presented at the Palais Bourbon for the benefit of Alsace-Lorraine.

The ambitions of the Braun family are fairly obvious; as artists, photographers, and industrialists they wished to succeed in the business of making art reproductions. We may ask, however, what interest an intellectual such as Saint-Victor had in promoting the work of a photographic enterprise. Because the letters written by Saint-Victor to the Brauns, which might explain the specific reasons for his involvement, have not surfaced, we have to turn for an understanding of the esthetic ambitions of the period to the statements and writings of other figures in the arts. These indicate that the elevation of taste was an important matter to intellectual and commercial leaders during the Second Empire. Francis Wey, a writer on art subjects and early promoter of photography, suggested that "all the arts would gain from a knowledge of the truth," which the fidelity of the camera image would make available.[11] The specific role that photography could play in improving the appearance of goods produced by a materialist society in competition with its traditional rival England also was discussed. Leon de Laborde advocated that public taste be improved by "state support of inexpensive publication of the most beautiful works of art, past and present."[12]

The art of the past, in particular the styles of classical antiquity and the Italian Renaissance, were considered the most appropriate models to emulate in the decorative arts, so it became necessary to acquaint young designers with these objects. However, even serious students of fine art had difficulty gaining access to lesser-known works in museums, which often secreted objects in inaccessible rooms and storage places. Accurate reproduction then became the only feasible means of familiarizing large

numbers of people with the works held therein. Therefore, the bourgeois art establishment, of which Saint-Victor was representative, welcomed the opportunity presented by photography to move the Museum outside its physical walls.

In addition to acquainting the general public with what the state regarded as good taste, this strategy was expected to enhance the artistic judgment of the large numbers of young artists employed in the design sectors of industry. Saint-Victor summed up this concept in the preface to a later catalogue of the Braun Company, when he wrote "What admirable lessons are offered by the dissemination of such fine examples!...the drawings chosen by M. Braun will chase away the terrible examples which warp talent in formation and corrupt taste at its source."[13]

The pathway to improved products lay not only in the general availability of proper models in the form of accurate reproductions, but in the fact that both bureaucrats and industrial interests supported the teaching of design (*dessin*) through the establishment of art schools in manufacturing centers. That Braun sought ways to make sure that his reproductions would reach students in these schools is indicated in a letter to Saint-Victor in which he claims to "have found the means to make prints whose price would be affordable by art schools." The reduction in cost was made possible by employing the Woodburytype process mentioned earlier. Braun went on to ask the critic if he might use his name for the first edition of the less expensive prints intended for this purpose. In a later communication, he inquired of Saint-Victor if sending an example of his school prints to Charles Blanc might result in "obtaining from him an official recommendation or a subscription for the Schools of France."

At the same time, the firm continued to produce the larger format carbon prints, which Braun envisaged selling to "people of sophistication" who might be beguiled by a luxuriously printed ensemble of images and text. The reproductions were available individually, at a price varying between two and nine francs each depending on the size, but Braun's preferred scheme was to sell them in ensembles by subscription to museums, libraries and drawing schools. The price for such subscriptions, in which the prints were available in several different sizes, ranged from 88 francs for a small format set of the frescoes of the Sistine ceiling, to 3,690 francs for the drawings of the Louvre, 4,312 francs for the drawings of the Albertina, up to 8,000 francs for a set comprising paintings of the Gallery of Lille. Among those who dispersed large sums for the Braun establishment products were the British Museum, the

South Kensington Museum in London (now the Victoria and Albert Museum), the Print Gallery of the Stuttgart Museum, and the city of Toulon. In 1869, a year of highly satisfactory sales, the largest purchasers of Braun stock were not his compatriots but foreign dealers, notably Charles F. Haseltine, of Philadelphia, with others in Boston, Moscow, Vienna, and Venice also making considerable investments in stocks of photographic reproductions.[14]

The fact that his business was not supported by the French government was a matter of disappointment for Braun. Interest in the use of replicas of masterworks had reached a high point during the 1850s, but by the end of the following decade, when the Braun firm had installed the technology for inexpensive large-scale reproduction, the idea that the photograph might serve as a model for the improvement of industrial design no longer was as persuasive. For example, while Braun's earlier *Fleurs Photographiées* had been highly praised in 1859 for the beneficent influence these studies of flowers might have on textile design, the exhibition of the art reproductions in 1867 brought no medal and no official recognition. This indignity provoked the complaint to Saint-Victor that "the French government has not deigned to recognize the importance and above all the influence of this publication." Ironically, the volume of sales in the United States and England indicates that the reproductions were highly regarded in these countries despite the absence of an "official" program for improving taste.

Within this context, the Braun/Saint-Victor correspondence is enlightening. Aside from revealing the mechanisms by which leadership in the field of art reproduction was achieved, the letters indicate Adolphe's prescience with regard to the demand in industrialized societies for machine-produced facsimiles of original art. Today, as museum and gift shops make available machine replications of large numbers of such objects, displayed almost cheek-by-jowl with their originals, we can suspect that the Brauns, Adolphe in particular, would have been immensely gratified to find that their dreams of popularization have come true "in the age of mechanical reproduction."

REFERENCES

1. *History of Photography*, vol. 3, no. 4 (October 1979), pp. 357-72

2. Gaston and Henri were half-brothers. The collection consists of 43 letters: 17 from Adolphe, dated from May 1868 to July 1876, with an undated letter apparently written late in 1867; 10 letters from Gaston dated May 1869 to August 1879; 16 letters from Henri, undated but pertaining to events between 1869 and 1871. The quotations from the letters have been translated by me.

3. Pierre Tyl, *Adolphe Braun, photographe mulhousien, 1812-1877*, Mémoire de Maîtrise, University of Strasbourg, 1982.

4. Charles Baudelaire, "La Public Moderne et la Photographie," in *Oeuvre Complêtes* (Paris, 1961), p. 1035 (my translation).

5. See Francis Wey, "Des progrès et de l'avenir de la Photographie," *La Lumière*, 1 (1851), pp. 138-139.

6. "Extrait des Raports du Jury Mixte International de l'Exposition Universelle," *La Lumière*, 7 (May 1857); P. Burty, "Exposition de la Société Française de Photographie," *Gazette des Beaux Arts*, 2 (May 15, 1859), pp. 210, 218-219.

7. Isabelle Jammes, *Blanquart-Evrard et les Origines de l'Edition Photographique Française* (Geneva, 1981), pp. 11, 124.

8. The process bears the name of its inventor, Walter B. Woodbury, a British photographer who took out a patent in 1864 for producing photographic prints using gelatine reliefs and metal intaglio molds.

9. Henri, living in Paris where he pursued a career as a painter until asked by Adolphe in 1870 to supervise the art reproduction aspect of the work at Dornach, appears to have been in actual contact with Saint-Victor, accompanying him to the theatre on a number of occasions.

10. Tyl, pp. 108, 115. As stated in *Le Moniteur de la photographie*, August 15, 1866, the reason advanced for not allowing photography was to save the works of art and the actual physical premises from careless operators who spilled corrosive substances on the floors and stairways.

11. Francis Wey, "De l'Influence de l'Héliographe Sur les Beaux Arts," *La Lumière*, 1 (1851), pp. 2-3, 6-7. Reprinted in Heinz Buddemeier, *Panorama, Diorama, Photographie* (Munich, 1970), pp. 258-66.

12. Tyl, p. 119 (my translation).

13. Paul de Saint-Victor, *Introduction au catalogue général de la maison Ad. Braun et cie*, 1880.

14. Information regarding sizes, prices and distribution of the art reproductions is given in Tyl, pp. 123-124.

The Grand View in England:
Worcester Cathedral from the Southwest

Michael Hallett

The depiction of the "grand view" in the nineteenth century was the domain of painters and engravers until after the public announcement of the invention of photography in 1839. To some extent, Paul Delaroche's comment on seeing an early daguerreotype that "from today painting is dead" becomes a reality within this context. In mid-Victorian England there was a move away from the precision and artistic license of the engraving to the truth and reality of the photographic print. The effect was to popularize the "grand view," be it a traditional English pastoral scene evoked by an English artist such as Constable, the amazing man-made structures of the sphinx and the great pyramids in Egypt, or the breath-taking natural splendor of the American West. Worcester Cathedral from the southwest is just one such "grand view," with a pedigree of visual analysis through drawing, engraving and painting to photography.

The River Severn meanders its way through the old County of Worcestershire in a north to south direction. The city of Worcester is mainly situated on the east bank of the river in the center of the county and is dominated by its Cathedral. Started in 1084, the present Cathedral is a double cross in plan, with a central tower at the intersection of the nave and transepts. Pevsner comments that "Worcester Cathedral from the west, looking across the Severn, is a superb sight. Looking from the east is out of the question now that the new road and roundabout have

removed all peace. The Cathedral lacks a real precinct. Ever since 1794 when a road was cut through its northeast angle, it has lost its seclusion."[1]

There are three distinct views of the Cathedral from what could be considered the southwest and all three can normally be seen from the west side of the river. The long view from the south-southwest, due to a bend in the river, will show sides of the river. A slight variation of this view can be seen from Diglis Fields on the east side of the river. The more popular middle view from Payne's Meadow will show the west bank, probably with a fence and gate in the foreground, as well as the east bank of the river with the Cathedral. The close view, again from Payne's Meadow, will show only the Cathedral, the east bank and the river.

Valentine Green's 1764 engraving [Figure 1] of Worcester viewed from the west, showing the 1313 bridge, is arguably the most famous depiction of the city. It shows landmarks which are of significance to the view under discussion. The tower towards the left of the skyline is All Saints Church, considered "a fine introduction to Worcester, as one crosses the bridge from the Welsh side" with the current structure built in 1739-1745. The large spire that dominates the city belongs to St. Andrew's Church. The church was first built in the twelfth century, the tower in the fifteenth century and the spire rebuilt in 1751. It is known locally as the "Glover's Needle," due no doubt to its shape and to Worcester's

Figure 1. Valentine Green, "Worcester Viewed from the West," 1764. Engraving, published in Valentine Green's "A Survey of the City of Worcester" (1764). From the author's collection.

Figure 2. J. M. W. Turner, "Worcester, Worcestershire." Copper engraving, 247 mm x 163 mm. Published in "Picturesque Views in England and Wales" in 1836. From the author's collection.

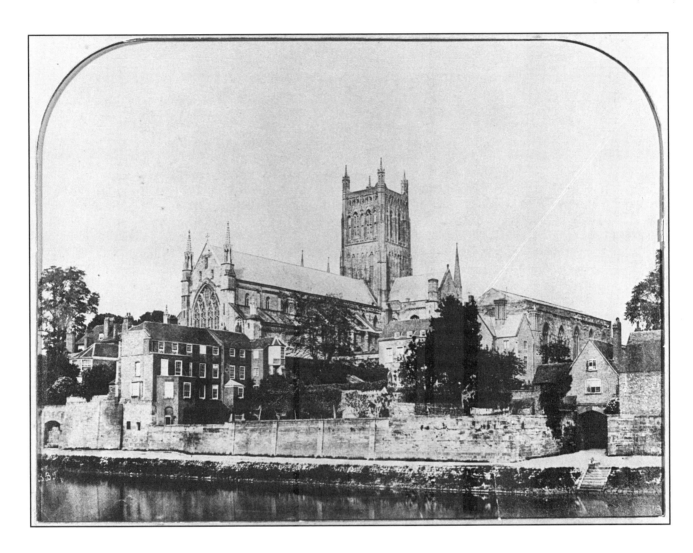

Figure 3. Anonymous, "Worcester Cathedral from the south west," pre-1864. Dyson Perrins Museum, Worcester.

association with the glovemaking industry. The tower immediately to the left of the Cathedral is St. Michael's Church, which was demolished in 1840. The eighty-foot mound to the right of the Cathedral is Castle Hill, which was leveled by Mr. Eaton, a bookseller, between 1833 and 1848. The Severn is shown as an industrial waterway; since the late sixteenth century generations of the Severn trow have carried agricultural products, salt, and coal up and down the river.

A copper engraving by T. Jeavons from a drawing of Worcester by J. M. W. Turner [1775-1851] [Figure 2] shows, with considerable artistic license, the Cathedral towering over a river scene.[2] The relationships between the Cathedral, the tower of All Saints' Church, and the spire of St. Andrew's Church are somewhat inaccurate. Neither do the trees on the west bank correspond to other illustrations.

One of the earliest surviving photographs of the Cathedral is the pre-1865 photograph showing the Cathedral prior to the Victorian Restoration [Figure 3].[3] It shows the west window before replacement in 1865, the earlier Cathedral tower and the prebendal house built upon the area of the monastic Rere-dorter. The prebendal house nearest the river was itself demolished in 1872.

Three of Britain's most prominent nineteenth-century topographical photographers, Francis Bedford, Francis Frith and Sir J. Benjamin Stone, photographed Worcester Cathedral from the southwest towards the latter part of the century. These three major collections are now held in one place through their ownership by the Birmingham Public Libraries.

Francis Bedford [1816-1894] began to practice photography by 1853, in which year he exhibited at the Photographic Society of London's first exhibition. His work, which concentrated on the architecture and landscape of Britain, was held in very high repute by his contemporaries and was widely published. In 1862 he took photographs of Palestine, Syria, Constantinople, Athens, and the Mediterranean islands. An unusual feature of the photographs was the inclusion of clouds which Bedford achieved not, as many thought, by painting on the negatives but by overlaying a second negative. Between 1864 and 1868 Bedford published, through Catherall and Prichard of Chester, photographic views of north Wales, Tenby, Exeter, Torquay, Warwickshire, and Stratford-upon-Avon, as well as a stereoscopic series, "English Scenery." By 1867 Bedford's son William [1846-1893] had assumed much of the operation of the family photography business, and many prints of this later period are more likely to be William Bedford's than his father's.

Of Bedford's work, Ovenden observes, "The soft caressing tone of the prints, the unassuming nature of pastoral life is seldom bettered in Victorian photography. Bedford's photographs illustrate what is perhaps one of the most important qualities in Pre-Raphaelite art, the harmonious existence of the natural and the human world."[4] Bartram suggests that "his views often, though by no means always, fit into the conventions of landscape painting with the placing of the figures and the 'correct' viewpoint. Overall he was the most proficient topographical photographer of the Victorian period."[5]

Francis Bedford's photograph of Worcester Cathedral and the River Severn of ca. 1892 [Figure 4] is a long view almost identical to a view taken by Frith in 1891. Bedford also took the middle view on the same occasion. A particular advantage of Bedford's long view is that it shows the relative positioning of the fences and gates on the west bank, as well as St. Andrew's Church and All Saints Church in relation to the factory sites on the east bank, north of the Cathedral.

Francis Frith [1822-1892] was certainly one of the great pioneer photographers of the mid-Victorian age. In the 1850s he travelled extensively with a camera, particularly in Egypt and Palestine. On his third expedition to Egypt in the summer of 1859 he reached the Sixth Cataract of the Nile. In 1860 he established a photographic business, F. Frith and Co., in Reigate, Surrey. Here he exploited the photographs of his Eastern travels, both in print sales and in book form, and also photographed many large mansions throughout England. He soon evolved his grand plan to produce a photographic record of the British Isles. This proved successful and by 1865 Francis Frith & Co. had become one of the largest photographic publishers in the world. As a publisher, Frith himself could not take photographs of every town and village so he employed "assistants" to take many of the photographs under his strict supervision. It is probable that within the Frith collection of photographs are examples of the work of many of the leading photographers of the day, including Francis Bedford, James Mudd, Walter Pouncy, and Frank Meadow Sutcliffe.

The most well-known of the Frith photographs of Worcester Cathedral were taken in 1891, and there are four prints from this period.[6] Of these early negatives, number 29298 is the most reproduced [Figure 5]. It shows the middle view with the fence and gate on the west bank almost obscuring the river. By 1885, Francis Frith had become increasingly involved in painting, poetry and philosophy and the business was managed by his son Eustace. In all

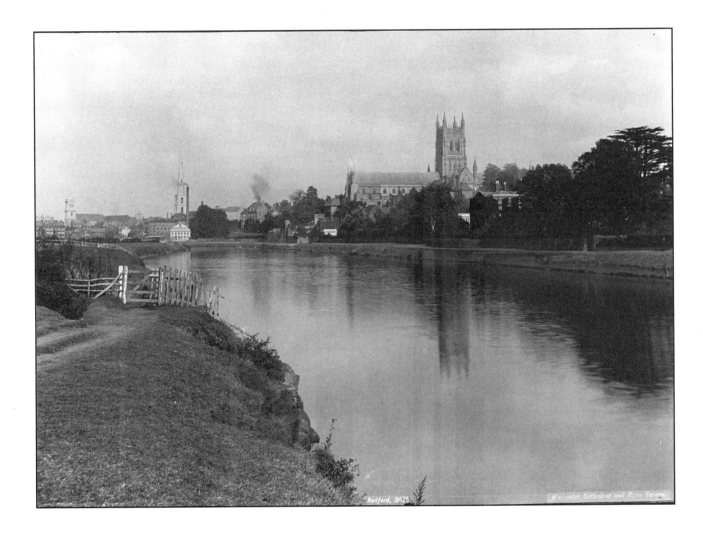

Figure 4. Francis Bedford, "Worcester Cathedral and River Severn," ca. 1892. From the original 10 x 12 inch negative. Birmingham Public Libraries.

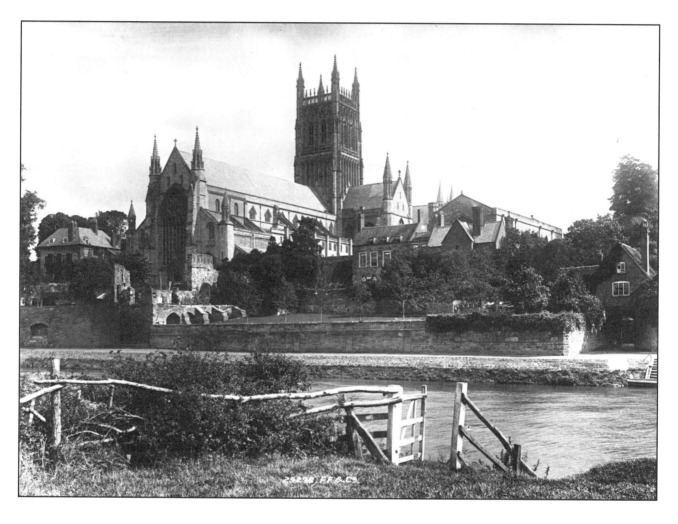

Figure 5. Francis Frith, "Worcester Cathedral, S.W.," 1891. From the original negative. Birmingham Public Libraries.

Figure 6. Thomas Bennett & Sons, "Worcester Cathedral from the south west," 1890s negative. Photographic postcard, ca. 1904. 140 mm x 87 mm. From the author's collection.

probability this photograph was taken by a local Worcester photographer, the most likely being T. J. Bennett of the firm Thomas Bennett and Sons. In advertising the opening of the new studio at 8 Broad Street, Worcester, in 1879, T. J. Bennett "hopes for a continuance of the patronage so liberally accorded to his late father...." It continues to promote "Landscapes and Architectural Photography, embracing views of Mansions, Churches, Schools, Gardens, Groups....[and] a large assortment of Cathedral and Local Views [as well as] Portraits of Celebrities."[7] Thomas Bennett and Sons also produced their own range of photographic postcards, distinct from reproductions of photographs, which includes a long view of the Cathedral [Figure 6].

Sir J. Benjamin Stone [1838-1914], called affectionately the "Knight of the Camera,"[8] was perhaps Britain's best-known late nineteenth-century amateur photographer. As a Birmingham business man, he became known as a slightly eccentric member of parliament more interested in photography than politics. As president of the Birmingham Photographic Society, he was elected in 1890 president of the Warwickshire Photographic Record. In 1897 the National Photographic Record Association was formed with Stone as its one and only president.[9] The purpose of the Association was to bring "together an important and truly national photographic record of all existing objects of interest as well as scenery, life, customs and history of time."

Throughout the life of the National Photographic Record Association, Stone was the largest contributor to the Collection, having produced over half the total 4,476 prints.

Stone's photographs were always taken with the same intent: "to show those who will follow us, not only our buildings, but our everyday life, our manners, and customs. Briefly I have aimed at recording history with the camera, which, I think, is the best way of recording it." He believed that "pictures should have explanatory notes to make them intelligible, for however good the pictures may be in themselves, they will be more valuable if used in conjunction with literary matter, condensed as much as possible, and of a perfectly reliable character."

Stone's photograph of "Worcester Cathedral from across the Severn," of 1899 [Figure 7] is unusual in that it extends the foreground interest with a lady at the gate on the west side of the river. Technically the print is undistinguished, Stone having some difficulty with the covering power of his lens, which is emphasized by his attempt to use camera movements to retain the vertical lines of the Cathedral. Stone's choice of lighting is not sympathetic to the Cathedral, supporting the suggestion that he was more interested in a mere record.

There were three events in the nineteenth century that led to the popularization of the topographical or picture postcard: the extension of the railway system in Britain,[10] the establishment of the Bank Holiday following the passing of the Bank Holiday Act of 1871, and the introduction of the cheap postal rate for the photographic postcard in 1894. The first two events led to the British holiday or "day out," and the third towards the viability of the photographic postcard as a souvenir of the occasion. In the editorial of the first edition of *Picture Postcard Magazine* in July 1900 the following observations were made: "Ostensibly but a mere miniature view of some town or place of interest to the passing traveller, a picture postcard is yet capable of possessing an interest and significance undreamed of by those who have not yet troubled to look into the matter."

On 1 September 1894 the British Post Office allowed private postcards to be printed and used with a halfpenny adhesive stamp. They were for "Inland Use" only and the first picture cards appear to be on the "court" size of card [115 mm x 89 mm]. It was not until 1897 that the first artistic designs, as distinct from views, began to appear and included the design of such artists as Mucha, Cassiers and Kirchner. From 1 November 1899, British-made cards of the Postal Union size [140 mm x 89 mm], which previously were available only on the Continent, provided a size of

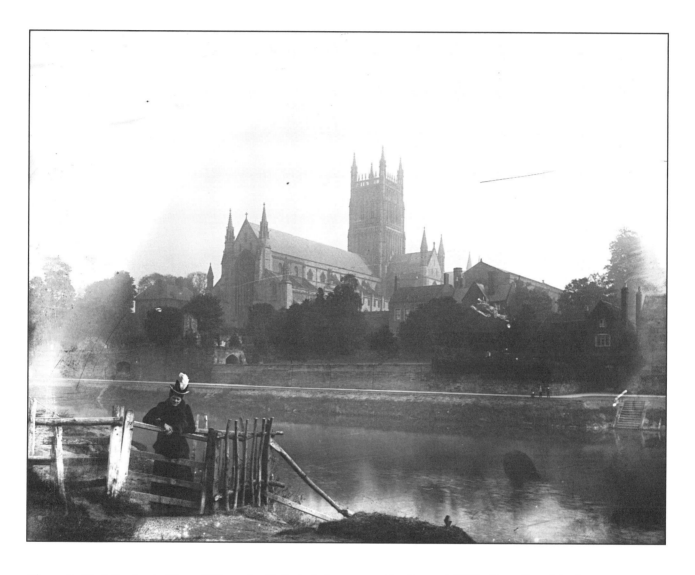

Figure 7. Sir J. Benjamin Stone, "Worcester Cathedral, from across the Severn," 1899. From the original 6 1/2" x 8 1/2" negative. Birmingham Public Libraries.

card more suitable for the picture postcard. Raphael Tuck & Sons published immediately the first photographic picture postcard. By the middle of 1900 the following firms were among those manufacturing picture postcards in Britain: the London Stereoscopic Company, Ellis & Wallery, C. W. Faulkner & Co., Beeching Ltd. [of the Strand], the Collectors' Publishing Co., the Picture Postcard Co., and F. Frith & Co. This signalled the beginning of the "Golden Age" of the postcard in Britain which was to last until the postal rate for postcards was raised to one penny on 3 June 1918.

The 1891 Frith version of Worcester Cathedral from the southwest has been published and republished in the "Frith Series" of postcards. It was published initially in the traditional manner of a photograph bled on all four sides, in sepia with the inscription "Worcester Cathedral, S.W." reversed out in the bottom left-hand corner, the reverse side of the card having a "divided back" with room for a communication on the left and the address on the right. This would indicate that while the photograph was taken in 1891, Frith was using the view as current from 1902 onwards. A certain amount of retouching has taken place with the straight lines of the Cathedral itself being accentuated. A later version, with heavy outlining on the Cathedral, has been tinted over the sepia base, with greens and yellows for the shrubs and trees, reds for the brickwork and blues for the Cathedral roof and sky.

Raphael Tuck & Sons were well-established art publishers to Queen Victoria prior to publishing their first postcards in 1899. They published a postcard in their "Oilette" series of cards, available in 1906, based on a fairly accurate representation of a postcard from the 1891 Frith version [Figure 8]. The exception is the extension of the pinnacles giving incorrect proportions to the tower, so providing a more stylized romantic notion of the Cathedral. The term "Oilette" is defined on the original packets containing sets of Tuck's cards: "'Oilettes,'" well termed 'The Aristocrats of Picture Postcards,' are reproduced in colours direct from the Original Paintings, the subject embracing practically every range." The only variation in the painting is a woman with basket and child on the towpath on the Cathedral side of the river.

Like Tuck's, Valentine & Sons, Dundee, also produced Christmas and other greeting cards in mid-Victorian times. Their main achievement was their comprehensive range of photographed view cards covering the entire British Isles. Their view of the Cathedral from the southwest, ca. 1897 [Figure 9], was reproduced in several guises, with more than one

Figure 8. Anonymous, "Worcester Cathedral," ca. 1906. Raphael Tuck & Sons "Oilette" postcard no. 7517. 140 mm x 89 mm. From the author's collection.

negative being reproduced from what appears to be the same photographic occasion. The postcards, all after 1904, include a card using the full image of the original negative and realistically colored. A lush green is used for the trees, and grass on both banks, a sand color for the masonry of the Cathedral, and red for the brickwork. A slate blue is used for the roof, and the sky graduates upward from pink to pale blue indicating a sunset in the northeast. Another is a lightly colored version but bled on all four sides. A similar coloring treatment on yet another card has the photograph in an oval, with a hop branch spreading from bottom left to top right and behind the oval. The city was the center of a major hop-producing county, with seven breweries and several pubs that brewed their own beer around 1900. It was not uncommon for the hop motif to be used in this way as it was popular with many itinerant workers in the industry to send such postcards home.

Other publishers of this photographic view during the "Golden Age" were E. E. Barrow, Foregate Street, Worcester; Harvey Barton & Son, Bristol; Burrow, Cheltenham; the "Celesque" series by the Photochrome Company, London and Tunbridge Wells; the Fine Art and Photographic Depot, the Commandery, Worcester; S. Hildesheimer & Company, London and Manchester; the JAY EM JAY series of Jackson & Son, Grimsby; Milton, London; the "Peacock Brand" produced by the Pictorial Stationery Company, London; J. Salmon, Sevenoaks; and the

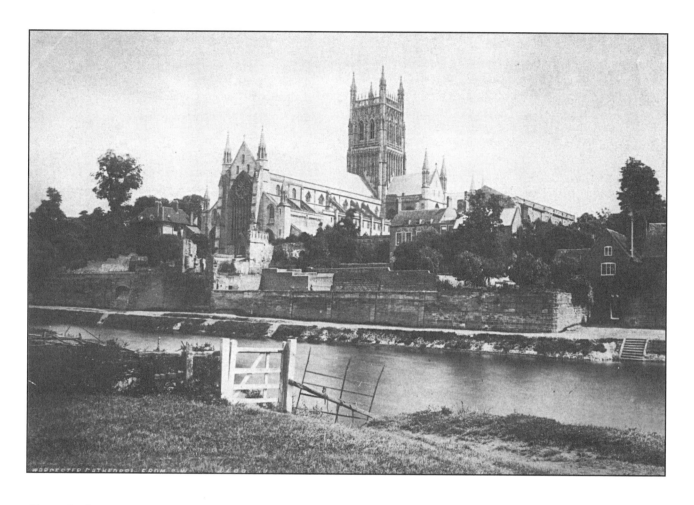

Figure 9. "Worcester Cathedral from S.W.," JV [John Valentine], ca. 1897. Albumen print. This is numbered 4499, with the alternative negative numbered 4561. 201 mm x 132 mm. From the author's collection.

"Orthochrome" series of A. & G. Taylor, London.

Since the planting of two avenues of trees on each side of the river around the turn of the century the "grand view" of the Cathedral has become partially obscured and an alternative view from the northwest has become popular. However, with the renewed interest in old photographs in Britain, the republication by The Francis Frith Collection of the 1891 Frith version of the Cathedral from the southwest has made this original view available again.

REFERENCES

1. Nikolaus Pevsner, *The Buildings of England: Worcestershire* (Harmondsworth: Penguin Books, 1968), p. 295.

2. Published in *Picturesque Views in England and Wales* (London: Longman & Co., 1836).

3. The west front is almost entirely Victorian. The west window is of 1865, but traces of the north and south doorways and part of the doorway arch are original. The major structural undertaking after 1864 was the restoration of the tower. Early nineteenth-century illustrations show a level parapet with a curved return to the corner turrets. The new design, announced in 1866, raised the parapet by two feet and pinnacles by seven feet.

4. Graham Ovenden, *Pre-Raphaelite Photography* (London: Academy Editions, 1972), p. 17.

5. Michael Bartram, *The Preraphaelite Camera: Aspects of Victorian Photography* (London: Weidenfeld & Nicholson, 1985), p. 182.

6. The numerical sequencing for the four prints of the 1891 period is 29298, 29299, 29301, and 29883. A later series of photographs, 73748-50, are from the post-1914 period.

7. *Littlebury's Directory of Worcester and District for 1879* (Worcester: Littlebury & Co., 1879).

8. For biographical information on Sir J. Benjamin Stone see, S. Roberts, "Knight of the Camera: Further Aspects of the Life of Sir Benjamin Stone, 1838-1914," manuscript document, 1980, Sutton Coldfield Library.

9. While Stone was president of both the Warwickshire and the National Photographic Record Associations, credit for the guidelines and methodology of the survey movements should be attributed to the Birmingham amateur photographer, W. Jerome Harrison.

10. The railway eventually came to Worcester in 1850 with the connecting of the Oxford, Worcester and Wolverhampton line. By 1870 the railways had almost completely taken over from the stage coach and mail coach as the method for long-distance travel and transporting mail.

ACKNOWLEDGEMENTS

The author would like to acknowledge assistance in the preparation of this paper from the following individuals and institutions, including, in some cases, the use of their copyright illustrations: Philip Allen, Birmingham Public Libraries, Harold Bradley, Maxine Bullock, John Buck, R. J. Collins, Michael Craze, Dyson Perrins Museum, Canon Jeffery Fenwick, Hereford & Worcester County Record Office, the Local Studies Library of Worcester City Library, Gladys Keighley, and the Worcester City Museum and Art Gallery.

A Quiet Nook for these Practical Days

Lee Fontanella

In the present article I focus on *Views in Wales. The Vale of Neath*, an album/book of mounted photographs by R. P. Napper. It bears no date. At the base of every page on which the photographs appear, we find "Photographed by the British and Foreign Portrait Company." The photographs, albumen prints from glass-plate negatives, measure an average 15.4 x 20.6 cm., and pages measure 37.3 x 27.6 cm. The bindery affixed the following seal: "W. Whittington, General Stationer. Printer, Bookbinder, and Machine Ruler, Post Office, Neath. Account Books. Made to Order. On the Premises." An advertising sheet, apparently prepared by Napper, was inserted at the end of the album/book. This does not bear the name of the aforementioned photographic company; in fact, it advises that "all communications may be addressed to R. P. Napper, Neath, Glamorgan." A letter written by Napper in 1864 bears the inside address of Newport, Monmouthshire; however, the fact of the advertisement's remittance address, combined with the binder's address, leads me to suspect that Napper wrote his letter in Newport, but was more strictly speaking a resident of Neath. I shall discuss this advertisement, Napper's letter, the probable date of the photographs, and the contents of the publication in the course of the present article.

There are thirteen photographs, and they appear in the following order, in the album/book I refer to here: "The Holly-Bush Tower" (title page), "The Cave —

Porth yr Ogof, Upper Clyn Gwyn," "The Middle Clyn Gwyn," "The Lower Clyn Gwyn," "The Dinas Rock — Craig y Dinas," "The Stone Bow — Bwa Maen," "The Dinas Cascade," "The Corbwll," "The Ladies' Fall — Yscwd Gwladis," "The Upper Scwd Ddwlu (bis)," "Napper's Glen." Only one of these ("The Ladies' Fall") [Figure 1] has a human figure in it, and two of them are different views of the same site ("The Upper Scwd Ddwlu"). I base a couple of fundamental claims in my article on the arrangement of these photographs as it is for the copy that I am using.[1]

The album/book is both photographic and literary, and without this understanding from the start, the meaning of the publication is distorted. I interpret the publication as being in the tradition of Thomas Pennant's *Tours in Wales*, I-III (London, 1810) and the publication of Henry Gastineau's views of Wales, which I address in the article. Both of these are, largely, publications pertaining to the lettered tradition, although they do contain engravings. Gastineau, in particular, was well known for his marvelous drawings of sites in Great Britain. [Figure 2] In his publications, the visual aspect gains in importance above that which it has in the Pennant volumes, although in Gastineau, the lettered tradition is still noticeably strong. I include samples of each, in an effort to illustrate the accomplishments of Gastineau over Pennant's sketch artist (Moses Griffith) and engraver (W. Angus) [Figure 3], and to

Figure 1: R. P. Napper, "The Ladies' Fall—Yscwd Gwladis," 20.6 x 15.4 cm. From "Views in Wales. The Vale of Neath."

hint at the approximation of Gastineau's prephotographic work to photography. Gastineau was not exclusively concerned with the Neath area, as Napper was in the album/book which interests us here, and Pennant dealt with North Wales.

Very little is known of R. P. Napper apart from his uneasy relationship with the Francis Frith of Reigate photographic firm (established by 1860). The few details I have are mostly derived from a brief manuscript letter written by Napper on May 29, 1864, to Ysidro de las Cajigas, who must have been an acquaintance of Antonio María Felipe Luis de Orléans, Duque de Montpensier (1824-1890). A resident of Sevilla and brother-in-law to Spain's Queen Isabel II, Montpensier was patron of several of the earliest photographers in Sevilla. It is no wonder at all that Napper should have focused on

Montpensier as one of his clients of greatest potential. In fact, the Vale of Neath album/book on which I base the present article was #263 in the library of the Duque and still bears his familiar, crowned sticker with numbering, and his *ex libris* book plate with "Antoine d'Orléans."

A close look at Napper's letter and at certain aspects of the Vale of Neath album/book allows us to determine quite well what Napper was up to, in terms of photographic undertakings and commerce. It is getting at the Napper issue from the back door, admittedly, but legitimately for his case. Also, the advertisement which was inserted in the back cover [Figure 4] is revealing about the chronology of Napper's work, just as his letter is about his motives. According to the advertisement, he was publishing, or had already published, Andalusian views when the Wales album/book reached Montpensier in Sevilla: "Now publishing, 'Napper's Views in Spain — Andalusia'...." It is hard to tell for certain whether Napper carried an already prepared Wales album to Montpensier when he went to Spain, or whether he shipped one to the Duque from Great Britain, with the advertisement, after he had had dealings with him or his acquaintances. Weighing all the facts which I have at hand, I suspect that Napper first made his Andalusian views and returned with them to Neath (or to Newport, Monmouthshire, from which place he wrote to Cajigas). I further suspect that Napper then made an initial set of views in Wales and that he used this work in three commercial ways: most obviously, to recoup the expenses involved in it; to announce four more suites on Wales which he said he was preparing; and, possibly, to recoup expenses in Andalucia, by calling attention to the Andalusian views as well as to the Welsh suites to come, all of which appear in the aforementioned advertisement.[2] He intended — at least with the last of the Welsh suites — to appeal to the self-pride of the landed gentry, much in the same way he was appealing to Montpensier in Sevilla, when he included the Duque's palace as one of the Andalusian views, and made over half of these in the Duque's own Sevilla. Would this have amounted to a work along the lines of Burke's *Guide to Country Houses*?

Napper announced to Cajigas the availability of seventy-one Andalusian views. His letter tells us in no uncertain terms that he had had a falling out with Frith, and that he was no longer associated with that company: "You will no doubt have been surprised at the long delay that has occured [sic] in bringing out my Spanish views. I have lately taken the whole affair into my own hands and Mr. Frith of Reigate has now nothing to do with it." Napper knew that the

Figure 2: Henry Gastineau's drawing of "Craig y Dinas, Breconshire," taken from "South Wales Illustrated in a Series of Views," 1829.

Duque wanted "2 copies of the volumes [of Andalusian views] bound up handsomely," and he proposed to Cajigas that their availability be made known to Montpensier. He would charge "considerably less than what Mr. Frith charged" for his photographs. He was willing to forward all these views for selection, or else make the selection himself and then have them bound. It is a fact that the Montpensier collection did contain many unbound copies of Napper's Andalusian views — and more than a single copy of some — so we may safely assume that Napper heard from Cajigas, then forwarded views for selection, which were never in fact found.

Probably, by the time of the hypothetical reply from Sevilla, Napper had made his Vale of Neath views and sent this suite along with the Andalusian views to Montpensier. If these speculations are correct, the Vale of Neath suite was probably made in late summer of 1863 or spring of 1864. Napper cautioned

in his announcement of the "Mansions..." series: "Many Houses are better Photographed in Winter, especially those much hidden by trees, and where the foliage does not form an essential part of the Picture." He may have planned to work on the Mansions series in winter 1864.

The more accomplished technique of the Vale of Neath views would lead us to suspect that they followed chronologically those made in Andalucia, although this cannot constitute the whole reason for that suspicion. In the Introduction to the Vale of Neath views, Napper claimed that he had "travelled in the 'five quarters' of the Globe," another reason to suspect that Andalucia might have antedated Wales. I think we can venture that Napper had served as a photographic envoy for Frith in Spain — probably on Frith's second (November 1857-May 1858) or third (summer 1859-1860) trip to the Middle East — and that Napper was eventually unsuccessful in representing Frith stylistically and/or technically; for

Figure 3: Moses Griffith's drawing of "Pistill Cain" (engr. W. Angus), June 1, 1810, from Thomas Pennant, "Tours in Wales," vol. 2 (1829).

Figure 4: R. P. Napper's advertising sheet, inserted between last page and back cover of "Views in Wales. The Vale of Neath."

Figure 5: R. P. Napper, "Napper's Glen," 15.4 x 20.6 cm. From "Views in Wales. The Vale of Neath."

Figure 6: R. P. Napper, "The Dinas Rock — Craig y Dinas," 15.3 x 20.5 cm. From "Views in Wales. The Vale of Neath."

Figure 7: R. P. Napper, "The Upper Scwd Ddwlu," 15.4 x 20.6 cm. From "Views in Wales. The Vale of Neath."

the Andalusian views are not exactly what we are used to getting in Frith's Series views. They are not usually of the 7 x 9 inch dimensions, not as toned, not as clear, and their subject matter is often less scenic and more peopled.[3] What is sure is that Frith distributed views made in his more customary format, style, and technique, of at least the following sites on the peninsula: Gibraltar, Granada, Sevilla, Málaga, Burgos, Tarragona, Toledo, Córdoba, Barcelona, San Sebastián — maybe also of Gerona and Avila.[4] I certainly believe that Napper did not work in all of these places, by any means, although we know he worked in Sevilla, Granada, and Gibraltar, according to his list of Andalusian views. Might he not have been one of those companions of Frith mentioned by Julia van Haaften in her presentation of Frith's works, those companions spoken of by Frith but never identified?[5] Perhaps Napper went ashore in Gibraltar and headed for Granada and Sevilla, where he found one of Spain's most eager, wealthy patrons of photography: namely, Montpensier, thirty-three years old — if Napper went ashore in late 1857, early in Frith's second trip.

Difficult dealings with Frith, who may have rejected Napper's Andalusian works, could have led to Napper's eventual obsessive devotion to Wales. The Vale of Neath, for example, becomes the best corner of the world, to judge by Napper's Introduction. From his third-person stance: "...nowhere has he met with so much beauty, in woods, falls, and glens, as in the Vale of Neath...." The Neath project might have signified his withdrawal from those "five quarters" and an assertive recognition of more familiar ground. If we believe that the British and Foreign Portrait Company was Napper's way of escaping commercial differences with Frith, we must recognize coincidentally that Napper's own commercialism continued to show through: in his solicitation, via Cajigas, to Montpensier; in his proposed photography of "Mansions" and "Country Seats" for "Gentlemen," who could procure views of their own and "their Friends' Residences" — a shrewd ploy which was in keeping with the royal patronage he must have witnessed in the thriving photographic atmosphere which surrounded the number-one citizen of Sevilla.

Napper's successful reversion to a little corner of the world has great significance. At the moment when it occurred it could have been interpreted as if in contrast to the broad, internationally oriented vision of Frith. More importantly, perhaps, it defined Napper as a claimant of the temporal present and the spatially immediate; he seemed less prone than so many of his contemporaries (Frith included) to discovering and reclaiming the past.

Attitudinally, Napper is a remnant of the Wordsworthian stance, not akin to latter-nineteenth-century internationalism. As such, he seems to herald that poetic nostalgia for hearth and home, which would become so natural among British poets of the First World War. His vision is narrowed, with a purpose, to little spots of earth, blessed by the suns of home and washed by her rivers — so to speak — rather than persistently embracing the vision of foreign fields. Thus, Napper could be interpreted as renegade from foreign adventure, back to the circumscribed and humble. His philosophical position echoes centuries of metaphors which proclaim the paradox of the great in the small, the sublime in the earthly, the noble in the humble. The waterfalls in the Vale of Neath "are not grand and imposing to the extent of an American or a Norwegian cataract; but they are more lovely, and better suited to please the lover of Nature." He echoes the early seventeenth-century (English) paradox "in little, comprehending much," which later translated more practically into Thoreau's observations of woodsy minutiae, or into William Cullen Bryant's "various language" of earthly Nature. Napper claims that one cannot "find anywhere so comparatively small a district so full of varied and beautiful scenery as the Vale of Neath. The lover of the picturesque will here meet it in every form."

None of this seems to ring of the bold, international commercialism of Frith, although it may have become a factor of Frith's quieter years.[6] It is, instead, reminiscent of the Wordsworthian mode, so it is fitting that Napper closed his suite with a quotation from Wordsworth. The quotation accompanies Napper's most personalized view ("Napper's Glen"), and in the album/book I use, it closes the book: "...full many a spot/ Of hidden beauty have I chanced to espy/ Among the mountains; never one like this;/ So lonesome, and so perfectly secure:/...." [Figure 5] The withdrawal to this Glen is a withdrawal into integrity, as much as it is an escape from the world's trials. It ends Napper's peripatetic observations, recollections, and musings, and it culminates in the Romantic Sublime: "...Far and near/ We have an image of the pristine earth/ The planet in its nakedness;..." In this final way, Napper *becomes* a Wordsworth; a Wordsworth of *The Prelude*, who grows philosophically and spiritually, as a result of a peripatetic, vital experience, with occasional visions of the sublime, as well as others of more mundane and negative value.

Napper, who has employed literary quotations in all of his texts in order to define his own experience, knows very well how he uses Wordsworth. He is

laying claim to Arcadia prior to its disappearance. That is why, in "this quiet nook" that is "Napper's Glen," it is worth taking note of "a squirrel [who] came up to within a foot or two of the camera, while the Artist was taking this view, and appeared not to be at all alarmed by the intrusion of a visitor."[7] Similarly, Wordsworth might have rejected the bustle of London and Cambridge or spurned revolutionary melees in Paris:

> It could not be more quiet: peace is here
> Or nowhere; days unruffled by the gale
> Of public news or private; years that pass
> Forgetfully; uncalled upon to pay
> The common penalties of mortal life,
> Sickness, or accident, or grief, or pain.

With these verses, specifically, Napper closed. He had expressed regret for a vanishing Arcadia on the occasion of at least three other views: "Dinas Rock — Craig y Dinas," [Figure 6] "The Stone Bow — Bwa Maen," and "The Dinas Cascade." In the first instance, he recognized that the quarrying of the Rock "has been a great advantage to the valley," commercially speaking, but "the quarries are destroying the grey and ivy-covered precipice, and changing the grandeur of its haughty beauty of strength to the lowly and unobtrusive beauty of usefulness." He found consolation in the fact that the destruction would take many generations, at the rate it was going. But the crude rails are there in the photograph, leading out from quarried Dinas Rock, as a threat to the Rock's permanence; in this sense, our historical perspective substantiates and enriches Napper's view. In the next instance ("The Stone Bow"), Napper fantasized a "preadamite" scene: "Who can say what strange preadamite creatures have crawled over it, or lived in the cave beneath it? Their dull, unspeculative eyes imaged this Bow of Stone long ages before the eye of man was blessed by the heavenly vision of the Bow of Promise." An unfortunately ingenuous Napper — victim, in a way, of the fatuous mentality of his industrial, progressivist, Darwinian times—saw cavemen as slow and unintelligent, at least lacking Romantic imagination. Nevertheless, the artistic conceit resulting from his lament is the best in the album/book: the cave dwellers of Stone Bow at some point invented the object (the bow) for which the site was named, although the site's geological formation was prior to the invention of the bow; Stone Bow already has lasted beyond the object for which it was named, because "villainous saltpetre" displaced the bow; may Stone Bow never meet the fate of its displaced, but historically accidental namesake.

Historically speaking, Napper was born a child of antithetical Romantic fantasy and scientific practicality. Fortunately for us, he never abandoned one mode while espousing the other. I contend, in fact, that he reverted to Romantic fantasy. The third of the examples mentioned above ("The Dinas Cascade") indicates why. Napper, here, is enchanted by the tale of an old guide, now deceased, who told of fairies on little white horses. "But although [the fairies] were visible no longer, [the old guide] had a thorough belief in their existence, very refreshing to meet with in these practical days, when very often seeing even is not believing." There is a terrible irony here: Napper, as sufferer of "these practical days," is also the professional and artistic heir to them. He is born into a world of technological photographic potential, where it is, of course, a bit surprising that "seeing even is not believing." Yet, that conviction makes him the very kind of photographer that he is. As he says in the text to "The Middle Clyn Gwyn": "The Photographer must copy Nature as he finds her, and cannot compete with the Painter, who may often 'snatch a grace beyond the reach of (Photographic) art.'" We must not confuse the issues. The willing romanticizer of literature was not the willing photographic pictorialist. His stance defines him within a growing photographic polemic of the day, while it makes him appear equivocal in his desire to find a difficult juncture between personalized visual nostalgia and commercial realism.

On second glance, Napper's intellectual inheritance of an atmosphere of "these practical days" was in evidence all around Neath, except, perhaps, in the Vale of Neath, the more specific location of Napper's wanderings. As early as Henry Gastineau's scenic drawings, the area just southwest of Neath is a "region of furnaces."[8] George Borrow, as might be expected, showed no mercy in his description of the same area: " ... almost every object looked awfully grimy"; "grimy diabolical-looking buildings"; "huge heaps of cinders and black rubbish"; "a horrid filthy place, part of which was swamp and part pool: the pool black as soot, and the swamp of a disgusting leaden color."[9] For Borrow, the area southwest of Neath, geographically opposite, but not distant from, the Vale of Neath, was "a singular mixture of nature and art, of the voices of birds and the clanking of chains, of the mists of heaven and the smoke of furnaces." In Borrow's literature, we begin to appreciate the contrast between "these practical days" and the Vale: furnace smoke and heavenly mists; chains clanking and birds' voices. Even the 1922 *Blue Guide* for Wales could not be kind to Neath or to Neath Abbey (of whose condition no traveler was fully tolerant, even a century before).[10] Neath was

"wholly given up to the coal, iron, and copper industries," but "is itself not unpicturesque." The Abbey was "somewhat smoke-begrimed." Southwest of Neath, time had not altered the scene. Indeed, the description is a perverse delight, especially for today's ecologically minded: "The scene here is one of utter desolation, for the acid fumes from the copper works, though said to be healthy for human beings, have destroyed almost all plant life, and grass is replaced by a meagre, sickly growth of yellow camomile."

The positivist mind that helped to bring destructive industry to southwest Neath is, at its root, that which made Napper the natural scientist who peeks through in the accompanying texts in the Vale of Neath suite. For he is not only photographic artist, storyteller, and descriptive guide to peripatetic wanderings. He is geologist in his observation of the moraine-like deposits of the Lower Clyn Gwyn, in his scientific definitions of the Dinas Rock and the Stone Bow (here, in lesser degree). He is piscatologist and reader of Isaac Walton in his mention of exceptional trout fishing ("The Corbwll"), and ornithologist in his description of the curious water ouzel, or dipper bird (ibid.). He uses this knowledge propagandistically, to entice the peruser to the Vale, just as he advises picnicking and cave explorations at "The Cave — Porth yr Ogof." He is an etymologist at pains to tell us the origin of the name of "The Ladies' Fall — Yscwd Gwladis," and "The Dinas Rock — Craig y Dinas."[11] More significantly for us, Napper is insistent on rationalizing his photographic vantage points: the view of Upper Clyn Gwyn is "from the side of the hill on which Clyn Gwyn farm is situated"; he justifies his high vantage point for "The Middle Clyn Gwyn," and the distant one for "The Lower Clyn Gwyn"; he takes two very different views of "The Upper Scwd Ddwlu" and intimates why [Figure 7].

Napper is also insistently our Guide, even to the point of informing us ("The Middle Clyn Gwyn") — as the most thorough guidebooks will—from what village to catch a specific train which will allow us to experience a specific site. It is another facet, I think, of his scientific method, and very in keeping with his intention to exhibit the beautiful descriptively, even matter-of-factly (although he is not consistently true to his stated intention in this respect). We always know where we are with Napper. This journey through the Vale of Neath is not entirely unlike reading the 1922 *Blue Guide* to Wales, except that the guidebook does not take these sites in precisely the same order. Generous when it can be — of course, because of its vested interests — the guidebook can even find powderworks in the Vale "not

unpicturesque." But in general, this book agrees with our artist's impressions; it calls the twelve-mile-long Vale "the most beautiful natural feature of Glamorganshire, though now largely industrialized," "rich in gorges and cataracts [and requiring] two days at least for complete exploration." Maxwell Fraser, in more modern times, returns the sylvan and legendary quality to the Vale: "Four miles up the Vale of Neath (Cwm Nedd), Glyn Neath is reached and industrialisation is forgotten in the sylvan delights of the upper Vale of Neath....Soon after leaving Glyn Neath all is beauty....Craig-y-Dinas, beneath which King Arthur and his Knights sleep, ...some of the wilder scenery."[12]

Napper's sylvan photographic/literary excursion is sprinkled with legend, too. There is the horseman whose corpse was found floating on the River Melte. It happened, naturally, on "one dark and stormy night," that phrase we associate with the opening of Bulwer-Lytton's *Clifford* — and which we associate with trite literary atmospheric contrivance. In "The Ladies' Fall — Yscwd Gwladis," he relates this name to Biblical and epic tales, not totally unlike what he does when in "The Lower Clyn Gwyn" he cites Byron's verses: "In famed Attica such lovely dales/ Are rarely seen...." With almost Neoclassical conviction, Napper associates his own work with the classical model, whether by retelling tales of the classics or by the frequent use of literary quotations to constitute his text.[13] It is his way of universalizing the sylvan dream which, paradoxically, he is temporalizing by photographing it and by calling attention to changes taking place in "these practical days."

Napper's *Views in Wales. The Vale of Neath* is a hotch-potch of literary genres, while it is, most obviously, a mixture of two visual media: letters and photographs. In "The Middle Clyn Gwyn," for example, he combines the odic verse of Cunningham, his own esthetic philosophy regarding photography, a justification of his photographic procedure in this instance, and guidebook information and description — all in conjunction with the visual image. His use of the visual image is an enticement to any peruser; but it is as much an informational — if not scientific — portion of a sometimes propagandistic guidebook. We are often tempted to think of such combinations of lettered and visual art as if the former supported the latter. Here, we may have a reverse situation, or at least one in which literature and the photographic illustration do not vie for priority or authority over one another. Many tipped-in photographic books could be studied to great advantage by first taking into account these conceivable priorities or lack thereof.

REFERENCES

1. The copy I use belongs to Santiago Saavedra. On May 19, 1987, C. S. Fruchter (New York) informed me that she had a similar album/book by Napper. Her copy indicated a different bookbinder, and instead of thirteen photographs, it contained ten, and they appeared in different order from the one I have seen. Nine of the ten were the same (to judge by the titles), and there was one more: "The Bed of the Neath River, Near the Source." On the other hand, the Saavedra copy had four images which did not appear in the Fruchter copy: "The Dinas Rock — Craig y Dinas," "The Dinas Cascade," "The Stone Bow — Bwa Maen," *one* of "The Upper Scwd Ddwlu" (Saavedra's copy has two different images of this title).

2. To judge by the discoloration pattern on the advertisement, this sheet has been tucked between the final page and the back cover of the volume all along. The works on Wales "in preparation," following the suite of views made in the Vale of Neath, were: "Choice Photographs of Welsh Scenery," "The Castles and Abbeys of Wales and Monmouth," "Views of the Welsh Coast," "The Mansions of the Nobility & Gentry of Wales & Monmouth." The last is of particular interest to us.

3. A sixth of the Andalusian views are of human types. And if I can trust my intuitions, some or all of the nine Andalusian views and photographs of Andalusian types in volume III of "Albert Edward, Prince of Wales, Photographs" (album in Windsor Castle) were realized by Napper; so, too, may be five of the six Gibraltar views in volume VI of same.

4. Strangely, The Francis Frith Collection, in Andover (Hampshire), informed me on April 18, 1985, that they were not aware of "any views of Spain within the material [they] hold." This is hard for me to imagine, although I myself have not seen their collection, despite the fact that I am graciously invited to do so.

5. *Egypt and the Holy Land in Historic Photographs: 77 Views by Francis Frith*, reprint edition, ed. Julia van Haaften (New York: Dover, 1980), p. xiii. For the most part, data concerning Frith are gleaned from the van Haaften introduction.

6. Even Frith very soon "settled down to regular family life" and, later, to landscape painting! See van Haaften, p. xix.

7. If only for the present occasion of this homage, who could forget here the illustrated treatise on the chipmunk, carried out by Dr. and Mrs. Henisch.

8. *South Wales illustrated, in a Series of Views, Comprising the Picturesque Scenery, Towns, Castles, Seats of the Nobility and Gentry, Antiquities, &c.* Engraved on Steel from Original Drawings by.... Accompanied by historical and topographical descriptions (London: I. T. Hinton and Holdsworth & Ball, 1829 [prob. publ. and date]). This second volume of a set is the one which concerns Wales specifically. The first volume (*Picturesque Beauties of England and Wales*, in a Series of Views from original Drawings by N. Whittock and H. Gastineau) bears no volume number, but does have the publisher and date. The sketch artists are listed as N. Whittock and H. Gastineau.

9. George Borrow, *Wild Wales: Its People, Language, and Scenery* (London: John Murray, 1901; rpt.), pp. 321-322.

10. *The Blue Guides. Wales*, ed. Findlay Muirhead (London: Macmillan & Co.; Paris: Lib. Hachette & Cie.), pp. 170-171, 210-212. Oddly enough, Gastineau (1829) depicted the Abbey as pastoral, with cows grazing in the ruins of its crypt.

11. George Borrow, in *Wild Wales: Its People, Language, and Scenery*, p. 323, does so for the placename "Neath."

12. Maxwell Fraser, *Wales*, II ("The Country") (London: Robert Hale Ltd., 1952; rpt. of earlier 1952 ed.), p. 284.

13. Quotations are from: Milton, Danté, Drayton, A. Cunningham, Byron, Mrs. Hemans, Skelton, P. B. Shelley, *Jesse's Country Life*, E. Cook, Cowper, Wordsworth. And the literary modes represented by these authors have great range: picturesque descriptive, sublime, odic, invocational and invitational.

Self-portrait Without Mirror

George Mauner

Figure 1. Cuno Amiet, Double Portrait, 1903. 94 x 114.5 cm. Exhibited at the Düsseldorf International Exhibition, 1904. Courtesy Schweiz. Institut für Kunstwissenschaft Zürich.

The Swiss painter Cuno Amiet (1868-1961) was an active participant in the great international exhibitions that were so popular during the early years of the century. His work, together with that of Ferdinand Hodler, was largely responsible for the reputation that Switzerland earned in those years as the source of the most strident avant-gardism of the German cultural sphere. Among the paintings that attracted the most attention at the Düsseldorf International Exhibition of 1904 was Amiet's large (94 x 114.5 cm.) *Double Portrait* [Figure 1], representing himself and his wife in full-length, walking toward each other. Each figure is independently framed, and the two units are brought together into a single horizontal format with a vertical division at the center. Each figure thus retains its autonomy and individuality, yet belongs ultimately to a unified, dual concept. That this fusion is an indispensable part of the artist's plan is indicated not only by the movement of the figures toward one another, but by the background, in which a vast, oval cloud unites the two pictures. In addition, at the bottom, Amiet has signed and dated the work across the dividing vertical strips, so that the numbers and letter "19C" are on one side, while "A03" are on the other. The initials are not only those of the painter, but while the C represents the artist's first name, the A on the side of his wife's image also refers to her first name, Anna.

The *Double Portrait* is composed of conceptual and realistic elements. The background is entirely invented and serves as a unifier on the levels of both design and symbolic content. The figures, on the other hand, are rendered with great attention to actual physical resemblance. Despite this, their attitudes have been calculated to convey the idea of a coming toward unity that has determined the pictorial structure, as well as the mirror image effect of the dated monogram. The painter strides forward assertively, hand in his pocket, comfortable in his role. His wife is more hesitant, pauses in her advance as she turns her head toward us and holds a bouquet in her hands. The opposition of active and passive, practical and poetic aspects of life, opposing equivalents necessarily united to form a harmonious whole, could not be more clearly illustrated. While Amiet's expression of the idea is strikingly personal, the theme itself is typical of the preoccupations of the Symbolist movement and Jugendstil art and illustration.

Several studies of Anna Amiet for her half of the composition exist [Figure 2]. Obviously she posed often and long for this major work. No studies for Amiet's self-portrait, however, are known. Amiet

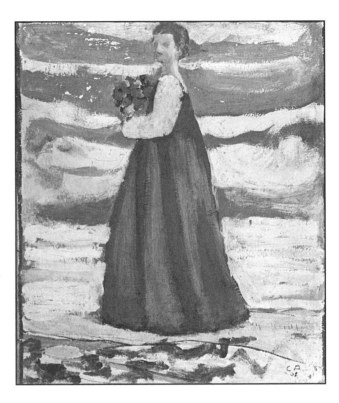

Figure 2: Study of Anna Amiet for Cuno Amiet's Double Portrait (1903). Courtesy Schweiz. Institut für Kunstwissenschaft Zürich.

painted an unusually large number of self-portraits, and in each case, in the tradition of self-portraiture, he had used a mirror in which to study his likeness. Clearly, that could not have been the case in painting the *Double Portrait*, since the painter depicts himself in profile and striding. What Amiet did in this case was to have recourse to a photograph [Figure 3].

He struck the pose he wanted to use before a white sheet, had a photograph taken and then copied with remarkable fidelity what the photo revealed. While he preserved the characteristic stance and even many of the details, such as the folds in his clothing, he did make a number of changes designed to enhance the pictorial concept he had imagined from the beginning. Most apparent is his conversion of the dark suit to a white one, with the result that his head, with its dark hair and beard, acquires increased power by contrast. Another contrast is created between the white suit and the dark dress of his wife. Amiet has also altered the suit jacket at the back, eliminating the flare that disrupts the smoothness of the contour of the body. This simplification of the

Figure 3. Photographer unknown. Photograph of Cuno Amiet, a study for his Double Portrait (1903).

close to that of the final painting, the self-image of the artist was to go through a number of subtle changes, most of them the result of information provided by the photograph.

Upon seeing the painting at the Düsseldorf exhibition, the scholar and critic Wilhelm Schaefer wrote,

> How many portraits there are in this exhibition, but none remains more impressed in my memory than Amiet's *Double Portrait*. Is it possible that this is because it is so strange? Art is not a pretzel bakery, but a religion that remains with us to the end—and we all want to live, not only to eat and drink—so perhaps I may be forgiven for couching my serious question in trivial generalities.[1]

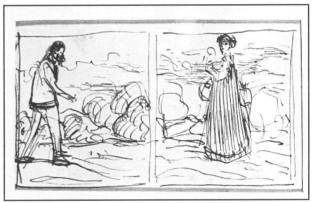

Figure 4. Cuno Amiet, preliminary ink drawing for Double Portrait (1903). Courtesy Schweiz. Institut für Kunstwissenschaft Zürich.

overall form unites it better with the flowing lines of Anna Amiet's figure. The white sheet used in the photograph served to isolate the silhouette-like form as an independent unit of symbolic value. The two poses were meant to be absolutely characteristic of specific individuals, and Amiet's rendering of himself had to be as accurate as that of his wife. The abstraction of nature as the backdrop that unites the two halves, however, not only emphasizes the symbolic level of the painting, but extends the symbolism of the particular into the realm of the universal.

Only one small preliminary study for the composition as a whole is known [Figure 4]. It is an ink drawing that, despite its diminutive size, already suggests that monumentality Amiet had intended from the start. While the figure of Anna is already

Amiet's procedures were effective, then, in creating this strangeness that lingers in the memory. The critic might have been surprised to learn that the practical expedient of a photograph had played a vital role in producing that sanctity that he attributes to art.

REFERENCE

1. Wilhelm Schaefer, "Schweiz," *Rheinlande* (1904), p. 363.

A bas la Phothographie[(1)]!!![sic][1]

Sandra Stelts

And now shall we agree that photography is a public calamity and social scourge, an appalling invention that will dishonor us in the future as it dries our minds and our hearts in the present, the last word of science and skepticism agreeing, as usual, to take away from us the little poetic and generous illusions that we still have![2]

The title "Down With Photography!!!" is an obvious clue that a reader can hardly expect the front-page story of the *Journal Amusant* to treat the relatively new art form in a sympathetic manner, and indeed the cover illustration[3] by the cartoonist Marcelin seems to characterize popular attitudes in the 1860s toward photography as a fine art [Figure 1]. Under the heading of "Les Portraits" the illustration presents a traditional putto, the personification of the arts and sciences, holding his artist's palette and brush, and putting the finishing strokes on an extremely graceful and idealized portrait of Diana, labeled "Autrefois," or "In the Past." Next to him works a putto with a camera in front of another portrait, this one of a rather plain and sour lady labeled "Aujourdhui," or "Today." The argument is plain—that photography is basically a mechanical, impersonal, warts-and-all means of reproduction. But that photography sought higher ambitions is clear from another cartoon [Figure 2] that presents the personification of "Photography" as a rather tough, pipe-smoking woman, whose puffs of smoke spell "I will bury Raphael, Titian, Van Dyck, etc."[4]

Within the context of a discussion of photography as a fine art, it is not so surprising, then, that among the portraits pictured under the heading "Some Celebrities After Nature and in Photographs," a group that includes Alexandre Dumas and the actress Mme Adelaide Ristori, we find caricatures of two painters, Jean-Auguste-Dominique Ingres [Figure 3] and Eugène Delacroix [Figure 4]. That these men should have been paired in a magazine of satire is also not entirely unexpected. For some years the two artists had already been identified as opposing leaders in a very public battle of doctrines; Ingres was the official leader of classical painting, Delacroix of the romantic movement.

In 1856 the editors of the *Journal Amusant* would have been quite aware of the struggle between the two men over Delacroix's election to the *Institut*, when Ingres' opposition had a great deal to do with the many rebuffs and rejections that Delacroix had received from the members of that body. (He was finally elected a member in 1857.) Ingres had repeatedly and in public referred to Delacroix as "the apostle of ugliness," and he did not confine his attacks on Delacroix as an artist; he once complained of "the odor of sulphur" when Delacroix left the room. The stuffy Ingres was also envious of the flair with which Delacroix, the more handsome and dashing of the two, seemed to lead his whole life. Delacroix for the most part confined his private, though often bitter, opinions of Ingres to his journal.[5]

225

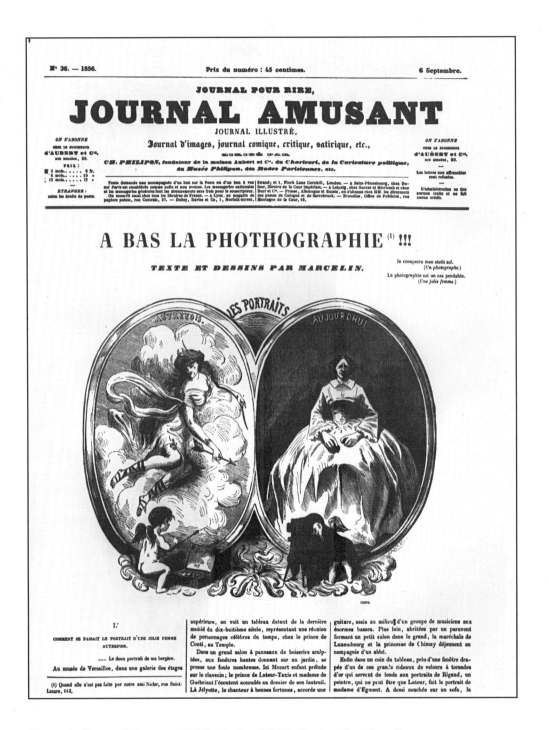

Figure 1. *"Journal Amusant "*(6 September 1856). *Cartoon by Marcelin.*

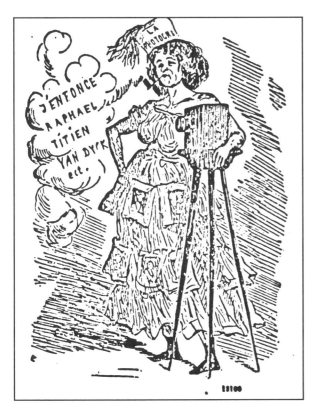

Figure 3. Marcelin. "Monsieur Ingres." "Journal Amusant," no. 36 (1856), p. 4. 3 x 3 inches. Courtesy of the Library of Congress.

Figure 2. Marcelin. "I will bury Raphael, Titian, Van Dyck, etc." "Journal Amusant," no. 36 (1856), p. 3. 4 x 3 inches. Courtesy of the Library of Congress.

Figure 4. Marcelin. "Monsieur Delacroix." "Journal Amusant," no. 36 (1856), p. 5. 3 x 3 inches. Courtesy of the Library of Congress.

The writer of our *Journal Amusant* article clearly intends to convey the impression that the positions of the two artists were not as secure as might be thought. The captions for their respective portraits read

Monsieur Ingres:

In life:
Majesty, a high and powerful forehead, the large eyes of an eagle, which fix the sun; a well-shaped aquiline nose, an imperious mouth, a chin square and willful, hair black and victorious over time, a head of a Roman emperor or of a Pope of the Middle Ages.

In a photograph:
A constipated grocer.

Monsieur Delacroix

In life:
Passion; eyes twinkling and waggish, an adventurous nose, the mouth of Mephistopheles, the hair of Romeo, a standard for Hoffmann.

In a photograph:
A scalper of theatre passes.[6]

Thus our writer/cartoonist Marcelin neatly finishes off both artists, with their battle ending in a draw. The *Journal Amusant* article makes clear that the rivalry between Ingres and Delacroix had already become so public that a journal of satire could juxtapose them and poke fun in such a witty fashion. It is probably also fair to say that this humorous yet pejorative piece provides another clue to both the official and popular attitudes in the 1860s toward photography's future as a creative and intellectual activity.

ACKNOWLEDGEMENTS

The author wishes to thank Professor George Mauner for calling her attention to the Delacroix/Ingres reference in the *Journal Amusant*, and Jacqueline Rogers for her careful reading of the translations.

REFERENCES

1. Marcelin, "A bas la phothographie[(1)]III," *Journal Amusant*, no. 37 (1856), p. 1. The footnote in the title (1) reads, "When it is not done by our friend Nadar, rue Saint-Lazare, 113." This cartoon was first reproduced in Rolf M. Krauss, *Die Fotographie in der Karikatur*, foreword by Bernd Lohse (Seebruck am Chiemsee: Heering Verlag, 1978), p. 55.

2. *Journal Amusant*, no. 37 (1856), p. 5.

3. For a fuller discussion see G. Mauner, "The Putto with the Camera; Photography as a Fine Art," *History of Photography*, vol. 5, no. 3 (July 1981), pp. 185-198.

4. *Journal Amusant*, p. 3.

5. For a more thorough treatment of the feud between the two painters, see S. Stelts, "Delacroix on Ingres: A Caricature," *Master Drawings*, vol. 20 (Winter 1982), pp. 374-376.

6. *Journal Amusant*, pp. 4-5. The author wishes to thank Professor Laurent LeSage for his suggested translation of the rather outdated occupation of "un marchand de contre-marques."

Carl Sternheim's *Die Kassette*: Photography and Art in the "Heroic Life of the Bourgeoisie"

Ernst Schürer

Carl Sternheim (1878-1942) has often been called the chronicler of the German bourgeoisie. Not well-known abroad, he has enjoyed a solid reputation as one of Germany's most original playwrights ever since the success of his first comedies in 1911. His highly controversial plays were censored until the end of World War I, continued to cause much controversy during the time of the Weimar Republic, and were banned during the Third Reich as the works of a Jewish author. For differing social and ideological reasons, Sternheim's comedies even had to overcome great obstacles in post-war Germany, both East and West, before becoming part of the general repertoire.

It is small wonder that these plays elicited such violent response; in his major comedies Sternheim violates the taboos of Victorian or rather Wilhelmian society and makes fun of the most sacred bourgeois conventions. An admirer of Molière, Sternheim closely observed the behavior of people around him — and also his own. He analyzed their aspirations, fantasies, and dreams, and exposed the gap between bourgeois ideology and the actions of the individual citizen. In an age that saw the rise of mass movements in politics, mass killings in war, and mass murder by governments, an age that proclaimed the death of the individual, Sternheim was a staunch champion of the rights of this self-same individual. He encouraged people to live according to their "own nuance," their own unique nature as individuals. At

heart an anarchist and strongly influenced by Friedrich Nietzsche,[1] Sternheim rejected the norms of Wilhelmian Society in regard to conventional Christian moral behavior as well as the claims of Charles Darwin and Karl Marx in regard to freedom of the human will and economic determinants. In his plays he accordingly tried to present an unvarnished, realistic picture of society and the world as he saw it.

After many failures and disappointments with historical and naturalistic plays as well as with neo-romantic verse dramas, Sternheim's breakthrough came in 1911 with the staging of his comedy, *Die Hose* (The Bloomers).[2] In it Sternheim had finally found his own topic as well as his personal language and style.[3] He no longer dwelt in the romantic past but turned his attention to the contemporary "heroic life of the bourgeoisie" as the author ironically called the theme of both this work and a subsequent series of plays. The second comedy is *Die Kassette* (The Strongbox), which Sternheim had begun in the autumn of 1910.[4] Following its premiere in November 1911, it caused even more theater scandals than *Die Hose*, for instance, in Munich's *Residenztheater* in 1912 and in the Vienna *Burgtheater* in 1920. Edson Chick reports about the stormy scenes that erupted in many theaters: "The response of the Burgtheater and Residenztheater audiences was by no means atypical. Early productions in smaller cities, specifically Mannheim and Magdeburg, were judged by audiences and cities to be indecent, wantonly and

distinctively negative, and in violation of all principles of art and culture."[5]

Sternheim's *Die Kassette* is of special interest since one of the main characters, Alfons Seidenschnur, is a photographer who plays a crucial role in the plot of the play. The role of photography in literature has been examined before, but in this comedy a photographer occupies center stage.[6] In the original version of the play, titled "Die Tante" (The Aunt), however, he is still a master tailor and dress designer who has spent his journeyman years in Berlin and Paris and affects a cosmopolitan air by interlacing his speech with French expressions and by constantly referring to his adventures abroad.[7] He is a philanderer and a favorite of the ladies in spite of the fact that he is married to a woman ten years his senior. His romantic past, his cosmopolitan attitude, his skill as a tailor, and his unabashed use of an unconventional vocabulary in describing female anatomy — proscribed in genteel society — insure his professional and personal success with his customers who fall like so many dominoes before his amorous advances. As befitting his profession, the bone of contention between him and the aunt is not her portrait, as in the final version, but a skirt which she considers too daring and therefore refuses to accept.

Why did Sternheim change the profession of Seidenschnur? Being a dandy, Sternheim seems to have admired competent modern tailors such as Mister Easton, a character in *1913* described as a real gentleman whose creations influence women "by giving wings to their imagination." (265) But for the general public not acquainted with globe-trotting master tailors, a tailor was probably too prosaic and not very convincing as a cosmopolitan Don Juan. As we shall see, photographers had a reputation as lady-killers in the popular imagination, and Sternheim therefore not only changed Seidenschnur into a bachelor, but he also turned him into a professional photographer. Wilhelm Emrich, the editor of Sternheim's *Gesamtwerk,* is of the opinion that the change was actually suggested to Sternheim by his wife: "The details of his new profession about which he speaks at the beginning (and possibly the new vocation for Seidenschnur altogether) Sternheim probably owes to his wife Thea who already at that time was an excellent photographer" (X, 784). Sternheim had married his wealthy second wife, Thea Löwenstein, née Bauer, in 1907 after a long and arduous courtship. [Figure 1] She was indeed an enthusiastic and accomplished photographer; over a period of nearly forty years she created what amounts to a photographic history of the life of a famous playwright. Her pictures of Sternheim — usually

Figure 1. Thea Sternheim in 1910. Original in Deutsches Literaturarchiv, Marbach a.N. All illustrations reproduced in Manfred Linke, "Carl Sternheim in Selbstzeugnissen und Bilddokumenten" (Reinbeck bei Hamburg, Rowohlt, 1979).

taken during the visits of famous guests and friends — are very carefully posed and arranged.[8] [Figures 2 and 3] Even after their divorce in 1927, she frequently visited Sternheim and took pictures at such occasions. Thea Sternheim's photographs also give us a further indication why Seidenschnur's profession was changed: they capture the bourgeois values of ostentatious wealth, social status and respectability represented by the mansions the Sternheims lived in, their dress and the general environment. [Figure 4] The romantic inclination attributed to many photographers is also very much in evidence in Thea Sternheim's photographs.

Considering the fact that Seidenschnur looks upon himself as an artist who desires to become a painter, Sternheim himself also contributed a great deal to the character since he considered himself an expert on art in general and especially on modern art. When writing about the life and significance of being an artist, he used a painter as a persona in his poems and plays to divert attention away from his own identity. In one of his earliest dramas, *Madonna!* (1895/96), the main character, an aspiring painter by the name of

Figure 2. Thea Sternheim, photographer. Carl Sternheim (right) with Frans Masereel, Belgian painter and wood-cut artist, in 1922 in Uttwil, Switzerland. Original in collection of Manfred Linke.

Figure 3. Thea Sternheim, photographer. Franz Pfemfert (left), founder and editor of the influential expressionist journal "Aktion," with Conrad Felixmüller, Expressionist painter and graphic artist, in 1923. Original in collection of Manfred Linke.

Carl Bernholm, is a thinly disguised self-portrait of the author. His second marriage provided Sternheim with the financial means to visit museums and art galleries all over Europe and to acquire a splendid collection of art works, especially many paintings by Vincent van Gogh, who was virtually unknown at that time. Edson Chick thinks that to a certain degree Sternheim even patterned Seidenschnur's character on his own: "Sternheim has given him some of his own weaknesses and vices: the obsession with dress and outward appearance as well as his erotomania."[9] To develop the figure of Seidenschnur the Sternheims could combine their knowledge of photography and art to arrive at a successful characterization.

The profession of tailor could also be switched to photographer because both are concerned with appearances, individual appearance as well as appearance as a distinguishing characteristic within a

society. Both a tailor and a photographer want to portray a person to his or her best advantage, and a more or less strict dress code has always served as a means of showing one's membership in a specific social class or profession. Before the invention of photography, wealthy burghers had themselves and their wives painted in their official or prescribed costumes for the benefit of their contemporaries and posterity. By 1900 and even earlier, the photographer had in many instances taken the place of the painter. While before only the wealthy had been able to afford a painting, now nearly everybody could have a photographic portrait taken. As Enno Kaufhold explains, "Just as before members of the nobility considerate of their prestige and the upper bourgeoisie had deemed it necessary to be portrayed by famous painters like Lenbach, now these same social classes — but especially the educated

Figure 4. Thea Sternheim, photographer. Claircolline, Sternheim's home in La Hulpe, Belgium, from 1913 to 1918. Original in collection of Manfred Linke.

bourgeoisie — judged it indispensable to go to the most recommended professional photographer who had won the largest number of awards. And the latter left no stone unturned to advertise their success as effectively as possible."[10] In photographs the bourgeois presented the image of himself and his family that he wanted to convey to his friends and to society in general. Collected in family photo albums, the photographs took on the role of portraits in the family tree of a noble house; they seemed to trace the lineage of the family and attest to its roots. Enno Kaufhold explains that "the mighty and especially the advanced educated bourgeoisie had their modern ancestral galleries made up. For that photography was indispensable."[11] When in Sternheim's *Bürger Schippel* (Bourgeois Schippel) (467-553) the déclassé day-laborer Schippel waits for the goldsmith Hicketier in the latter's bourgeois living room, he admires the furnishings and leafs through the family photo album left ostentatiously on the table. He comments: "Solid ladies and gentlemen altogether, relatives, respectable, dignified. Golden brooches and necklaces. Heavy signet rings." (503) Confronted

with these symbols of bourgeois respectability,[12] the vital and energetic but illegitimate Schippel, who has no family and friends and therefore lacks all the prerequisites to achieve the admired status, feels ill at ease.

Sternheim's portrayal of Seidenschnur in *Die Kassette* is, therefore, important for several reasons. First, it gives us a fairly accurate picture of the position and status of a photographer in German society at the turn of the century. Secondly, the play mirrors the conception of a photographer in the popular imagination of that period. In that sense, Seidenschnur is type-cast. His importance is underscored by the title of the play, which refers to the strongbox with the stocks and bonds Krull hopes to inherit as well as the black film-holder with photographic plates, the *Filmkassette*, that Seidenschnur uses.

In the course of the play the audience learns that Seidenschnur is very successful as a star photographer. He had opened a studio in Krull's hometown five years ago, after studying his profession in the mecca for photographers, Paris,

where he was the star pupil of Reutlinger. In an earlier version of the play he tells Fanny, "O madame, you should have known our boss, the old Reutlinger: A la fin il n y a (sic!) que deux réproductions du monde. Molière et Reutlinger. That was his daily motto." (X, 785) He boasts to Krull that in competitions his studio has won gold and silver medals on five occasions. To Lydia he mentions that his work has found recognition in the highest levels of society. He is earning over 6,000 Marks per year, more than Krull, who hates his profession as a teacher at the local *Gymnasium*, the classical German high school. He even carries the title "Professor" but is earning a yearly salary of only 5,200 Marks after twenty-one years of service. On the basis of his education, his profession, and his income, Krull, however, is a member of the educated bourgeoisie, the *Bildungsbürgertum*, while Seidenschnur, in spite of his good financial standing, is not totally accepted into the ranks of the bourgeois society of the town. When Krull shows his reluctance to return the photographs of Elsbeth, she chides him: "A rootless photographer insults a propertied lady in high society and called to my defense, you find nothing wrong with him, but…" (379) Nevertheless, Seidenschnur's status rises in Krull's eyes when he learns that Seidenschnur attended high school and speaks Latin. Later he is quite willing to accept him as his son-in-law since he is educated, has a good income, works hard and has enough imagination to get ahead.

The action of the play is set in motion when Seidenschnur brings the prints of a photographic portrait he has taken of the spinster aunt Elsbeth, whose money Krull hopes to inherit. Elsbeth, on the other hand, uses her wealth to dominate and manipulate the family according to her wishes. "She wants a position of absolute authority in the house," states Burghard Dedner.[13] When Krull's first weak wife Sidonie was still alive, Elsbeth had been the real mistress of the house, and when Sidonie died she obviously would have liked to take her place. But her young, beautiful, and sexy niece Fanny had also moved in and become a powerful rival for the attentions of Krull, emerging as the victor in this first battle. As Lydia tells Emma, "Auntie constantly warned her about Fanny; even on her deathbed she gave Mother no peace and started questioning her about her wishes in regard to Father should it be the Lord's will to summon her away." (367) As Krull's new wife, Fanny is determined to take her rightful place in the house and evict Elsbeth if necessary. Her youth and sexuality are ranged against Elsbeth's money and will to power, with Lydia vacillating between the two. Krull tries to placate and satisfy

both, and thereby places himself into an impossible position. The portrait of her aunt gives Fanny another opportunity to strike out against her enemy since she looks behind the smooth facade Elsbeth has presented to the camera.

In the first act several aspects of Seidenschnur's character are established, first of all, his prowess as a lady-killer. This facet of his personality is delineated by Fanny when she attempts to alert her husband to the danger of being cockolded by Seidenschnur. She warns him repeatedly, "He is a Don Juan. No woman is safe with him." (415) Later Krull confides to Elsbeth, "A picture of a man, by the way. A first class Don Juan and philanderer." (421) But Krull is so anesthetized by the thought of future riches that he does not recognize the danger signals, although he is aware of the popular opinion that professional photographers belong to a group of men such as race drivers, ski instructors, famous actors and opera singers who because of their glamorous profession are very successful with women.[14] These men do not belong to the ordinary world of the bourgeoisie; they appear to be rich and seem to earn their money without much effort. They live seemingly adventurous lives that appeal to the romantic imagination of women who feel trapped in their world of dull routine and bourgeois respectability. A proper *Spiessbürger* like the narrow-minded Krull rejects them—"I detest photographers and druggists" (421)—but Seidenschnur fully lives up to his role by presenting himself as a youthful hero, a Romeo and veritable Tarzan who swings on a rope to reach the balcony of his beloved, quoting Shakespeare and calling on literary models of famous lovers. First the servant maid Emma, then Krull's daughter Lydia, and finally Krull's wife Fanny, all fall victim to his charms. Lydia tells Emma, "I had a heavenly dream. As I was about to step into a lake for a swim, a man was standing in it, erect, singing. . . . Did I ever tell you — the man in the water looked like Seidenschnur?" (365/7) Her dream reminds one of *Jugendstil* postcards by Fidus or of photographs of nudes.

Seidenschnur has little trouble in seducing Lydia. He does so in an extremely erotic — even obscene — photographic session when Lydia volunteers to be his model to repay him for the loss he has suffered because of her aunt's rejection of her portrait. Since he does not dare to ask her into his studio, he brings his camera into Krull's living room, thus invading the inner sanctum of the bourgeoisie. Seidenschnur uses an old-fashioned plate camera on a tripod with a rubber ball to work the shutter. Standing straddle-legged behind the camera — which becomes an extension of himself — with his head under the black

cloth and squeezing the rubber ball, he turns the session into a photographic seduction. He implores Lydia: "Now let's use the time before they surprise us. I have the camera ready. Or have you changed your mind?...You look like a vision in the bright sun. Therefore, full light, *plein air*. Greedily the camera is tearing open its lens to devour you." (398) Running back and forth between camera and model, he arranges her: "May I ask you to assume a position against the desk. The back leaning against it slightly....The left leg a little forward, perhaps....A little more. Just a little." He then starts undressing her verbally: "Where would be Phidias' fame if the most beautiful Hellenic women had not offered him their glorious body without shame. Or Michelangelo — still a little more. In your figure there is an abundance which is not conspicuous, a rare *pli*...Bust forward, or rather stomach in." He places her in that position and runs to the apparatus.

> Perfect beyond belief. And now, please: one, two, three, four. Many thanks! Right away, once again, if you please. But now let's take a profile shot, sitting, more *clair obscur*. Legs crossed nonchalantly....Look how hungrily the camera lies in wait for you....Your image flows into the lens, Lydia, straight into the chambers of my heart. Otherwise separated from the cosmos by the cloth, they feed me with passionate charm until I go mad. (398/400)

When he kisses Lydia he accuses the focusing screen of having seduced him and blames his ardor on it. While trying to divert Lydia's attention away from his seduction by invoking higher aesthetic concerns such as his artistic calling and their common musical experiences, he intensifies the erotic atmosphere by quoting a poem reminiscent of Lydia's erotic dream. But his attempt is much more contrived and artificial in that the persona of the poem desires to tear off her or his clothes, stand on a white heath wrapped in ice, and be blown away into eternity. This is a vision of the photograph of a nude, the white body of a woman standing on a white sheet against a black background, a picture Seidenschnur would like to take of Lydia. However, he carefully hides his intentions behind aesthetic double talk: in the poem the erotic aspect is neutralized by first covering the heath with snow and then putting the body on ice, so to speak. For good measure it is then removed from this earth altogether. These fine aesthetic distinctions, however, are lost on Lydia, who falls into Seidenschnur's arms like a ripe fruit. She addresses him in quasi-religious terms as her savior: "You are the light, the truth, and the life."

(402) As is appropriate for a photographer, the Biblical "way" has been replaced by "light."

When later Seidenschnur tries to talk Fanny into letting him take her picture, it becomes obvious that he has used his seduction-by-camera technique on more than one female customer. He employs some of the same phrases and the same erotic vocabulary: "My lens is burning to devour you, to catch the significant contours of your head, of your figure in *clair obscur* and expressive fashion. We poor artists depend to such a high degree on the model!" This role Fanny is quite willing to assume. When Seidenschnur raves about his artistic aspirations, she assures him, "And I am your muse, your model!" (453) He can in future exhibit the portraits of the "beautiful Mrs. Fanny Krull as advertisement for his show windows." (414)

Seidenschnur's actions conform to the popular conception of the bourgeois who assumed that in the secrecy of their studio photographers were busy taking nude pictures of accommodating female models and engaging in sexual libertinage. A shadow of this prejudice surfaces when Elsbeth describes her photos, "They are indecent with the raised knee," (375) and Krull later intensifies her description, "To capture you on the photographic plate like a theater princess with raised legs!...You look like a woman without shame, a prostitute walking the street. Whore!...A clever mixture of valkyrie and concubine." (388/389) While the serious photographer had to avoid all appearance of actually taking nude pictures in order to protect himself and not lose his customers, his popular reputation as a libertine bohemian — modelled on the stereotype of the poor painter in Paris — made him an interesting figure in society.

Seidenschnur's artistic ambitions actually have an important function in the play. He considers himself neither a craftsman nor a businessman, but rather an aspiring artist.[15] The picture postcards which Krull has sent back from his honeymoon he calls "in bad taste," (370) "insulting kitsch, trash, a disgrace to the profession." (371) Lydia calls him repeatedly a "divinely inspired artist" (367/371), his picture of Elsbeth "a perfect work of art." (370) Everybody agrees that Seidenschnur has captured the very essence of Elsbeth in his "photographic painting." (382) Even Elsbeth is at first happy with her picture, until her rival Fanny makes fun of it, comparing her to Lady Macbeth by Schiller — both Fanny and Lydia show their ignorance by attributing all literary allusions to Schiller — and her posture modelled after a famous painting of Blücher showing him crossing the Rhein in pursuit of Napoleon during the Wars of

Liberation. Elsbeth now realizes that the picture tells more about her true self than she is willing to admit, namely her will to power and her determination to overcome all opposition to establishing herself as absolute master of the household. Being totally egocentric, she wants to control the lives of the people around her and exploit their talents. After taming Krull and making him an accomplice she now wants to include Seidenschnur in her menagerie. She does so in the fifth and final act.

This fifth act of the play focuses on Seidenschnur's ambitions as an artist. It has been criticized as redundant since it seems to repeat the first act. Actually, there are significant differences since the action of Act I is raised to a higher level. In Act I, the patriotic, bourgeois Krull has come back from a traditional German honeymoon tour along the Rhine. He ecstatically reports on the views he has seen, "proud castles," the "German River," the Germania national monument celebrating the foundation of the Second Empire in 1871, the Lorelei, the bronze statue of the German Emperor at Koblenz, the fortress Ehrenbreitstein, all views reproduced on picture postcards.[16] As a matter of fact Krull and his wife had the picture criticized by Seidenschnur taken against such a picture postcard backdrop in Koblenz. Krull was intoxicated by being with Fanny, savoring the wine of the region and carousing with friends, a typical situation celebrated in many a popular song.

In contrast, the cosmopolitan Seidenschnur had made his honeymoon trip to Italy, the mecca of German artists from Dürer to Goethe. We must remember that he married Lydia also for her inheritance, which he hopes will enable him to fulfill his dream to become a painter. He comes back from the south intoxicated with new impressions imparted to him by the masterworks of Botticelli, Raphael and Michelangelo: "I received, I must say, decisive artistic inspiration." (446) When Elsbeth asks him for photographs of the country through which he has travelled, Seidenschnur has little to offer: "Only few pictures were taken. In such a free artistic atmosphere I was disgusted with my profession and desired something more sublime." (447) And later on he asserts, "I am sick of slaving — I want to become a painter." (450) He expects Krull to finance his studies. To prove his artistic talents he shows him one of his paintings, a still-life with asparagus. But Krull is not impressed. Sternheim once wrote that the real artist "has seen something essential, conceptually unique, behind the appearance presented by the moment and by nature which he was able to represent."[17] Krull sees only the surface and asks maliciously, "Why asparagus? I thought you would

show me at least a crucifixion, or Plato's Symposium." (458) He expected his son-in-law to follow in the footsteps of the great masters by selecting often-painted topics from ancient and Christian culture and mythology but Seidenschnur informs him, "One doesn't paint literature any longer, rather strictly according to nature. Expressionism." (458) Since expressionism was the predominant art movement at the time, Seidenschnur uses the term to impress Krull. He uses it, however, without understanding it, since the expressionist artist wanted to portray the inner essence of things, and not nature. Actually Sternheim inserted the references to Expressionism only for the second edition of 1926 (584),[18] but in 1910 Wilhelm Worringer's *Abstraktion und Einfühlung* (Abstraction and Empathy) had already been published and Wassily Kandinsky's *Das Geistige in der Kunst* (The Spiritual in Art) followed in late 1911. Krull looks at art with both eyes open and considers the practical side: "From the very beginning they were not edible these asparagus from color? If they only were! If you could paint your lunch and dinner....(458) He refuses to yield even when Seidenschnur assures him, "If I give up photography I shall be able to support my family within a very short time." (458)

In the end Seidenschnur also succumbs to the charms of stocks and bonds and surrenders to Krull to collaborate with him in serving the strongbox. But there is an important difference: while Krull forfeits the love and respect of his wife, Seidenschnur, the eternal paramour, forsakes a higher goal, his vision to rise above human passions and become an artist. Love and art are supplanted by the rule of money. Except Lydia, who is too weak and romantic, all characters are disloyal, Elsbeth to the family she pretends to honor, Krull to Fanny, Fanny to Krull, Seidenschnur to Lydia and Fanny, but since this is a comedy all arrange themselves. They continue living in an extended family which certainly is not a "community of souls" (366) as Lydia would like to have it but rather a "cesspool of moral depravity" (386) as her father calls it. This accommodation to existing circumstances becomes clear in the last conversation between Elsbeth and Fanny, when the latter defends her rightful place in the kitchen and wants no change as long as possible. When Elsbeth refers to the proverbial rotten egg which is bound to show up once in a while, Fanny takes it to mean Krull and answers, "For sure. One replaces it with another one." (455) Namely Seidenschnur. She then wishes her aunt a pleasant and ironic "Good night." (455) Elsbeth's last words are full of surprise mixed with admiration: "How the young folks develop!" (455) In

the last analysis, Elsbeth is also a victim; in a later-omitted dialogue she tells Krull, "I did not get my property by accident. I served a beast, sacrificed my youth and my charms so that this uncle preferred me in his testament to half a dozen nephews and nieces." (X, 793)

Seidenschnur's desire to become an artist reflects the debate ongoing at that time about the aspirations of photography to be considered a fine art. In the first part of the play Seidenschnur is the champion of artistic photography, but he "also chases a fashionable contemporary phantom of artistic calling and modern thought in order to deceive himself about the prosaic nature of his actual occupation."[19] In an earlier version the artistic aspects of photography had received even greater attention in a dialogue between Fanny and Seidenschnur, when the photographer boasted about his art. "We can come so close to a person, to his characteristics in gesture, posture, dress and milieu as only the really divinely inspired artist.…One puts one's soul into the work. What a measure of energy is alive in the moments when one gets a person ready for the lens. How sharply, how fiery the eye sees a corner here, and an ugly empty space there. How the sharpest reason observes the length of exposure, and how much depends upon the delicate dexterity of the hands during development and printing." (X, 785)

Sternheim describes the state of professional photography around the turn of the century. Twenty years earlier, artistic considerations were considered secondary: "For most professional photographers questions of lighting, poses, requisites and background were the limits of their claim to 'art.' Even if they were open-minded in regard to art they persisted in formalities."[20] By the time *Die Kassette* was written, the situation had changed dramatically: "Immediately after 1900 the relationships between photographic and painting portraiture are the closest. The photographers no longer leave it exclusively to the painters to do the official representative portraits. With apparent matter-of-courseness they photograph the leading personalities of the time."[21] But the self-confidence of some photographers was only skin-deep. This seems to be the case with Seidenschnur. His visit to Italy — the cradle of Western art — has fueled his artistic temperament and his artistic calling gains the upper hand. He now obviously questions the pretensions of photography. His doubts reflect the opinion of many of his contemporaries who still looked upon photographers as failed painters. Baudelaire called them outright "peintres manqués."[22] They were thought of either as pseudo-artists or charlatans, or as craftsmen and businessmen who had

a hard time making ends meet. In addition, they were not fully accepted into bourgeois society but remained as outsiders at its fringes. This ambiguous position of being neither fully integrated into bourgeois society nor being a genuine artist is very annoying and troublesome to Seidenschnur. He worries constantly about losing the social position he has reached by hard work. By marrying Lydia and by giving in to Krull's wishes, he now can take the inheritance into account and must no longer rely solely on his income as a photographer, just as Krull no longer has to depend exclusively on his salary from his teaching job.[23] Seidenschnur has now achieved bourgeois respectability, has become an insider by being appointed as a guard of the Holy Grail of the bourgeoisie, the strongbox. By first being a boarder in Krull's bourgeois home, by then becoming his son-in-law, and finally sacrificing his non-bourgeois dream of becoming an artist, Seidenschnur has qualified himself fully for induction into the ranks of the bourgeoisie.

All of the characters of the comedy are willing to betray their own nature, to give up their "individual nuance," as Sternheim called it, to conform to expectations and norms imposed by the inheritance which Elsbeth dangles before their eyes. By renouncing their individualism, however, they perversely gain power and prestige in the bourgeois world. The fact that they actually will not inherit the money does not detract from the social reputation and power they have gained, since appearances count more than reality in this world. Krull has fully realized this illusionary character of the bourgeois when he asserts about the strongbox, "Sleepless nights do not inform me at all about its real value. However, I grow strong, full of high spirit when supported by the glow/illusion/appearance of the reputation which property bestows on me. I stretch my claws into the world toward people and make them dance in submission before the chimera." (441/442) Krull has joined the dance around the golden calf, and is going to become a worse tyrant than Elsbeth, his first victim being Seidenschnur, who in turn will victimize Lydia.[24]

Seidenschnur contributes to the illusionary character of this society by portraying its members in socially prescribed poses. Actually we have a double illusion, since the photograph takes the place of the person, and the artificial pose replaces natural behavior. While artists like Vincent van Gogh and the Expressionists rejected the crass materialism of the bourgeoisie and revolted against the *juste milieu*, the photographer as shown in Sternheim's *Die Kassette* is a champion of a society in which money is the

measure of all things, in which sexuality triumphs over love and in which in the end everybody is corrupted and makes an arrangement that preserves the status quo.

Wilhelm Emrich wrote about Sternheim and his comedies in general, "He has cut the Gordian knot in which until today all contemporary writers — and not only writers — find themselves hopelessly entangled, that Gordian knot which is tied in such a way that society by freeing individuals subjects them to the forces and coercion of its struggle for power while on the other hand the 'free person' can only realize himself by consciously or unconsciously adopting the social norms and rules of the game and by giving himself up in the process."(5) *Die Kassette* is a perfect example of this process. Since it is a comedy, Sternheim tells us his unpalatable truth in a humorously satiric fashion to sugar-coat the bitter pill. His humor develops from the clash between illusion and reality, from the double dealings and double crossing of the double-faced characters, and especially from the double meaning of the dialogue. In this manner he unmasks the pretension of Wilhelmian society and shows its true face, which most often we do not recognize in the faded photographs handed down to us from those days.

REFERENCES

1. Cf. Herbert W. Reichert, *Friedrich Nietzsche's Impact on Modern German Literature* (Chapel Hill: The University of North Carolina Press, 1975), pp. 29-50.

2. For a discussion of the state of German comedy at that time, Sternheim's cooperation with Max Reinhardt, and the literature models for Sternheim's *Die Kassette*, see Hans-Peter Bayerdörfer, "Sternheim: Die Kassette," in Walter Hinck (Ed.), *Die deutsche Komödie vom Mittelalter bis zur Gegenwart* (Düsseldorf: August Bagel, 1977), pp. 213-232.

3. Rhys W. Williams, *Carl Sternheim. A Critical Study* (Bern and Frankfort/M: Peter Lang, 1982) (Europäische Hochschulschriften, vol. 494), p. 73; and Eckehard Czucka, *Idiom der Entstellung*. Auffaltung des Satirischen in Carl Sternheim's "Aus dem bürgerlichen Heldenleben" (Münster: Aschendorff, 1982) (Literatur als Sprache, Band 2).

4. Carl Sternheim, *Die Kassette*. In *Gesamtwerk*, edited by Wilhelm Emrich, vol. 1, pp. 361-465. All page references without volume numbers in the text of the article refer to the first volume of the edition. Reference to other volumes of the *Gesamtwerk* in the article are preceded by the volume number.

5. Edson M. Chick, *Dances of Death. Wedekind, Brecht, Dürrenmatt and the Satiric Tradition* (Columbia, S.C.: Camden House, 1984), p. 68.

6. Erwin Koppen, *Literatur und Photographie. Über Geschichte und Thematik einer Medienentdeckung* (Stuttgart: J.B. Metzler, 1987).

7. For a complete history of the genesis of the play, see Carl Sternheim's *Gesamtwerk*, vol. 1, pp. 583-587, and vol. 10, pp. 714-796.

8. See Manfred Linke, *Carl Sternheim in Selbstzeugnissen und Bilddokumenten* (Reinbeck bei Hamburg: Rowohlt, 1979) (Rowohlts Mongraphien no. 278).

9. Edson M. Chick, p. 65.

10. Enno Kaufhold, *Bilder des Übergangs. Zur Mediengeschichte von Fotografie und Malerei in Deutschland um 1900* (Marburg: Jonas Verlag, 1986), pp. 85-86.

11. Enno Kaufhold, p. 86.

12. Not only the family photo album but also Hicketier's house and living room have a symbolic function. Cf. Karl Ludwig Schneider, "Des Bürgers gute Stube. Anmerkungen zur Raumsymbolik in Sternheim's 'Bürger Schippel' und Kaiser's 'Von morgens bis mitternachts,'" in Renate von Heydebrand und Klaus Günther Just (Eds.), *Wissenschaft als Dialog. Studien zur Literatur und Kunst seit der Jahrhundertwende* (Stuttgart: J. B. Metzler, 1969), pp. 242-248.

13. Burghard Dedner, *Carl Sternheim* (Boston: Twayne, 1982) (Twayne's World Authors Series TWAS 671), p. 42.

14. Erwin Koppen, pp. 149 ff.

15. Cf. Enno Kaufhold, pp. 86 ff.

16. Burghard Dedner, p. 45, remarks that "Krull's perception of the world is obviously formed by the prefabricated patterns of travel brochures." However, travel brochures were extremely rare at that time except for the *Bädekers*, while postcards were purchased and mailed to relatives and friends by nearly everybody, including Krull.

17. Manfred Linke, p. 119.

18. Manfred Durzak, *Das expressionistische Drama. Carl Sternheim - Georg Kaiser* (München: Nymphenburger Verlagshandlung, 1978), p. 77, considers Seidenschnur's remarks about expressionism as "Sternheim's own criticism of the movement."

19. Hans-Peter Bayerdörfer, p. 220.

20. Enno Kaufhold, pp. 70-71.

21. Enno Kaufhold, p. 85.

22. Erwin Koppen, p. 62.

23. Hans-Peter Bayerdörfer, p. 220.

24. Burghard Dedner, pp. 48-49.

Holidays in Grindelwald
by Werner Miller[1]

Translated from the Swiss-German
by Marianne von Kaenel Mauner

Many, many years ago when we were all small children, my brother and my two sisters were sent up to Grindelwald to spend their holidays at the parsonage with the "Glacier-pastor," as he was called. I had to stay home, because I was too young. My brothers and sisters met a whole lot of other children up there, and when they came home they were tanned from the mountain sun and red with enthusiasm. They couldn't tell enough about the wonderful and dear pastor and his wife, about playing "hide-and-seek" in the garden of the parsonage and "Indians" down at the Lütschinen River, and about all the tricks they played and all the trips they took, the hikes up to the Waldspitz, to the Scheideggen, and especially to the Zäsebärghorn.

Oh, the Zäsebärghorn! That was the most beautiful place! Round about, nothing but glaciers, and sometimes an avalanche would come down over the rocks and it sounded like a thunderstorm. But if you tilted your head way back, way, way back, up in the blueness of the sky you could see the summit of the Viescherhorn.

They also talked a lot about their little friends, about "Seppeli Änishänsli" and "Madeleine Rägenass." And there were many days when they set them up as examples for us, Seppeli and Madeleine. All of this made a great impression on me. It was a new world, a world that made me want to get to know it, and I was ever so sorry that I couldn't have been along in Grindelwald for the holidays.

Again and again, they kept talking about an elderly gentleman who spent all his summers in Grindelwald, a guest who came to the parsonage quite often. This was Mr. Schapiro. When they said, "Mr. Schapiro," there was an enormous amount of affection in the way they pronounced the name, "Schapiro." And every time it was as if a golden sunray fell into our nursery with that name. Mr. Schapiro must have been a great friend, and he must have been very fond of children. There was nothing more wonderful at the parsonage than when you could hear somebody call through the garden, "Mr. Schapiro is here!" That made the boys come down like lightning from up in the trees where they had been sitting. The girls let go of the Heidi books they were reading, and they came to meet Mr. Schapiro and they begged him to please, please come to the little garden house, come to play, come to play Charades or other little games.

He didn't always want to play. Sometimes a carriage was waiting for him in front of the portage. In it was his huge camera case. But he took as many children along as he could, and he sat amidst them like a rose in a bouquet of daisies, surrounded by the children. Off they went to the upper glacier, and the flower bouquet of children was singing:

> Our Mister Schapiro
> Has came back from Russia,
> The scenes on his Papiro
> Could not be any lusher.

Mountains, cows and glaciers far
In photos he will capture
For the pleasure of his Czar
those eyes they will enrapture!

[Unser Freund Herr Schapiro
Ist von Russland kommen,
Hat auf seinem Papiro
Alles aufgenommen,
Gletscher, Berge, Kuh und Schaf
Bringt er seinem Zaren,
Vivat unser Fotograf
Mit den weissen Haaren!]

This was sung to the melody of a popular song about Emperor Napoleon.

I just loved hearing about it: the games, and the rides in the carriage and the singing, all with Mr. Schapiro. I couldn't understand why I was considered to be too small to go to Grindelwald. But maybe, maybe next year. Maybe next year we'll go back to the parsonage and I will go along. But one day Mili, the younger of my two sisters, told me something else about Mr. Schapiro.

"Every Sunday," she said, "every Sunday, after their sermon, he came to the parsonage and all the children crowded around him, and then, then, he gave every one of us a franc," she said.

"What?" "A franc! Yes! All you had to say, very properly, was 'Good Morning, Mr. Schapiro,' and then you had to put out your palm, and he would put the franc into it." When I didn't want to believe this, she showed me her piggy bank and the floor of it was thickly tiled with shiny new silver francs. Oh, my God! I held my hand before my eyes. It almost blinded me. Every Sunday morning, one franc. A whole shiny silver franc. And it felt so pleasant in one's palm. And it was earned so easily. My goodness! This Mr. Schapiro, he must be so rich. Well, I liked him. It wasn't for nothing that my mother in those days called me Uncle Piggy Bank, because I was so concerned about my little piggy bank and I was worried because my little copper pennies seemed to always stay at the same level. Now, I saw a new possibility of earning more, or making this little crowd of coppers grow with silver francs. Good gracious! Next summer, it's got to be, it's got to be Grindelwald — Schapiro — hand out, stretch your hand out — franc, a silver franc! Mili, my sister, had a strange shell, a kind of monstrosity from the North Sea. When you held it to your ear, you heard the sea in it, you heard the roaring of the sea. But now I had something to hold up to my ear, too. My little penny piggy bank. That made much more beautiful music. And many times I held it up to my

ear during this winter and it went "pang — pang — pang." Every Sunday morning, I'd be getting them, the silver francs from Mr. Schapiro.

The next summer came and already I was told, "Don't think you can come and sit down at the table at the parsonage with dirty hands like that!" And then something happened, and I couldn't go to Grindelwald because we did not go to Grindelwald that summer....[2]

It was several years before I was able to go there. But during those years that I had to wait for the holidays in Grindelwald I often asked myself, who really was Mr. Schapiro? I knew nothing about him except that he was a gentleman full of goodness and full of little silver francs. That is a lot already, the goodness, of course. And something else I knew: that he was a Russian, that he was elegantly dressed, with grey gloves and a silken lavallière scarf, such as artists wear.

I would have loved to know more about him, and when I finally came up to Grindelwald, the very first morning I went to the back of the village, where the church and parsonage are, near the old trees. I was full of curiosity about this wonderful place where my brothers and sisters had been and about Mr. Schapiro. My first visit was to the churchyard, and for a long time I stood at the grave of the Glacier-pastor who had passed away the year before. Oh, I would have loved for the pastor to be standing next to me in the warm sun, to see the red geraniums blazing in their window boxes and to hear the buzzing of the meadows in bloom, and to see the glaciers glisten up above his beloved Grindelwald. But I felt as if I heard a little melody coming from the grave, something that sang,

Oh, do not mourn my passing away.
To paradise I've gone to stay,
There I'm even better off
Than down in Grindelwaldner-Dorf.

[O chlagit nit bin iser Lych
dr einzig Ort isch ds Himmelrych
was ysereim no besser gfallt
wan hie — im scheenen Grindelwald!]

I went on, passing between the gravestones and the crosses, over to the parsonage. I went once around the garden, through the hazelnut bushes, and finally, finally, I had enough courage to go up to the entrance, the entrance to paradise, and knock gingerly at the door. Right away a black angel appeared with a pipe in his mouth and asked me what I wanted. And when I told him, his face broke into a friendly smile and he opened the door for me, and he showed me everything — the garden, the gardenhouse where

they had played Charades, the parsonage with the visitors' parlor.

At the end he led me to the study of the Glacier-pastor. And then my black angel took a fat book off the shelf and showed it to me. What heaven! It was an album, a kind of chronicle of the parsonage, with pictures and little verses that everybody had put there, even little rhymes made up by the Glacier-pastor. I was jubilant when I saw a faint photograph that said, "Zäsebärghorn 1898." I saw a little group of children in the middle of the alpine flowers. In the center was the pastor with a black beard and a wide black hat — the Glacier-pastor — and my brothers and sisters were there with long, long alpenstocks and little faces that were so happy, as if they were little Edelweiss blossoms themselves. And there, that nice boy with the funny curls on his forehead. That must have been Seppeli _nish_nsli. I seemed to recognize him.

And now I even know how Mr. Schapiro looked. Everywhere in this album were pictures of him: short and sturdy, with silvery curls surrounding his friendly face. And everywhere he was, he also had his big camera with him. In one of the pictures it showed him with his head stuck in the camera! From the back you could see his legs under the big black cloth, and the pastor had written a little rhyme under this:

> Mr. Schapiro's pictures are
> The pride of people near and far.
> The Czar says when he looks at them:
> "Beautiful-ski gospodim!"

> [Der Herr Schapiro het drückt,
> Das ild isch sicher glückt,
> Und gsehts der Zar, so seit er gly:
> Mus ssere ssere schönsky sy!]

This album was a great source for me, together with some tales that I collected from Grindelwald inhabitants. And now I know just about everything about the rise and the end of Mr. Schapiro.

As we already know, he was a Russian, and he was a photographer. More than that, he was the court photographer to the Czar of Russia. He got this job all by himself. He started very modestly, as we can see on the picture of his shop from the year 1880. But through his art, and his taste, and with his lavallière, he made headway and became known in St. Petersburg. Soon every aristocrat wanted to have his picture taken by Mr. Schapiro. But the high point of his career was the famous jubilee of the Psheobrazhenski Regiment and the jubilee of the Belalakaja Hussars. During the festivities of these regiments, Mr. Schapiro had taken pictures of life in the regiment as well as of every one of the officers, each looking like Achilles himself. And if his profile was more a Psheobrazhenski profile than an Achilles profile, he worked with some spotlights and made highlights in a way that the officer came out looking classically beautiful, like an Achilles. All of the aristocracy and all of the military in St. Petersburg were enthusiastic about these pictures. And the Emperor heard about it so that both the Czar and the Czarina wanted to see those photographs. And they were fascinated by them and under every one of them the Czarina read,

> Wsewolod Wodschdoschni Wassilieff
> Schapiro.

When she read that she said, "Wsewolod, Wsewolod — you are my man! I have to have my picture taken by you!"

For some time both the Czar and the Czarina had been concerned about Russia. The Russian people weren't satisfied, and here and there they were talking about revolution. But the Czar and the Czarina couldn't be everywhere all the time and they couldn't see to it that everything was in order because their empire was so enormously big. This is how, inspired by Mr. Schapiro's photographs, the Empress had this idea: if she could not be close to every one of her subjects *in persona*, she could at least be there *in effigibus*. And she could make herself beloved by her people in this way. No house and no home, from Nowaja Semlia up to the Caucasus, should be without its portrait of the Czar and the Czarina. And as soon as the festivities of this particular jubilee were over and the Emperor's carriage regained the castle, whom did you see inside the carriage, sunk in the pillows: serious and silent, with the huge Russian camera obscura, and rosy and happy under his big Astrakhan cap that was pulled way down over his ears, Wsewolod Wodschdoschni Wassilieff Schapiro!

As was to be expected, the "Figibus," or the photographs that had been taken of the Czar's family, came out beautifully. The Czar was pictured in all his majesty with the Alexander Star on his chest and his beautiful forehead full of good thoughts for his people. And next to him, on the throne, the Czarina in multiple splendor, in her tiara, her beautiful eyes, and her little son, whom she held on her lap in front of her beautiful d_colletage. It seemed as if, from all that splendor, even the angriest revolutionary would have to capitulate. And the Czar and the Czarina were really enchanted by the photographs. They even told Mr. Schapiro personally how much they liked them. And not only that. In the name of St. Lukas, he became the Court Photographer of the Imperial Majesty, the Czar of Russia: he,

"Wwsewolod Wwodschodschni Wassilieff Schapiro!"

His pictures of the family of the Czar could be found everywhere in Russia. And thanks to his Court Photographer, the Czar was now able to look into every Russian house and see what was going on there. He was there when, in Siberia, they sharpened their knives to cut up a polar bear. And he didn't blink when one of the sailors on the Volga took a big sip from his vodka bottle. And the mother of all of Russia was able to look into the poorest village and she could see how high the corn grew. But not only the majesty of the ruling couple and the love of the Romanoff dynasty was carried into the most remote village of the Russian Empire, but also the four little words that were written under every one of those photographs in the right-hand corner in fine, old-fashioned handwriting: "Wwsewolod Wwodsdosny Wassilieff Schapiro."

From then on, all winter long, the most elegant sleighs stopped in front of the residence of the Court Photographer. And while snowflakes danced, his servant Igor opened the door of the carriage and Sasha led the ladies and gentlemen upstairs and helped them to get out of their heavy fur coats. There was no end to the sparkle and splendor from all the medals, the St. Michael's Cross, and the Medal of the Order of Sts. Peter and Paul.

That hot summer, when it became more quiet in the studio of Mr. Schapiro, the Grand Dukes and Grand Duchesses of St. Petersburg had left for their country estates. After they all had left, Mr. Schapiro would recall another Grand Duchess who had a beautiful profile and the most beautiful and whitest shoulders in the world. She was a Duchess of snow and ice, who could be seen high up there from Grindelwald. It was the Hasli-Jungfrau. He longed to be there with the Glacier-pastor at the parsonage and with his crowd of children. But he had to stay put until the Czar allowed him to go away, allowed him to go away with a kind letter just as one summer, when he wrote him the following one. It was a letter full of humor. He said:

> Today I am leaving for Zarskoje-selo
> For horseback riding or riding the 'Velo.'
> His Majesty won't return till September.
> I'm free from photography till then.
> Please remember!

> [Är verreis jetz uf Zarskoje-selo
> Wöll dört sech erhole — uf em Ross oder uf
> Siner Majestät allerhöchstem Velo,
> Bis im Herbst si z Sankt Petersburg nümme
> me gsee lo,
> Es möchti bis denn der Herr Hoffotograf
> Fotografisch ne si lo ...!]

Now, Mr. Court Photographer was free, free to travel! "Bobrusche," he said. "Bobrusche ddjaddjavjet." And he closed up his camera and Igor and Sasha packed his suitcases. And then he went on his trip, and he travelled day and night, day and night, always following the red evening clouds where the sun had gone to sleep, until he finally came into the West, and into the country where the landscape becomes steep and rises sharply up to these red clouds with the pink turrets that look like castles that peer down from above the clouds. Deep, deep down below little locomotives huffed and puffed — tsch, tsch, tsch, and tsch, tsch, tsch — and they carried Mr. Schapiro with his things up through the narrow valley, barely missing the rocks on the side. And Engineer Rubi sang:

> Now we're at the journey's end
> Arrived at last in Switzerland
> The "Count" from Russia's back, heigh-ho!
> What joy the parsonage will know.
> A joy that comes just now and then
> When our Foto-Graf (photo-Count) is here
> again.

> [Jetz si mr a dr Viescherwand
> An yserem Ziel im Schwyzerland,
> Die wärde Freud im Pfarhus ha,
> Dr Graf vo Pee-tersburg isch da,
> Die wärde Freud im Pfarhus ha,
> Dr Foto-Graf — isch wider da!]

The next morning, he rang the pastor's doorbell and the pastor's wife said, "Hedi, please go and open." And Hedi ran down the stairs and opened and ... "Oh, Mr. Schapiro! Hello, hello, Mr. Schapiro!" And already the pastor was up from the table, his wife had thrown the iron down on the ironing board and they both ran to the door. "Mr. Schapiro is here! Good morning, Mr. Schapiro!" Everybody called through the garden, "Mr. Schapiro is here! Good morning, Mr. Schapiro!" "Mr. Schapiro!" Every branch called out, and every little robin. And the boys came sliding down the branches from the trees, and the girls came running out of the garden house and there was jubilation around Mr. Schapiro. He had one child at every finger, and on every one of his coattails. And they sang and danced around him:

> Our dear friend Schapiro,
> Has returned from Russia.
> And he brought his Papiro
> But he left his Kasha.
> On his photos one can find
> Great Czar with his castle.
> And look, there is the little Czar
> With his Cossack's tassle.

And we children soon shall see
All this lovely treasure.
Then we all shall dance with glee
To show him our great pleasure.
Schapiro, holleradiriri-ho! holleradiriri-ho!
Schapiro, holleradiririho!

[Unser Freund Herr Schapiro
Ist von Russland kommen.
Hat er auch sein Papiro
Wieder mitgenommen?
Steht darauf der grosse Zar
Vor dem Kaiserschlössli?
Oder gar der Kleine Zar
Als Kosak mit Rössli?
Alles wird Herr Schapiro
Seinen Kindern zeigen.
Ihm und seinem Papiro
Singen wir im Reigen:
Schileringgelibujäää...
Schileringgelibujäää...
Schileringgelibujäää...]

And then it started all over again, with Charades and riddles and carriage rides and silver francs and so forth. And this is how it went every year.

And Mr. Schapiro's hair turned grey. And Mr. Schapiro's hair turned white. But his cheeks were always like two roses. And every June, when the meadows in Grindelwald were full of blooming Queen Anne's lace, Mr. Schapiro would appear. He would appear in the meadows at the same time as the green-white Queen Anne's lace parasols. With his own silken green parasol, he could be seen walking back to the parsonage.

This is how it went until the first World War. But when the great fire that swept over Europe was extinguished and when the nations returned to normal, Mr. Schapiro did not return to Grindelwald. All the many letters written by his Grindelwaldner friends couldn't bring him back. Mr. Schapiro had gotten lost in the bloodbath that killed the family of the Czar during the Russian Revolution. He was not heard of again. But he was not forgotten. His memory stayed alive with everyone who had ever come to the Grindelwaldner parsonage and who had received his friendship and his kindness. And when many years later, on a Sunday morning, old Mr. Änishänsli gave a shiny silver coin to his little grandchild for his piggy bank, and when, at that moment, sunshine glistened in the boy's hair, then I was sure that it was a greeting from Mr. Schapiro.

As for myself, I was not among those who received the silver francs of the Court Photographer of the Czar and who were able to house it in their little piggy bank of memories. I want to do something for the memory of Mr. Schapiro. I want to add a story to my own memoirs:

> Chapter One has now been told
> Of "Holidays in Grindelwald,"
> Which I dedicate on this papiro
> To the memory of Wwsewolod Wassily Schapiro!
>
> [Ferie z Grindelwald — das isch dr Titel,
> Jetz kenne mr afe — serste Kapitel,
> I widmes, mit Dinten uf Papiro
> Em Wwsewolod Wassilj Schapiro!]

REFERENCES

1. Originally privately printed in 200 copies in Solothurn, 1961, as *Ferie z Grindelwald, Landhauskantate, Fürio, Fürio*. Werner Miller (1892-1959) was a noted painter and designer whose works can be seen in the art museum of Solothurn.

2. A lengthy excursus here on the painter, Cuno Amiet, is omitted in this translation.

Thinking about Stieglitz, Once More, With Feeling

Estelle Jussim

Much has been written about this man, and inevitably one comes up against a summary statement like this: "Alfred Stieglitz, photographer, aesthete, propagandist, and art dealer, was without question the most important single figure in the development of modernism in America."[1] It would seem to be obvious that "Stieglitz is amazingly difficult to write about."[2] The measure of the man is burdened with too many monuments. To approach him through his authorized biographers is rather like approaching a sacred mountain: the path to the holy of holies is so well-trodden that no new path seems available, the light from the sanctuary too brilliant to permit close scrutiny of the idol, the high priests and priestesses too vigilant, the litanies hyper-hypnotic.

To approach Stieglitz through art history and criticism is somewhat less like visiting a temple, but still subjects the would-be critic to the blinding glamor of names like Matisse, Picasso, Rodin, Marin, Georgia O'Keeffe, artists whose careers in America Stieglitz, often unselfishly and with great personal sacrifice, helped to establish.

To sort the pious proclamations in the attempt to discover omissions, contradictions, or outright myths, to locate the psychological center of a personality, or to seek the true boundaries of his photographic talent in the space of a short essay is impossible to accomplish in the depth which the subject demands. And to limit oneself to evaluating only the most

important of his innovations or accomplishments is itself a herculean task.

Consider what is claimed for him: in photography itself, he is credited with having been the father of modernism. He established one of the first and most significant photographic groups in America, the Photo-Secession, in 1902. His gallery "291" was one of the first to encourage the careers of major European and American avant-garde painters and sculptors well before the revolutionary Armory Show of 1913. He provided equal gallery access to photographs despite the prevailing opinion that the camera was only a mechanical toy. His publication, *Camera Work*, was not only the most important photographic journal of the first decades of the twentieth century, but was the first to publish the work of writers like Gertrude Stein.

His photographic career itself was considered a series of "firsts:" he is variously credited with having been the first to photograph at night, first to photograph a blizzard, first to photograph rain, the first to demonstrate that a picture could be snapped, developed and printed in the then amazing time of thirty-five minutes, for news photography. He was the first American to gain international acclaim as a member of the secessionist Linked Ring Brotherhood, among the first to experiment with Lumière's autochromes, among the first to discover the artistic uses of Pizzitype paper, among the first Americans to

exploit platinum papers, the first American photographer to establish the artistic use of the camera for a snapshot effect of the unposed "moment in time," the first American to have a substantial group of his photographs accepted into the permanent collection of a major American art museum, the first American to insist that photography had its own distinctive characteristics and merits equal to any of the so-called "fine arts." This is an almost stupefying list of accomplishments, to which must be added the frequent comment that he was completely original in his pictures.

Like Gaul, the study of Stieglitz's life and career is usually divided into three parts: the early period, from 1883-1901, when he went back and forth to Europe, there encountering various avant-garde movements in both photography and painting; the middle, or "Photo-Secession" period, from 1902-1917, when he established himself as the tireless leader of the avant-garde in the United States; and the late period, from 1917-1937, when he became the acknowledged guru of photography and artistic wisdom, "an American seer."[3] This periodic arrangement oversimplifies not only a complex man but a complex period. His long life — beginning with his birth in Hoboken, New Jersey, in 1864, to his death in New York City in 1946 — encompassed a revolution in photographic ideals and technology, exemplified the anguish of the artist in materialist America, and ultimately saw the victory of both photography and modernist painting in the battle against academy and establishment conventionalisms. To put it in a single word, Stieglitz was, and represented himself as, a *rebel*: not in politics, not in social reform, not in economics, not in psychology, but in the life of pure form, the life of aesthetic ideals. However much he can be discovered to have been a synthesis of the Orphism of Arthur Dove, the lyrical Abstractionism of Kandinsky and O'Keeffe, the Symbolism of the writer Maurice Maeterlinck, or fauvist simplifications, however much he actually appropriated the ideas of Peter Henry Emerson, Max Weber, Charles Caffin, Maurice de Zayas, or most significantly, Edward Steichen, he saw himself as a rebel and revolutionist, and he was, moreover, exceedingly morose when he believed that his rebellion had been preempted by others.

The specific psychological etiology of that rebellion must remain indeterminate. André Malraux believed that "Artists do not stem from their childhood, but from their conflict with the mature achievements of other artists; not from their own formless world, but from their struggle with the forms which others have imposed upon life."[4] Yet the childhood of Stieglitz is

revealing and prophetic. He was the eldest son of a successful German-Jewish immigrant, who established himself ultimately in New York City and in Lake George, New York. His parents were sociable, liberated, intellectual, art-loving, and given to violent squabbles over money. Frau Stieglitz could not stay within a budget, and until Herr Stieglitz mastered the woolen trade, little Alfred was treated to a nasty succession of parental money fights, so nasty, in fact, that he forever after detested talking about money, was loathe to ascribe a dollar price to the artifacts he sold, and accepted a life of comparative poverty rather than engage in the customary wheeling and dealing of art gallery commerce.

While the subject of money was made disgusting to the child, there were other compensations on the family scene. As the oldest child, Alfred was the center of attention, a position of hierarchical importance which he assumed was his absolute right in later life. His father was an aristocratic tyrant who dominated the family with the same kind of lofty arrogance, loquacity, and garrulous hauteur that Alfred was to reveal in his later gallery years, in his persona as the American sage. Great crowds of friends and acquaintances came and went. There was always generous encouragement for artists — in fact, the Stieglitz ménage supported an indigent painter — and always, constantly, there was talk of the arts and great admiration expressed for painting.[5] The Stieglitz house was, in effect, a transplanted European salon in which Alfred's later celebrated view of art as a "collective" of the elite undoubtedly received its original impulse. At the same time, with no threat of contradiction, his parents encouraged romantic individualism, a worship of genius in the best mid-nineteenth-century mode.

This view of the romantic hero as the great individual who bestows upon the masses his greatness and vision was, of course, basically autocratic and elitist, not in the democratic American vein. It was more aligned with the ideas of Friedrich Nietzsche and his solitary *Übermensch* who would dispense heroic largess than with, say, Walt Whitman's "I Sing America," with its celebration of the democratic vision, a glorious equality out of which all humanity would rise to new heights of selfhood and enlightenment. All his life, Alfred viewed society and the artist as inimical, irreconcilable enemies, and it is not surprising, perhaps, that his favorite book was Goethe's *Faust*.

It should not be forgotten that for all he iterated and reiterated "I am an American," Stieglitz was educated in Berlin, at the Polytechnic Institute. Discovering that he had little interest in mechanical engineering

but much in photography, he secured the attention of Dr. Hermann Wilhelm Vogel, whose invention of orthochromatic film was to make possible many of his young student's photographic achievements. Although he was a major investigator of photographic sciences, Vogel could hardly keep pace with Alfred's driving pursuit of perfection, his tireless experimentation, his revolutionary attempts to discover the absolute limits of the photographic processes of his time. During these brief years of hectic exploration, he tested what was then a startling idea: as long as any kind of light is available, there can be photography.

In an absolutely literal sense, the availability of new technologies created the potential out of which young Alfred could produce his significant innovations. It was the introduction of ready-made dry gelatine plates, films and emulsions twenty times faster than previous materials,[6] and relatively small hand-held cameras, which made it possible for Stieglitz to develop a particular photographic aesthetic based on the new capacity for low-light conditions and for the hand-held, seemingly informal "snapshot."

The aesthetics of photography in the 1870s and early 1880s were under the domination of one man, Henry Peach Robinson, the greatest of the English pictorialists. Robinson was noted for his composite pictures in imitation of the sentimental and moralizing tableaux of his contemporary genre painters. To have a print resemble a painting was the height of photographic ambition, and Robinson's many influential books, published in many editions and many languages, offered easy hints for painterly compositions in the grand manner.[7] Robinson's techniques of combination printing, using a multiplicity of negatives to achieve one predesigned master composition, may be admired today in the work of such photographers as Jerry Uelsmann, but in the 1880s it was beginning to be felt that such manipulation was contrary to some intrinsic nature of photography.[8] The example of the daguerreotype, with its mastery of detail, sharp focus, and straightforward recording of "reality," was elevated to represent the very essence of photography. Between these two antipodes — the ideal of imaginative pictorialism, the ideal of discoverable reality — Stieglitz would have to wend his way toward the formal purism he ultimately espoused.

His first corpus of images of any interest was taken on a vacation trip to Italy in 1887, when he was a curly haired, slight young man of twenty-three. In that year, he received his first award for "A Good Joke; Venice," from no less a luminary than Peter Henry Emerson, one of the most provocative figures of English photography, whose direct influence on Stieglitz has been overlooked until recently.[9] "Dr. Emerson. Wasn't he that irritating man — sort of a fanatic, really — who preceded Stieglitz?"[10] This is the delightful opening sentence of Nancy Newhall's work on one of the founders of modern photography. Emerson was only eight years older than Stieglitz, but by the time he came to compliment young Alfred's print for having "the most spontaneous" quality among the heaps of pictures he had been judging for the *Amateur Photographer*'s "Holiday Work" competition,[11] he had already achieved a magnificent body of work, superlative platinum prints and photogravures of the Norfolk Broads and East Anglia, and he was in the process of writing a book which proved to be the opening salvo in the war against the pictorialist ideals of manipulation and painterly imitations.

Alfred had been heavily under the influence of painterly aesthetics in Berlin. "Then he became aware of Emerson, and 'truth to Nature,' and the delicate beauty of a platinum print. A great light seemed to burst upon him, illuminating not only where he had been trying to go in the past but where he was truly going in the future."[12] This "truth to Nature" ideal was not that of the scientific precision for which earlier critics like John Ruskin had praised the daguerreotype. This was rather a view of the natural world which suggested that "a photographer could imbue ordinary subjects with artistic quality bearing a personal stamp; consequently there was no need to resort to the artificialities of the fine art photographers."[13] By using differential focus instead of edge-to-edge sharpness, Emerson contended that photographers could make a subjective selection of the point-of-view in the camera, thereby removing once and for all the denigration of the camera as a mere mechanical contrivance incapable of producing "art."

During the writing of his *Naturalistic Photography*, Emerson wrote to Stieglitz in Berlin to inquire if the young bilingual American would consider translating the manuscript into German. Stieglitz was, therefore, the first American to have the privilege of reading Emerson's revolutionary theorizing. The experience of encountering this first statement concerning "pure photography" was overwhelming. What Emerson was declaring was that photography was an independent medium, with its own intrinsic characteristics and with the potential to create great art, that it could produce art because it could permit the expression of personal vision, that its primary effects lay in the unretouched image of reality, and that this effect should never be diminished by

combination printing or manipulation. To cap it all off, Emerson — flying in the face of the edicts of Henry Peach Robinson — also declared that composition did not depend on painterly "rules or formulas."[14] That photography might be an independent medium, to be admired in its own right, was a declaration of personal freedom to Stieglitz. According to Nancy Newhall, Emerson's ideology of naturalistic photography "became Gospel to the young Stieglitz, and apart from a few manipulative experiments, he adhered to them personally all his life."[15]

Whether Stieglitz ever acknowledged his debt to Emerson, or whether he incorporated Emerson's ideas into his own ego, guiltlessly and with the sublime disregard of genius, cannot concern us here. Emerson remained true to his first vision of photography, essentially that of the nineteenth century. Stieglitz, thanks to the impact of French Impressionism, Post-Impressionism, formal abstraction, and cubism, became the exponent of purism and the spirit of the twentieth century.

The America to which Stieglitz returned in 1890 was a severe disappointment to him. It resembled a materialist hell, where the great robber barons — Mellon, Carnegie, Rockefeller, J. P. Morgan — were ruthlessly squeezing out all opposition. The next twenty years saw the struggle of the government to control the mammoth trusts. It was a time when photographers like Jacob Riis and Lewis Hine would use the camera to strip complacency from the bourgeoisie. But not Stieglitz. He was horrified by the materialism, but for him there could be only one sublime mission: to cultivate the barbarians through art. He was among those who viewed the new enlightenment as destined to come from liberated modern individuals who could transform the masses. Only in this context can we understand Stieglitz's apparent disdain of social realities. If photography or painting were to serve humanity, it would be through the example of "art as the only true expression of the individual in our mechanized society."[16] Instead of condemning him as an elitist, we should perhaps view Stieglitz as naively sharing the optimism of a certain era: that the arts could literally become the Savior of all that was worthwhile in the human condition.

Stieglitz, however, did not believe that it was only through the work of a solitary individual that such a messianic purpose could be achieved. He polemicized. He proselytized. With glass slides he lectured and demonstrated to the members of the various camera clubs in New York City what it meant to wait for the precise moment, whether in a snowstorm ("Icy Night," 1898) or on trolley tracks ("The Terminal," 1898) or when the driver of a horse-drawn coach might make the precise gesture that created for Stieglitz the optimum aesthetic moment when all the desired components of an image were in exactly the right relationship. It was certainly Emerson's idea of pure photography that he was promoting, photography created in the camera and not in the darkroom.

Stieglitz was part of an international movement that saw him as its American representative; yet, in America, he knew he needed allies. These he soon found in Edward Steichen, Frank Eugene, Gertrude Käsebier, Joseph T. Keiley, and Clarence White. With these, and other proponents of the new photography, Stieglitz founded the influential movement known as *Photo-Secession*, in imitation of European secessionist movements in the visual arts.

This was 1902. What was paradoxical about the Photo-Secession was that its primary aim was "the advancement of pictorial photography."[17] The problem of what constituted "pictorial" photography had become even more complicated by the invention of yet additional photographic technologies that permitted direct manipulation of the print by sponging, brushing, spraying, or scratching. These processes, which included gum bichromate (1894), oil pigment (1904), and bromoil (1907), seemed to guarantee that photography would be free forever from the stigma of being totally dependent on mechanical devices. The conception was that handwork was necessary to create "art," and so, thanks to special pigments, textured papers, and deliberately painted effects, many of the Photo-Secessionist pictures resembled more the traditional graphic arts of drawing, etching, engraving, aquatint, or lithography, than they did the ideal of the unretouched, pure image selected from nature by a discerning and "artistic" eye. It is decidedly odd that while Stieglitz was an adherent of what became known as "straight" photography, he was nevertheless encouraging the work of Käsebier and Clarence White, among others who imitated the aesthetics of painting unabashedly.

Especially in his magnificent publication, *Camera Work*, which he edited and published in fifty numbers between 1903 and 1917, is this paradox apparent. While the more zealous of his followers treat *Camera Work* as a modernist Bible, it is surprisingly uneven, more to be lauded perhaps for its publicizing of the works of Rodin, Matisse, Picasso, than for its many exquisite small reproductions. The pictures themselves, when they were not by his greatest colleagues, were often mere hackwork, and the total

environment in which they appeared would strike many modern sensibilities as campy, sentimental, and high-blown.

A typical example of this environment might be Stieglitz's own photograph, "The Flat-Iron Building, New York," which appeared in *Camera Work* in 1903. The plate is impressively simple, sharing the aesthetic character of the French Impressionists with the influence of Japanese woodblocks. In compressed, decorative space, Stieglitz managed to create the fine detail and well-organized masses in which the traditional graphic arts had succeeded so well. Yet this perfect little picture, which stands so well on its own, was preceded by a long essay on the architecture of the Flat-Iron Building, a dreadful poem "To the 'Flat-Iron'" by "S.H." — no less than Sadakichi Hartmann, the elegant art critic who became one of Stieglitz's advocates — and the whole was accompanied by a photographic landscape by one Arthur E. Becker that resembled nothing less than a distraught green lithograph.

There was, in fact, and to put it quite bluntly, an almost incomprehensible amount of junk in this most famous of camera journals. Only the greatest photographic reproductions culled out of these can withstand contemporary scrutiny. Yet their importance at the time was incalculable. "The impact of these pictures lay not in their style, for they were admittedly painterly, but in the very fact that they were *photographic* restatements of painterly concerns."[18]

Simultaneous with his activities in the journal, Stieglitz, much influenced and probably led by the painter-photographer Edward Steichen, opened the "Little Gallery of the Photo-Secession," at 291 Fifth Avenue. Soon it would be called only "291." It was opened for reasons which become clear if we recognize that Stieglitz had one major obsession and one obsession only: to make photography the equal of the other visual arts; by extension, to make of himself, as a photographer, the equal of artists. The dual purpose of "291" was to permit photographs to be judged in the same setting and under the same conditions, and, if need be, side-by-side with paintings, drawings, watercolors, and the traditional graphic arts. What was avant-garde in painting would serve only to free photography all the more from the conventions of the past.

Steichen went abroad, to Paris, and from Paris there shortly emanated work for exhibitions by Rodin and Matisse (1908), Toulouse-Lautrec (1909), Henri Rousseau and Cézanne (1910), Picasso (1911), Picabia (1913), Brancusi and Braque (1914) and Severini (1917). John Marin also received an exhibition. Not only were the most advanced modernist artists exhibited for the first time in America, but Stieglitz also gave room to the world's first exhibition of children's art (1912) and to black African sculpture (1914). The most anti-establishment movement of all time, that of the Dadaists, was given its primary American push through Stieglitz's publication of a now rare and precious journal, *291*. In other words, on all fronts and in as many ways as possible, Stieglitz was helping to establish the equality of the arts, as well as the freedom of all the arts to express whatever was important to individuals.

With the notable exception of William Innes Homer's all too few comments in *Alfred Stieglitz and the American Avant-Garde* (1976), the aesthetic interaction between what Stieglitz exhibited at "291" and what and how he was photographing at the time has never been adequately explored. He did boast, however, that Picasso had said of his photograph "The Steerage" (1907) that Stieglitz was working in the same way that he was. This can only imply that Stieglitz saw himself as a proponent of pure form in which the four edges of a two-dimensional rectangle became the playing field for the dance of abstract shapes. John Szarkowski had remarked that "sometime before 1910...the character of his work changed. It is as if the earlier pictures were ideas recorded by his camera, and the new ones discovered in it."[19]

With the opening of the Armory Show of 1913, the first major exhibition of avant-garde European art in the United States, Stieglitz undoubtedly recognized that his own personal crusade was over. While the works of the modern masters were exploding in the face of an uncomprehending and outraged American public, Stieglitz quietly put on an exhibition of his own photographs. After that, the spirit seemed to go out of him. William Homer conjectures that it was his failing marriage to an unsympathetic woman which was the primary cause of his despondency and lack of productivity immediately after 1913. But this was perhaps only a small part of his recognition that he was no longer the undisputed, if self-appointed, leader of modernism in America. For a man whose ego demanded the center of attention, the fact that he had been deliberately kept out of the preparations for the Armory Show must have been bitter.

In 1917, an era in photographic and visual art history suddenly came to an end. *Camera Work* petered out with a mere thirty-seven subscribers, the building housing "291" was about to be torn down, America entered the first World War. But it was perhaps that so much was coming to an end that prepared him for a new beginning. That new

beginning was, of course, his first meeting with Georgia O'Keeffe. The story is well known, but bears repeating. Seeing in her first abstract watercolors the rather patronizing but apparently erotically exciting idea of the first statement of "woman" in art, he became infatuated with her. With O'Keeffe as both personal and artistic inspiration, he began what is probably his most important *oeuvre*: a continuity of over five hundred prints of portraits of O'Keeffe produced between 1917 and 1937. Most of these have remained in relative obscurity because of their presumed erotic content. But Stieglitz had found a new obsession: not only O'Keeffe herself, but the idea of a new kind of portraiture, one which would not portray the face alone, but which would depict a subject from all its facets. "Hands, feet, torsos, tones and lines, molded by every possible experience, mood and emotion — taken over the years — all belonged."[20] The first showing of some of these O'Keeffe portraits was at a retrospective exhibition of his work at the Anderson Galleries in 1921. They made a tremendous impact on his audience, with one critic writing, "Intimacy with woman's body is translated into the equivalent of man's most acute and crucial contact with everything in life....Stieglitz's photographs of woman are the image of a total immersion in life."[21]

Other writers described this exhibition as having shattered all traditional concepts of portraiture, of evoking character in the same way that only "great psychological novelists and artists of the Freudian school of psychoanalysis" could portray.[22] The idea that only a *series* of pictures of an individual could reveal personality might be linked to the cubist idea of viewing the subject from all sides, but it was perhaps for Stieglitz more of a liberation of a poetic impulse for which the abstractionists and the cubists had provided only the preliminary impulse. This poetry depended on synecdoche, a figure wherein the part stands for the whole. It was a kind of poetry that resembled the work of his disciple, Paul Strand, at least in its formal aspects.

The year 1923 was another turning point. If one writer had seen the O'Keeffe portraits as "woman's body...translated into the equivalent of man's most acute and crucial contact with everything in life," then that idea of *equivalent* came now to dominate Stieglitz's interests. In the summer of that year, at Lake George, Stieglitz made his first small photographs of clouds, pictures he later titled "Songs of the Sky" and "Equivalents." And here he begins to reveal what may have been for him the underlying impulse of all his photography: the idea of Walter Pater's to the effect that all art approaches the

condition of music. It was an aesthetic ideology pursued by O'Keeffe in her own abstractions, one which had been encouraged in Stieglitz by his contacts with the Orphists, particularly Arthur Dove. The superlative, poetic messages of these small prints were, indeed, like songs, but purely nonverbal. Words cannot describe them, although words can attempt to describe his intentions. To at least one writer, the pictures were "the graphs of Stieglitz's spirit creating in 'remote' figures the generalizations — ideas of attraction and repulsion, struggle and unity, peace and conflict, tragedy and deliverance — that emerge from every individual experience to become part of our knowledge and preparation for other experience."[23]

Stieglitz himself wrote, in what can only be described as gush, that he wanted a series of pictures that would force the composer Ernest Bloch to exclaim, "Music! Music! Man, why that is music! How did you ever do that? And he would point to violins, and flutes, and oboes, and brass...."[24] The photographer even claimed that Bloch responded exactly as desired, verbatim, which seems rather unbelievable, even if true. But there was much more than music in his intentions. He confessed that the cloud pictures were an opportunity to "put down my philosophy of life — to show that my photographs were not due to subject matter — not to special trees, or faces, or interiors, to special privileges...."[25] For Stieglitz, these cloud pictures, the *Equivalents*, were the summation of over forty years of photography, and if he considered them as such a summation of such a distinguished career, it may be that these need to be studied more than any others of his work.

Stieglitz always seemed to be seeking what literary critics call "the objective correlative," that visual or verbal correspondence to the artist's mood or to the ideas he wishes to communicate. Equivalence, however, became the single most obfuscating part of his achievement. We can only have the greatest sympathy for Minor White, who spent much of his career trying to explain what "equivalence" really meant. Perhaps the closest he ever came was in this statement: "The power of the equivalent . . . lies in the fact that [the photographer] can convey and evoke feelings about things and situations and events which for some reason or other cannot be photographed."[26]

One of the greatest and most vociferous of the straight photography advocates, Alfred Stieglitz, turned toward abstraction, symbolism, and mysticism. The cloud pictures, the "songs of the sky," are among the most beautiful, most subtle, most evocative of all his creations, especially if they are studied quietly in a still room. What became absurd

were his and his disciples' exegesis on their meaning or intention.

There was a final period of Stieglitz's activities as a gallery owner, of which the most significant achievement was probably the introduction of Paul Strand to the public. First at the show of "Seven Americans," then at the Intimate Gallery, which was part of the Anderson, and again at An American Place, his last gallery, Stieglitz continued to espouse the cause of modernism, anti-establishment art, photography which broke with convention, and any impoverished artist whom he felt deserving of support. From 1929 to 1946, An American Place ran about seventy-five exhibitions, of which the only new photographic work shown was by Ansel Adams and Eliot Porter. In 1933, at a time when he seemed most discouraged by the Depression, and by the unassailable ignorance and conservatism of the American public, he was about to destroy the collections of photographs taken by his colleagues during the "291" period. Fortunately, the Metropolitan Museum of Art requested and accepted these, and his own prints of that era as well, for the permanent collection.

His spirits were also buoyed by an almost cloyingly eulogistic book about him, hastily put together by literary, theatrical, and artistic luminaries, including Lewis Mumford, Paul Rosenfeld, Waldo Frank, John Marin, Marsden Hartley, Gertrude Stein, Sherwood Anderson, and Paul Strand. The book, *America and Alfred Stieglitz* (1934), codified his real and imaginary achievements in Whitmanesque hyperbole, correctly, however, serving notice on the American public that it had conceived, neglected, and rejected a genius in a new art form. Unfortunately, it established the idea that Stieglitz had sprung somehow, like Minerva from the head of Jupiter, from some God of Photography, a total original, a total innovator. Any reassessment of the fulsome praise lavished on him is made much more difficult by the irritating persona which Stieglitz assumed in his later years. His zeal for perfection had begun to cripple the souls of many of his friends. His possessiveness about her work forced even his wife, O'Keeffe, to beg that he attempt some gallery sales. His obsession with the absolute, the ultimate purism, was "imperceptibly converted into a kind of hyperesthetic, ultracritical refusal."[27] He had developed a solipsistic inversion, "a tendency to dramatize his thoughts in terms of his own destiny, the prestige and magnetism of his own personality."[28] He talked compulsively, in a manner characterized by some as lacking in scholarly or critical logic. Logic, of course, was not demanded by the hordes of women who came to adore him, almost literally to kneel at his feet.

In the words of one of his biographers, who was being perfectly serious as she wrote this, "As the form of a Gothic cathedral is a symbol of reaching toward the skies, and includes in the magic of its very being the point it aspires to touch, so the clean, sharply defined cubes are the parts of An American Place…are in simple and forthright manner a symbol of holding the Kingdom of Heaven within"[29] If that were not sufficiently Biblical to persuade us that we are in danger of committing a mortal sin if we do not worship the personage of Alfred Stieglitz, we have pronouncements from the sage himself which come dangerously close to being such a parody of scripture that they can only provoke laughter. For example, an awestruck person asked Stieglitz who he was. The sage replied, "I am the moment. I am the moment with all of me and anyone is free to be the moment with me. I want nothing from anyone. I have no theory about what the moment should bring. I am not attempting to be in more than one place at a time. I am merely the moment with all of me."[30]

One would almost be tempted to think that Stieglitz was here pulling Dorothy Norman's attractive young leg — she did become his mistress, after all — except for the well-documented fact that in his last years he talked incessantly, endlessly, ferociously, orgiastically, pompously, messianically, and often, at the same time, with a miraculous humility. But talk he did, and his talk was what many went to An American Place to hear. The contradictions of the simplicity and control of his photographs — so abstract and removed from the quotidian, especially the late city-scapes taken from his high window at the Hotel Shelton — with the almost disorganized verbosity of his gallery talks were unbearably painful to his serious admirers. His fellow New Yorker, Berenice Abbott, could say, "In the case of Stieglitz, who was an institution within himself, and who was God to many, and to many others not at all, he did make, when he ventured outside himself, a few great pictures."[31]

In the opinion of many other critics, however, Stieglitz made more than just a few great pictures. Yet what seems significant about the career of Alfred Stieglitz is not whether he managed to create great pictures, but that he raised the most fundamental questions about the nature of photography in each of the periods of his work. Everything that Stieglitz did or thought can be considered from the point of view of these major questions: *What is it in photography that distinguishes it from all the other visual arts? What are the limitations, the opportunities, the specific*

characteristics of photography? Can photography seek and discover new forms of expression unattainable in the other arts, or will it always rely upon the same pictorial aesthetic as does painting?

Stieglitz was trapped into several paradoxes of his own making and several more that arose out of his specific historical context. In the attempt to elevate photography to the same level of appreciation as one of the fine arts, he insisted that each photographic print be unique, perfect, as rare and therefore as precious as a limited-edition etching, aquatint, copper or steel engraving, or lithograph. Whether he realized it or not, he was, therefore, denying that aspect of photography that made it the single most important medium for the multiplication of images since the invention of typographic printing. By denying the multiplying potential of photography, a potential made possible by the negative/positive process invented by William Henry Fox Talbot, by denying that photography had any mechanical aspect, he was attempting to demonstrate that photography could partake of the hand-crafted aspects that had always distinguished the fine arts. Simultaneously he was subverting one of photography's essential characteristics: "Many of my prints exist in one example only. Negatives of the early work have nearly all been lost or destroyed. There are but few of my early prints in existence. Every print I make, even from one negative, is a new experience, a new problem. For, unless I am able to vary — add — I am not interested. There is no mechanicalization, but always photography."[32]

The darkroom, then, was as important to Stieglitz as it was, and remains, to many other photographers, despite his insistence that it was the art of pre-visualizing that was the art of photography. Photography did not begin and end, as Peter Henry Emerson had seemed to suggest, with the composition, timing, and precision of the eye in conjunction with the camera, as an extension of one sense. Photography, to the contrary, was a complex process, which only began with the camera, continued with fatiguing, patient work in the darkroom, and ended with the appropriate matting of the picture for display on a wall.

Upon careful, slow, and reverent scrutiny, the "equivalent" pictures might be illuminated by this passage from Suzanne Langer concerning the fundamental property of art: "It is detached from the rest of the world in that all of its parts are charged with heightened meaning — none of its relationships seem accidental, all of its properties seem important to its meaning...it is...a crystallization of the essence of the phenomenal world in a form that can be immediately perceived."[33] None of the parts of Stieglitz's mature photographs seem accidental: that is true. All of the properties of a Stieglitz photograph — from composition to print quality, from idea to the choice of paper — seem important to its meaning. Many of his photographs, especially the later ones, crystallize some particular essence of the phenomenal world in a perceivable, apprehensible form. These are the characteristics of many great paintings, although much of this conception of art seems to emanate from the necessity of making a statement about the three-dimensional world on a two-dimensional surface, a problem shared both by painting and photography.

Stieglitz himself seemed to apply one more criterion of greatness which was, to him, of greater significance, and imponderable, immeasurable, subject to the most individualist interpretation: "Is the thing felt — does it come out of an inner need — an inner must? Is one ready to die for it?...That is the only test."[34] It is a test which only a compulsive perfectionist, an elitist, a truly romantic individualist, a seer whether phony or real, an artist committed with all his heart and soul to the creation of significant work, could demand. It is a test that postmodernists would scorn: we no longer die for art.

REFERENCES

1. Milton Brown, *American Painting: From the Armory Show to the Depression* (Princeton, New Jersey: Princeton University Press, 1955), p. 39.

2. Harold Clurman, "Alfred Stieglitz and the Group Idea," in *America & Alfred Stieglitz* (New York: Literary Guild, 1934), p. 267.

3. Dorothy Norman, *Alfred Stieglitz: An American Seer* (New York: Random House and Aperture, 1960, 1973).

4. Quoted in Vernon Young, *On Film: Unpopular Essays on a Popular Art* (New York: Quadrangle, 1972), p. 284.

5. See general discussion of his background in Dorothy Norman, *Alfred Stieglitz: An American Seer.*

6. Helmut Gernsheim, *Creative Photography: Aesthetic Trends, 1839-1960* (New York: Bonanza Books, 1962), p. 115.

7. See especially Robinson's *Pictorial Effect in Photography.*

8. More probably, this concern came out of some attempt to separate the goals and ideals of painting from photography, for one of the most salient characteristics of photography in the early days of daguerreotypy was its ability to record minute detail.

9. "Overlooked" is not perhaps the only word which might be used: the sad fact is that Stieglitz published not one word by Emerson in the many issues of *Camera Work*.

10. Nancy Newhall, *P. H. Emerson: The Fight for Photography as a Fine Art* (New York: Aperture, 1975), p. 3.

11. Quoted in Nancy Newhall, *P. H. Emerson*, p. 54.

12. Nancy Newhall, *P. H. Emerson*, p. 55.

13. Helmut Gernsheim, *Creative Photography*, p. 119.

14. Nancy Newhall, *P. H. Emerson*, p. 103.

15. Nancy Newhall, *P. H. Emerson*, p. 103.

16. Milton Brown, *American Painting*, p. 39.

17. Doris Bry, *Alfred Stieglitz: Photographer* (Boston: Museum of Fine Arts, 1965), p. 14.

18. Jonathan Green, ed., *Camera Work: A Critical Anthology* (New York: Aperture, 1973), p. 19.

19. John Szarkowski, *Looking at Photographs* (New York: Museum of Modern Art, 1973), p. 74.

20. Doris Bry, *Alfred Stieglitz*, p. 18.

21. Harold Clurman, "Alfred Stieglitz and the Group Idea," p. 271.

22. Herbert J. Seligmann, "291: A Vision through Photography," in *America & Alfred Stieglitz* (New York: Literary Guild, 1934), p. 117.

23. Harold Clurman, "Alfred Stieglitz and the Group Idea," p. 271.

24. Herbert J. Seligmann, "291: A Vision through Photography," p. 119.

25. Quoted in Nathan Lyons, ed., *Photographers on Photography* (Englewood Cliffs, New Jersey: Prentice-Hall, 1966), p. 112.

26. Quoted in Nathan Lyons, *Photographers on Photography*, p. 170.

27. Harold Clurman, "Alfred Stieglitz and the Group Idea," p. 277.

28. Harold Clurman, "Alfred Stieglitz and the Group Idea," p. 276.

29. Dorothy Norman, "An American Place," in *America & Alfred Stieglitz* (New York: Literary Guild, 1934), p. 149.

30. Dorothy Norman, "An American Place," p. 135

31. Quoted in Nathan Lyons, *Photographers on Photography*, p. 16.

32. Quoted in Herbert J. Seligmann, "291: A Vision through Photography," p. 116.

33. Quoted in John Ward, *The Criticism of Photography as Art* (Gainesville: University of Florida Press, 1970), p. 22.

34. Dorothy Norman, "An American Place," p. 137.

The Salon Club of America and the Popularization of Pictorial Photography

Gillian B. Greenhill Hannum

The Photo-Secession was the premiere organization of pictorial photographers in the United States during the early years of the twentieth century. It was the tangible expression of Alfred Stieglitz's belief that the work of a group with a common aim could have a significantly stronger impact on the world of photographic art than could the efforts of individuals working independently. The key to membership in the Secession was agreement and sympathy with Stieglitz's aims and opinions. Much of the best photographic talent of the day joined up, although some photographers, whose work alone might have entitled them to admission, were rejected on philosophical grounds, a fact Stieglitz freely admitted, although without mentioning names.[1]

Because of Stieglitz's strong personality, many pictorialists saw the need for an alternative to the Photo-Secession, for a group run along populist lines which would encourage a new generation of artistic photographers. One effort to provide such an alternative was the Salon Club of America, the brainchild of two midwestern photographers, Louis Fleckenstein of Faribault, Minnesota, and Carl Rau of LaCross, Wisconsin. Their aim was to form an organization that would emulate what they understood to be the aesthetic criteria of the Secession, but which would meet with broad, popular appeal.

The club's stated purpose included "Firstly, to be democratic and give a fair opportunity to all who

exhibit; secondly, to encourage new talent; thirdly, to show no favoritism and to give every picture a fair judging."[2]

Just what the Salon Club meant by "democratic" is never clearly defined, and it seems a strange choice of terminology for a group with what amounted to exclusive membership. Undoubtedly, its use was intended to emphasize the new club's opposition to what it viewed as Stieglitz's dictatorial policies.

The group was quietly organized late in 1903 by eleven pictorialists whose work had successfully passed salon juries at recent exhibitions in Philadelphia and Chicago. The acceptance of work at an important salon or exhibition remained a criterion for membership throughout the club's existence. Fleckenstein and Rau invited the following photographers to join them: Jeanne E. Bennett of Baltimore; Walter Zimmerman of Philadelphia; Curtis Bell of New York; Wendell G. Corthell of Wollaston, Massachusetts; John W. Schuler of Akron, Ohio; Julius H. Field of Berlin, Wisconsin; the Parrish sisters of St. Louis; Ralph Berger of Reading, Pennsylvania; and Herbert Hess of Crawfordsville, Indiana. They were soon joined by Carl Bjorncrantz, Nellie Coutant, Zaida Ben-Yusuf, Adolph Petzold, Harry Hall, C. H. Claudy, Charles Fairman, Wilbur Porterfield, and Rudolf Eickemeyer, Jr. Each received a letter like the one sent to Adolph Petzold, dated November 6, 1903:[3]

Dear Sir: —

Would you be willing to join a club, composed of ten members,[4] all prominent in amateur photographic circles, who are forming for the purpose of mutual pleasure and advancement in Artistic Photography? It is proposed to admit only workers of recognized ability, who have had pictures exhibited at the more prominent Salons, and your name has been suggested as one of the elligibles [sic]. The plan, briefly, is as follows:

A mounted print will be started on the rounds each month by member No. 1, accompanied by a blank sheet of paper headed with title of print, data concerning its making, printing process, and name of artist, and forwarded to member No. 2 on route list. Member No. 2 will likewise add a print and data sheet, and write a constructive and comprehensive criticism of print No. 1 on the sheet provided, and pass it along to member No. 3 and so on. The prints and criticisms will make the circuit twice, so that all may see what has been said of each print, after which the print and accompanying criticism sheet will be returned to its respective owner.

There will be no expense other than postage in forwarding from one member to the next.

You can readily see the advantage of being a member of this club. It will bring you in close touch with the best known pictorialists of the American Salon, as well as affording you a means of seeing work each month in the modern printing processes, such as gum-bichromate, ozotype, kallitype, glycerine-platinum, etc. Your work will also pass under the criticism of ten able workers each month which, as you know, will be a great benefit in aiding you in your future work and furnishing new ideas; the standard will be kept at the top notch, besides which, our club will be very exclusive, no one being eligible except those whose names are to be found in the catalogues of our leading Salons.

Kindly signify your pleasure on enclosed postal and return to me at once, that there may be no delay in perfecting arrangements for an early start.

Yours truly,

[signed] Louis Fleckenstein

This circulation of albums of members' work imitated that of the Postal Photographic Club of the United States which was founded in 1885,[5] and it remained an important function of the Salon Club throughout its existence, the membership being divided into several "regional divisions" when the mailing route became too lengthy.[6]

Rapidly, however, the mission of the Salon Club expanded. There were many photographers working outside the realm of the Photo-Secession, and the Salon Club quickly attracted their attention. Walter Zimmerman explained it this way:

> This club was formed less than a year ago, from men and women who are interested in pictorial photography, and who have their work hung at photographic Salons of the highest class. It is well known that it started as a mere interchange association, but its members found that there was a larger and a better work before them than the contributions to the monthly portfolios, and for some months it has not only participated in the work of the American Salon, but in other pictorial photographic exhibitions.[7]

The first American Photographic Salon opened in New York in December of 1904. It was sponsored by the American Federation of Photographic Societies, a group formed in June of that year and comprised of representatives from a number of camera clubs around the country and in Canada, including the Salon Club.[8] Although Fleckenstein's Salon Club issued the invitations to the organizational meeting for the Federation, the event was held at the rooms of the Metropolitan Camera Club in New York City. Curtis Bell, a member of both clubs, was elected President of the new Federation. Salon Club members filled key committee roles.

The exhibit, held at New York's Clausen Galleries, drew 10,000 entries. When the judges had finished their task, 175 photographers were represented by a total of 369 prints. The Photo-Secession, following Stieglitz's directive, remained aloof, but a number of prominent Europeans as well as American pictorialist F. Holland Day participated in the show.

During the summer leading up to the exhibit, the photographic press was filled with attacks by Curtis Bell and his associates on Stieglitz, who they accused of being a "monopolist," of trying to undermine their show, and of dictating the future of pictorial photography. The bitter battle was fueled by the critic, Sadakichi Hartmann, who left the Secession camp during this period due to a personal split with Stieglitz.

Hartmann seems to have been deeply involved in a number of intrigues involving groups opposed to the Secession. In the summer of 1904 he drafted and personally signed the letters sent by the Salon Club to invite German and Austrian photographers to participate in the upcoming Salon.[9] Finally, on September 2, 1904, Stieglitz received a letter from Hartmann announcing that the critic had "wheeled over to the other side."[10] His motives for doing so remain somewhat murky but seem to rest mainly on jealousy and wounded pride. He complains in his letter of "shabby treatment," of a lack of invitations to Photo-Secession dinners, and of Stieglitz's unwillingness to advance him one dollar on an article he was writing for him. It is also possible that he saw his influence with Stieglitz waning, and felt he might have more input elsewhere.

In any case, Hartmann turned on Stieglitz with a vengeance and directed his energies towards supporting the opposition. In blistering attacks in the photographic press written under the appropriate pseudonym "Caliban," he assailed Stieglitz as the dictator of American photography and sought to stir up dissent even within Photo-Secession ranks.[11]

Following his defection, Hartmann also helped to recruit members for the Salon Club. Rudolf Eickemeyer, Jr., certainly the Salon Club's biggest "catch," was at least partially "reeled in" by Hartmann, as the two had earlier collaborated on several projects. Already an established pictorialist in the 1890s, Eickemeyer did not join the Photo-Secession, although letters from him to Stieglitz indicate that the latter was interested in featuring Eickemeyer in an early issue of *Camera Work*. This never happened. A rift developed between the two photographers, aided and abetted by Hartmann, towards the end of 1903. Eickemeyer, who considered himself Stieglitz's equal, remained independent until 1904, when he joined forces with the rival Salon Club and exhibited ten pictures in the First American Photographic Salon.[12] His most active years with the club were 1904 and 1905, when he chaired the National Preliminary Jury for the Second American Photographic Salon. He was still at least marginally connected with the group in 1907 when he submitted entries for "Foreign Exhibitions" to that body.[13]

Eickemeyer and Hartmann knew each other well, and the latter proclaimed Eickemeyer's *Fleur-de-lis* "one of the best photographs ever produced in America, and only second to Stieglitz's 'Winter on Fifth Avenue'."[14]

Eickemeyer's affiliation with the Salon Club was a boon to that organization for in many ways Eickemeyer was the most important non-Secessionist

of his day. [Figure 1] His name figures prominently in accounts of the group's activities for several years. In 1905 he opened a studio, David and Eickemeyer, at 246 Fifth Avenue, just down the block from Stieglitz's famous "291." His activity in artistic photography and salon circles declined markedly around 1907 due to professional pressures, but for several years he added real stature to the Salon Club movement.

Curtis Bell sought to gain prestige for his fledgling organization by recruiting the foremost independent pictorialists of his day. Eickemeyer and F. Holland Day were the most logical targets. Letters in the Day Collection at the Norwood Historical Society in Massachusetts reveal Bell's efforts to woo the eccentric photographer.[15] Day was even offered virtual control of the prestigious Art Committee of the Federation if he would agree to join up.

Despite his strong stand for independence, Day might have been tempted to accept this offer as it would have restored him to national prominence, but before Bell was able to persuade him, fate interposed. On November 11, 1904, the Harcourt Building, which housed Day's studio, was levelled by fire. Everything was lost — over 2,000 negatives, his own prints, and much of his personal art collection. Only a few prints which he had at his home in Norwood were saved. He contacted Curtis Bell immediately, asking to have all the prints he had submitted to the New York Salon returned at once. Bell attempted to reassure Day, and the pro-Salon photographic publications editorialized on the "good fortune" which had sent Day's best prints to New York, thereby saving them from destruction, but Day was adamant.

Bell persisted, as late of May of 1905, in his efforts to secure Day's participation in the Salon movement, if not as a member, then at least as a juror, but to no avail. The shock of his loss and the time and effort required to begin anew required Day's full attention. Without his direct involvement, the American Photographic Salons lost their best chance for innovative leadership.[16]

Stieglitz severely criticized the American Photographic Salons and refused to review them in *Camera Work*.[17] While independent reviews of the exhibitions vary, in one respect the Salons were a great success. Each travelled to major host cities across the country, were hung in museums (for example, the Chicago Art Institute), and were viewed by thousands.

The exhibitions also forced Stieglitz to admit that some good work was going on outside the ranks of the Photo-Secession. A young Massachusetts photographer named George Seeley had twelve pictures in the First Salon, which impressed Stieglitz

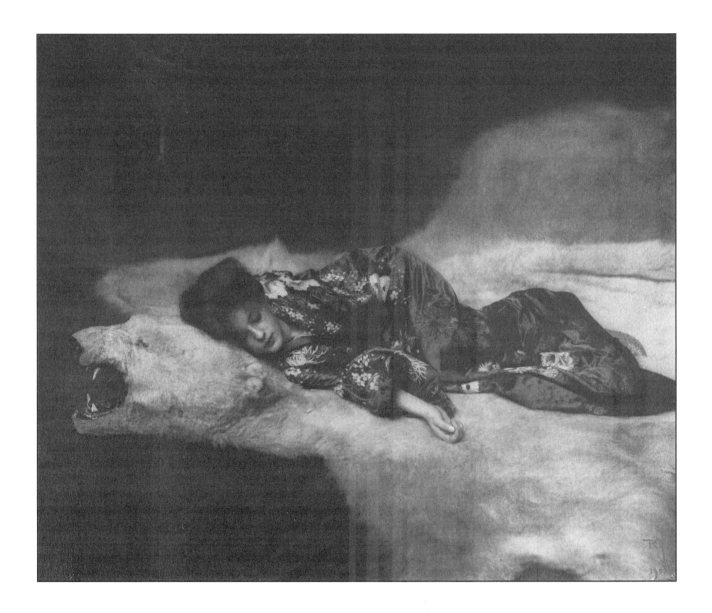

Figure 1. Rudolf Eickemeyer, Jr., "In My Studio" (portrait of Evelyn Nesbit), 1902. Carbon print, 19 x 24 inches. Courtesy of the Hudson River Museum. This photograph was one of seven exhibited by Eickemeyer in the Second American Photographic Salon of 1905-1906.

to such an extent that he immediately invited Seeley to join the Secession as a Fellow,[18] a step Seeley finally took in late 1906, only after his first pictures appeared in *Camera Work*.[19]

Sadakichi Hartmann in his review of "The Salon Club and the First American Photographic Salon at New York"[20] named Curtis Bell, Adolph Petzold, Walter Zimmerman, and Jeanne Bennett as the strongest of the Salon Club exhibitors.

After the deluge of submissions in 1904, new jurying procedures were established for the Second American Salon. Twelve local juries were set up in the twelve cities scheduled to host the show, and entrants were requested, though not required, to submit their work there first. A preliminary national jury made up of eminent photographers such as Eickemeyer, Fleckenstein and the Parrish sisters then reviewed the work. Finally, as in the First Salon, a jury of painters made the selections for the exhibition. John La Farge chaired the group, which included such well-known artists as William Merritt Chase, Robert Henri and Kenyon Cox.[21] The constant turning to painters of the day is symptomatic of the lack of self-confidence among the rank and file of pictorial photographers who sought external verification that photography was truly "art." Bell also believed it impossible to find a truly unbiased jury of photographers during this highly politicized period of photographic history. Stieglitz, on the other hand, tirelessly advocated photographic judges for photographic art.

Three hundred and fifty prints were selected for exhibition at the Second Salon. And once again, the show attracted a wide audience. In Chicago, for example, 55,521 people viewed the show.[22]

Unlike the Photo-Secession, the American Photographic Salons continued to award prizes to individual exhibitors. This was a concession to the numerous local camera clubs which, under Salon Club leadership, made up the American Federation of Photographic Societies, sponsors of the shows. The awarding of prizes in the Third American Salon was limited to three purchase prizes, selected by the final jury.

By the Fourth Salon (1907-1908), trouble was brewing. Elitism was cropping up and a disproportionate number of the photographs selected for exhibition came from the Preliminary Jurors themselves. In fact, one-fifth of the entire show was work submitted by photographic jurors! Of the 239 frames hung, 97 were the work of Salon Club photographers, representing 22 of the club's members.

Many of the original Salon Club members became discouraged with what they viewed to be a lower quality exhibition and ceased participating about this time. Indeed, in 1907 only about half the members submitted work to the Salon. In fact, in 1907 the Salon Club officially withdrew from the American Federation of Photographic Societies. Club officers felt that because their organization was not an entity with club rooms, facilities and so forth, it did not reap the benefits of membership in a federation that stressed the interchange of club privileges as one of its major features. News of the split appeared in the September 1907 issue of *Western Camera Notes*, the Salon Club's "official organ."[23] The Salon Club itself seems to have disintegrated soon thereafter, probably as a result of Louis Fleckenstein's move to Los Angeles, also in 1907.

The American Federation continued to sponsor Salons until 1913, but after 1907 participation and interest came mainly from the midwest. Submissions dropped from 9,100 in 1904 to 1,200 in 1907. Local and preliminary juries were eliminated and a five-man jury, made up mainly of museum directors, passed judgment on the prints. Regionalism took over and photographs were hung according to the photographer's club affiliation. After 1910, the exhibitions were limited to domestic work only, as no foreigners were invited to submit entries. In 1911 only 96 prints were hung as a result of declining quality and interest.

The 1912-1913 Salon was the last. Participation by important societies was dwindling and few workers of national reputation submitted work. Unlike the Photo-Secession, which ended with a single, climactic presentation at the Albright Art Gallery in Buffalo, the Salon Club and the American Photographic Salons died out with barely a whimper.

It was the end of an era. Pictorialism gave way to so-called "straight" photography, and to a whole new generation of photographic artists. Yet the richness and complexity of the pictorialist era, the battles and politics, the maneuvering and counter-maneuvering, must not be overlooked nor over-simplified. It is important to understand that the Photo-Secession and the Salon Club were not battling so much over aesthetic issues as over tactical ones.

In the years following the First American Photographic Salon, many ambitious photographers realized that the road to fame and recognition could best be travelled via Stieglitz and the Secession. George Seeley, Zaida Ben-Yusuf, Oscar Maurer, Herbert Hess and Jeanne Bennett are among those who early showed support for the Salon movement, but later joined forces with Stieglitz.[24] The fact that

the Secession welcomed such "former enemies" into the fold reinforces the argument that no basic differences in artistic philosophy, style or technique separated the two groups. Indeed, upon pledging allegiance to Stieglitz, the errant pictorialists were accepted with open arms. Their work shows no stylistic change as a result of such shifts in affiliation.

In the end, Stieglitz won the battle, largely because he was the best communicator. He was a master of the printed word, and used it often as effective propaganda. The impression of Stieglitz and the Photo-Secession as the "lone pioneers" of American art photography is, however, false. They were not working within a vacuum, as is often implied, but were, instead, constantly being spurred on by the competitive and opposing forces which brought the Salon Club into being.

REFERENCES

1. National Gallery of Art, *Exhibition of Photographs by Alfred Stieglitz* (Washington, D.C.: National Gallery of Art, 1958), p. 13.

2. Roland Rood, "The Photographic Salon at New York," *American Amateur Photographer*, 16 (December, 1904), p. 519.

3. Louis Fleckenstein, letter to Adolph Petzold, November 6, 1903. The Getty Center for the History of Art and the Humanities, Santa Monica, California.

4. Observant readers will note that the magical number of ten members was surpassed right from the start.

5. Charles E. Fairman, "The Increase of Postal Photographic Societies," *American Annual of Photography*, 19 (1905), p. 245.

6. Anonymous, "The Salon Club," *Western Camera Notes* (May 1907), p. 140.

7. Walter Zimmerman, "The Salon," *The Photographic Times-Bulletin*, 36 (December 1904), p. 531.

8. Anonymous, "A Federation of American Photographic Societies for the Exhibition of Pictures and Education in Photographic Art," *The Photographic Times-Bulletin*, 36 (August 1904), p. 348.

9. Text of Hartmann's letter, dated June 30, 1904, is reprinted in *Camera Craft* (April 1905), p. 247.

10. Sadakichi Hartmann, letter to Alfred Stieglitz, undated, Yale Collection of American Literature.

11. Caliban, "The Inquisitorial System," *The Photo-Beacon*, 16 (November 1904), pp. 346-348.

12. A. Horsley Hinton, letter to Alfred Stieglitz, July 23, 1904. Yale Collection of American Literature.

13. Anonymous, "The Salon Club," *Western Camera Notes* (August 1907), p. 219.

14. Sadakichi Hartmann quoted in Harry Lawton and George Knox (eds.), *The Valiant Knights of Daguerre* (Berkeley: University of California Press, 1978), p. 196.

15. Curtis Bell, letter to F. Holland Day, July 19, 1904. Norwood Historical Society, Norwood, Massachusetts.

16. Estelle Jussim, *Slave to Beauty* (Boston: David R. Godine, 1981), pp. 162-164.

17. Alfred Stieglitz, "The First American Salon at New York," *Camera Work*, 9 (January 1905), pp. 50-52.

18. Weston Naef, *The Collection of Alfred Stieglitz: Fifty Pioneers of Modern Photography* (New York: Viking, 1978), p. 430.

19. Weston Naef, *The Collection of Alfred Stieglitz*, p. 134.

20. Sadakichi Hartmann, "The Salon Club and the First American Photographic Salon at New York," *American Amateur Photographer*, 16 (July 1904), pp. 210-219.

21. Christian A. Peterson, "A History of Exhibitions of Photography in America: 1887-1917," unpublished Master's thesis, Department of Fine Arts, Syracuse University, 1982, p. 87.

22. Christian A. Peterson, "A History of Exhibitions of Photography in America: 1887-1917," p. 88.

23. Anonymous, "Salon Club," *Western Camera Notes* (September 1907), p. 244.

24. Jeanne Bennett, letter to Alfred Stieglitz, September 9, 1905. Yale Collection of American Literature.

The Wheelman and the Snapshooter
or, the Industrialization of the Picturesque

Jay Ruby

"There is one reflection which can hardly fail to suggest itself to a recent arrival in Cyclonia, and that is the strange but undeniable fact that every third cyclist is a photographer. Perhaps photographer is too harsh a term to apply to these well–meaning persons; the justice of the case would be met in most instances by describing them as dabblers in photography. They are for the most part harmless, and operate chiefly on each other, and on their friends and relations. It is to be hoped, by those who are interested in such matters, that future generations may not be interested in such matters, that future generations may not be reduced to the necessity of taking their impressions of the personal appearance of the greater lights of cycling from these libellous productions. The advertising columns of the cycling papers are full of announcements of photographic materials fitted for conveyance of tricycles. The way in which cameras fold up into impossible dimensions, and so to speak almost annihilate space, is among the things no fellow can understand. I have never myself encountered one of these artists at work, but I have been told that the camera is designed to screw on to the wheel, the machine itself forming a tripod stand, and that a number of sensitive plates can be stowed away inside the backbone, or at least

quite out of sight: but that perhaps is an exaggeration. "[1]

Amateur photography and recreational cycling became enormously popular pastimes during the 1890s. While at first glance they may seem unrelated, there is a similarity in their appeal and an historic connection that goes back to the very beginning of both technologies. The earliest bicycles, called célerifères [later, vélocifères], "had no pedals or steering mechanism. They were simply beams on wheels, one behind the other, propelled by striking out with the feet as though skating....In the year after Waterloo, Nicéphore Niépce, best known as the father of photography, produced an improved vélocifère with a slimmer horizontal member and much larger wheels. The front wheel was still rigid, but demonstrations of the machine in the Luxembourg Gardens impressed spectators with its bustling speed."[2]

An examination of these recreations provides some insight into the relationship between technology and turn-of-the-century American culture. The success of the industrial revolution created an increased need for middle-class moral recreations and, at the same time, offered a mechanized solution through cycling and picture–taking. The discussion begins with a brief description of the ideological underpinnings of these recreations, followed by an examination of technological changes in cycling and photography and their impact.

Nineteenth-century America was a place where the aristocratic notion that one should cultivate good taste and acquire worthwhile avocations was expanded to include the ladies and gentlemen of the burgeoning middle class. All who had acquired leisure time were expected to participate in literary, musical, artistic, and scientific endeavors. Forays into nature to collect botanical or zoological specimens and render "plein-air" sketches were particularly popular.

An interest in nature as a place of inspiration and recreation is, of course, at the heart of the romantic movement. One manifestation is the search for the picturesque — the æsthetic pleasure derived from the observation and depiction of scenes of rustic and pastoral nature displaying irregular or asymmetrical elements. It was a movement away from overly idealized depictions which did not represent actual locales and topographical renderings thought to merely reproduce without interpreting.

Because it was necessary to travel in order to naturalistically interpret actual places, sketching excursions became the stock in trade of the Victorian landscape artist as well as admirers of picturesque images. "...if the picturesque embodied a means for describing nature, it also induced an attitude, a response, in the observer....The lover of the picturesque became a traveler, seeking out the remote and exotic parts of the world because they often were the most picturesque."[3]

The transformation of America from agrarian and rural to industrialized and urban caused corresponding changes in popular notions of the picturesque. The newly affluent middle-classes of the late nineteenth century were encouraged to seek a refuge from the frenetic pace of urban society in the beauty of the countryside. As a consequence, "...there developed a 'back to nature' movement which attracted wide popular support at the turn of the century and created institutions which remain today. Part therapy and part nostalgia, this 'Arcadian Myth' permeated the thinking of a good portion of the urban middle and upper classes."[4]

The "back-to-nature" movement signalled major changes in the practice of the picturesque. First, it democratized the concept. No longer was it the pastime of the rich and powerful but "ordinary city dwellers longed for contact with the natural world, and headed for the wilderness and the suburban backyard."[5] Secondly, it became domesticated, that is, the locales where the beauty of nature could be found were often far less exotic and remote than spots of picturesque beauty. The park or the suburb now sufficed. And lastly, nature lovers were able to

incorporate the products of industry into their quest for the rustic without apparent conflict. One escaped into nature via train, canal boat, bicycle and, later, motorcycle and automobile, and returned home not with pen and ink sketches but photographs. "Americans saw a photographic version of nature tailored to the emotional needs of an urban world....The camera enabled nature lovers to shut out the undesirable and, through the principles of art, to refine the world into permanently beautiful form."[6] The irony of riding the "iron horse" to photograph a countryside being permanently altered by the railroad was apparently not understood. In fact, the ability of the picturesque to accommodate the intrusion of culture into nature, or the "machine in the garden" made it the perfect æsthetic for America in the throes of the Industrial Revolution.[7]

Prior to the last decade of the nineteenth century, it was technically difficult to be an avocational photographer. The complex, cumbersome, expensive and non-standardized qualities of the process confined amateur photography to a few hardy souls who were often as interested in the technical problems of physics and chemistry posed by exposures and processing as they were in making pictures. Consequently, most outdoor photography was practiced by professionals who overcame the technical limitations of the medium because of the market for landscape stereoviews and the commissions offered by railroads to document the scenic attractions along their routes.[8]

There were, however, some exceptions. The American Photographic Exchange Club was formed in the 1860s so that amateurs could share images they produced. Robert Eskind's study of the club suggests that "the Photographic excursion into the countryside was the point and end of most of the amateurs' designs and planning..."[9] He cites Charles Wilson's April 25, 1862 *American Journal of Photography* article, "the Charms of Photography," as evidence that these photographers appropriated the picturesque as their æsthetic — "when we reach this point (that is, a scene in the country), then our vacations prove of benefit both to mind and body; then will the habits of the city be thrown aside, our energies, used up in the counting room, be renewed, true relaxation be had, and that which we sought but did not know how to find be gained — change. Photography can give us this. It will as before stated, develop tastes which we were ignorant of possessing, change the course of our pleasures in this direction, afford us amusement simple in its acquirement and inexpensive in its practice; one entirely unselfish as it give pleasure to all our friends, and...endless in its charms..."[10]

industrialization of American cities produced a large number of affluent, educated people who needed a means of recreating themselves. Many people now saw the camera as a way of exploring pictorial form, capturing the beauty of nature, and preserving the memory of a pleasant afternoon. Photography became a socially acceptable form of moral recreation and rational pursuit to which ladies and gentlemen could apply themselves.[11]

At the same time that amateur photography emerged as a national obsession, cycling experienced a parallel development. Like the camera, the bicycle, in the form of the high-wheeler and other proto-types, had been around since the middle of the nineteenth century. However, it was not until the innovations of the late 1880s that the technology was sufficiently advanced to make cycling a widely accepted pastime.[12] "The dangerous high model gave way to the chain–driven 'safety' with equal wheels in 1889. Cycling became a craze, complete with cross–country races and national conventions. Despite laments about declining morals and rising skirts, the young sought emancipating distance from watchful elders. The National League of American Wheelmen lobbied for better roads, street–lighting, and curbing."[13] For ten years, Americans were caught up in a frenzy over the bicycle. It is difficult to estimate the number of cyclists. They easily numbered in the millions. "The U.S. census does not include the number of cycles in the country as of 1890, but it does list over a million and a quarter such machines in 1900."[14]

The impact of the bicycle was immediately noted. "As a social revolutionizer it has never had an equal. It has put the human race on wheels and has thus changed many of the most ordinary processes and methods of social life. It is the great leveler, for not 'till all Americans got on bicycles was the great American principle of every man is just as good as any other man, and generally a little better, fully realized. All are on equal terms, all are happier than ever before, and the sufferers in pocket from this universal fraternity and good will may as well make up their minds to the new order of things for there will be no return to the old."[15]

There are a number of parallels between the recreational cyclist and the amateur photographer. The attraction was partially motivated by a fascination with technology — the gadgets, sundries, and accessories one could obtain for the wheel and the camera.[16] Catalogs for both instruments are filled with devices which "improve" and "enhance" the experience. One could obtain clothing expressly made for wheeling and photographic excursions.

The expense involved in becoming a properly

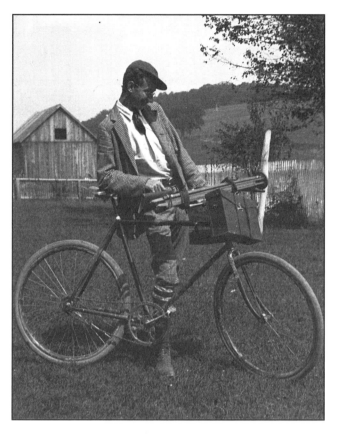

Figure 1. Francis Cooper, Pleasant View, Pennsylvania. Self-portrait, ca. 1897. 3 1/2 x 3 1/2 inches. Collection of the Author.

The American Photographic Exchange Club was among the earliest manifestations of a movement which came into its fullest expression at the end of the century. By 1890, manufacture of glass dry-plate negatives with predictable exposure times and standardized, prepackaged chemicals and printing papers made it possible to be a photographer without having much technical knowledge. The photographic industry reduced the cost of cameras and lenses and at the same time promoted the idea that picture-taking was an uncomplicated pleasure, now available to everyone. Camera clubs and photographic societies proliferated. Exhibits, salons, periodicals, and general media attention blossomed.

Cultural and technological conditions were ripe for the flowering of an avocational artistic photography and the development of the casual snapshot. The

outfitted cyclist or amateur photographer was high. Bicycles cost approximately $100 in 1895 and cyclists often spent as much as the cost of the vehicle on accessories. The 1899 catalog of the Rochester Camera and Supply Company lists the cost of a basic 5 by 7 inch Poco Cycle Camera as $35.00 with various accessories, such as the bicycle clamp, totaling at least as much as the camera alone.[17] Combining the two activities meant an investment of hundreds of dollars. Considering that a laborer's annual wage could be as little as $150, these activities were clearly designed for the affluent.[18]

While some enjoyed these hobbies alone, many people were attracted by the social life surrounding them. They became legitimate courting events, since "proper" women could go cycling as well as be photographers. A couple could travel through the countryside on their wheels, stopping now and then to snap a picture, without arousing the least bit of suspicion of impropriety.

There were numerous local cycling clubs as well as the League of American Wheelman, which acted as a lobbyist for good roads, provided their members with touring maps, listings of repair shops, discounted hotels and restaurants, and sponsored races and excursions. In a similar fashion, the amateur photographer could join local and national camera clubs and photographic societies which provided darkrooms, exhibition space, technical instruction, and excursions, as well as "member–only socials." In Philadelphia, for example, there were at least ten camera clubs and photographic societies and at least as many wheeling organizations. An avid cyclist or photographer could focus his or her social life entirely on these organizations.

During the 1890s, group cycling excursions from the city to the countryside were commonplace, often organized by a neighborhood wheeling club such as the Pennsylvania Bicycle Club.[19] The picturesque traveler experienced the health-giving qualities of nature from his wheel on country roads. Often cyclists took along a camera to preserve the memory of a pleasant afternoon in the country. The camera became another accessory that every properly outfitted cyclist had to have.

As Hillier noted in the quotation above, the bicycle manufacturing industry was aware that many cyclists enjoyed obtaining snapshots of their wheeling excursions. In 1897 Pope, one of the oldest and largest bike makers, ran "The Columbia Bicycle Prize Competition in Photography." The brochure states that the purpose of the contest is "to make better known by Columbia advertisements the delights of bicycling in its truest and best appreciated aspect — to do this it is necessary to depict the natural bicycle

scenes of every-day life." Six prizes, consisting of various Columbia and Hartford bicycles, were offered for pictures that displayed Columbia bikes in "the best and most attractive surroundings and background…with the bicycles in motion, with rider or riders…and pictures with…an attractively gowned girl or woman on any bicycle."[20]

Photographic companies also responded to this new market by producing cameras and accessories specifically designed for the cyclist. The Tele Photo Cycle Poco — a 5 by 7 inch glass plate negative camera — was manufactured by the Rochester Camera and Supply Company and described in their catalog as "first introduced in 1895 by us exclusively, and…especially designed for wheelman. Since their advent, tourists, huntsman, canoeists, and the public in general have seen the practicability and advantages over the other styles, having become the most popular camera that we manufacture. Other manufacturers seeing its worth have copied the style as closely as possible, trying to avoid our patents. This alone, should commend it to the trade in general. For wheelmen there is nothing so pleasing as photography in connection with their tours, as it calls to mind the many beautiful scenes through which they have passed. The Cycle Poco is the wheelman's companion, being made very light and compact and can be easily carried on the wheel without inconvenience. It is equipped with two tripod plates fitting our bicycle clamp, which can be placed on the handle bar of the wheel, the wheel serving as a tripod....The case can be attached to the frame of the bicycle with our cycle camera carrier, without injury to the camera, case, or wheel. No jar or movement being discernible."[21]

Most cyclists were primarily interested in wheeling and therefore content with unselfconscious snapshots taken with simple box cameras that replaced the more formal studio cabinet card portraits of cyclists and their wheels. There were, however, some avocational photographers who saw the bicycle as a means to travel to the countryside to capture a landscape or a scene from a farmer's life and to seek a respite from the problems of urban life.

Often, members of photographic groups were also cyclists who wished to pursue both interests at the same time. For example, the Columbia Photographic Society of Philadelphia had an ad hoc group who called themselves "The C.P.S. Wheelmen." Their activities were noted in "The Camera" — the society's official publication. In Vol. 1, No. 1 [July 1897] there is a story on page 2 entitled "C.P.S. Wheelmen to Atlantic City." On the same page is an announcement of a "Photographic Outing on the Wheel" — an excursion to New York in July, planned by the Outing

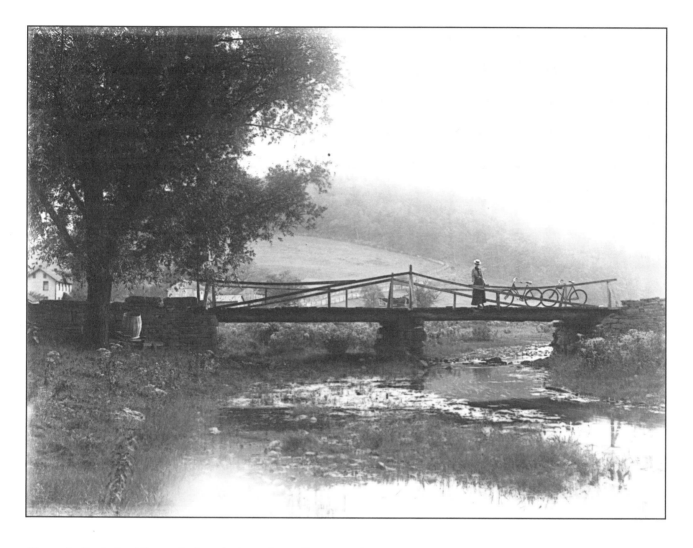

Figure 2. Portrait of Gertrude Crawford, McCoysville, Pennsylvania, ca. 1897. Francis Cooper. Courtesy of Helen Cooper Fanus.

and Entertainment Committee. On page 3 the League of American Wheelmen slogan "Give us good roads" appears with the following, "The 'C.P.S. Wheelmen' want every member of the C.P.S. who rides a wheel to affiliate with them. Club runs are numerous, and photographically illustrated."

In the "Pinholes" column, Vol. 1, No. 3 [Sept. 1897], the following appeared: 1. "During the national meet of the L.A.W.[League of American Wheelmen] , held in this city last month, the use of our dark room was tendered to visiting members of that organization who belonged to the fraternity of 'camera friends,' a privilege which was taken advantage of by quite a number"; 2. An article on page 23 entitled, "By Cycle to New York" recounts the journey of two C.P.S. Cyclers [one being George R. Siddall, the author of the article]. They took a train to Princeton and "New Brunswick was reached in time for dinner, which we got with the proper discount at the L.A.W. Hotel."

In Vol. 1, No. 4 [October 1897] three cycling-related items appear in the "Pinholes" column. "Mr. J. Samuel Stephenson, who stands so well up in the list of contestants for the prizes offered by the L.A.W. is an active member of the C.P.S. That he is exceeding popular with all who know him is attested by the hearty assistance he is receiving in his ambitious efforts. Send in your applications on Stephenson's blanks and help him win out." Next, "Kolb has a complaint to make which should be brought to the attention of the L.A.W. officials. During a recent cycling trip through New Jersey he broke one pedal, and, to his great annoyance, found no authorized L.A.W. place where he could saw off the superfluous leg, and as a consequence was compelled to push ten miles over a hill with one leg and carry the other strapped to his handlebar." Finally, the "C.P.S. Wheelmen—Runs for October" offered a listing of five weekly trips to local spots like Valley Forge.

Not all cyclists or photographers belonged to these clubs. Francis Cooper of Philadelphia, a medical student at the University of Pennsylvania in the 1890s, provides us with an example of a sportsman who enjoyed the recreation of wheeling and the artistic outlet afforded by photography without belonging to any organization.[22] By chance, many of Cooper's original photographs, negatives, albums and notebooks survive. They offer us a rare glimpse of a turn-of-the-century wheeling and camera enthusiast. From 1896 to 1901, Cooper traveled to the central Pennsylvania countryside to hunt, fish, bicycle and photograph landscapes and farm scenes, as well as record the spoils of his hunts. His photographs are examples of the creation and appreciation of picturesque landscapes as this form of expression

found its voice among some Philadelphia photographers. While courting his wife, Gertrude, Cooper often took bicycle trips on the back country roads where he would portray his fiancée beside a pond fishing and on a bridge with her bicycle. Some of these photographs were displayed at local and international exhibits. Like many of his contemporaries, Cooper's interest in artistic photography and cycling was exhausted by the first decade of the twentieth century.

The bicycle provided the nature lover a mechanized way to explore the countryside. It also offered a chance for speed, and a practical means of transportation in the everyday world. But the interest was short-lived and by the first decade of the twentieth century the bicycle craze was over. Sales plummeted. Wheeling Clubs closed their doors. The League of American Wheelmen was soon disbanded. The transportation industry offered new mechanized devices for travel: the motorcycle and the automobile. The desire for touring the countryside did not change, only the means. The bicycle was the avant garde for industrialized private transportation.

The auto tourist was the twentieth century version of the picturesque traveler and the national park became our symbol of nature transformed by culture. "The Long Trail grew shorter year by year as automobile roadways pushed along the footpaths of the past. Before long the ubiquitous 'Model A' touring cars spelled the end of wilderness lovers as prairie schooners had to the Indians. Tourist associations and auto clubs, local promoters and even nature enthusiasts urged that primitive areas be opened up with roads and hotels and all the advantages of national parks."[23]

While photography did not alter our society in the physical way the bicycle did, it was certainly not a flash–in–the–pan fad. The cycling craze died within a decade, while the interest in photography has continued to grow. The picturesque became the clichéd picture postcard notion of scenic beauty. The picturesque aristocratic traveler was transformed into the ubiquitous vacationer. The need to escape into nature and bring an image of the experience back to the city remains unchanged.

The industrial revolution created living conditions which made escape to the countryside a psychological and physical necessity. At the same time, it "manufactured" a means of accessing and symbolically preserving the very environment it now threatened. The camera and the bicycle are industrial revolution artifacts that reflect an attempt to accommodate the intrusion of the machine into the garden.

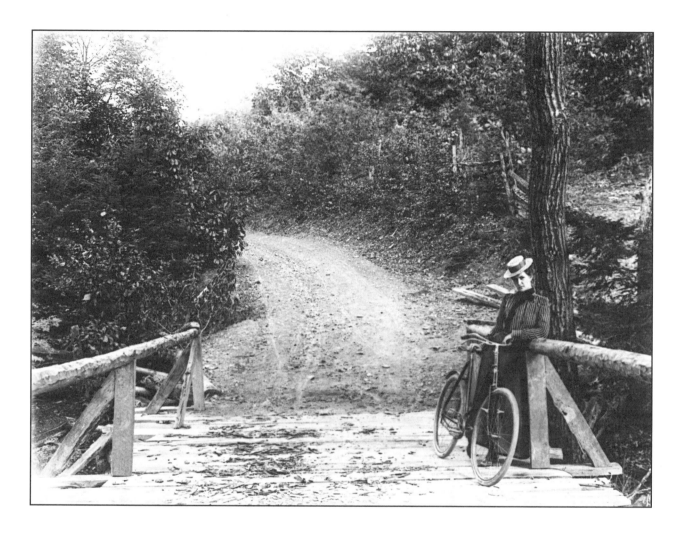

Figure 3. Gertrude Crawford, McCoysville, Pennsylvania, ca. 1897. Francis Cooper. Courtesy of Helen Cooper Fanus.

REFERENCES

1. Viscount Bury and Lacy Hillier, *Cycling,* Longmans, Green and Co., London [1889] p. 51.

2. John Woodfoode, *The Story of the Bicycle,* Universe Books, NY [1970], p. 7-8.

3. Deakin 1967: 3.

4. Peter J. Schmitt, *Back To Nature: The Arcadian Myth in Urban America,* Oxford University Press, N.Y. [1969] p. viii.

5. Schmitt, *ibid,* p. 3-4.

6. Schmitt, *ibid,* p. 153.

7. Leo Marx, *The Machine in the Garden: Technology and The Pastoral Ideal.* New York: Oxford University Press [1979].

8. "From the time of the introduction of commercial photography in 1839 until the later 1870s, the technical complexities of the photographic process were so great that only professional photographers and a very few avid amateurs chose to pursue the practice....Twenty years later nearly anyone interested in obtaining photographs, regardless of his practical knowledge of optics or of photographic chemistry, could at least press the button on a simple hand camera....The change in practice of photography from the dominance of the professional to that of the amateur revolutionized the photographic industryand the social role of photography." Reese Jenkins, "Technology and the Market: George Eastman and the Origins of Mass Amateur Photography," *History and Technology* 16[1], [1975], p. 1.

9. Cited in Robert W. Eskind, "The Amateur Photographic Exchange Club [1861-1863]: The Profits of Association." Unpublished MA Thesis, University of Rochester [1979], p. 70-71.

10. Eskind, *op. cit.,* p. 70.

11. "They [that is, amateur photographers] shared in common a conception of their activity as primarily a 'rational recreation' designed to improve the mind, while providing amusement and moral entertainment for the photographer's family and friends." [Eskind, *op. cit.,* p. 56]

12. The limited scope of this paper makes it impossible to deal with all aspects of the 1890s cycling craze or to explore the bicycle as a means of transportation or any number of equally fascinating but tangential topics.

13. H. Wayne Morgan, *Unity and Culture: The United States 1877–1900,* Penguin Books, NY, [1971], p. 35.

14. Smith, Robert A., *A Social History of the Bicycle: Its Early Life and Times in America,* American Heritage Press, McGraw-Hill, N.Y. [1972], p. 195.

15. Cited in Smith, *ibid.,* p. 112 from an unspecified 1896 *Scientific American* article.

16. Smith, *op. cit.,* p. 24

17. Catalog in author's collection.

18. He points out that "Because a new machine costs £12 or so, the equivalent of £70 today, the labourer who would have been thankful to pedal to work could not afford it until machines became available on the cheap second-hand market." [Woodfoode, *op. cit.,* p. 49.]

19. F.P. Prial, "Cycling in the United States," *Harper's Weekly Magazine* [August 30, 1890], p. 669-672.

20. 1897 "Columbia Bicycle Prize Competition brochure." Author's collection.

21. "Photographic Apparatus Catalog." Manufactured by Rochester Camera and Supply Co., Rochester, N.Y. [1899], p. 14–15.

22. For a more complete description see my article, "Francis Cooper, Spruce Hill Photographer," *Studies in Visual Communication* (11)4, [1985] .

23. Schmitt, *op. cit.,* p. 173

Cecil Beaton: Photographer as Courtier

Mark Haworth-Booth

The late Sir Cecil Beaton (1904-1980) photographed the British royal family from the thirties to the seventies. His diaries reveal him to have been a romantic royalist, enamored by the Windsors as individuals and as representatives of the royal house. His first major photographs of the monarchy were made at the express personal command of Her Majesty Queen Elizabeth in summer 1939. Beaton, the stylish portraitist for *Vogue* and debonair man of mode and the moment, was summoned to Buckingham Palace to photograph Queen Elizabeth and thus began his long career as official photographer of the British royal family. In the 1970s the ailing photographer decided to sell his negatives and prints to the London auctioneers, Sotheby's, but he retained for himself his archive of portraits of the royal family, the negatives, color transparencies and prints. He bequeathed all of these to his much-admired secretary Eileen Hose, MBE. She, in turn, bequeathed these works to the Victoria & Albert Museum. During the spring and early summer of 1987, Miss Hose made arrangements for the transfer of the archive to the V&A and, with the present writer, chose an exhibition to represent the best of Beaton's royal portraits. Miss Hose died on 19 August 1987 and the exhibition, "The Royal Photographs by Sir Cecil Beaton," took place during the autumn and winter as a memorial to her generosity and an indication of the scope of her bequest. It is estimated to comprise some 8,000 negatives and color transparencies, and probably well over 10,000 vintage prints in black and white. The archive will be available through the museum's Print Room and will be explored in a forthcoming book to be published in 1988 by the former director of the museum, Sir Roy Strong, whose personal friendship with the photographer, and with Miss Hose, drew this bequest to the V&A.

This brief note suggests something of the value to historians of an archive of such extensiveness and subject-matter. As the museum's exhibition suggested in 1987, the archive contains many different poses from the same session. Small adjustments were made from composition to composition, with small but all-important changes of facial expression. The portraits of the royal family were public symbols intended for dissemination throughout the world's newspapers and magazines. Beaton's press-cutting books, in the V&A's Archive of Art and Design, attest to the world-wide circulation of his royal photographs. Beaton's first important photographs of Her Royal Highness The Princess Elizabeth (now H. M. Queen Elizabeth II) were taken when she was sixteen years old and had recently assumed one of her first public appointments, as Colonel of the Grenadier Guards. Beaton's photographs showed a shy but self-confident young woman dressed in a simple style appropriate for wartime conditions, with cap and insignia, and placed before a backdrop which Beaton had taken from an eighteenth century rococo painting. This image of a

royal princess mobilized for the war, but also set apart and evocative of a gentler past, appeared in the media of the British Empire in 1942. After the restoration of peace in 1945, Beaton photographed The Princess Elizabeth again, this time in a delightful short-sleeved dress decorated with butterflies and flowers. Once again, she is set before a rococo backdrop, this time augmented with real sprays of flowers in the foreground. Back-lighting burns away the backdrop and provides a bright aureole for the princess's shoulders, head and hair. This photograph and others from the same session were widely illustrated in the press. They inaugurated a post-war time in which the promise of youth, beauty and softer seasons was symbolized in the person of the nineteen-year-old heiress-presumptive to the throne. This time the princess looked candidly, and perhaps with greater assurance and poise, at the camera and, thus, into the eyes of her millions of subjects.

At the present writer's request, Miss Hose contributed a fine remembrance to the museum's exhibition catalogue: "The Royal Portraits: A Note by Eileen Hose."[1] She wrote fondly and appreciatively of Beaton's team — his printers and lighting technicians and, not least, Miss Bell and Wendy Saunders: "Inevitably, at some time or other, retouching had to be done to some prints, very discreetly, of course." The retouching of the print shown here as Figure 1 is probably invisible in the illustration here. The fall of the dress on the right was adjusted by retouching and the awkward shape "re-cut," as it were, to Beaton's own satisfaction. The gently curving dress echoes the curve of the princess's cheek outlined against her hair. The hair too was retouched to tidy up loose curls. Elegance was for the most part achieved during the session, but details could be attended to afterwards by Beaton's expert helpers following his directions.

However, Beaton's discretion as a courtier-photographer went a great deal further. In 1963 he published his handsome collection, *Royal Portraits*.[2] The frontispiece to this folio volume is Figure 2. This close-up portrait is recognizable as being a detail of the photograph taken eighteen years before. Beaton exactly indicated the cropping he required, which places the fine curve of the cheek close to, and emphasized by, the left-hand border of the frame. His instructions also simplified the modelling of the face, so that the face of a young girl now becomes the more idealized face of a monarch. Perhaps most interestingly, the head appears to be set at a slight angle, recalling the face of Venus in the famous Uffizi Botticelli.

Cecil Beaton saw in his 1945 portrait a new kind of portrait appropriate for the 1960s. With one decisive instruction he drew out of the earlier picture a new one: a queen whose face is set against the light, neutral backgrounds typical of the sixties (borrowed perhaps by Beaton from Irving Penn). The close-up draws the monarch's face into closer liaison with her subjects. The photographic style adopted, perforce, a graininess appropriate to the more direct ethos of the sixties. And in perhaps the most delightful stroke of the courtier, Beaton also removed eighteen years from the age of the monarch to whom he was devoted and whom he served so well. In this portrait, Queen Elizabeth transcends time and becomes the Queen of Love.

REFERENCES

1. "The Royal Portraits; A Note by Eileen Hose," in *The Royal Portrait Photographs by Sir Cecil Beaton* (London: V&A Museum, 1987).

2. Sir Cecil Beaton, *Royal Portraits*, introduced by Peter Quennell and printed in gravure by C.J. Bucher Ltd. of Lucerne for Weidenfelt and Nicolson, Publishers, London, 1963.

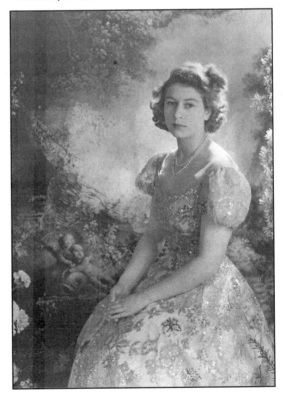

Figure 1. Cecil Beaton, portrait of The Princess Elizabeth, 1945. Silver gelatin print. Courtesy of the Victoria & Albert Museum, London.

Figure 2. Cecil Beaton, detail from 1945 portrait of The Princess Elizabeth, used to portray H. M. Queen Elizabeth II eighteen years later in the frontispiece to his 1963 folio volume, Royal Portraits. Courtesy of the Victoria & Albert Museum, London

271

Offensive Weapons on the Domestic Front

After Fannie Farmer left to start her own School of Cookery in 1902, the Boston (Massachusetts) Cooking School soon folded. Its equipment and faculty were transferred to the newly founded Simmons College, whose mission was to train women in those practical and technical skills that would enable them to earn their own living. The Department of Domestic Science was one of the first to be set up at Simmons College.

Simmons trained professionals and offered a degree program in cookery for teachers. As a compromise with the Boston Cooking School, Simmons also offered a one-year course to women planning to be homemakers — the "diamond-ring course."[1]

This silver-gelatin cabinet card, made by Thompson of Camden, New York, in 1902 or later, shows a Simmons student festooned with the accoutrements of her profession: drapery hooks, dust pan, dish towels, dust cloths, egg beater, rug beaters, children's books, kitchen matches, and a hemline decorated with dinner bells. From the Wm. B. Becker Collection.

REFERENCES

1. Laura Shapiro, *Perfection Salad* (New York: Farrar, Straus, & Giroux, 1986), pp. 118-119.

Kathleen Collins

"Permanent Authentic Records"
The Photographs of Edwin Hale Lincoln

Wm. B. Becker

When an automobile struck and killed Edwin Hale Lincoln in Pittsfield, Massachusetts, in 1938, the accident deprived the world of a talented, active photographer who also happened to be a veteran of the American Civil War. But before his death at the age of 90, Lincoln produced an extensive body of exquisite platinum prints. These pictures, produced during the second half of his long life, concentrate on simple subjects such as flowers or sailing ships. They transcend mere documentation through mastery of technique, sensitivity to basic photographic values and creativity of approach. They stand out from other photographs of their time by virtue of their directness and avoidance of retouching and other manipulation. Lincoln's photographs bridge the gap between the classic documentary camera works of the nineteenth century and the "straight" photography of the twentieth century as adopted by the New Objectivists, the f/64 group, and others who rejected the conventions of pictorial and secessionist styles.

Edwin Hale Lincoln (1848-1938) entered the photographic profession in 1876 in Brockton, Massachusetts, and first achieved fame for his early dry-plate studies of wooden sailing vessels, photographs made between 1883 and 1889.[1] Lincoln was acclaimed by naturalists for his photographic survey, *Wild Flowers of New England*, self-published as a series of four hundred platinum prints in 1914. His work presents an unusual challenge for the photographic historian in stylistic matters, bearing no

overt similarities to the well-established studio, amateur or photo-secessionist schools which were his contemporaries in the early years of the twentieth century. There is, however, reason to believe that Lincoln's approach to photography can best be understood when considered in the context of an American design school not generally associated with photography: the Arts and Crafts movement.

Inspired by the writings of the English essayist, critic and reformer John Ruskin (1819-1900) and by the socialist poet and artist William Morris (1834-1896), the Arts and Crafts movement in America is best known today for the pottery wares of Grueby, Rookwood, and Pewabic, and for the so-called "mission" furniture produced by Elbert Hubbard's Roycroft Shops and by Gustave Stickley's Craftsman Workshops.

Gustave Stickley (1857-1942), of Syracuse, New York, provided the movement with its strongest American voice, dispensing his designs and philosophies in a series of furniture catalogues, pamphlets, and a magazine, *The Craftsman*, published from 1901 to 1916. Distinctive in its typography and layout, printed on fine paper, and often impassioned in its promotional prose, *The Craftsman* clearly shares some important characteristics with another influential magazine published from 1903 through 1917, *Camera Work*. While *Camera Work* championed the flamboyant avant-garde photographers and artists of the period, *The Craftsman*, as its name implies,

Figure 1. Edwin Hale Lincoln, Osmunda Cinnamomea (Cinnamon Fern). Platinum print, 9 1/4 x 7 1/2 in. Published in "Wild Flowers of New England" (1904) and "The Craftsman" (March 1915). Wm. B. Becker Collection.

Figure 2. Edwin Hale Lincoln, Podophyllum peltatum (Mandrake. May-Apple). Platinum print, 9 3/8 x 7 3/8 in. Published in "Wild Flowers of New England " (1904) and "The Craftsman" (May 1915). Wm. B. Becker Collection.

promoted a quieter, more meticulous approach that emphasized simplicity and clarity of design in furnishings and living-style.

The English architect and designer C. F. A. Voysey provided a keynote for the Arts and Crafts movements in England and America by observing, "Simplicity requires perfection in all details, while elaboration is easy in comparison with it."[2] Stickley's foreword to the first issue of *The Craftsman* states the intent "to teach that beauty does not imply elaboration or ornament; to employ only those forms and materials which make for simplicity, individuality and dignity of effect."[3] (These sentiments, of course, were early predecessors of Mies van der Rohe's famous dictum, "Less is More.")

That Edwin Hale Lincoln was working in a personal and distinctive style was recognized by 1916, when a magazine writer observed,

> Because of the general appreciation of the wide possibilities of photography as an art, there have sprung up various schools of photographers; and, as in each of the arts, there are always some individualists who eschew all schools and strike out along their own lines, to express through the lens and sensitive plate, instead of the delicate camel's-hair brush, their appreciation of one or another phase of nature.[4]

That Lincoln's distinctive photographs were consistent with the ideals of the American Arts and Crafts movement can be deduced from their inclusion in *The Craftsman* for March, April, May, and June 1915. At this time, Stickley listed photography among the "Arts and Crafts" for which subscribers to his magazine could obtain expert advice on request.[5] Lincoln's photographs illustrated "A Plea for the Wild Garden" in the March 1915 issue, which also carried a profile of the photographer, "A New England Flower Lover." The magazine noted,

> *The Craftsman* has had the good fortune to secure from Mr. Lincoln a series of pictures of the flowers which bloom in April, May and June throughout our Northeast country. These will appear in our magazine in the months in which they appear in the New England wild gardens and we feel sure that they will meet with the response that such simple beauty must always win from Nature's true lovers.[6]

The article concludes with the hope that the flower photographs will lead to greater efforts towards nature preservation:

> Mr. Lincoln's work in connection with the wild flowers of New England we think will not only bring great pleasure to the world through his really beautiful photographic studies, but will also in time awaken toward flowers that wonderful New England conscience, which up to the present has never been appealed to in vain for the protection of any principle.[7]

Captions to two of the accompanying photographs praise them for bringing out the "decorative qualities" of their plant subjects.[8] Thus, Lincoln's work fulfills dual purposes: aesthetic and practical, "decorative" photographs that have the capacity to educate and inspire conservation. This duality was an early ideal of the Stickley Arts and Crafts philosophy:

> …we may claim that artistic creations often attain a double end. They are useful and, at the same time, they afford keen sensuous pleasure. They minister to our physical needs, and they deal with questions of harmony of line and color."[9]

Another ideal of the Arts and Crafts movement, a vestige of William Morris's socialist impulses, was the suggestion that an artist-artisan's work and life ought to be harmoniously integrated. An early Stickley pamphlet explained:

> One who would enter upon this work must pledge himself to set aside imitation. He must come to his drawing-board or working bench dispossessed of the insistent memories of old models. He must vigorously represent to himself the needs of the typical individual of the present age: that is, the man or woman whose life is harmoniously made up of the elements of work, rest, and recreation that it is impossible to separate it into its component parts.[10]

Thus, extra significance must be attached to the remark by Raymond Comstock in *The Countryside Magazine*:

> There is a joy in hearing Edwin Hale Lincoln tell of his work — for the pleasure that one reads in the telling. To him the flowers and the photographing of them are at one with the great thoughts of life — are interwoven with every emotion and recollection. His home, his boys, his daughter, his wife—anecdotes of them all are interspersed with incidents of the quest for flower photographs, and frequently the one is linked with the other.[11]

276

Figure 3. Edwin Hale Lincoln, Viburnum Alnifolium (Hobble Bush. American Wayfaring Tree). Platinum print, 7 1/2 x 9 1/4 in. Published in "Wild Flowers of New England " (1904). Wm. B. Becker Collection.

Figure 4. Edwin Hale Lincoln, Lilacs. Platinum print, 13 1/8 x 10 1/4 in. Published in "The Craftsman" (March 1915). Wm. B. Becker Collection.

The author described Edwin Hale Lincoln as "the companion and co-scholar with men whose names live in the history of American arts...." But the photographer modestly avoided the word "art" in his own description of his work:

> There is no record so true as the good photographic study; and as we see the conditions of plant life eternally changing everywhere, the value of these permanent authentic records to future generations cannot be over-estimated.[12]

While photographic writers, in two articles published after his death, praised Lincoln's technique, they also quoted him as cautioning against over-emphasizing technical matters:

> No manufacturer will ever succeed in building brains into a camera," he once told a beginner. "Brains are the most

important single element in making pictures. You can buy all the gadgets on the market and try all the plates and films and hyper-stuff, but you'll never make worthwhile pictures unless you use intelligence." His method was to determine what served his purpose best and then to stick to those products and procedures. He was not adverse to improvements, but he recognized the folly of constantly changing his methods.[13]

Lincoln's craftsmanlike concern for the subtle and permanent platinum paper he used led him to be among the last customers for the material in the United States. Undaunted, he imported it himself, by the aid of a cryptic yet effective five-word cablegram: "Platinotype London K three Lincoln."[14] According to an early collector of Lincoln's photographs, Franklin L. Jordan, Lincoln was greatly distressed when platinum paper was taken off the market:

> One day he appeared in my office shouting: "They have taken platinum paper off the market, even in England. There isn't any more anywhere in the world. And I have a lot more prints to make. What am I going to do?" I suggested that he would have to coat his own. "How do you do that? Do you know how?" I told him that I had never coated any, but Paul Anderson down in [New] Jersey was pretty clever at it, and he had better write and find out how he did it. "Write nothing!" snorted the old war horse. "I'll go down there and see him. Where does he live? Give me his address. When is there a train? Call me a cab...." And then, calming down and his eyes softening, 'There, there. I always go off half-cocked. If I started now I would get down there about midnight and that wouldn't be any good. Isn't this the day they serve corned-beef hash at the City Club? We will go and have some of that, and then I'll get the midnight train and be at that fellow's house before he's done breakfast tomorrow morning"— and he was, ninety years old, and all.[15]

Lincoln's platinum prints were not limited to his extraordinary flower studies. He prepared photographic essays on commission on various Massachusetts mansions and estates; he produced a portfolio of tree photographs and another of orchids. He also made platinum prints from a series of early dry-plate negatives of sailing vessels, primarily yachts and other wooden ships. These negatives were taken

Figure 5. Edwin Hale Lincoln, "Str. Bristol Going Under Brooklyn Bridge." Ca. 1886. Platinum print, 6 1/4 x 9 1/2 in. Wm. B. Becker Collection.

by Lincoln between 1883 and 1889, often showing the fast-moving ships under full sail. This feat was accomplished from the decks of chartered tugboats, with the aid of a rubber-band-driven shutter. In 1933, Lincoln told an interviewer that he was the first to photograph the celebrated yacht *America*, namesake of the famous cup. The *America* photographs, it was also reported, were the earliest of his marine studies and the source of his first national reputation.[16]

The ship photographs were apparently printed on several occasions over a period of many years; a series of ninety-nine platinum prints, believed to be from the 1920s, is in the collection of the Boston Public Library, with smaller groupings in the same institution and at the John Crear Library.[17] A portfolio of fifty-three photographs, dated 1929, is in the collection of the Lenox (Massachusetts) Library Association, entitled *Platinum Prints of Ships, Whalers,*

Barks, Barkentines, Brigs, and Brigantines, Coasting and Fishing Schooners; Typical Wooden Vessels of the Nineteenth Century.[18] Lincoln's knowledge of ship architecture and sailing is evident in these photographs and reinforced by their often detailed titles. The ship photographs provide a fascinating parallel to *Wild Flowers of New England* (1917) and two subsequent collections of botanical subjects, *New England Trees* (undated) and *Orchids of the North Eastern United States Photographed from Nature* (1931). The emphasis on classification of the various vessels and their sail configurations serves as a sort of nautical taxonomy. In George Dimock's perceptive essay on Lincoln's work, another comparison is made, between the vanishing wild flowers and the venerable ships: "his photographs reveal the sailing ships of the nineteenth century to be no less fragile, beautiful, yet doomed than the wild orchid...whether his subject

279

Figure 6. Edwin Hale Lincoln, "Sch. Yacht America in Vineyard Sound." Signed, hand-tinted platinum print, 7 1/2 x 9 1/2 in. Wm. B. Becker Collection.

was flower, ship, tree, or mansion, Lincoln's treatment remained the same. He presented each at its most typical, most quintessential, and therefore most beautiful and enduring."[19]

Lincoln's choice of the elegant and unfading platinotype process shows his commitment to preserving his "permanent authentic records" for future generations. His own highly individualistic approach to photography and his life-long dedication to clarity of form and design provide startling evidence that modern "straight" photography did not spring up suddenly with the Paul Strand issue of *Camera Work*, with Weston's vegetable series, or Steichen's thousand exposures of a cup and saucer, but rather has historical antecedents, including the works of a tall, grey-bearded Civil War veteran, an American craftsman and lover of wild flowers.

ACKNOWLEDGEMENTS

The author is indebted to Dr. Gloria O. Becker for research assistance; to Mr. and Mrs. William Porter of Birmingham, Michigan, for the use of their reference materials and expertise on the American Arts and Crafts movement; and to George Dimock for frequent suggestions, guidance and encouragement.

REFERENCES

1. Franklin L. Jordan, "Edwin Hale Lincoln, Master Photographer," *The American Annual of Photography*, vol. 59 (1945), p. 67.

2. David M. Cathers, *Furniture of the American Arts and Crafts Movement* (New York: New American Library, 1981), p. ix.

3. Gustave Stickley, Foreword, *The Craftsman*, vol. 1 (October 1901), p. i.

4. Raymond Comstock, "A Photographer of Nature— Edwin Hale Lincoln," *The Countryside Magazine*, vol. 22 (June 1916), p. 345.

5. (advertisement) The Craftsman Services Department, *The Craftsman*, vol. 27 (April 1915), page 28a.

6. Unsigned article (probably by Gustave Stickley), "A New England Flower Lover," *The Craftsman*, vol. 27 (March 1915), p. 689.

7. "A New England Flower Lover," p. 689.

8. Unsigned article (probably by Gustave Stickley), "A Plea for the Wild Garden," *The Craftsman*, vol. 27 (March 1915).

9. Gustave Stickley, *Chips from the Workshop of Gustave Stickley*, Gustave Stickley, Syracuse, New York (undated pamphlet [1901]), n.p.

10. Gustave Stickley, *Things Wrought* (Eastwood, New York: The United Crafts, January 1902), pp. 7-8.

11. Raymond Comstock, p. 345.

12. Raymond Comstock, p. 348.

13. Unsigned article, "Flowers and Trees by Edwin Hale Lincoln," *U.S. Camera*, vol. 5 (July 1942), p. 23.

14. Franklin L. Jordan, p. 70.

15. Franklin L. Jordan, p. 70.

16. "Frederick Dana Hawes, Lenox Naturalist, 85, Travels 2000 Miles to Take Picture of One Orchid for Great Photo Collection." Newspaper clipping, ca. 1933, author's collection, source unknown.

17. *The National Union Catalogue Pre-1956 Imprints*, vol. 333, p. 628.

18. George Dimock, *A Persistence of Vision* (Lenox, Massachusetts: Lenox Library Association, 1981), p. 28.

19. George Dimock, pp. 36-37.

Photojournalism Around 1900:
The Institutionalization of a Mass Medium

Ulrich Keller

Photojournalism is not the powerful social institution it used to be before the advent of television. While this seems a good moment to ask questions about its structure and history, and while many such efforts have indeed been made in recent years, the situation remains surprisingly opaque, especially with regard to the origins and formative years of the genre. Prominent editors and photographers like Stefan Lorant, Wilson Hicks, and Tim Gidal have tended to lay claims to the "invention" of photojournalism (of the "modern," mass-oriented variety, at any rate) in their own early careers. This widely accepted view by and large equates the emergence of photojournalism as such with the rise of the narratively developed picture article, or "photo-essay," supposedly in the decade of ca. 1928-1938.[1] What is problematic in this theory, apart from its self-serving character, is the reduction of a complex institutional framework to a particular editorial presentation form within a narrow time limit. The rich legacy of imaginatively laid out photo articles from the early part of the century remains unacknowledged. And the decisive historical impulse is attributed to the creative genius of a few individuals who, unaffected by the notorious constraints and biases of the press, managed to introduce an essentially unprecedented form of human, even humane communication.

Historians of various persuasions, on the other hand, have preferred to tie the "birth" of

photojournalism to the perfection of the halftone printing block in America towards the end of the nineteenth century.[2] As we will see, the historical evidence indeed supports this view; the all-important question of the consequences and the meaning of this incisive technological innovation remains controversial, however. In some quarters it has become customary to attribute epochal changes in the human perception of the world to the switch from manual line engraving to photographic tone imagery, in and by itself.[3] Again, however, we seem to be dealing with an undue simplification of very complex matters. Whatever new perceptions may have been generated by the halftone-based picture press, it is difficult to imagine that the generative force emanated directly from the tonal (as opposed to the former linear) constitution of the picture on the printed page. More plausibly, the halftone block prompted a new organization of pictorial journalism; and if there were new meanings, the changed institutional framework as a whole was responsible for their formulation.

In other words, it seems important to understand that photojournalism is more than a certain new reproduction technology, and also more than a certain configuration of text and pictures on the magazine page. Instead of discussing the "halftone effect" and the "photo-essay" as isolated entities, we propose to see them as integral parts of a complex historical structure, one which combines aspects of an

individual profession and a corporate business, a social institution and a technical apparatus, a set of routine practices and a cluster of ideological assumptions. The following attempt to give a succinct account of the constitutive elements as well as the principal historical phases of photojournalism best begins with what most authors would probably agree to call the "prehistory" of the genre, i.e., the five decades that elapsed before the newly invented reproduction medium of photography could be effectively married to the slightly older publication medium of the illustrated newspaper.

I. THE PREHISTORY OF PHOTOJOURNALISM

Photojournalism at its peak was awesome. When the Republican convention of 1952 nominated Eisenhower for president,

> forty people from *Life* went to Chicago, including fourteen photographers. Technicians from the magazine installed a ton and a half of stroboscopic flash equipment inside the International Amphitheater ceiling so Gjon Mili could photograph the delegates and the proceedings "candid," as the expression was then. *Life* laid on radio-equipped taxis to transport staffers scattered in eight different hotels to the 1,500 square feet of space inside the...convention headquarters. There also was a jeep for heavy photographic equipment, and a pair of motorcycles for rapid transport across Chicago. Managing editor Edward K. Thompson...eventually received 35,000 negatives shot by his fourteen men, had 2,000 of them printed, used 56 in the magazine. The story ran for a cover and fourteen pages in the issue of July 21, 1952.[4]

The triumphal opening picture of *Life*'s coverage of the Eisenhower nomination is reproduced as Figure 1.

Not quite a century earlier, Abraham Lincoln's presidential campaign produced only a couple of photographs to speak of. Brady's inauguration picture was shot from an unfavorable location, out of the crowd, with the result that the distant, diminutive protagonist of the event can hardly be made out.[5] The second, more famous photograph belongs in the *carte-de-visite* category. Also a Brady product, it was taken shortly before the election of 1860 and featured on the cover of *Harper's Weekly* shortly afterwards [Figure 2]. As the photographer liked to claim later, Lincoln

attributed his victory at the polls to the combined effect of the photograph and his Cooper Union speech. No independent confirmation of Brady's story has surfaced so far, and it seems rather doubtful that his *carte-de-visite* was circulated widely enough for any considerable public impact, but that is a side issue.[6] What concerns us here is the picture's oblique relation to press and journalism. It is generally not well understood that Brady, far from maintaining any formal association with contemporary illustrated newspapers, functioned as an independent entrepreneur and studio operator specializing in all kinds of photographic portraiture. Only a small percentage of his output possessed any news value at all, and for the most part, Brady marketed such publicly relevant likenesses in the form of mounted, original prints of various formats. Only rarely, and inevitably "translated" into woodcuts, did some of his photographs appear in *Harper's Weekly* and *Frank Leslie's Illustrated Newspaper*.

The form of the famous Lincoln picture clearly reflects the very tenuous link between the camera and the press. Essentially, we are looking at a conventionally posing man in an artificial studio setting. Place, time, and circumstances of the exposure are a matter of conjecture. During any given business day, Brady must have photographed countless customers — famous or not — in this generic fashion. Static and timeless as they appear, his pictures were primarily produced for display in the portrait albums that graced contemporary parlors. Their reproduction in magazines represented a secondary utilization which did not have a demonstrable impact on their formal conception. To be sure, the unwieldy cameras of the time with their slow negatives did not lend themselves to a more dramatic style to begin with; even such cumbersome equipment, however, would have permitted more time- and place-specific, more distinctly topical images, had the need existed.

The overriding technical factor preventing a close cooperation between the newspapers and the cameramen can be found elsewhere: in the slow advance of photomechanical printing methods. More than half a century elapsed between Daguerre's epochal invention and the early 1890s when it finally became commercially feasible to reproduce photographs as photographs in large newspaper editions. Prior to this point, the continuous tones of the camera image had to be transcribed into line engraving — which meant that there was little incentive for newspapers to employ photographers on a regular or even just intermittent basis. The picture reporters on the payroll of *Harper's*,

Figure 1. G. Skadding, Eisenhower triumphant. From "Life" 21 July 1952.

L'Illustration, The Illustrated London News, etc., were all draughtsmen whose sketches were produced at considerably lower cost than wet collodion glass negatives in big view cameras. Invariably representing battles, accidents, and ceremonial events at the peak moment — whether or not the artist had been there — the sketches also were more exciting than images out of the camera, which usually arrived too late and could not record fast action anyway. And while the drawings of the Special Artists were usually imprecise, if not altogether fictitious in character, this did not give an edge to the photographic images, because the latter lost their specific mark of authenticity when transferred to woodblocks.[7]

Thus it is no wonder that until ca. 1885 the history of photography does not know of a single photographer who specialized exclusively in news reporting, or worked solely for press organs for any length of time. Limited and instructive exceptions to the rule were prompted only by major wars, which held sufficient incentive to a few enterprising men such as Brady, Beato, and Fenton to embark on extended news photo campaigns. Even the longest of these, Brady's two-year campaign covering the Civil War with dozens of cameramen, was just that: a temporary effort, not a permanent news gathering machinery. Moreover, with his galleries in Washington and New York continuing to turn out a large volume of *cartes de visite*, portraiture still seems to have been Brady's mainstay product. And if his grand war reportage eventually ended in bankruptcy, it was precisely because no commercially viable link could be forged to the existing pictorial mass media. As it seems, Brady derived only publicity but no revenues from the publication of his images by *Leslie's* and *Harper's*. For profits he had to rely on the marketing of original prints through his galleries and perhaps a few book and stationary stores. The large potential audience of Brady's war documentation could not be reached in this haphazard way, and retail sales proved altogether inadequate to cover the enormous production costs of ca. $100,000.[8]

If the prehistory of photojournalism is therefore the story of an ideally indicated but practically unfeasible alliance between camera and printing press, we encounter a fundamentally different situation around the turn of the century. Figure 3 is indicative of the change. The cameraman, while anonymous, can be identified as one of several photographers on the staff of the news agency Underwood & Underwood, which regularly furnished pictures to *Harper's Weekly*. He

Figure 2. M. Brady, carte-de-visite portrait of Abraham Lincoln, 1860. Courtesy Library of Congress.

must have used a light, fast, hand-held camera fitted with a telephoto lens; most likely he operated from a privileged, cordoned-off press location, and it is entirely possible that Teddy Roosevelt's expressive performance was directly addressed to the press. We need not stress that the resulting photographs were reproduced *as* photographs on the magazine page. Furthermore, since the photographer submitted a whole series of images, an editor had to think about an effective layout strategy. He found an intelligent, witty solution, indeed, foreshadowing the fact that photojournalism was going to be a matter of teamwork, with editors and art directors destined to add an important creative dimension to the photographer's basic camera work. The contrast to Lincoln's campaign photograph of 1860 is certainly striking. Under the pressure of corporate employers catering to mass audiences, news photography has developed a captivating, dynamic style. Instead of a posed portrait we are presented with exciting close-ups of a statesman in action.

While a technological and aesthetic watershed separates the Lincoln portrait from the Roosevelt spread, no principal difference seems to set the latter apart from the Eisenhower photograph of 1952 [Figure 1]. In both cases, professional magazine photographers produced split-second exposures with telephoto lenses; and in both cases, an experienced magazine staff used halftone reproductions for effective visual presentation on the magazine page. Admittedly, *Life* opted for bold enlargement of a single picture across two pages — but blockbuster halftone formats had been common in the illustrated press since 1900. Admittedly, too, the Eisenhower picture was taken indoors, under favorable lighting conditions, but where required *Harper's* photographers had taken similar snapshots in courtrooms or congressional meeting halls forty or fifty years earlier.

There can be no doubt, then, that the much-debated "birth" of photojournalism *pre*dates, rather than *post*dates, Theodore Roosevelt's presidency. The years from 1890 to the beginning of the First World War can indeed be identified as the formative period, one which was inaugurated but not wholly defined by the halftone innovation. It was at this time that photojournalism established itself technically and aesthetically, as a professional career and a social institution. The complexity of the phenomenon warrants a detailed analysis.

II. THE CONSTITUTIVE ELEMENTS OF PHOTOJOURNALISM

Somewhat crudely, and leaving aside for the moment all practical and ideological ramifications, it is possible to distinguish three basic ingredients in the organizational infrastructure of early photojournalism: a new brand of newspapers using halftone illustrations based on photographs in lieu of woodcuts based on drawings; a new type of news agency distributing photographs rather than texts; and a new generation of photographers equipped with small, fast, hand-held cameras instead of slow and big ones mounted on tripods. To begin with the first and most important (even if somewhat overrated) element, it was the advent of the halftone printing block that prompted the transition from pictorial to photographic journalism.

WHEN THE PRESIDENT MAKES A SPEECH

Figure 3. Underwood & Underwood, Roosevelt speaking. From "Harper's Weekly," January 26, 1907.

Halftone Pictures

On an experimental basis, halftone reproductions were used since 1867 in weekly magazines and since 1880 in daily papers. But only after substantial improvements had been made by American inventors in 1889-1890 did it become feasible for large-circulation newspapers to print photographic halftone illustrations regularly in large quantities. The development was significant and amounted to a radical redefinition if not a second "invention" of picture journalism.[9] True, fifty years earlier the rise of the illustrated weeklies had produced the eminent cultural phenomenon of a *permanent, institutionalized supply of news pictures to mass audiences*. The shockwaves of the event had been registered in Wordsworth's notorious attack on "Illustrated Books and Newspapers":

Discourse was deemed Man's noblest attitude,
And written words the glory of his hand....
Now prose and verse sunk into disrepute,
Must laquey a dumb Art that best can suit
The taste of this once-intellectual Land.
A backward movement surely have we here,
From manhood, — back to childhood....
Avaunt this vile abuse of pictured page!
Must eyes be all in all, the tongue and ear
Nothing? Heaven keep us from a lower stage! [10]

In spite of the anxieties it spawned in some quarters, early picture journalism was a relatively modest affair in terms of the quantity of reproductions involved. Until 1873 not a single daily newspaper carried images regularly, and the illustrated weeklies devoted to the publication of

news for the general public were few in number, perhaps less than two dozen in all of Europe and America. It can be estimated that the total volume of news pictures to which a given country's public was exposed rarely exceeded 100 per week. By 1910, after the fast, efficient halftone block had all but eliminated the older reproduction technologies, the statistics reveal a dramatic increase. Hundreds of illustrated dailies and weeklies were now published in every industrialized nation, and the total number of pictures published reached staggering proportions, at least by contemporary standards. Fourteen daily newspapers in New York City *alone*, for example, inundated their readers with an average of 903 pictures per week in 1910.[11] While the steep rise is attributable to a variety of factors, few experts will deny that the halftone block was the single most important of these. The permanent supply of news pictures to the urban mass audiences, at any rate, had established itself on a markedly higher level than in the woodcut era.

Significantly, it was no longer possible to launch a wholesale attack on the legitimacy of the pictorial press, as Wordsworth had done half a century earlier. Instead, the danger was now seen in the excessive quantity of reproductions. As *Harper's Weekly* declared in a 1911 editorial on "Over-Illustration," "We can't see the ideas for the illustration. Our world is simply flooded with them."[12] Popular picture consumption had become a fact of life; only its extent and pervasiveness remained subject to debate.

Apart from quantities, there is a qualitative side to the halftone revolution. In a justly acclaimed analytical investigation of countless manual and photomechanical printing techniques of the late nineteenth century, Estelle Jussim claimed that the halftone picture creates "an optical illusion with surrogate power" where line engravings had rendered more subjective, less reliable images. While Jussim is only thinking of art reproductions, the intellectual historian Neil Harris has broadened her claim of the halftone's "illusionary" and at the same time "objective" powers to include all kinds of photomechanical imagery, especially in newspapers and magazines.[13] According to this view, the halftone process reproduces a given "reality" more "realistically" than ever; in a somewhat tautological manner, it is seen to simply repeat and confirm what exists already. However, if we take the position that is nowadays perhaps more tenable — that reality is not given but rather socially constructed through competing representations — a different conclusion suggests itself. The power of the halftone technology then arises precisely from the fact that it bestows the

quality of authentic "reality" on constructed, in many cases biased and contrived scenes. Under this assumption our interest shifts automatically from the technical intricacies of line engravings and dot screens to the institutional framework behind and around them. It is this social instance that formulates the meanings and messages that photomechanical printing encodes "realistically" for mass consumption in a merely secondary operation. It is this social instance that must be analyzed.

Press Photographers

If the halftone block had made the newspapers accessible to photography around 1890, it was substantial improvements in emulsions and camera design that made photography attractive to the papers. The fast gelatin dry plates and roll films of the 1880s, coupled with the hand-held snapshot cameras made possible by them, opened up the realm of movement and action to photography.[14] Previously, the newspapers had relied on the camera for a very limited subject range, especially portraits and sites. Even with the halftone innovation the newspapers would have continued to make very broad use of hand art, had it not been for the new emulsions, which ensured that instead of a few selected subjects photography could now be used to cover practically the whole range of newsworthy subjects. Combined, the halftone block and the gelatin emulsion represented an irresistible force which proceeded with breathtaking speed to ban graphic imagery from the illustrated press. Within fifteen years, many daily and weekly newspapers replaced their draughtsmen with cameramen. By 1900 a large corps of press photographers existed in America, and with the steady increase in the volume of news imagery published, this corps kept growing until it spanned the world in an ever more finely woven capillary network.

Inevitably, the subject range covered by this press corps became almost limitless. From a war in Asia to a railway accident in Brazil, a presidential campaign stop in Little Rock, Arkansas, and the little girl feeding a pigeon in Central Park, everything could take the form of a news photograph. Especially the trivial phase of the expanding spectrum of news imagery deserves to be emphasized here. Important events had always been illustrated. Trivial incidents made an appearance in force only around 1900 and they have stayed with us ever since, underscoring once more that this is the period from which modern photojournalism should be dated.

In press archives, one can occasionally find visual

Figure 4. Underwood & Underwood, press platform at President McKinley's funeral procession. Courtesy Hastings Galleries, New York.

evidence of the newly won importance of photojournalism. An Underwood & Underwood stereograph of president McKinley's funeral procession, to cite just one instance, features a wooden platform populated by a whole battalion of press photographers [Figure 4]. It is not a sensational picture, but it confirms that in a matter of a few years photojournalism had become an built-in feature of public life. A point is reached where no important event can take place without extensive photographic coverage. More than that, it is obvious that these newspaper representatives are highly privileged witnesses of the event in progress. Forty years earlier, only one photographer is known to have been present at the no-less-important event of Lincoln's inauguration, and he had to be content with a peripheral, impractical vantage point. In 1901, however, a large platform is expressly built to give the press photographers an optimal viewpoint: they now act as lieutenants of powerful news organizations and millions of readers. Clearly, the

alliance of the press and photography has produced an institution of consequence.

The Spanish-American War appears to have been the first major armed conflict in history to be depicted primarily by photographers, as opposed to draughtsmen. It came too soon, however, to lead to any highly organized form of coverage. This distinction belongs to the Russo-Japanese War, which took place half a world away from the United States but nonetheless became subject to more massive photographic documentation than all previous wars together. *Collier's* alone employed six photographers on both sides of the front, not to mention a host of correspondents.[15] Again, no principal difference sets this monumental effort apart from the superbly organized photo campaigns of foreign wars and domestic pomp and circumstance that *Life* magazine was to stage a few decades later.

While the bulk of the growing army of press photographers consisted of lowly staffers careening about town on motorcycles in pursuit of accident victims and police interviews, a few specially talented photojournalists soon obtained high status as chroniclers of "big-time" news events. The heyday of star-photographers on the order of Erich Salomon and Margaret Bourke-White was to come later, but already in the early 1900s some press photographers began to circle the globe, accumulating large expense accounts and representing big-time publishers and millions of readers at the major events of the day. The days of intermittent, entrepreneurial news photography by men such as Fenton, Brady, and Gardner with their limited resources and distribution networks had definitely come to an end.

One man deserves to be singled out in the present context as the epitome of the species of the "big-time" news photographer, if not the emerging profession of photojournalism in general. Born in 1856 in England, Jimmy Hare became a photojournalist of the first hour when, after years of freelancing for illustrated magazines, he was hired as a full-time staff photographer by the *Illustrated American* in 1895. Three years later he switched to *Collier's*, a newly founded weekly destined to play a leading role in the early phase of photojournalism. Hare's first major assignment was the Spanish-American War; a few years later he was back in the camps and trenches as the most productive member of *Collier's* camera team covering the Russo-Japanese conflict. In the following years, Hare continued to document major domestic news stories, such as the sensational exploits of pioneer aviators from the Wright brothers to Bleriot. A last challenge was provided by the First World War, which Hare covered in the service of *Leslie's*

magazine. When he retired he was a celebrity of sorts. Newspapers and press associations frequently paid homage to him with articles and honorary memberships, and shortly before he died, a colorful biography was published about "the man who never faked a picture nor ran from danger." True, the star photojournalists of the *Berliner Illustrierte Zeitung* and *Life* were to reap greater fame, but Jimmy came first.[16]

All this said, the fact remains that, as a class, early photojournalists were still relatively unsophisticated in their use of aesthetic and discursive strategies. Even the best Hare photographs look plain and unexciting next to those of Felix Man, Henri Cartier-Bresson, and Margaret Bourke-White, who managed to impress recognizable "authorial," if not artistic, signatures on their work. Early photojournalism was marked by a clear aesthetic deficit, and the as yet very rudimentary editorial planning and processing procedures alone cannot account for this deficit. An additional factor comes into view when we remember that the pay scale and social prestige of any incipient profession tends to be too low to attract eminent talents. More importantly, it seems that in looking for inspiration from other branches of photography and the arts in general, early press photographers were not likely to be richly rewarded. Most of contemporary painting and all of "Art" or "Pictorial" photography were entrenched in elitist social rituals, lofty ideologies, and romantic to symbolist styles. A photojournalist could find precious little stimulation for his daily work here, which thus never escaped the narrow confines of a cut-and-dried routine operation. Only the 1920s brought a dramatic narrowing of the gap between art and industry, technology, mass communication. Formerly despised contexts of picture-making in science, industry, advertising, and press now came to be accepted as legitimate fields of aesthetic productivity, and steeply rising earnings lent these fields an additional lure. To put it in the form of a speculative example, if around 1900 someone wanted to build an oeuvre and a reputation by means of camera work at all, he or she had hardly any choice but to join the Photo-Secession and to produce dream-like gum prints of languid females in symbolic guises. Only the functionalistic reorientation of the arts in the 1920s provided the context in which photojournalism could become a challenging aesthetic practice likely to attract individuals of talent and ambition.[17]

Photo Agencies

In addition to newspapers using halftone illustrations and a corps of press photographers using snapshot cameras, a third factor contributed essentially to the institutionalization of photojournalism: the emergence of agencies disseminating photographic news pictures. At the root of this latter development was the fact that not even the greatest newspapers with the most versatile staff photographers could cover every important news event, especially if it happened in an unpredictable moment and place. Therefore, a mechanism was needed which could supply a newspaper with pictures of noteworthy occurrences beyond the reach of its own investigative apparatus. This intermediary function was assumed by picture agencies, which made it their business to secure photographs of worthwhile subjects for sale to subscribing newspapers.

A typical image of this kind is reproduced in Figure 5. It goes without saying that the sinking of the *Titanic* represented the type of unforeseeable and inaccessible event that must always elude planned, systematic news coverage. However, an anonymous amateur photographer was at hand on one of the rescue ships, and he found the opportunity for a snapshot as some survivors of the catastrophe approached the *Carpathia*. The resulting picture was aesthetically poor, but the subject matter made it sensational. The New York-based photo agency, Bain's News Picture Service, somehow got hold of the snapshot and distributed it to many newspapers that otherwise would have gone without illustration of the *Titanic* episode.

Photo agencies not only bought pictures from outside sources, they also employed their own staff photographers, some of whom generated unprecedented in-depth reportages of the political scene. In 1899 George Grantham Bain, director and photographer of a fledgling picture agency, decided to attach himself to the office of the American president. Over an extended period of time, Bain accompanied McKinley on every trip and also gained frequent access to the White House for formal portrait sessions. The product of this sustained effort was a voluminous reference album containing hundreds of news pictures, meticulously numbered and captioned for commercial distribution.[18] [In Figure 6, the caption to the second picture in the third row reads, " 'What a mighty power for good is a unified nation,' Pres. McKinley at Memphis, Tenn." Elsewhere the date of October 1899 is given.] Naturally, an individual newspaper never could have afforded to devote so much attention to a single political figure. For picture agencies, on the other hand, which catered to the American press as a whole, a profitable line of business opened up here.

Figure 5. Bain's News Picture Service, Titanic lifeboats on way to the Carpathia, 15 April 1912. Courtesy Library of Congress.

As far as I can see, no similar undertaking had ever been carried out under earlier presidents. The Bain album marks the historically significant transition from the intermittent pictorial news recording method of the nineteenth century to the permanent, institutionalized mode of coverage made possible by the increasingly complex machinery of photojournalism at the beginning of our own century. It is a mode of operation that has been perfected ever since. When President Lyndon B. Johnson woke up at 6:30 a.m. in his White House living quarters, he pressed two buttons: that of his body guard and that of Yoichi Okamoto, his personal photographer. Okamoto was one of two persons permitted to enter the Oval Office without knocking, and within the first three months of Johnson's term he took 11,000 pictures.[19] Bain was more conservative in his use of film, but he set the basic pattern for a long line of White House photographers.

Historically, it is worth pointing out that *verbal* news reportages became subject to distribution by commercial agencies already during the 1830s, i.e., as soon as a host of mass circulation newspapers emerged in Paris and other metropolitan centers. Given the fact that the big picture magazines made

their appearance soon thereafter, one might expect to see the establishment of *pictorial* news agencies during the 1850s and 1860s, but no such development occurred. For one thing, there was only a small number of news-oriented illustrated weeklies, just one or two per country, and since each of these pursued limited national interests, few picture topics would have been in sufficiently broad demand to warrant commercial distribution. Furthermore, as long as most news images took the form of drawings, quick forwarding to a multitude of subscribing papers would have been difficult because of duplication problems. Photographic copying of drawings, for example, would have involved a considerable loss of time and graphic quality.

As we have seen, it was the halftone revolution that prompted a sudden, massive demand for news photographs, while the simultaneous introduction of fast gelatin emulsions solved the duplication problem. On this basis, picture agencies could be operated profitably for the first time in history. Beginning in the mid-1890s, such institutions indeed sprang up on both sides of the Atlantic. Founded in 1895, the Bain News Picture Service is generally credited as the first professional establishment of this

Figure 6. G. G. Bain (?), President McKinley traveling, 1899. Courtesy Hastings Galleries, N.Y.

kind. Its dimensions were modest, however; Bain had a laboriously accumulated picture "morgue," but for a long time he was his Picture Service's only photographer (using a 5x7 folding Kodak). The fee for the use of a news picture was initially set at $5. The first large picture agency was Underwood & Underwood, which entered the field in 1901 and soon employed a host of staff photographers. The age of the corporate giants began around 1909 with International News Photos, which primarily catered to the Hearst newspapers. Specialized picture services with a thematic focus on sports, culture, geography, etc., were to follow. In the late 1920s, several German agencies made the significant decision to concentrate exclusively on the distribution of narrative photo sequences, or essays. At the same time, the instantaneous transmission of photographs by wire became possible, dramatically increasing the international exchange of news pictures. No doubt, over large stretches the evolution of these agencies is identical to the history of photojournalism.[20]

IV. THE INSTITUTIONAL BIASES OF PHOTOJOURNALISM

With the emergence of halftone illustrations in newspapers and the concomitant appearance of an army of press photographers and a host of commercial photo agencies, the depiction of news events in the press lost its former intermittent and improvised character; it also lost its innocence. Large and powerful social institutions never fail to develop their own inherent biases. Photojournalism in the broadest sense had become the eye of society; it had established itself as a complex apparatus of observation. As we know from Heisenberg, however, everything in this world is affected by and changes under observation. And the bigger the machinery of observation, we may add, the greater will be the impact on the object of observation. Set up as a giant organization *opposite* the flow of the historical events, photojournalism, too, could not escape changing the nature of these events; even more fundamentally, it could not help changing the definition of what was a news event and what was not. We choose two typical and pervasive photojournalistic practices to illustrate our statement: the staging of events according to camera exigencies; and the aggressive expansion of photographic coverage into previously shielded private spaces. Especially in this area of institutional biases, the definition of the "halftone effect" as a solely technically conditioned one reveals its shortsightedness.

Penetrating the Private Sphere

The distinction between "public" and "private" is a very basic distinction in human life, and most societies set down clear demarcation lines between the two spheres. It is easy to see why the institutionalization of photojournalism was bound to create problems in this respect. In order to attract readers and to boost circulation, newspapers naturally pressured their cameramen to produce sensational, unprecedented pictures. In the traditionally inaccessible private sphere, such pictures could be reaped in large numbers — provided the photographer was prepared to disregard the partly unwritten rules protecting this sector from public exposure. As a result, our century has been marked from the beginning by an unresolvable conflict between the press, which claims the right to inform the public, and the individual trying to defend his or her privacy. Needless to say, it has largely been a losing battle for the individual. As the pictorial press grew to massive proportions and perfected its technical arsenal, it was able to dismantle many traditional barriers of taste and propriety. To cite just one class of subjects, photographs of accident or murder victims, as well as grief-stricken relatives, were originally considered unfit for reproduction in newspapers but became acceptable during the 1920s at the latest. The gradual admission of television cameras into American courtrooms since the late 1970s (the camera trained on the defendant's face as he is sentenced to death) represents the most recent stage in this relentless development.

A photograph of the great German statesman Bismarck on his deathbed in 1898 allows us to study the problem at an early point, before the privileges and restrictions of photojournalism had been legally defined [Figure 7]. What we see in the picture is not a public figure lying in state, but an unrecognizable old man, the face distorted in agony, the bed in disarray. It is a kind of view normally seen only by the closest relatives of the deceased, and it is hard to name a reason why anyone else should have a right to share this moment of pathetic intimacy. Willy Wilcke and Max Priester, the authors of the photograph, however, intended it for commercial distribution. A major German publishing house had already offered to purchase the picture rights for the then spectacular sum of DM 30,000 (ca. $18,000 at today's exchange rate) and twenty percent in royalties when it turned out that the photographers had acted without permission of the Bismarck family, having secretly entered the death chamber through a window in the

Figure 7. W. Wilcke and M. Priester, Bismarck on his deathbed, 1898. Courtesy Staatliche Landesbildstelle Hamburg.

early morning hours. In the ensuing court trial, it was determined that the taking of the picture in itself did not represent an offense because photojournalism was too recent a phenomenon to have been regulated legislatively. The unauthorized intrusion of the room, however, was interpreted as a violation of domestic peace and punished by jail sentences of three and six months.[21] From a modern point of view, the verdict seems harsh, but we should remember that under the pressure of the mass media our concepts of the value and extent of privacy have been reduced to an historically unprecedented minimum.

The illustrated newspapers around 1900 offer many less pathetic examples of the beginning dismantling of privacy. It is not rare, for example, to come across halftone illustrations of prominent men such as Pierpont Morgan and John Rockefeller swinging their walking-sticks at press photographers in relentless pursuit of their famous prey. The contemporary press itself vented endless and unproductive complaints about the intrusiveness of the growing army of photojournalists, and a cartoon of 1907 found an emblematic formula for the beleaguered "prominent citizen photographed in the act of refusing to be photographed" [Figure 8].[22] However, as a built-in, structural bias of photojournalism, the disregard for privacy has proven impervious to protest and legislation. In our own days there is no dearth of incidents such as Pius XII's valet selling a secretly made film of the Pope's agony to the press; an Italian magazine publishing a photograph of Jacqueline Onassis in the nude on a Greek island; or of a Miami newspaper making female visits to Gary Hart's townhouse the subject of CIA-style photographic surveillance.

Staging, Manipulation

Another built-in bias of photojournalism has to do with the fact that in order to photograph an event persuasively and effectively, press photographers are under permanent pressure to manipulate the event to some degree or other. In the early twentieth century, it became difficult to conceive of any public function which either would not have taken place at all or would not have assumed a very different form had press cameras been absent.

In fairly simple form the problem can be studied where a newsworthy episode occurs before photographers have a chance to put their cameras in position. In such cases it is tempting for late arrivers to stage a "replay" of the incident; indeed, this

Figure 8. "A prominent citizen photographed in the act of refusing to be photographed." From "Cosmopolitan," July 1907.

quickly became a notorious photojournalistic practice. More commonly, no interesting events appear to take place at all, and in such periods editors and photographers are under pressure to make things happen, simply in order to feed the printing presses and to please the news-hungry masses. Artificial events of this kind included social meetings, automobile races, aviation shows, etc. From about 1900 on, these were often financed by press tycoons for the benefit of their staff photographers.[23] Hearst even included wars in this category when he told his cameramen, "I furnish the war, you furnish the pictures." It was due to this attitude, incidentally, that the Russo-Japanese War could receive such massive photographic coverage in American newspapers in spite of the fact that no vital U.S. interests were at stake. It was the first armed conflict to be treated as a pure spectacle for the entertainment of an uninvolved mass audience. In a manner of speaking, the Russian and Japanese battalions became gladiators in the arena of the Western illustrated press.

As an unspectacular, everyday example of the artificial news images or "stunt" photographs circulated daily since the advent of photojournalism, we reproduce the anecdotal scene in Figure 9. Frances Benjamin Johnston operated a studio which specialized in portraits and architectural views but sometimes ventured into the news sector as well. Since Johnston lived in Washington, D.C., she was close to many individuals of national importance and occasionally even took pictures of the presidential family.[24] Figure 9 shows Roosevelt's son Quentin holding a flower up to the nose of Rosewell Pinckney, son of the White House mailman. The point of this clearly staged picture is that Rosewell is black; in the Age of Reform this was a politically useful message to broadcast for a president, and a stage has been reached where the camera offered itself as a ready and sufficiently malleable tool to do precisely that. Cleverly manipulated, Johnston's photograph is emblematic of a new genre of photographic pseudo-events, a genre which did not exist ten or twenty years earlier but has stayed with us ever since.

While minor anecdotal incidents such as the Roosevelt-Pinckney encounter could easily be manipulated by press photographers, the latter had, of course, much less control over major public events. As we have seen, for decades state ceremonies and other official events were staged without taking the special needs of cameramen into consideration. With the advent of organized photojournalism, this changed quickly and incisively. The rehabilitation of Dreyfus in 1906 was perhaps the most notable French

295

Figure 9. F. B. Johnston, *Quentin Roosevelt and Pinckney Rosewell at play, ca. 1904. Courtesy Library of Congress.*

news event of the year. Since it represented a face-saving effort on the part of the government, much depended on the public perception of the ceremony; apparently, the army brass in charge of it geared the choreography towards optimal photographic coverage.[25] From a postcard series published by E. Le Deley's Heliotype Company, we can gather that prior to the event a high officer explained to a large group of reporters and press photographers *"comment les choses vont se passer"* [Figure 10]. In other words, the men were given a preview, which made it easy for them to be in the right place at the right moment during the complicated sequence of ceremonial proceedings. Moreover, after the conclusion of Dreyfus's solemn reinstatement in the army, the protagonists of the event remained sufficiently aware of the presence and importance of the press to stage a friendly, informal conversation — just for the benefit of the cameras [Figure 11].

Trivial as they are, the postcards have an emblematic meaning: by 1906 photojournalism had become a major force; ruling elites had no choice but to incorporate it in the strategy and technology of government. Formerly, public ceremonies had been staged primarily to suit a few privileged individuals and social groups. Now they began to be tailor-made for the camera's glass eye — and the millions it stood for. The privileged position of the press photographer seemed to translate into a new and privileged witnessing role for mass audiences. Through photojournalism, it became possible to give the general public an unprecedented sense of participation even in the most remote and exclusive political events. We need not stress, though, that this participation was and is of an illusory nature: news photographs show us packaged, ready-made, inalterable events.

Figures 10 and 11. E. Le Deley, Dreyfus rehabilitation, 1906. Courtesy Bibliothèque Nationale, Paris

Professional Ideology

The crystallization of professional biases took place not just on the level of practical procedures but also on that of ideological representations. In the early years of news photography, no strong apologetic impulses of this kind has existed. When Fenton photographed the Crimean War, his thinking was not governed by any specifically *professional* imperatives. The justifications for what he chose to record and how he chose to record it were made not by Fenton the newsman but by Fenton the gentleman. For example, by avoiding pictures of dead and wounded soldiers, by neglecting to portray men of the rank-and-file, and by principally giving his officers' portraits a loyal and uncritical character (in spite of the gross misconduct of some of these men), he reproduced prejudices peculiar to the social elite to which he belonged. His principal and nearly exclusive allegiance was to his class, rather than his profession.

Brady's, Gardner's, and O'Sullivan's uninhibited commercialization of blood and gore in the American Civil War began to change this order of priorities.[26] By the early 1900s photojournalism had developed a full-fledged professional ideology that took precedence over social loyalties and ethical principles. Photojournalists liked to describe themselves as "servants of the public" and as "determined *at all costs* [italics mine] to serve [their] millions of masters," and they used this self-styled public mandate as an excuse for any breach of sanctioned conduct desirable in the interest of their own careers and their employers' circulation figures.[27] "Delivering the goods" — as the great and uncompromisingly "professional" Jimmy Hare once called it — became press photography's supreme imperative; everything else was negotiable, if not manipulable.[28]

Even the risk of death was comprised in this imperative. From Fenton, Brady, and others of their generation, no one expected any particular display of bravery under fire, and tall stories to the contrary, they were careful not to expose themselves to danger: their modest personal business interests did not justify it. Half a century later, big corporate and individual stakes were involved in war photography; consequently, it came to be considered normal "that the news photographer...will risk his life for a film on the battlefield." A typical representative of this new breed of danger-courting war photographers struck a contemporary observer as a "fanatic" who "crept through those terrible trenches, hugging the huge camera that enabled him to serve 'the people at home.'" The trenches were those dug by the Japanese around Port Arthur in 1905 and most likely the cameraman was Richard L. Dunn of *Collier's*. When Dunn braved the Russian fire to take a picture of a huge Japanese mortar firing a shell, he was asked why he did not wait for a lull, photograph the gun at rest, and then "paint in your negative some dust and stuff, with a little dot way up in the air." The characteristic answer was, "Yes, I suppose I could do that, but then it would hardly be *the real thing*."[29] Why a dot in the air was worth the risk of life, whether the real thing was also a useful and informative thing, and more generally, what legitimation there was for the American press to subject the Russo-Japanese to massive photographic coverage — reasoning of this kind has been suspended by the automatism of professional thinking. In the field of war reportage the cruelty of photojournalism's built-in imperatives indeed manifests itself more openly than elsewhere. For a war picture to be credible and marketable, it must have been taken under dangerous conditions; with perverse logic, the "reality" of a war photograph can ultimately be guaranteed only by the death of its maker, in addition to the bloodiness of the subject.

A related domestic facet of this professional ideology comes into view in a contemporary article on "yellow photography" in which the following, possibly authentic, incident is recounted. A New York press photographer is ordered to provide his city editor with a snapshot of Lemuel Ely Quigg sitting beneath a Ryan portrait conspicuously signed, "From your friend Thomas F. Ryan." In trying to procure this politically damaging news picture, the photographer discovers that Quigg's desk stands opposite the portrait of his ally. With reference to the allegedly unfavorable lighting conditions, the clever cameraman manages to move both desk and owner to the opposite wall where the incriminating exposure is made. Mr. Quigg loses votes, as intended, while the photographer, in a precise formulation of his profession's inherent norms, declares unequivocally, "If I had to show that Mr. Ryan's photograph was not in the room at all, I'd have got it. That's my business."[30]

V. PHOTOJOURNALISM: THE EDITORIAL DIMENSION

As a matter of some complexity, the editorial aspects of photojournalism can be adequately discussed only in the framework of a lengthy separate study. In conclusion of the present article, a few summary remarks on the subject must suffice.

Even though historians and curators of photography with their vested interest in the ideology of the genius and the masterpiece prefer not to discuss the subject, it is apparent that especially in the context of weekly magazines and feature articles photojournalism requires teamwork on many levels; the message received by the reader/viewer is shaped partly, if not primarily, by writers, editors, and art directors. In fact, the pictures taken by the photographer on location represent only the raw material, which receives its definitive form and meaning during weeks of sophisticated processing procedures in editorial offices. And the finished picture story does not always preserve a close resemblance to what the cameraman intended and observed on his assignment.[31]

Life magazine referred to its picture articles as "photo essays" and made no secret of the belief that it had invented both the label and the thing itself, with an honorable mention given to German forerunners around 1930. As a matter of fact, in some form or other, photo stories had been published since the late nineteenth century, and as early as 1909 one of Lewis Hine's highly significant contributions to the genre was described as a "photographic essay."[32]

True, the photojournalistic art form of the photo-essay — like any other art form — underwent a historical development which, crudely put, led from low to high visual impact, from simple to complex structural design. Still, even in the early years one comes across surprisingly sophisticated and imaginative solutions, and it would not be difficult to identify an early and very "similar" forerunner for every developed, mature example of the photo story.

The previously discussed snapshot series of Roosevelt giving a speech [Figure 3] certainly qualifies as a witty and effective experiment in spite of the simple grid pattern adopted for the eight images. In other instances we encounter more complex presentation modes (narrative differentiation, fusion of verbal and pictorial elements, etc.), which are generally supposed to have emerged without noteworthy precedents in the late 1930s. Paul Rainey's article about arctic hunting adventures in the December 1910 issue of *Cosmopolitan* is a case in point [Figures 12 and 13]. A large and interesting — by contemporary standards perhaps exciting — snapshot of a polar bear emerging from a bath in the ocean serves as a "grabber" (as movie experts would call it) to open the piece. Throughout the article a variety of picture formats is used — oval and square, large and small, vertical and horizontal, even with a few film strips added (the significance of the latter in introducing dynamic,

narrative patterns to the printed page need not be emphasized). Thus a remarkable visual variety presents itself to the eye, and since the pictures are within limits permitted to infringe upon and interrupt the progression of the text, a certain fusion of the principal discursive elements has been achieved. To be sure, Rainey's text is still very much the backbone of the article. That the power of the pictures is not fully understood as yet is also evident from their somewhat haphazard grouping, with scenes from different episodes united on the same page. Moreover, pictures are rarely found in the company of the appropriate text sections, indicating that the dialogue between the two components remains to be fine-tuned.[33]

Clearly, however, we are witnessing here the experimentation with editorial streamlining techniques which the photo-essay was to display in fuller measure in the 1930s. It would therefore be a gross simplification to single out one year or a brief period between 1928 and 1938 as the sudden birthdate of the photo-essay, or photojournalism in general. As we have tried to show, the technical prerequisites, the institutional infrastructure, the professional practices and biases and the presentation forms of photojournalism all emerged in the late nineteenth century. They went through a continuous evolution until their inherent dynamics and public relevance were curtailed by the ascendancy of television.

Figure 12. P. J. Rainey, "Bagging Arctic Monsters..." From "Cosmopolitan," December 1910.

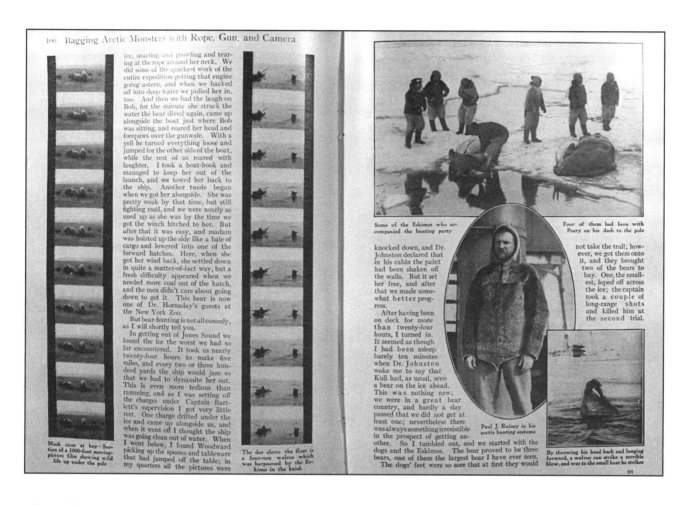

Figure 13. P. J. Rainey, "Bagging Arctic Monsters...." From "Cosmopolitan," December 1910.

REFERENCES AND NOTES

1. W. Hicks, *Words and Pictures* (New York: Harper & Row, 1952), pp. 27 ff.; Tim N. Gidal, *Deutschland — Beginn des modernen Photojournalismus* (Lucerne: Bucher, 1972), passim; "Photojournalism in the 1920s: A Conversation Between Felix H. Man, Photographer, and Stefan Lorant, Picture Editor, 1970," in Beaumont Newhall, ed., *Photography: Essays and Images; Illustrated Readings in the History of Photography* (New York: Museum of Modern Art, 1980), pp. 271 ff. Reference to the halftone technology and early photo stories in newspapers is made by most of these authors, but only as marginal and essentially pre-historical factors.

2. R. Taft, *Photography and the American Scene: A Social History, 1839-1889* (New York: Macmillan, 1938), pp. 419 ff.; R. Hassner, *Bilder for miljoner; Bildtryck …fran de forsta blockbockerna…till den moderna pressens nyhetsbilder och fotoreportage* (Stockholm: Raben & Sjogren, 1977), pp. 183 ff. (Hassner's book is one of the best researched and most informative studies published in the field of photographic history. The discipline's continuing preoccupation with vintage photographs of high exhibition and market value can help to explain the lack of an English edition.) Two Ph.D. dissertations are also relevant here: R. S. Schunemann, "The Photograph in Print: An Examination of New York Daily Newspapers, 1890-1937" (University of Minnesota, 1966); and R. S. Kahan, "The Antecedents of American Photojournalism" (University of Wisconsin, 1969).

3. The narrow focus on the effects of the halftone technology per se is characteristic of numerous related studies; as typical examples we mention: Neil Harris, "Iconography and Intellectual History: The Half-Tone Effect," in J. Higham and P. K. Conkin, eds., *New Directions in American Intellectual History* (Baltimore: Johns Hopkins, 1979), pp. 196 ff.; and M. Roskill, "New Horizons: The Early Life and Times of Photojournalism," in *Views: The Journal of Photography in New England*, vol. 8 (Winter 1987), pp. 6 ff. Contributions of this kind are usually indebted to Estelle Jussim, *Visual Communication and the Graphic Arts; Photographic Technologies in the Nineteenth Century* (New York: Bowker, 1974, 1983). Jussim's book in turn is based on William M. Ivins' eminently brilliant study, *Prints and Visual Communication* (Cambridge, Mass.: Harvard, 1953). What tends to be forgotten is the fact that both Ivins' and Jussim's views are very largely focused on the photomechanical reproduction of art works in books and cannot be extended to the huge and complex phenomenon of the pictorial press without major adjustments.

4. D. J. Hamblin, *That Was the Life* (New York: Norton, 1977), p. 41.

5. Reproduced in D. M. and P. B. Kunhardt, *Mathew Brady and His World* (Alexandria, Va.: Time-Life, 1977), p. 95.

6. J. D. Horan, *Mathew Brady, Historian with a Camera* (New York: Bonanza, 1955), p. 32.

7. For pre-photographic picture journalism see: M. Jackson, *The Pictorial Press: Its Origins and Progress* (London:Hurst & Blackett, 1885); C. Thomas, "Illustrated Journalism," in *Journal of the Society of Arts*, vol. 39 (30 January 1891), pp. 173 ff.; and P. Hodgson, *The War Illustrators* (New York: Macmillan, 1977).

8. Kunhardt (1977), pp. 56 ff.; Horan (1955), pp. 35 ff.; R. Meredith, *Mr. Lincoln's Cameraman, Mathew B. Brady*, 2nd rev. ed. (New York: Dover, 1974), pp. 88 ff.

9. In addition to the literature listed above (reference 2), see H. and A. Gernsheim, *The History of Photography From the Camera Obscura to the Beginning of the Modern Era* (New York: McGraw-Hill, 1969), pp. 539 ff.; E. Ostroff, "Etching, Engraving and Photography: History of Photomechanical Reproduction," and "Photography and Photogravure: History of Photomechanical Reproduction," in *Journal of Photographic Science*, vol. 27 (1969), pp. 65 ff. and 101 ff.

10. W. Knight, ed., *The Poetical Works by William Wordsworth*, vol. 8 (Edinburgh: Paterson, 1886), p. 172.

11. Schunemann (1966), pp. 102 ff. In the picture magazines, halftone photographs outnumbered engravings by the late 1890s. (C. K. Shorter, "Illustrated Journalism: Its Past and Its Future," *The Contemporary Review*, vol. 75, 1899, pp. 481 ff.)

12. *Harper's Weekly*, vol. 55 (29 July 1911), p. 6.

13. Jussim (1974), p. 288; Harris (1979), pp. 198 ff. Jussim clearly states that she is primarily interested in the modalities of transmission. "The meanings transmitted do not concern us here" (p. 12); that's exactly the problem.

14. Compare Gernsheim (1969), pp. 397 ff.

15. L. L. Gould, R. Greffe, *Photojournalist: The Career of Jimmy Hare* (Austin: Univ. of Texas, 1977), pp. 31 ff.; C. Carnes, *Jimmy Hare, News Photographer: Half a Century with a Camera* (New York: Macmillan, 1940), pp. 152 ff.; *The Russo-Japanese War: A Photographic and Descriptive Review…*(New York: Collier, 1905).

16. See the above-listed biographies.

17. For Art Photography, see U. Keller, "The Myth of Art Photography: A Sociological Analysis," and "The Myth of Art Photography: An Iconographic Analysis," in *History of Photography*, vol. 8 (October-December 1984), pp. 249 ff.; and vol. 9 (January-March 1985), pp. 1 ff. For the changing concerns of the 1920s, especially in Germany, see D. Mellor, ed., *Germany: The New Photography, 1927-33* (London: Arts Council of Great Britain, 1978).

18. The anonymous album is part of the legacy of Underwood & Underwood. Since this firm did not enter the field of news photography until 1901 and Bain is the only photographer known to have accompanied President McKinley in 1899, it seems likely, though not certain, that the anonymous album is Bain's. J. Price, "Press Pictures Have Come Far in Half a Century," in *Editor and Publisher*, vol. 71 (February 19, 1938), p. 7.

19. Y. Okamoto, "Photographing President LBJ," in R. S. Schunemann, ed., *Photographic Communication: Principles, Problems and Challenges of Photojournalism* (New York: Hastings, 1972), pp. 194 ff.

20. See Price (1938), pp. 7, 37 ff.

21. The story of this picture has been told by F. Kempe in "Ein Bild das vernichtet werden sollte," in *Zeitmagazin*, supplement to *Die Zeit*, vol. 22 (5 August 1978), pp. 14 ff.

22. To cite just a few of countless complaints: "Newspaper Invasion of Privacy," in *Century*, vol. 86 (June 1913), pp. 310 f.; A. B. Reeve, "The Humour of Yellow Photography," in *Cosmopolitan*, vol. 43 (July 1907), pp. 411 ff.

23. Compare B. Garai, *The Man from Keystone*, (New York: Living Books, 1966), pp. 17 ff.; H. Erman, August Scherl; *Damonie und Erfolg in Wilhelminischer Zeit* (Berlin: Universitas, 1954), pp. 242 ff.

24. For information about Johnston see P. Daniel and R. Smock, *A Talent for Detail: The Photographs of Miss Frances Benjamin Johnston, 1889-1910* (New York: Harmony, 1974).

25. For a history of the Dreyfus scandal see J.-D. Bredin, *The Affair: The Case of Alfred Dreyfus* (New York: Braziller, 1986); the reinstatement, pp. 484 f.

26. At Gettysburg, Gardner and O'Sullivan paid very little attention to anything but dead bodies and left the battlefield soon after the burial operations were completed. In one instance they dragged a body over a distance of 120 feet in order to manufacture the famed picture of the "Rebel Sharpshooter." W. Frassanito, *Gettysburg: A Journey in Time* (New York: Scribner's, 1975), pp. 33, 186 ff.

27. W. G. Fitz-Gerald, "After the World's News with a Camera: A New Profession and Its Perils," in *Harper's Weekly*, vol. 51 (16 February 1907), p. 232.

28. Gould, Greffe (1977), p. 43.

29. The preceding quotes are from Fitz-Gerald (1907), pp. 230, 232. The mortar firing a shell is reproduced in *The Russo-Japanese War*, p. 128.

30. Reeve (1907), pp. 411 ff., 416.

31. The history of the photo-essay has not been written yet. A very useful discussion of the early developments (but with little emphasis on questions of narrative structure and aesthetic design) is offered by Hassner (1977), pp. 213 ff. For the developments since the 1920s, see Hicks (1952), pp. 27 ff.; and T. M. Brown, *Margaret Bourke-White, Photojournalist* (Ithaca, N.Y.: Cornell, 1972), pp. 63 ff. For further literature and commentary see U. Keller, *The Highway as Habitat: A Roy Stryker Documentation, 1943-1955*, exhibition catalog (Santa Barbara, California: University of California, 1986), pp. 33 ff.

32. For *Life*'s view of the history of the photo-essay, see *Photojournalism* (New York: Time-Life, 1971), pp. 53 ff. For Luce's "invention" of the term "photographic essay," see "The Camera as Essayist," in *Life* (April 26, 1937), pp. 62 ff.; and V. Goldberg, *Margaret Bourke-White: A Biography* (New York: Addison-Wesley, 1987), p. 180. In point of fact, the term "photographic essay" was applied as early as 1909 to a series of Hine photographs published by *Everybody's*. W. Hard, and R. C. Dorr, "The Woman's Invasion," in *Everybody's*, vol. 19 (December 1909), p. 799.

33. P. J. Rainey, "Bagging Arctic Monsters with Rope, Gun, and Camera," in *Cosmopolitan*, vol. 50 (December 1910), pp. 91 ff.

303

Atrocity Propaganda in the First World War

John Taylor

That history is a commodity like any other, to be purveyed, used and discarded, sometimes re-worked or otherwise transposed to new effect, is clearly seen in the shifting perception of atrocity during and after the First World War. From 1914-18 atrocities were matters of fact: but from 1919 these facts began to dissolve and disappear.

Photographic evidence of atrocities has to be understood in a similar vein — that is, as facts they have value only if they can be *used*. What follows is an outline of the use of atrocity photographs rather than an assessment of the quality or content of any particular group of photographs. This approach has a curious effect, of which the reader should be aware, upon the body of material under review: the pictures themselves are at the back of the writing, as it were, whilst in the foreground are the discourses that support them and within which they come to have meaning. The aim, then, is not to investigate what the pictures showed so much as how they came to be anchored to a set of meanings and for what purpose. To carry out this work we have to make what appear to be detours into Government propaganda, and newspaper practice. These are not detours at all, but moves towards the center of the agencies in which meaning is made. The assumptions of the people working in these sites were crucial to the meanings that were chosen to overlay and define the amorphous category of atrocity.

The use of atrocity is not confined to the world of representation, but has immediate material effect as we can see it in the progress or lack of it in the post-war tribunals. In 1919 it was estimated that altogether some 30,000 Belgian citizens had been unlawfully murdered.[1] The Commission of Responsibilities that was set up to prepare indictments for condemnable acts decided that out of a total of 280 major atrocities, 39 had been in Belgium. But in 1921 only 12 of these could be brought to court. And of the six cases brought by the Franco-Belgian mission, only one was proven, sending a subordinate officer to prison for two years whilst the General who was held to be responsible not only escaped but became a hero in his own country. So after three years and one minor conviction, the prosecution went home in disgust.[2] By the 1920s, governments had no use for atrocities, and the category began to fade away. Books were written to prove that the worst of them had never happened.[3]

But throughout the progress of the war itself, at least from the French and British perspectives, there was no doubt of German guilt. The certainty rose out of, was tested by, and then rested upon the most solid foundations in the world, the great judiciaries of the allies.

An atrocity was any damage or death, usually to the *civil* world of property and people, which did not accord with the conventions of war. These were set in line with an ideal, almost chivalric, conduct, in which only soldiers and fortifications were destroyed with

agreed, civilized weapons.[4] A curious process of forgetfulness, elision or suppression allowed this easy distinction to be drawn between the civil and the military, in spite of the overwhelming evidence and practical use made of populations as a *whole,* which were placed at the center of the military-industrial complex.[5] Ignoring, or not fully knowing, this allowed the British (and likewise all combative nations) to distinguish themselves from their enemy, who were accused in essence of the misuse of modern technology.

The Germans and their allies in Eastern Europe were said to be guilty of atrocities because they broke with the conventions of war that until then had placed it within society and polity, set out in treaties and international law.[6] In fact, the category of "atrocity" was self-sealing: it was whatever the enemy did, but most particularly what it did to wreck *civil*ization. Hence atrocity was an elastic term that encompassed destructions as diverse as damage to medieval architecture, the murder of civilians, and the use of diabolical weapons such as gas, bombs, dum-dums, torpedoes and liquid fire. The use of this huge category of atrocity was two-fold. Firstly it demonstrated what everyone already assumed through many years of nationalism and xenophobia nourished in the growth and clash of Empires; namely, that war was an evolutionary necessity,[7] and that Germany on its present freakish course was a mutant that had to be eradicated.[8] Secondly, atrocities were extremely useful if, through fear, they stiffened the resolve of the civilian population, and through the desire for revenge hardened the soldiers so that armies would go on killing one another.[9]

The judiciary who first gathered the depositions and pronounced upon them were not insulated against these political considerations. On the contrary, the political use of legal enquiries was well understood. One of the most substantial of these, commonly known as the Bryce Report into alleged atrocities in Belgium, was rushed out soon after the Lusitania was sunk in 1915, when it was expected to have the maximum impact upon American opinion.[10] Lord Bryce was a distinguished diplomat, and had been ambassador to the United States from 1907 to 1913. And since his Report had the form of law, and the imprimatur of Government, to doubt that the crimes had taken place, as the soldier-poet Siegfried Sassoon said, would have been unpatriotic.[11]

The Report was a 360-page account of crimes, with an appendix of 300 pages of selected case histories. It enumerated details of rape, murder and mutilation based entirely upon circumstantial evidence, and it was sold for one penny, the price of a newspaper, to reach a wide audience. The aim was to level a general charge against the Germans rather than to conduct a legally enforceable enquiry, which anyway would have been impossible to stage during the war, and might well have found too many cases unproven.[12]

The form of the Report was based upon an earlier French example, which was explicit in describing the violation of thirty women, and the Paris edition of the British picture paper, the *Daily Mail,* said it would "send another thrill of horror through the civilized world."[13] It pointed out that much of the evidence was unfit for newspaper publication but soon after it was translated and sold for a penny by the *Daily Chronicle.*

It is through this easy transference of rumor and account into quasi-legal proceedings, which then appeared in reports, and then in descriptions in the newspapers, that we see the orientation of these powerful groups towards each other, supporting each other to establish a regime of truth. It is as if the world of print, phenomenally expanded because of advances in the technology of presses and paper,[14] could be likened to a hall of mirrors, each reflecting the information and values of the other in an unbroken circuit. There is no consciousness or conspiracy in this (although individuals did conspire with and against each other for much more specific aims); it is the system itself which is mutual, productive and reproductive.[15]

The network that informed this particular regime of truth even then was cast much wider than the printed word: it included cartoons,[16] posters,[17] high art,[18] and photographic evidence.[19] The whole matrix of *re*-presentation fulfilled a variety of purposes: it was proof, commentary and memorial. It offered both instruction and entertainment. Instruction was the preserve of Government. The War Propaganda Bureau at Wellington House was run by the Liberal politician and social reformer, C. F. G. Masterman. His department produced, translated and distributed books, pamphlets and speeches that dealt with the origins and progress of the war, and aimed to influence opinion overseas.[20] Films and thousands of photographic prints, cartoons, drawings, maps and diagrams were assembled and sent abroad for use in newspapers and magazines, for lantern slides, for cigarette "stiffeners," postcards, posters, exhibitions and shop window displays.[21] Many of the publications were illustrated, usually with cartoons, and many dealt with atrocities. Typical titles were "The Beast," "Frightfulness in Theory and Practice," "German Barbarism," and "Slavery in Europe."[22]

The imaginative drawings, posters and so on — only some of which were sponsored by the

Government — did not have the authenticity of the photograph as evidence. They could only be indicative or emblematic of barbarity, rather than eye-witness proof. The only reprographic mode that bore an indexical relation with the scene, the sense of someone having "been there," was photography. But it was not applied systematically to the coverage of atrocities. The Bryce Report and the early French reports of 1915 contained no photographs. It was not until 1916 that the French began to include photographic "proofs," and even then they were few in number, restrained in content and restricted largely to masonic rather than visceral destruction: these were four photographs of ruined churches, nineteen of ruined villages, and one portrait of a child who had lost an arm. In the final seven French Reports from 1916 to 1919, more photographs of a similar kind were used to illustrate the characters of the main charges. There were two pictures of a sinking ship; two of fruit trees chipped down; two of harsh proclamations; one of a cemetery used as a latrine; two of starved workers; and sixty of ruined houses, churches, factories, agricultural machinery and towns.[23]

Photographs were more widely used in a slimmer volume, a 100-page booklet entitled *Belgium and Germany,* which was translated from the French and distributed to neutral countries by Wellington House.[24] The text was cautious and academic in tone, but the photographs showed not only wrecked buildings, [Figures 1 and 2] but the entry and exit wounds of forbidden bullets, [Figure 3] and the grotesque corpses of civilians. [Figure 4] In general, for reasons of self-censorship to accord with accepted levels of taste or because photographs of brutal murders were too difficult to obtain, pictures of dead flesh were usually foregone in favor of pictures of *text.* The German posters, placards and proclamations issued in France and Belgium were reproduced in facsimile in another Wellington House book of 1916, called *Scraps of Paper.* Every German justification was dismissed by the editor, who said that the Belgians offered no provocation and yet were murdered in much greater numbers and more savagely than the Germans would admit.[25] Facsimile reproductions of diaries and notebooks that described various atrocities and "proved" the accounts were widely used in yet another propaganda book called *Germany's Violations of the Laws of War 1914-15,* which also included photographs of forbidden bullets.[26]

Photographs of vile murders or mutilation were much rarer, though they did exist: a group of German civilians murdered by Russians; two French babies with bayonet wounds in their chests — which

it was said may have been faked; and many Serbians killed by Austrian and Hungarian soldiers.[27]

An official but unusually explicit book of 1915 dealt with this theater of war. Entitled *How Austria-Hungary Waged War in Serbia,* it contained details and photographs of some of the hundreds of civilians who had been murdered and mutilated in horrible ways.[28] A year later, a more fully illustrated version of the book was submitted to the Serbian Government as an official Report, and with the support of the British Government was translated and aimed in particular at neutrals in the United States.[29]

There is no doubt that photographs of savage incidents existed, but these were not widely available in the public domain during the war, in spite of the massive literature that described the most horrendous acts. Photographs of atrocities against people rather than property were more readily available *after* the war, when they were used to publicize the horror of war in general, rather than for partisan or nationalistic propaganda. A British example is *Covenants With Death,* published by the *Daily Express* in 1934 when disarmament, if not pacifism, was on the political agenda. And a German example is the pacifist Ernst Friedrich's *War Against War!* of 1924, which placed against hundreds of photographs captions in German, French, English and one other language: "the book may have appeared in as many as forty languages, including Russian and Chinese" and "over one million copies eventually were distributed worldwide" through the author's efforts and "under the auspices of the trade union movement."[30] It seems that the most shocking photographs were used by pacifists, and perhaps this effect of photographic realism, the possibility that it might induce revulsion against the war amongst the people who would then refuse to fight and clamor for peace, weighed heavily with the censors when the war was being fought.

Atrocity propaganda, carefully garnered and distributed, was useful for the Government, but it was also part of the economy of news. Stories of repulsive acts had a currency, a value that was measured in the increased sales of newspapers. And photographs of atrocities (within its elastic definition) were vital to the economy of the daily and weekly illustrated press. By 1915 the trade in photographs had become a colossal business in which copyright and profits were fiercely contested, not least by Government itself.[31] Since the official photographs were often so delayed that their news-value was diminished, or were anyway too dull by the standards of the press, there was strong competition amongst the newspapers for exciting pictures. Official

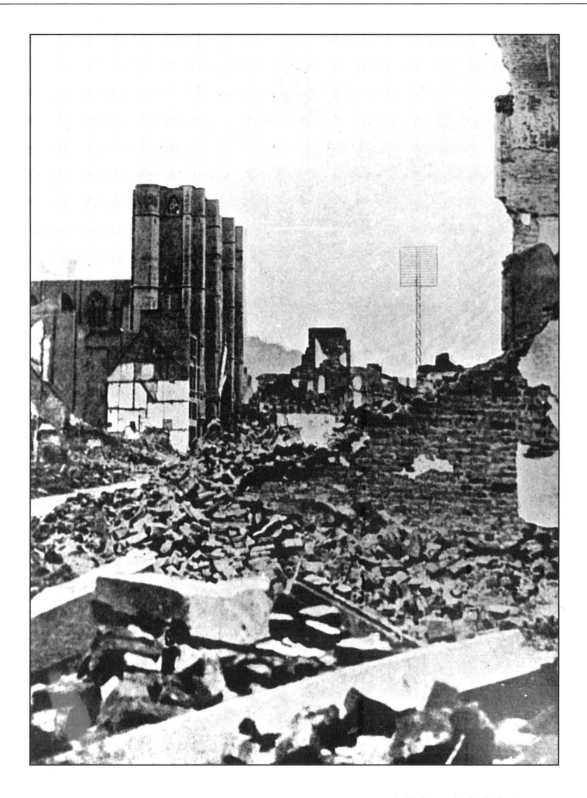

Figure 1. "The dead city of Dinant; the scene of the worst massacre of all those of which the German Army was guilty in Belgium." From Henri Davignon, "Belgium and Germany," 1915.

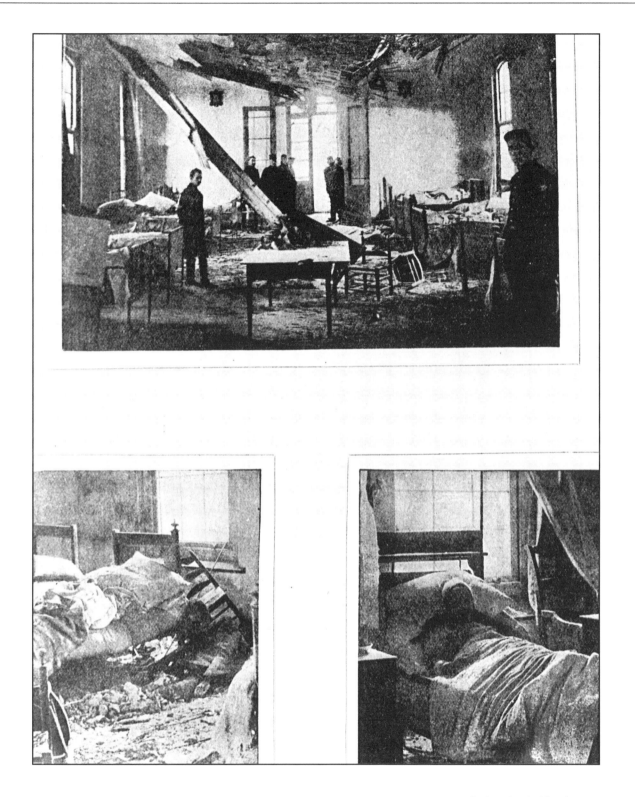

Figure 2. "The hospital of Lierre protected by the flag of the Red Cross systematically bombarded by the German Army. The principal hall—a wounded Belgian and an infirm old woman were killed there." From Henri Davignon, "Belgium and Germany," 1915.

309

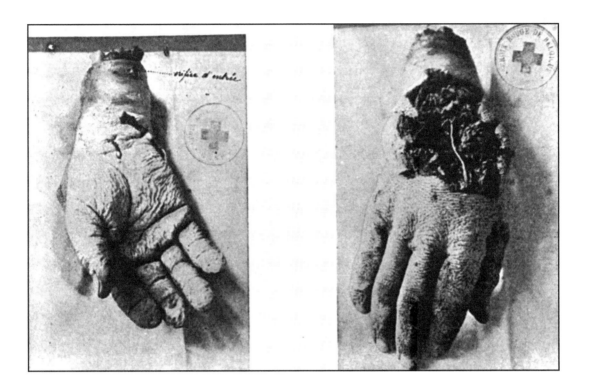

Figure 3. *"Wound caused by an expanding bullet." From Henri Davignon, "Belgium and Germany," 1915.*

photographers on the Western Front had been asked for pictures of "blood and iron" but were unable to supply them,[32] so the press looked elsewhere.

They set out to attract amateur photographers who had either been at the Front or were caught up in dramatic events, and they offered considerable cash incentives. In 1915 both the *Daily Mail* and the *Daily Mirror* offered prizes and fees that totalled £5,000.[33] When the liner *Falaba* was torpedoed, the passenger who took pictures of survivors taking to the lifeboats was at first paid £200 by the *Mirror* for just one of the "thrilling photographs" which showed the "scenes of horror" as the ship sank, the subject of *War's Most Wonderful Pictures*.[34] Later this £200 cover shot was awarded the £1,000 prize in the August "Special Number" of the *Mirror*, which was full of the "First Year of War Pictures."[35] Thrills and spills of any sort were the staple of the industry.

As part of big business the profitability of the press lay in sales based less upon instruction than entertainment.[36] It was a highly differentiated

business, with many titles spread across national daily and Sunday newspapers,[37] London evening papers and local dailies and weeklies. By far the greatest number of photographs were published in the popular national dailies such as the *Daily Mirror* and the *Daily Sketch*. At a halfpenny each, these were the cheapest papers, aimed at the newly arrived and marketable lower-middle-class. Journalists had long expressed fear of the "yellow press": it was a complaint intimately linked with the massive growth and therefore intrusion from the 1880s of the lower-middle-class into what had once been the preserves of the professional classes, a phenomenon we can merely note here.[38] This struggle for status amongst the fractions of class should be remembered, however, because the success of the press as a whole was set upon much the same foundations.

The basis for the popularity and therefore the profits of the industry was the recognition that news-value was a commodity (not a thing-in-itself). From the 1830s, the most saleable items continued to be

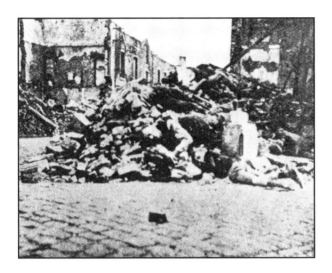

Figure 4. "Photograph taken at Tamines showing the bodies of persons who had been shot on the ruins of a burnt house." From Henri Davignon, "Belgium and Germany," 1915.

"human interest" stories, the kaleidoscope of events clustered around "murders, rapes, suicides, burnings, maimings, theatricals, races, pugilism and every sort of devilment...."[39] By the turn-of-the-century the press was said to resemble the brutality of the Roman arena, the Spanish bull-ring and the English prize fight all rolled into one.[40]

In time of war, news-value as such did not change. Instead, there were other pressures, most notably from the Government, which channelled all the information from the Admiralty and the War Office through the Press Bureau.[41] Its obvious purpose was to ensure that nothing of military use reached the enemy, though it also ensured that nothing of potential political harm reached the public. As Sir George Riddell (owner of the popular *News of the World*) said, "the public knows only half the story. They read of the victories; the cost is concealed."[42]

Government censorship was resisted by the press, not because they lacked patriotism or refused to practice self-censorship (they were assiduous in both), but because censorship was often clumsy. Complaint centered upon the advantage some papers had in obtaining news: the uneven application of censorship was in effect a restraint of trade — and this was often done for political purposes. When the Director of the

Press Bureau wanted to use the statutory powers of the Defence of the Realm Act against *The Times* and *the Daily Mail* (both owned by the press baron Lord Northcliffe) his efforts were defeated by someone within the administration, by a politician anxious to secure newspaper support.[43] This battle amongst the newsmen and the politicians was occasionally important,[44] but usually the press relied upon its everyday practice, trading in stock items of news-value amongst which atrocity stores were standard. They fitted neatly into the category of "human interest," and suited the Government's interest in a public resolved to "fight to the finish."

When the first French Report on atrocities was published, Sir George Riddell had a long talk with Lloyd George, over lunch and a game of golf, about its detailing of sexual crime. Lloyd George thought the details should be published verbatim, and so the Report was given a good press in England.[45] *The Times* apologized to its readers for such full reports of horrible incidents, but this was necessary to show the nature of the "wild beasts" of Germany.[46] A few days later, recalling the fate of women and children in Belgium, *The Times* thundered at women, "Do you realize that the one word 'Go' from you may send another man to fight for King and country?"[47] Thus German barbarism was directly tied to British volunteering.

Generations of teaching had been based upon the differences of blood and temperament amongst the nations. It is not surprising, then, that the excited but simple headlines, such as "The Longest Battle Ever Known on Earth,"[48] were matched with accounts of atrocities because they fitted nationalistic assumptions and so were very easy to understand. They reduced to everyday news-values the often too heroic struggle between Christians and the pagan worshippers of Odin.[49]

Most people could not focus on the war: it was too big. Unlike them, the military chief Lord Kitchener could not focus on the detail. When he and Lloyd George were discussing the "outrages" in Belgium, he said, "What is the good of discussing that incident: all war is an outrage!"[50] This may have been true, but it was certainly unimaginative. The Government had entered the war ostensibly to save Belgian neutrality, but Belgium was a country that no one cared much about.[51] Newspaper talk of "violation" made it much easier to see the political-military solution as a proper response to the *rape* of a nation, especially when the press went so far as to dwell upon "little poignant details" of naked and mutilated girls.[52]

Rumor had it that the Germans chopped the hands off Belgian children. There were plenty of eye-

witness accounts, but no one in Britain had ever seen the victims. The rumor, however, reached the Canadian Government, which suggested that a boat load of maimed refugees should be sent to the U.S. to enlist sympathy for the Allied cause, and the British were bound to say that they had seen no mutilated Belgians. Besides, said an official, this would be an improper stunt for the Government since "ocular" proof could only be given on the music hall stage,[53] though he might have added "or in the popular press." Lord Northcliffe offered £200 for a photograph of mutilated children, but the prize was never claimed. By 1915, Northcliffe and every other responsible journalist no longer believed the story, but it went on being told until the end of the war.[54] Nothing, it seems, could prevent people from continuing to believe what they had been encouraged to believe. Even the *absence* of photographs was used as a proof of guilt, since obviously those who committed the crimes were careful to cover up all traces.

Rumors set within the discursive framework of the law, or at least broadcast with the support of the Government and underpinned *either* by the absence of photographs or by a sufficiency of them in books and newspapers, was turned into a commonplace, an assumption, a given and immoveable knowledge. Press and Government, for different reasons, fed the anti-German feeling until the nation had been lifted to a level of neurosis that occasionally spilled into irrationalities.[55] These in turn had to be curbed by yet another intervention of Government as it sought a new equilibrium for the popular agitated mind. Excesses fueled by the Government began to produce excess. A normalized but sharpened fear of the enemy became a hysterical projection of crime where none existed. In 1914 a young woman in Dumfries, Scotland, fell prey to the atmosphere of criminality and was moved to add to it. She claimed to have received a note from her sister in Belgium which had been scrawled as the girl lay dying, tortured by the Germans.[56] These unexpected lies could not go unchecked, or they endangered all the fragile universe of law now mixed with rumor. The story was a fabrication, and so the girl was tried and convicted of forgery. This was necessary because it doubly protected the integrity of the state by condemning hollow lies and allowing the judiciary, the press and the people to make more solid the stories that were left to circulate.

In 1914-15 the times were especially fevered. By 1917 the public was said to be bored with war news. Whereas in 1914 everyone was "thrilled to the marrow" to hear of the "heroic deaths of friends," by 1917 they only wondered how long it would take the widows to re-marry, and bald heads behind the windows of the West End Clubs yawned as they looked at the enormous casualty lists.[57]

Talk of peace revived an interest in atrocity propaganda in Government and in the Northcliffe press, since both sought Germany's unconditional surrender. Both were involved in creating and propagating the most notorious canard of the war, in which the Germans were accused of boiling down the bodies of dead soldiers and turning them into lubricating oil, pig food, and manure.

The basis of the reports in *The Times* from April 16-19, 1917, was a piece in the German press which had referred to a *kadaververwertungsanstalt*. In the *Daily Mail* the story appeared under the headlines "The Human Corpse Factory." It explained how an advertisement for the Thermo-Chemical Company was in fact an attempt to find an engineer to direct the factory for the destruction of bodies.[58]

On the 20th of April, the Germans protested that the story must have begun with a mistranslation of the word *kadaver*, which was never used for human bodies, but only for the carcasses of animals. [Figure 5] This protest began some correspondence amongst linguists in *The Times*, but it was a very fine detail.[59]

Since it was well known that the people of India, Egypt and the Far East believed there could be no paradise for souls whose bodies had nourished a pig, it was suggested in Parliament on the 30th of April that the Government should use the story for propaganda purposes abroad. Lord Robert Cecil, the Parliamentary Under-Secretary for Foreign Affairs, said the Government had no such plans, and knew no more than was published in the press, "though there was nothing incredible in the charges." But the idea that the story would make good propaganda had been made as early as the 20th of April by the Foreign Office News Department to the War Propaganda Bureau at Wellington House. A pamphlet on the corpse factory was already in the hands of the printer by April 23rd, and a second was in preparation, though in the words of a civil servant in "no case [were they] to have the appearance of official publications."[60] C. F. G. Masterman always claimed that he would not make propaganda out of such press reports,[61] but in this case he sanctioned the pamphlets and wanted the replies to questions in Parliament to be kept vague, avoiding any detailed information as to the actual translations in preparation.[62]

There seems to have been some further division of responsibility within Government departments that certainly had the effect of obscuring the precise course of the story as it moved from the press into the

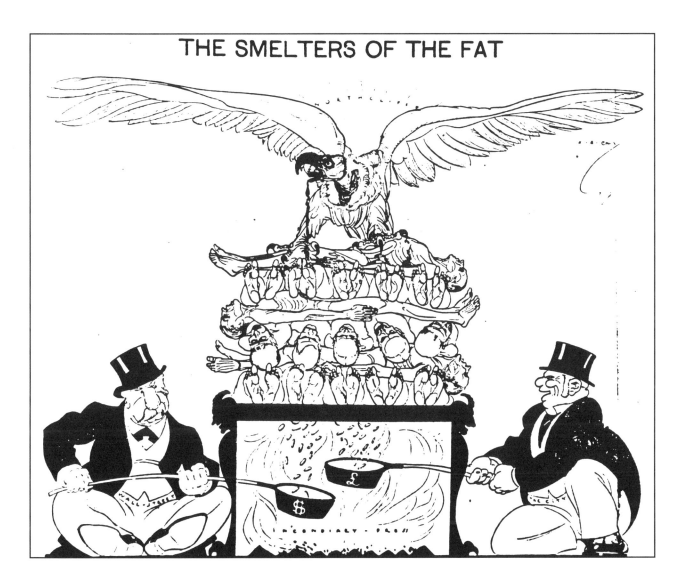

Figure 5. "*The Smelters of the Fat. Deliberately misusing for its own purposes the fact that the Germans extract fat for technical purposes from the carcasses (Kadaver) of horses killed in battle, the ghoulish Northcliffe press has been spreading the ghastly story that the Germans have also been using human corpses (Leichname) for this purpose. This piece of Northcliffe 'frightfulness' received the official semi-sanction of Lord Robert Cecil. Our cartoon shows who are furnishing the fat and who are fattening off it.*" *From "The Continental Times," An Independent Cosmopolitan Newspaper [published in Germany, Austria, Switzerland, Scandinavian countries, and in the Balkans], Friday, June 1, 1917.*

Government's propaganda agencies. It was the India Office which found itself handling the *kadaver* correspondence, although it was not clear to the officials why this should be so, as they themselves did not wish to use the story.[63] In response to various requests for further information, they took their direction from the Foreign Office, and repeated on the 26th of April that whilst the Government had no independent evidence of the truth of the accounts, "in view of the many atrocious actions of which the Germans have been found guilty, in defiance of all the dictates of civilization and humanity," there did not "appear to be any reason why it should not be true."[64]

Corroborative evidence seemed to come from the Front. On June 17th a senior British officer claimed there were fewer than 200 German graves on the Vimy Ridge, which had been the scene of "tremendous battles." There were indications that corpses had been taken away in boxes "to hide their real purpose."[65] This claim offered no proof at all of the factories, nor could it do so, but it did demonstrate the effect of the press reports on a Brigadier, who then wrote his own letter to the press in Canada. His account became lodged in the British Government machinery as another piece of circumstantial evidence.

Later still, on September 17th, yet another piece of circumstantial evidence turned up at the newly formed Department of Information in the form of a pair of photographs. They showed German soldiers standing by a military wagon which was stacked up with corpses that had been tied together. There was nothing to show where or when the photographs had been taken, but nonetheless they had been forwarded by Brigadier-General Charteris for propaganda purposes.[66]

For a long time it had been known that the Germans had little regard for their dead — or at least so *The Daily Telegraph* had said in 1914. Corpses were stripped, tied together with wire and taken back to Germany two or three thousand at a time in "trains of the dead," where they were burned in blast furnaces: "the mighty organisation will not suffer a truck to go back empty, a dead man has no further use for them."[67]

These photographs of Charteris' did not and could not show the corpse conversion factory, but once again they showed that part of the story was true, exactly that part that anyone might expect to see. Entraining the dead was bound to be more visible than the inner workings of the factory itself.

In forwarding the photographs, Charteris was no doubt hoping to prolong the life of a story very dear to his heart, a story that had been his own invention.[68]

As head of Army Intelligence in France he had come across two photographs: one showed a train load of dead soldiers on their way to cremation, and the other showed a load of dead horses labelled *kadaver*. He wanted to shock the Chinese, who were still neutral, so he transposed the caption and sent out the picture and the story to Shanghai, hoping that it would find its way back to Europe.[69]

The story spread and worked its way into the systems because the press were avid for scandal and because officials were also ready to believe their own propaganda concerning the bestiality of the Germans. The most meager and suggestive information had only to be placed in the press and propaganda agencies for it to grow from rumor to irrefutable accusation.

Although atrocity propaganda was supposed to reveal some fundamental truth about the barbarity of the enemy, it could do nothing of the sort, since there was no essential truth. But it was put with such force, so consistently and in such abundance that even when it seemed incredible it was hard to discount. People in authoritative positions sanctioned it, broadcast it, and even invented it, although an investigation into these routes was unthinkable. As long as the Germans were to blame, nothing could be said about the barbarians that were to bring them to defeat. The British had too much at stake, and too much already lost to allow even a sight of their methods, let alone a description of them that was also a critique. As soon as the war ended, most of the records of the information and propaganda agencies were destroyed, and Masterman's own papers are still closed to scrutiny.

Obviously, in the promotion of "black" propaganda, there is no need to imagine conspiracy amongst officials. Something much more subtle is at work, something for which even the term complicity is too conscious of self. Instead, we have to look at the fluidity of the system, which belies the attempts at demarcation. When the mind-set of the people is similar, it seems that information that exists in the system, that is recognized by the system, can flow across the otherwise separated departments and various types of intelligencers. Each component of the system presents an overt distinction from its neighbor: but covertly the components are more linked than separated. Hence they can appear to have arrived at a similar conclusion (about German barbarism, for example) by different means, thus presenting an hegemony that cannot easily be countermanded, and perhaps not at all from within those parts of the system which construe it. The elaboration of the atrocity as something that was a

quality of the enemy, something that belonged to the enemy as a fatal characteristic, enabled the British (in this case) to escape the calumny of guilt. It was as if they were in no sense to blame; the war was not their fault.

If we abandon the attempt to describe the deaths of ten to thirteen million people as either noble sacrifice or wanton murder, we can see them all as the product of the political-military-industrial complex, the product of the combination of nationalism, the arms-race and the mass production of commodities. It was the combination of inventions that led to the "technical surprise" of the First World War. As well as transferring inventions into new applications, the power of the new commodities was further enhanced by standardization and minute specializations in the division of labor. Photography had its place within the matrix: in part it was a branch of optical munitions. The technology of observation spilled out from binoculars, gun-sights and range-finders into the permanent "sight" of the photographic maps produced by the Royal Engineers and the Royal Air Force. As part of the armory, photographic realism had a direct use in surveillance of the enemy.

As we have seen, photographic realism was installed in the press, where it offered a different kind of knowledge, the diversionary use of horror. But the censorship kept control of this realism, because too much of it, too many German corpses or any British ones, would have been bad for morale.

And amongst the Government's uses for photography, the detail of Charteris' pictures is instructive: the photograph does not determine its meaning, or rather, there is no inherent meaning within the photograph. Instead, meaning for the photograph is to be found everywhere except in the picture itself — it is in the relations that exist in the web of discourse.

The combinations of inventions led to an enormous potential which was unleashed to catastrophic effect, and destroyed many of the assumptions of social, political and military discourse. It is well known that where the combatants met, these technologies produced an unexpected reverse in tactics from advance to defense, forcing the armies to set-down and entrench. But even as this mimicry of each other's plans made for stalemate along the Front, the stasis was more apparent than real. Even as they played themselves out, they unleashed in both the West and East greater forces still, with consequences more dire for their grip on world-order than ever they imagined or feared.

REFERENCES

1. E. L. Bogart, *Direct and Indirect Costs of the Great War*, Carnegie Endowment for International Peace (Oxford, 1919), p. 282.

2. J. M. Read, *Atrocity Propaganda, 1914-1919* (New Haven, Connecticut: Yale University Press, 1941), pp. 281-283.

3. See J. M. Read, *Atrocity Propaganda*; Arthur Ponsonby, *Falsehood in Wartime* (E. P. Dutton, 1928); G. S. Viereck, *Spreading Germs of Hate* (Duckworth, 1931).

4. J. M. Spaight, *War Rights on Land* (Macmillan, 1911).

5. E. J. Leed, *No Man's Land; Combat and Identity in World War I* (Cambridge University Press, 1979).

6. J. W. Garner, *International Law and the World War*, volumes I and II (Longmans, Green and Co., 1920).

7. H. W. Koch, "Social Darwinism as a Factor in the 'New Imperialism,'" in H. W. Koch, ed., *The Origins of the First World War* (Macmillan, 1972), pp. 329-354.

8. George W. Crile, *A Mechanistic View of War and Peace* (Macmillan, 1915).

9. J. M. Read, *Atrocity Propaganda*, pp. 6-11.

10. K. G. Robbins, "Lord Bryce and the First World War," *The Historical Journal*, no. 2 (1967), p. 260.

11. Siegfried Sassoon, *Memoirs of a Fox-Hunting Man* (Faber and Faber, 1929), p. 294.

12. Trevor Wilson, "Lord Bryce's Investigation into Alleged German Atrocities in Belgium, 1914-15," *Journal of Contemporary History*, vol. 14 (1979), pp. 369-383.

13. J. M. Read, *Atrocity Propaganda*, p. 154.

14. See *Printing in the Twentieth Century* (The Times Publishing Company, 1930); and H. Wickham Steed, *The Press* (Penguin, 1938).

15. Paul Rock, "News as Eternal Recurrence," in Stanley Cohen and Jack Young, eds., *The Manufacture of News* (Constable, 1981), revised edition, pp. 64-70.

16. See H. Pearl Adam, *International Cartoons of the War* (Chatto and Windus, 1916).

17. See Martin Hardie and Arthur K. Sabin, *War Posters Issued by Belligerent and Neutral Nations, 1914-1919* (A. & C. Black Ltd., 1920).

18. See F. Derwent Wood's sculpture, "Canada's Golgotha, the Crucifixion of a Canadian Soldier," 1918, published in *The Illustrated London News* (January 11, 1919), p. 45; also *Royal Academy Pictures*, 1916 and 1917.

19. See *The Crimes of Germany — Being an Illustrated Synopsis of the Violations of International Law and of Humanity by the Armed Forces of the German Empire. Based on the Official Enquiry of Great Britain, France, Russia and Belgium.* With a Preface by Sir Theodore A. Cook. Being a Special Supplement issued by "The Field" Newspaper, revised and brought up to date with extra illustrations (The Field, 1917); Benjamin Vallotton, *In the Land of Death* (Cassell, 1917); Joseph Bedier, *German Atrocities from German Evidence* (Librairie Armand Colin, 1915). See also references 24, 26, 28, and 29 below.

20. M. L. Sanders, "Wellington House and British Propaganda During the First World War," *The Historical Journal*, no. 1 (1975), pp. 119-146; M. L. Sanders and P. M. Taylor, *British Propaganda During the First World War* (Macmillan, 1982).

21. Ivor Nicholson, "An Aspect of British official wartime propaganda," *The Cornhill Magazine*, vol. 70, no. 419 (1931), p. 597.

22. Public Record Office, London (PRO), T102/20, list of pamphlets and books published by Wellington House.

23. J. M. Read, *Atrocity Propaganda*, p. 156.

24. Henri Davignon, *Belgium and Germany* (Thomas Nelson and Sons, 1915).

25. Cited in Nicholson, "An Aspect of British official wartime propaganda," p. 598.

26. J. O. P. Bland, *Germany's Violations of the Laws of War, 1914-15* (Heinemann, 1915).

27. H. T. Wilkins, *Mysteries of the Great War* (Philip Allen, 1935), pp. 114-115.

28. R. A. Reiss, *How Austria-Hungary Waged War in Serbia* (Librairie Armand Colin, 1915).

29. R. A. Reiss, *The Kingdom of Serbia. Report Upon the Atrocities committed by the Austro-Hungarian Army during the First Invasion of Serbia*, translated by F. S. Copeland (Simpkin, Marshall, Hamilton, Kent & Co., 1916).

30. Ernst Friedrich, *War Against War!* Introduction by Douglas Kellner (Journeyman Press, 1987), p. 7.

31. M. L. Sanders and P. M. Taylor, *British Propaganda During the First World War*, p. 122.

32. Imperial War Museum, London, Ministry of Information Papers, Box 3, File 22, correspondence relating to miscellaneous contracts with photographers, letter dated 18 March 1917.

33. *Daily Mirror*, 24 February and 2 March 1915; *Daily Mail*, 20 May 1915.

34. *Daily Mirror*, 31 March 1915.

35. *Daily Mirror*, 2 August 1915.

36. H. Wickham Steed, *The Press*, p. 17.

37. J. M. McEwen, "The National Press During the First World War: Ownership and Circulation," *Journal of Contemporary History*, no. 3 (1982), pp. 459-86.

38. Geoffrey Crossick, ed., *The Lower Middle Class in Britain* (Croom Helm, 1977).

39. Cited in Stephen Koss, *The Rise and Fall of the Political Press in Britain*, vol. 1: *The Nineteenth Century* (Hamish Hamilton, 1981), p. 414.

40. J. A. Hobson, *The Psychology of Jingoism* (Grant Richards, 1901), p. 29.

41. See M. L. Sanders and P. M. Taylor, *British Propaganda During the First World War*. For an official contemporary account see Sir Edmund Cook, *The Press in War Time* (Macmillan, 1920).

42. Sir George Riddell, *War Diary, 1914-18* (Nicholson and Watson, 1933), p. 210.

43. Stephen Koss, *The Rise and Fall of the Political Press in Britain*, vol. 2: *The Twentieth Century* (Hamish Hamilton, 1981), p. 245.

44. See Lieutenant-Colonel C. à Court Repington, *The First World War, 1914-18*, vol. 1 (Constable, 1920), pp. 36-41, for an account of his report on the shell shortage scandal of 1915.

45. Sir George Riddell, *War Diary*, p. 52.

46. *The Times*, 8 January 1915.

47. *The Times*, 13 January 1915.

48. Selwyn Image, *Art, Morals and the War* (Oxford University Press, 1914), p. 6.

49. H. Wickham Steed, *Through Thirty Years*, vol. 2 (Heinemann, 1924), p. 37.

50. Sir George Riddell, *War Diary*, p. 53.

51. Wickham Steed, *Through Thirty Years*, vol. 2, p. 36.

52. Irene Cooper Willis, *England's Holy War* (Alfred A. Knopf, 1928), p. 133.

53. Public Record Office, London, PRO FO 371/1912.

54. W. Irwin, *Propaganda and the News* (Whittlesey House, 1936), p. 143.

55. Caroline E. Playne, *Society at War, 1914-1916* (Allen and Unwin), pp. 47-50.

56. J. M. Read, *Atrocity Propaganda*, p. 37.

57. N. Lytton, *The Press and the General Staff* (Collins, 1921), p. 1.

58. *Daily Mail*, 18 April 1917.

59. *The Times*, 20 April 1917.

60. Public Record Office, London, PRO FO 395/147. Letter dated 20 April 1917 from Wellington House to the Foreign Office.

61. Lucy Masterman, *C. F. G. Masterman, A Biography* (Frank Cass, 1939), p. 293.

62. Public Record Office, London, PRO FO 395/147. Letter dated 23 April 1917 from Wellington House to the Foreign Office.

63. Public Record Office, London, PRO FO 395/147. Note by the India Office, 24 April 1917.

64. Public Record Office, London, PRO FO 395/147. Letter from the Foreign Office to the India Office, 26 April 1917.

65. Public Record Office, London, PRO FO 395/147. Letter from a Brigadier General in France to Press Gallery, House of Commons, Ottawa, Canada, 10 June 1917.

66. Public Record Office, London PRO FO 395/147. Letter from War Office to Ministry of Information, 17 September 1917.

67. *The Daily Telegraph*, 15 December 1914.

68. "Kadaver," *The Nation*, 31 October 1925, pp. 171-2. And see Charteris' denial reported in *The Nation*, 7 November 1925, p. 201.

69. P. Knightley, *The First Casualty* (Harcourt, Brace, Jovanovich, 1975), p. 106.

News Photography in the News

Steven F. Joseph and Tristan Schwilden

The staple diet of the early news photographer consisted of public ceremonies and the aftermath of disasters. It was a lucky photographer who could afford to ignore what Gernsheim has identified as the two preconditions for success: favourable light conditions and the avoidance of moving people.[1] On 7 August 1862, August De Bedts was fortunate enough to be on the spot when the steeple of St. Martin's Church caught fire in the provincial Belgian town of Courtrai. From a vantage point on the opposite side of the market square, he caught the conflagration as it consumed the church. When he subsequently decided to issue a series of eight full-plate images of the event, he conceived the set as "before" and "after" shots: one view of the church before the fire, three shots during the conflagration, at six- or seven-minute intervals between five past four and twenty-five past four in the afternoon, and three views of the debris.[2] In fact, the final view of the ruins, showing a group of workmen posing amidst the rubble, could stand in for any number of nineteenth-century images of the aftermath of catastrophe.

De Bedts' series is out of the ordinary in that he was able to record the event as it unfolded. Often, photographers had to be content with views of ruins, especially when the catastrophe was as sudden as an explosion. The partnership of Jos. Delehaye & J. Sluyts ran one of the leading firms in Antwerp in the late 1850s and early 1860s. At the exhibition of industrial arts in Brussels in 1857, they demonstrated their versatility by showing studio portraits, group studies, views, glass positives and reproductions of paintings from the Antwerp Museum.[3] Delehaye & Sluyts seem to have been keen to extend their range of activity into the genre of news photography. Of the aftermath variety, their view of the Place de Meir in Antwerp after a fire [Figure 1] is unusual for its size, but is no more than a competent recording of the scene of the disaster, with groups of onlookers examining the ruins at a safe distance.

Somewhat unexpected were the consequences of another field trip by Delehaye & Sluyts in the wake of a similar event. In October 1857, a wing of the Entrepôt Royal, a storage depot, collapsed with the loss of several lives. Some bodies were recovered right away, while others remained buried in the rubble. Salvaging operations began, and workmen toiled round-the-clock for thirty-six hours to clear up the debris. What happened when Delehaye & Sluyts arrived to record the scene on the Sunday after the devastation appeared in the pages of the French photography periodical *La Lumière* two weeks later: "At twenty minutes to twelve a photographer installed himself before the scene of the accident to take a view. At the moment the camera was in place and the artist had focussed [it], the order was given to the miners to stop work and to stand still so as not to impede the photographic operation. The immobility led to a general silence in place of the hubbub. All of

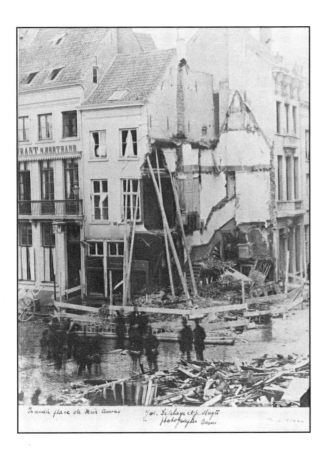

Figure 1. Jos. Delehaye & J. Sluyts, "Incendie Place de Meir Anvers." Salted paper print, 39.6 x 28.4 cm. Courtesy of the Print Room, Bibliothèque Royale Albert Ier, Brussels.

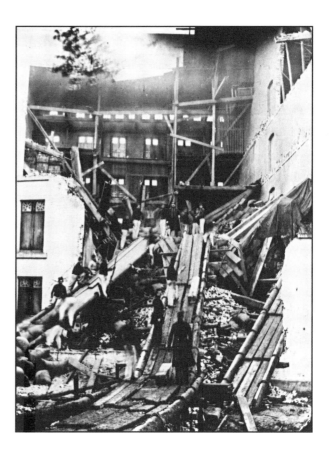

Figure 2. Jos. Delehaye & J. Sluyts, "Catastrophe arrivée à l'Entrepôt Royal d'Anvers. Vue prise le 1er Novembre 1857 au moment ou l'on a trouvé les traces de l'ouvrier Martens, retiré vivant des décombres." Salted paper print, 22.0 x 16.1 cm. Courtesy of the Print Room, Bibliothèque Royale Albert Ier, Brussels.

a sudden moans were heard. People went to the spot whence the cries were coming. It was indeed a victim buried alive underneath the rubble."[4] The precise moment was recorded by Delehaye & Sluyts [Figure 2], and they can be forgiven the slight overexposure visible at the top of the image, given the astonishing circumstances to which the caption refers. The victim turned out to be a workman called Martens, who, after he was pulled from the wreckage shaken but otherwise uninjured, recounted that he had been on the fourth floor at the moment the building had collapsed. He plunged to the basement, but was saved from being crushed by some beams which formed a sort of canopy above his head. He lay entombed in his "cage" for nearly two days, weakened through shock and encroaching dehydration. As the correspondent for *La Lumière* reported, "[Martens] stated that the despairing cries

which he made were the last he was capable of. Therefore he considered the photographer to be his saviour." Delehaye & Sluyts, who had arrived to record a disaster, precipitated a triumph; in attempting to take a news photograph, they became news themselves.

The Chevalier L.P.T. Dubois de Nehaut was a contemporary of Delehaye & Sluyts, a committed amateur rather than a competent professional. He was particularly attracted by the possibility of documentary and news photography, often overcoming unfavourable lighting conditions and the slowness of wet collodion photography in the process.[5] Louis Pierre Theophile Dubois de NeHaut was a circuit judge in Lille, northern France, who moved to Brussels in December 1851, to pursue his business interests but also perhaps because he found himself out of sympathy with the politics of Napoleon

III. He took up photography soon afterwards, and by 1854 he was giving full rein to his major preoccupation as a photographer — capturing motion in a satisfactory manner. Dubois' views of the Place des Nations, the square on which he lived, are amongst the first really successful photographs of street scenes; he manages to keep the blurring of people and traffic to a minimum, particularly by his use of a high vantage point. In the same year, he also took a series of photographs documenting the buildings and inhabitants of the newly opened Zoological Gardens in Brussels. The most striking images are of the animals themselves, including pelicans, herons and a study of the elephant Miss Betzy performing a balancing act for her keeper.

Dubois searched for subjects to demonstrate his mastery in capturing motion with the wet collodion process, and his natural inclination was for the upbeat public ceremony rather than woe and catastrophe. To celebrate the Silver Jubilee of King Leopold I of the Belgians in 1856, an unprecedented series of festivities were planned. These took place over three days, 21 to 23 July, and included a solemn mass, colourful processions and the inauguration of commemorative fountains. It is not known at what stage Dubois hit upon the idea of recording these events for posterity, but he set about overcoming the political and practical obstacles in his path. On the political front, it is clear from the freedom of movement that he enjoyed that he received permission (and probably active backing) from the Court and government. Technically, he had to master the logistics involved in positioning a battery of cameras along the route of ceremonies and in developing the resulting negatives on the spot. For assistance, he called upon Baron Louis Alphonse Humbert de Molard, a fellow member of the French Photographic Society.

Over the three days of the festivities, Dubois and his team produced sixty negatives; from these, he printed thirty-four images, which he subsequently registered for copyright in an album that is now in the holdings of the Bibliothèque Royale Albert Ier in Brussels. The first day of festivities, 21 July, culminated in a service of thanksgiving, celebrated in the open air on the Place St. Joseph before the King, members of the royal family and an array of civic and military dignitaries. Cameras were placed high up in buildings round the square, and the negatives were developed in an adjoining mansion temporarily equipped with a darkroom. This part of Dubois' photo-reportage went off without a hitch, if we are to believe his own commentary contained in the copyright album in the Royal Library. The photographers must have been inconspicuous from their high vantage points and went about their business unimpeded.

However, inconspicuousness could not be guaranteed during other parts of the festivities, and this was to lead to a public incident that is a second example of how an early Belgian news photographer became news himself. Dubois was determined to record as much of the celebrations as possible. The third day, 23 July, was marked by spectacles of a more popular sort, including a procession of historical cavalcades and allegorical floats, which was scheduled to move slowly through the town. Dubois' image, "L'arrivée des photographes établis sur le chemin de fer," [Figure 3] shows the team setting up their equipment on the railway siding running parallel to the Allée Verte, the starting point of the procession. It is probably the first photograph ever taken of news photographers at work, and demonstrates that Dubois fully appreciated that he was breaking new ground, and wanted this recorded for posterity. Dubois (wearing a wide-brimmed hat), Humbert de Molard (adjusting a lens) and the team were at ground level, and therefore much more visible, even exposed, than they had been when photographing the rest of the ceremonies. The attention that the photographers attracted, and the complex interactions that their activity provoked amongst others present that day could almost be seen as a metaphor for photography's emergent ability to shock, disturb and influence. First of all, the untoward sight of the cameramen captured the interest of a journalist, who set down in print an eye-witness account of Dubois' techniques and methods on the day:

> On the riverside bridge and on the railway by the quai, a colony of photographers had established their cameras. All the floats which passed stopped an instant in front of the bridge and were immediately photographed. The prints will be made into an album for presentation to the King. The photographic equipment occupied three railway carriages, one a darkroom; and in the semi-obscurity of this latter a strange figure was moving, covered in a thick mane of hair planted on a slim body, and who, original and fantastic as could be, excited a lively curiosity. The peasants took this singular personage for a gnome, and made the sign of the cross as they passed in front of his magic mirrors. We were

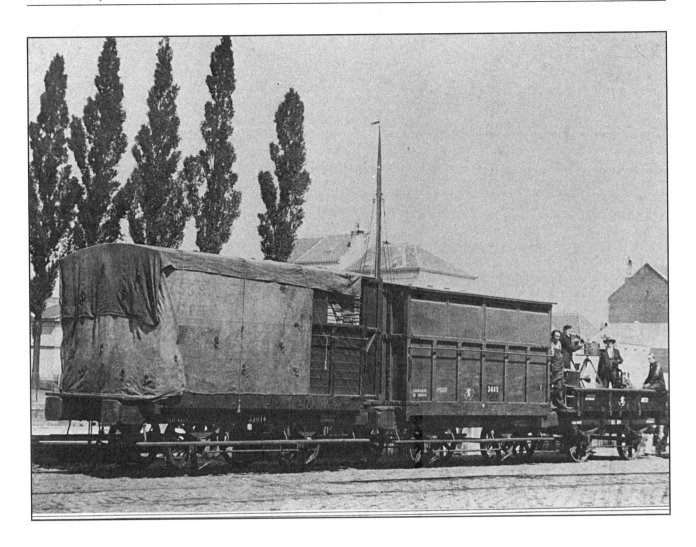

Figure 3. L.P.T. Dubois de Nehaut, "L'arrivée des photographes établis sur le chemin de fer." Salted paper print, 16.4 x 23.5 cm. Collection T. Schwilden, Brussels.

told he was a famous photographer; he had several colleagues, one of whom, fat, lively and bedecked with medals, bore a remarkable resemblance to Joseph Preudhomme.[6] He wore a prodigiously wide-brimmed hat, and every time he finished photographing, he used it to cover up the lens of his camera, stopping the sun in its tracks like Joshua, for the [glass] plate to be removed. He operated so skillfully that he was a pleasure to watch."[7]

While Dubois, "fat, lively and bedecked with medals," excited the admiration of an educated observer such as this anonymous journalist, there is a hint, in the superstitious reaction of the peasants to

Dubois' hirsute assistant, that the photographers were the target of more direct interest. It is not surprising therefore to learn that some individuals took the opportunity to indulge in a certain amount of rowdiness at the photographers' expense. In the copyright album, a group portrait of the team sitting round on the railway wagon [Figure 4] is accompanied by a commentary, in which Dubois explains that the photographers had been subject to two quite different sorts of unwanted pressure. "The photographers harassed by the artists deliberating on the platform of their convoy whether to continue despite the insults of the people mounting the carriages who made obscene gestures at them and whom they were forced to photograph instantly in

Figure 4. L.P.T. Dubois de Nehaut, "Les photographes embêtés par les peintres délibèrent sur la plateforme de leur convoi." Salted paper print, 20.2 x 16.6 cm. Courtesy of the Print Room, Bibliothèque Royale Albert Ier, Brussels.

representing reality, and one that therefore posed a direct threat to their livelihood. Their reaction to Dubois' activity shows the extent to which they were prepared to go, amounting virtually to intimidation, in order to combat this perceived threat. That this incident was taken very seriously is evidenced by the fact that no less a person than the Mayor of Brussels had to intervene personally to restore order, and avert a near diplomatic incident.

Even if history has proved that, in the long term, the artists had every reason to feel threatened by photography, in the specific case of Dubois' work, they had wildly overreacted, since Dubois' intention to publish the series came to nothing in the end. Nevertheless, as photography was making a first hesitant step in the direction of a new genre — the photo-reportage — that July afternoon in 1856, it was assailed not just by artists who feared the new medium, and some peasants who reacted with suspicion, others demanding snapshots of themselves, but also by a perturbed head of state who wished to censor the truth behind an uncomfortable episode by having the photograph that depicted it destroyed. Not to mention the journalist who thought that the phenomenon of news photography was newsworthy in itself, a solipsistic media event *avant la lettre.*

this position offensive to public morality. At the request of His Majesty who has received the only print recording this episode of the festivities, the negative was destroyed...."

On the one hand, the photographers had to contend with vulgar behaviour, bordering on the riotous. Simultaneously, as Dubois goes on to relate, the photographers' work was impeded from another source: the graphic artists who had also been commissioned to record the festivities. "I have decided not to [publish] for the present despite the threats of the artists and architects who sent a deputation to me...demanding that I hand over the negatives which I had made without their advance permission under threat of legal action for plagiarism. [They] were only able to hurl into the water the hat described in the newspaper *L'Emancipation,* the intervention of the Mayor Charles De Brouckère having preserved the colony of French photographers from outrages against our persons."

The extraordinary incident demonstrates in a very concrete way the widespread suspicion with which the new medium of photography was greeted by graphic artists as a rival and more accurate means of

REFERENCES

1. H. & A. Gernsheim, *The History of Photography* (London, 1969), p. 266.

2. Bibliothèque Nationale, Paris, Département des Estampes et de la Photographie, Fonds Eo mat.

3. *Catalogue de l'exposition...des arts industriels en Belgique* (Brussels, 1857), pp. 44-45.

4. *La Lumière,* vol. 7, no. 46 (14 November 1857), p. 183.

5. For a full biographical study, see S. F. Joseph and T. Schwilden, *Le Chevalier L.P.T. Dubois de Nehaut (1799-1872); Sa Vie et Son Oeuvre* (Brussels, 1987).

6. Fictional character, of corpulent build, created by the French writer Henri Monnier.

7. *L'Emancipation Belge,* vol. 37, nos. 206-207 (24-25 July 1856), p. 1.

About the Birth of the Minox

Figure 1. P. and J. Parikas, photographers. The inventors of the first working model for the Minox camera, taken in Tallinn (Estonia) in 1936. From left to right: Hans Epner (engineer), Karl Indus (optician), Walter Zapp (inventor), Nikolai Nyländer (photographer), Richard Yourgens (financial supporter).

It has always been widely accepted that the first set of industrially produced cameras, the Minox, was made in 1938 in Riga (Latvia). I should like to challenge these suppositions, and state that the story of the Minox began some years earlier, in Tallinn (Estonia).

In the accompanying illustration, one can see the men who made the working model of the first Minox in Tallinn in 1936. The idea for this tiny camera came from the inventor Walter Zapp (born 9 April 1905); his drawings for the construction of the camera were finished in the years 1934-1935. The details for the design of the Minox were completed by the talented engineer Hans Epner, the lenses were ground by the optician Karl Indus, design and production money was provided by Richard Yourgens, and the name "Minox" was contributed by the photographer Nikolai Nyländer.

In 1936 the working model for the Minox was finished, but no investors could be found to underwrite the production. So Walter Zapp and Richard Yourgens went to the VEF plants in Riga and there the contract was signed on 10 June 1936. This is the beginning of the Riga chapter of the development of the Minox. But in many of the patents from various countries, the drawings and technical explanations were those developed for the Tallinn Minox; indeed, the first one was from Finland in December 1936.

Finally we can say with certainty, for the use of future photographic historians, that the inventor of the Minox was Walter Zapp, the birthday of the Minox is 1936, and the birthplace is Tallinn.

Walter Zapp wrote, on 18 August 1981, "It's not enough to have a good idea — you must find many good conditions for the realization. My greatest thanks to Estonia for such fine possibilities as I found there. I spent only a fifth of my life there, but these years were decisive."

Peeter Tooming

"Fearful Catastrophe on the Great Western Railway"

Joan M. Schwartz

On the evening of Thursday, 12 March 1857, a little more than a mile outside Hamilton [Canada West, now Ontario], the westbound train out of Toronto plunged through a timber swing bridge on the Great Western Railway line and plummeted sixty feet into the Desjardins Canal. It was the worst railway accident in the history of the colony. Reckless journalists speculated upon the instability of bridges along the GWR line, but the mishap was, in fact, caused by a broken front axle which forced the locomotive to leave the track and drop onto the timbers of the bridge. The entire structure collapsed under the impact and the whole train broke through the gap. The engine and tender crashed through the frozen canal. The baggage car, striking a corner of the tender, was thrown to one side and fell about thirty feet from the engine. The first passenger car landed on its roof, breaking partly through the ice; the next passenger car fell on its end and remained that way.[1]

Doctors were rushed to the scene from as far away as Toronto and rescuers worked through the moonlit night in search of bodies. By Friday noon, the death toll was approaching sixty. Most of those who escaped had been sitting in the rear of the second car. Among the dead were many prominent citizens — merchants, military men, and clergy. In the aftermath of the accident, the mails were delayed and freight traffic was interrupted. A day of public mourning was declared. Stores closed, parliament adjourned and an inquest was ordered. Photography played a key role in both the news coverage and official investigation of the event.

The public was voracious for news of the disaster. A week after the catastrophe, the Hamilton *Spectator* reported, "The demand for newspapers in this city, since the fatal occurrence of Thursday last, is without precedent in Canada."[2] An extra run of regular issues plus extra editions were produced to satisfy the public's appetite for details of the crash, reports of funerals and interments, and progress of the inquest. Not only written accounts, but also visual documentation of the accident scene had a ready audience. In the absence of illustrated newspapers, a spate of engravings hit the market, and it is clear that photography formed the basis of several of them.[3]

The lithographic view published by the proprietor of the *Morning Banner* [Figure 1] was credited to an "ambrotype by R. Milne."[4] Hamilton artist Hardy Gregory produced two lithographs; one was credited "from a Daguerreotype by D. N. Preston" [Figure 2].[5] The other, from an "ambrotype by D. N. Preston" [Figure 3], accompanied the pamphlet *Full Details of the Railway Disaster of the 12th of March, 1857, at the Desjardin Canal, on the Line of the Great Western Railway.*[6] Milne and Preston were established Hamilton photographers and both braved the blustery March weather to record the newsworthy occasion.[7] One or the other was likely responsible for an unattributed salt paper print of the disaster scene [Figure 4] donated to the National Archives of Canada in 1982.[8]

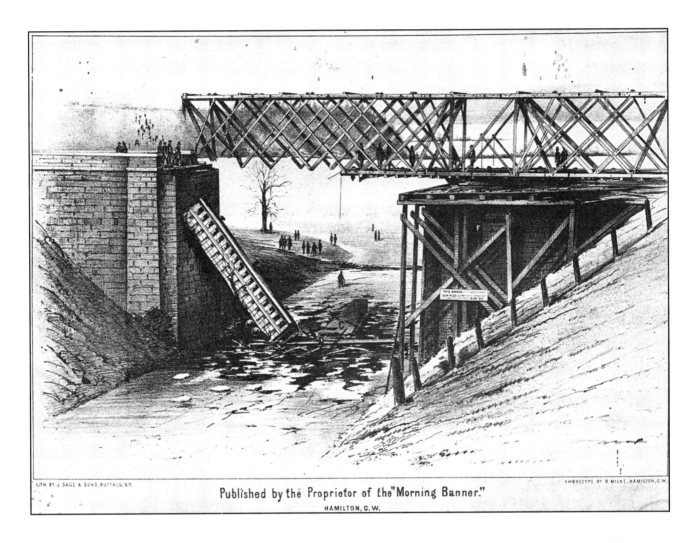

Published by the Proprietor of the "Morning Banner."
HAMILTON, C.W.

Figure 1. Lithograph published by the Proprietor of the "Morning Banner" and printed by J. Sage & Sons, Buffalo, N.Y., from an "ambrotype by R. Milne, Hamilton, C.W." Courtesy of the National Archives of Canada, W. H. Coverdale Collection of Canadiana, C-41060.

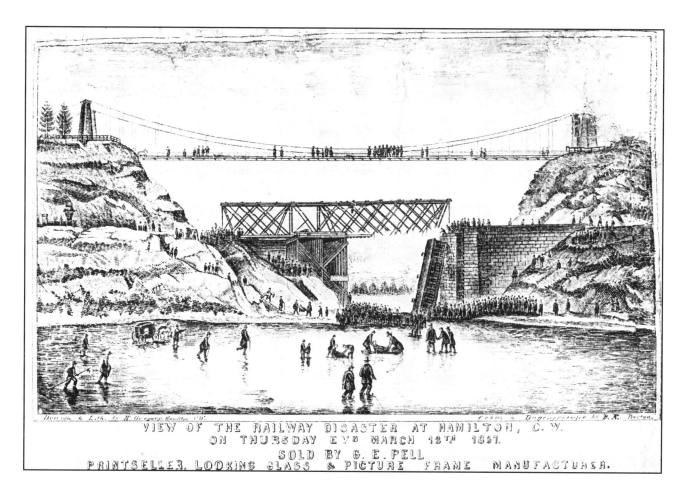

Figure 2. "View of the railway disaster at Hamilton, C.W. on Thursday Evn March 12th 1857. Sold by G. E. Pell, Printseller, Looking Glass & Picture Frame Manufacturer. Drawn & Lith. by H. Gregory, Hamilton, C. W. from a Daguerreotype by D. N. Preston." 99 x 171 mm image on 127 x 183 mm sheet. Courtesy of the National Archives of Canada, C-92477.

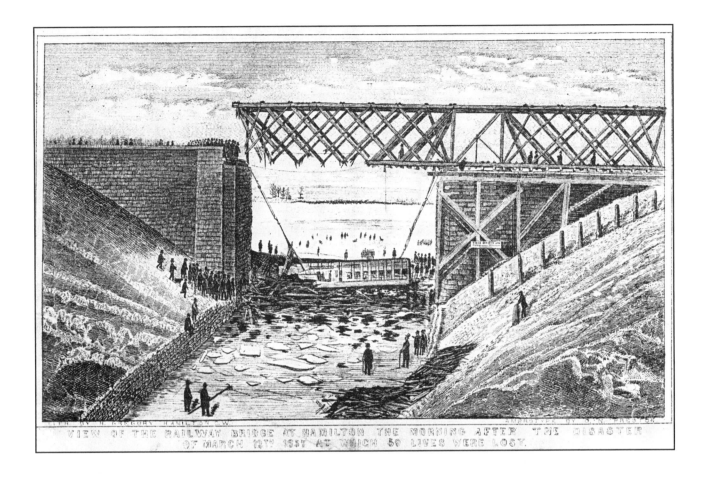

Figure 3. "View of the Railway Bridge at Hamilton the morning after the disaster of March 12th 1857 at which 59 lives were lost. Lith. by H. Gregory, Hamilton, C.W. [from an] Ambrotype by D. N. Preston." From "Full Details of the Railway Disaster of the 12th of March, 1857, at the Desjardin Canal, on the Line of the Great Western Railway," 1857. 94 x 161 mm image on 126 x 185 mm sheet. Courtesy of the National Archives of Canada, C-121126.

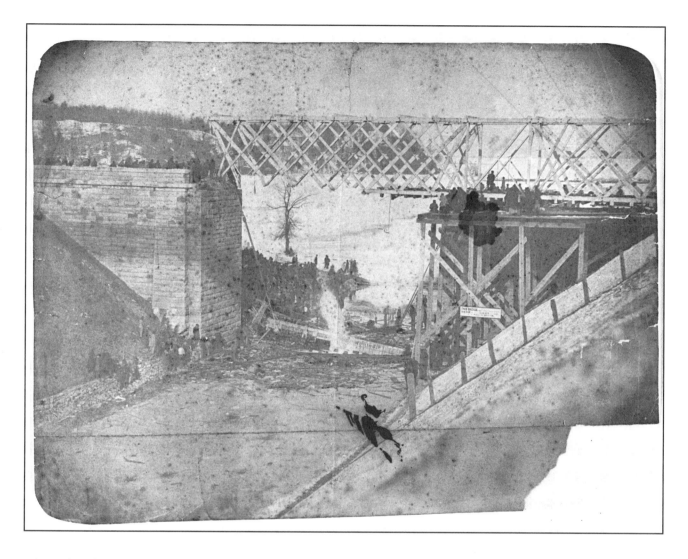

Figure 4. Salt paper print of the bridge over the Desjardins Canal near Hamilton, Canada West, after the accident of 12 March 1857. The photographer is not known; however, the vantage point is the same as the one chosen by Milne for his view published by the "Morning Banner." 246 x 328 mm. Courtesy of the National Archives of Canada, PA-135158.

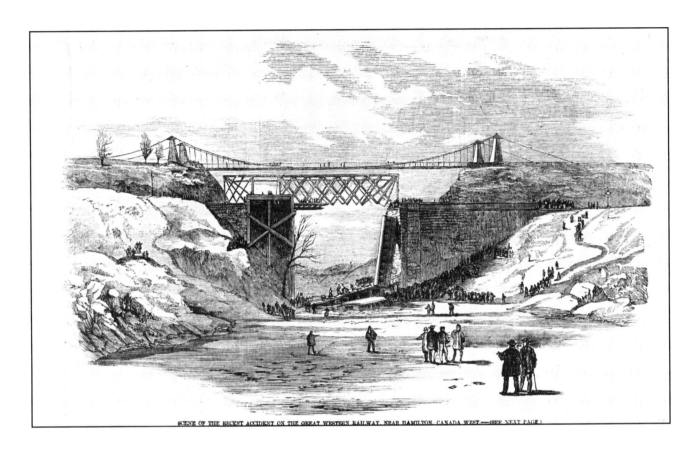

SCENE OF THE RECENT ACCIDENT ON THE GREAT WESTERN RAILWAY, NEAR HAMILTON, CANADA WEST.—(SEE NEXT PAGE.)

Figure 5. "Scene of the recent accident on the Great Western Railway, near Hamilton, Canada West," "Illustrated London News," 4 April 1857, p. 323 (bottom). The editors acknowledge at the conclusion of the accompanying text, "Frightful Railroad Accident in Canada" (p. 324): "We have to thank several correspondents for obligingly forwarding photographs and sketches of the above catastrophe, in addition to the original of the representation engraved upon the preceding page." Courtesy of the National Archives of Canada, C-1520.

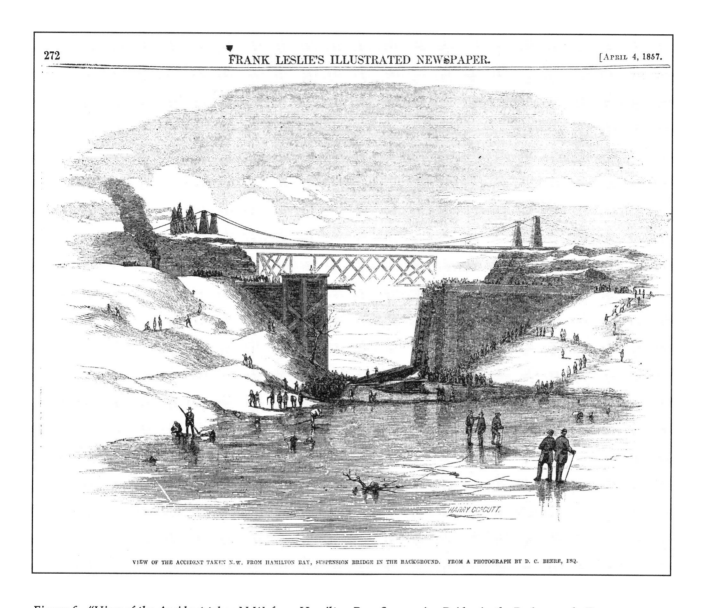

Figure 6. "View of the Accident taken N.W. from Hamilton Bay, Suspension Bridge in the Background. From a photograph by D. C. Beere, Esq.," "Frank Leslie's Illustrated Newspaper," 4 April 1857, p. 272. Courtesy of the National Archives of Canada, PA-149269.

An unnamed correspondent furnished a view of the disaster scene for publication in the *Illustrated London News* [Figure 5]. This view, clearly based on a photograph, was published unattributed. However, the discovery of yet another view in *Frank Leslie's Illustrated Newspaper* [Figure 6] has made it possible to identify the photographer. The engraving in *Frank Leslie's* appeared with the caption, "View of the Accident taken N.W. from Hamilton Bay, Suspension Bridge in the background. From a Photograph by D. C. Beere, Esq."[9] A comparison of the two views shows the essential elements — the railway cars, the broken timbers of the railway bridge, the pylons and cables of the suspension bridge — to be the same. Even the pair of gentlemen in the right foreground are similarly placed — the one on the left in a wide stance with his back to the camera, the one on the right with a cane in his hand. A second group of onlookers appears to their left. Only the details embellished or edited by the hand of the engravers are different. The photographer was likely Daniel Manders Beere, who with partners William Armstrong and Humphrey Lloyd Hime constituted the well-known Toronto firm of Armstrong, Beere & Hime.[10]

Photography, however, served more than journalistic purposes. The initial use of photography "as a practical operational tool" by the Canadian Government appears to have followed the Desjardins Canal bridge disaster.[11] The local newspaper reported:

> Photographs have been taken by Mr. Milne, under the order of Mr. Richards, of every important fracture in the timber of the bridge. Also of the Jury when engaged in examining the bridge, and of the reporter of the *Spectator* taking notes on that occasion.[12]

Mr. Richards was the barrister acting on behalf of the Crown under orders from an official of the Board of Works. The government was heavily involved in the construction and operation of railways and canals, and, in the investigation of the accident, photography was given a role in the documentation process. An account of the proceedings of the inquest into the disaster reported:

> PHOTOGRAPHS.— The Photographs of the various parts of the bridge were here inspected by various of the Jurors. They are taken by Milne....We are not aware that a similar use of Photography has ever been made before, and certainly it has never been pressed into the service of a Jury to the same extent.[13]

Milne's photographs were not only examined by the jurors in the course of the inquest but also incorporated into the report of the investigation into the causes of the disaster submitted to the Commissioners of Public Works by Frederick Preston Rubidge. Rubidge, a civil engineer who had been connected to the Department for fifteen years, "was instructed by the Assistant Commissioner of Public Works to examine the track and remains of the bridge, and report to the Government." His lengthy statement carried the postscript: "The accompanying plans, sketches and photographs, are referred to as illustrating many of the foregoing remarks."[14]

Photography was put to another pioneering use in the aftermath of the accident, and again Milne was the official photographer:

> PHOTOGRAPHS FOR THE IDENTIFICATION OF THE BODIES AS YET UNCLAIMED — By orders of Mr. Brydges [Managing Director of the Great Western Railway], Mr. Milne, the Photographer, has sent a force of artists to the freight sheds with several sets of apparatus. They are taking likenesses of the unrecognized dead. This is a novel, and at the same time a most excellent plan, so that months or years hence, if any of the deceased should remain so long not identified, their friends may recognize them.[15]

The effectiveness of this ingenious scheme was never really tested for, by 2 April, the death toll stood at fifty-nine, and all but one of the victims had been identified before burial.[16]

Milne's views have long since disappeared; however, Milne's work became the center of a controversy over the commercial value of photography when the matter of his reimbursement arose:

> At the time of the investigation into the causes of the catastrophe at the Desjardins Bridge, in March last, a photographer residing at Hamilton, Mr. R. Milne, was employed by the Assistant Engineer of the Department, to make some photographs showing the fractures of some of the broken portions of the structure;...for this service, Mr. Milne sent in an account of £36.00, a Sum which appeared to be so exorbitant, that the Commissioners of Public Works declined paying it, and the claimant brought an action for the recovery of the Amount against Mr. Rubidge, the Assistant Engineer.[17]

The Department defended its decision and the action resulted in a verdict for the Plaintiff of £22.10.0; however, in true government fashion, court costs and professional fees more than offset the difference and, in the end, it cost a total of £41.0.3 to settle the issue of Milne's payment.

The railway disaster occasioned yet another innovative use of photography as a means of informing the general public.

> THE MONUMENT.— Following up the suggestion we threw out for the erection of a monument to commemorate the never to be forgotten event of the 12th inst., at the Desjardin's Canal Bridge, Mr. A. H. Hills, Architect, of this city, has prepared a beautiful design, a daguerreotype of which has been taken by Mr. D. Preston, and now lies at this office for inspection.[18]

In 1857, images of railways, bridge, and disasters all commanded tremendous popular appeal and views of the Great Western Railway bridge disaster combined all three of these highly saleable subjects. At least two photographers took advantage of the commercial possibilities in the tragedy at the Desjardins Canal, and their work, despite the subject matter, was described with the prevailing rhetoric and enthusiasm usually accorded photographs by zealous newspaper editors. Referring to Milne's photographs of the shattered bridge timbers the *Spectator* noted, "many of them are beautiful specimens of art."[19] The newspaper also advised its readers that "Mr. Milne will have for sale some most beautiful views of the scene of disaster."[20]

Clearly the camera served several documentary purposes and, in so doing, demonstrated useful new applications of photography. The work of Milne and Preston on the occasion of this newsworthy railway disaster form the foundation of a documentary tradition in Canadian photography, a tradition greeted enthusiastically and subsequently sustained financially by government and public. If the actual photographs of the Great Western Railway disaster of 1857 have not survived, their significance in the history of photography in Canada is not diminished.

ACKNOWLEDGEMENTS

This essay first appeared in the Winter 1987-88 issue of *Archivaria*, the Journal of the Association of Canadian Archivists, and is republished here with permission of *Archivaria*. The author wishes to extend her thanks to her colleagues at the National Archives of Canada: Richard Huyda, for sharing his research on early Canadian government photography; Tom Hillman, for his assistance in locating some obscure references in the records of the Department of Public Works; and Margaret Houghton, Special Collections Archivist of the Hamilton Library Board, who kindly offered valuable new information.

REFERENCES

1. A description of the accident which appeared under the heading, "Fearful Catastrophe on the Great Western Railway. Awful Loss of Life," in *The Semi-Weekly Spectator and Journal of Commerce* (Hamilton), 14 March 1857, p. 2, col. 7, probably first appeared in *The Daily Spectator* of 13 March 1857; however, to the great frustration of the author, pages 1 and 2 of the issue are missing from both the microfilm and original versions held in the National Library of Canada.

2. *The Daily Spectator*, 18 March 1857, p. 3, col. 1; also *The Weekly Spectator*, 19 March 1857, p. 1, col. 1.

3. *The Daily Spectator* announced in its 16 March 1857 issue: "Sketch of the Disaster. A lithographed view of the fatal spot, as it appeared just after the dreadful catastrophe, is now in course of preparation, taken from a sketch by Mr. Rise of this city...." (*The Daily Spectator*, 16 March 1857, p. 2, col. 8.) At the end of that week, an advertisement appeared: "Just Published!! A Beautifully Tinted Engraving of the Shattered Bridge! over the Desjardins Canal taken from the Bay..." (*Ibid.*, 21 March 1857, p. 2, col. 8.) A few days later, the paper informed its readers: "The Late Disaster. Just published at this office, a Lithographic view of the scene of the late disaster at the Desjardins Canal Bridge, from an Engraving on stone by a first rate Artist..." (*Ibid.*, 25 March 1857, p. 2, col. 7.) Yet another advertisement called attention to the fact that "The Late Catastrophe pamphlet [was] accompanied by [a] lithographic view of the scene [by] W. A. Shephard & Co." (*The Semi-Weekly Spectator*, 28 March 1857, p. 1, col. 7.) This last advertisement refers to the view by Hardy Gregory reproduced as Figure 3 and mentioned in Note 6.

4. *The Morning Banner* was a newspaper published in Hamilton between April 1854 and the end of 1857 when it was superceded by *The Times*. Issued at first three times a week and then daily, *the Morning Banner* was variously known as the *Reform Banner and Railway Chronicle and the Daily Reform Banner*.

5. Hardy Gregory was an artist and engraver active in Hamilton between 1856 and 1865.

6. *Full Details of the Railway Disaster of the 12th of March, 1857, at the Desjardin Canal, on the Line of the Great Western Railway*, Hamilton: William A. Shepard & Co., 1857.

7. Robert Milne was listed as a daguerreotypist in Hamilton by the *Canada Directory* (published by John Lovell of Montreal) in 1851. David N. Preston first appears in Hamilton directories in 1853.

8. National Archives of Canada, Documentary Art & Photography Division, Charlotte M. Horner Collection, Photography Accession No. 1983-104.

9. The cover story of the 4 April 1857 issue of *Frank Leslie's Illustrated Newspaper* was titled, "The Terrible Railroad Massacre." "A wide sweeping calamity has fallen upon the people of Canada," the article began. "By the aid of the photographic art and the hand of genius, we present to our readers some of the most prominent incidents of this event" (p. 265). In truth, only one of the twelve illustrations was based directly on a photograph.

10. Beere's photographic career is examined in the author's "Daniel Manders Beere," *History of Photography*, vol. 8, no. 2 (April-July 1984), pp. 77-82.

11. I am grateful to Richard J. Huyda for making available to me information on the use of photography by the Canadian government from his manuscript on photographer Samuel McLaughlin.

12. *The Daily Spectator*, 19 March 1857, p. 2, col. 3; also *The Weekly Spectator*, 26 March 1857, p. 2, col. 7.

13. *The Weekly Spectator*, 9 April 1857, p. 4, col. 2.

14. Rubidge's report was reproduced in its entirety in the pamphlet *Full Details of the Railway Disaster...*, pp. 41-45.

15. *The Daily Spectator*, 16 March 1857, p. 2, col. 5; also *The Weekly Spectator*, 19 March 1857, p. 3, col. 5.

16. *The Weekly Spectator*, 2 April 1857, p. 4, col. 1.

17. National Archives of Canada, Executive Council of Canada, Minute Books (State Matters), RG 1, E1, vol. 81, p. 185, 20 November 1857; see also Records of the Department of Public Works, RG 11, Series A.3, Vol. 139, file 1609, 31 October 1857.

18. *The Daily Spectator*, 26 March 1857, p. 2, col. 5; also *The Semi-Weekly Spectator*, 28 March 1857, p. 1, col. 5.

19. *The Weekly Spectator*, 9 April 1857, p. 4, col. 2.

20. *The Daily Spectator*, 16 March 1857, p. 2, col. 5; also *The Weekly Spectator*, 19 March 1857, p. 3, col. 5.

Joseph Zacharia: New Zealand Postcard Photographer

William Main

Despite its modest role, the humble postcard offered all sorts of incentives to photographers in New Zealand, some of whom developed it according to the specialized needs of their community. No where is this better demonstrated than in Wellington, where circumstances saw it evolve into a vital comment on the times through the camera of Joseph Zacharia. But before we look at his career, let us examine some factors that led to this man's involvement in the business of providing images for this popular fad.

When the postcard began to gain momentum as a means of cheap communication, New Zealand's population at the turn of the century probably was not enough to tempt local firms to make capital investments in this field. In the main, our million or so population were happy to draw on imported cards, which were cheap and colorful. While some photographers may have been tempted to supply small editions of photographs for the local trade, few if any were prepared to give up their primary means of making money through portraiture. But as public interest in postcards grew, there came an ever-increasing demand for a home-grown product.

It was about 1903-1904 when New Zealand photographers began to interest themselves seriously in the business of supplying views for the postcard trade. Generally they accomplished this by supplying standard views of our towns and cities, taking care to keep people in the background so that these images would not so readily become dated. In the bigger centers, demand for these standard views took on such great proportions that images were committed to the lithographer's stone, where editions could be brought out costing a penny or two per card. Some enterprising firms of photographers found that it was cheaper and less troublesome to get quality printing done in Germany. Supplementing their offerings of local postcards, stationers and suppliers maintained a wide range of foreign views and celebrities.

As the cult of postcard collecting grew, so did the volume and turnover. The New Zealand Post Office recorded the statistic that 14 million cards were sent through its offices in the year 1909, a remarkable figure for a country of our size.

For those who didn't live in our cities and towns, a local photographer could always be relied upon to furnish "Real Photographs" as postcards. These were normally contact-printed onto stock photographic paper that came complete with the word "Postcard" printed on the reverse.

This was the environment that greeted Joseph Zacharia when he entered into the business of postcard production. Born in 1867 in Hokitika and educated in Christchurch, New Zealand, he began his working life apprenticed to a jeweler. Later he went back to his birth place, the West Coast, where he established a pawnbroker's business in Greymouth. Moving to Wellington in the mid-1890s, he continued as before until 1905, when he added the products of a

photographic agency to his business enterprises. It was about this time that he discovered that cameras would move quickly in his shop if they were accompanied by actual examples produced with the equipment on display.

In addition to maintaining a retail outlet, he provided a number of services that would have endeared him to members of the photographic community. He provided the use of a darkroom and gave assistance to those who wanted to improve their photographing and printing skills. He also maintained a portrait studio on Manners Street, Wellington. This was close to the City's fire brigade and thus he was on hand when part of the Parliament buildings were burnt down in 1907. [Figure 1] Certainly this close proximity lends some weight to the belief that he always slept with a loaded camera by his side. But while jewelry and pawnbroking occupied a large part of his family's interests in the town, what he enjoyed most was getting out and about, photographing groups of people in a variety of activities. Ships arriving in Port [Figure 2], people lining the docks, school sports and outings at the seaside, elegantly dressed women at the race course, football players, bands, and funeral processions acted as a magnet to this camera.

In placing so much emphasis on people in his pictures, Zacharia was something of an exception to the norm as far as postcard operators were concerned. Those employed by companies and firms whose business it was to go into large print-runs of postcards tended to shy away from including people in their pictures, because images of people would easily be dated by fashions or seasonal costuming, and those postcards would more likely go unsold. Zacharia's intentions were a complete reverse of this tendency. He wanted as many people as possible to feature in his photographs because this helped him sell his small print-run editions of "Real Photographs." The commercial success of this ploy can be seen in many examples where an "X" has been drawn above the head of an individual with an inscription on the back drawing the recipient's attention to the sender's portrait.

How much did Zacharia charge for his postcards and was it a profitable venture? Hearsay has it that he might have charged sixpence each for his "Real Photograph" postcards. If this was the case, then they must have been some of the dearest on the market. This assumption that he charged two to three times the going rate for a postcard is based upon the slang term for a sixpenny coin current at the time. Linking this catch-phrase with his own name, he signed his cards "Zak." No matter what he charged, his sales

Figure 1: "Zak" Photo (Joseph Zacharia). "Parliament Buildings on Fire, Dec. 11, 1907, 2:30 a.m." 5 1/2" x 3 1/2," image no. 321.

Figure 2: "Zak" Photo (Joseph Zacharia). "Scene at Wellington, N.Z. on arrival of the R.M.S. 'Ionic' with 700 passengers aboard." September 8, 1908. 3 1/2" x 5 1/2", image no. 1724.

probably would not have paid enough for him to live solely off of the proceeds of his postcard business, judging by the relative scarcity of his postcards on the market today.

While there are no records that tell us how many prints he made from each negative, it is thought that he did not print more than a dozen or so from each plate, although at some official gatherings where potential customers congregated in the thousands, he would have increased the printing run accordingly.

When we analyze the numbering system he used on his postcards with the date neatly printed alongside each entry in his record book, it seems that he began operations sometime around 1907. The last numerical listing was made on 13 November 1915. Using this information, we can estimate how many postcards he produced during his career as a photographer. It seems likely, therefore, that he made somewhere in the vicinity of 20,000 plates, but this numbering system doubtless included other studio work. Nonetheless, when one studies the diversity of his output, we can only marvel at his industry.

It is very difficult to compare with Zacharia's the work of other photographers of this period. Little information about Zacharia appears in the standard historical texts. Although a few of his photographs have turned up in various contemporary publications, he doesn't seem to have made a practice of selling his work in this manner. Yet he understood that topical interest in his images would soon dissipate unless he had them ready for sale as soon after the event as possible. The story has it in New Zealand that he would photograph the crowd at a local football match, rush back to his darkroom, process the results, and have the prints on display as the game was ending. [Figure 3] He was well used to working under the kind of pressure encountered by photojournalists.

Zacharia seldom resorted to posing his subjects, preferring to photograph candid settings. On top of this, no event was too small or insignificant for his camera. Sunday school picnics seem to have occupied as much of his time as Dominion Day celebrations. The benefit of his diffuse energies has

Figure 3: "Zak" Photo (Joseph Zacharia). "At the Merivale Athletic Match." 1910. 3 1/2" x 5 1/2", image no. 20.191

left an important documentary record to social historians.

About 1920, he sold his business interests in Wellington with a view to emigrating to New York, where most of his family had settled. While waiting for his visa to come through, he took a temporary job with an Assurance Company, a job that would last for twenty-five years! When he did make it to America in 1947, his disposition, energy, and ability to adapt to new challenges were seriously hampered by his advancing years. After a couple of years in the States, he returned to Wellington where he died in 1965 at the age of 98. He treasured his album of photographs to the end, according to his obituary. Unfortunately, these were accidentally destroyed only days before a curator from the New Zealand National Museum called to inspect them.

Today in New Zealand, his photographs sell for prices well beyond Zacharia's wildest imaginings. In time it is hoped that the study of Joseph Zacharia and other postcard photographers around the world can yield well-deserved recognition for these commercial practitioners and a wealth of sociological and historical information about the period in which they flourished.

Trude Fleischmann: Vienna in the Thirties

Anna Auer

The year 1895 was a memorable one in Vienna. Sigmund Freud, in cooperation with the Viennese doctor Josef Breuer first published his "Studies about Hysteria"; the initial performance of Arthur Schnitzler's "Liebelei" took place at the famed Burgtheater; and it also happened to be the year that the first Jewish Museum anywhere in the world opened its doors.[1]

On March 16, 1986, I visited Trude Fleischmann in Lugano, Switzerland. She remembered very vividly the time she lived in Vienna, and especially her first encounter with the Austrian architect Adolf Loos (1870-1933) and Peter Altenberg (Austrian writer, 1859-1919). Trude Fleischmann speaks with a soft Viennese accent, whose melodiousness remains undiminished despite living in the United States for thirty years. Only its low pitch somehow does not quite go with her fragile appearance. Her personality is a fascinating combination of charm and utter frankness.

Trude Fleischmann was born December 18, 1895, the daughter of a comfortably situated Viennese Jewish family. Her father was a merchant, her mother "an exceedingly intelligent woman," according to Fleischmann. It was she who was to ask her young daughter if she would like to decide on photography as her life's work, this in turn-of-the-century Vienna,

a truly unheard of, progressive idea.

Trude Fleischmann remembers herself as a smallish, plump little girl with dark hair, who was given to adoring her pretty, blonde cousin. That cousin already owned a camera! Trude badly wanted one too. Finally at the age of nine years she received as a Christmas present the long-awaited camera.

At an early age Trude was able to go to Paris, where she studied the history of art briefly, but soon returned to her native Vienna. Here she joined as an apprentice the best-known photo studio, that of Madame D'Ora (Philippine Dora Kallmus, 1881-1963), and was put to work retouching photographs. This type of work demands great precision and is very time-consuming. Madame D'Ora reproached her for working too slowly, Trude quit, and left the same day. She still retained her firm resolution to become a photographer, however. Looking around for another atelier where she might work, she chanced upon a window display on the Opernring featuring portraits of contemporary greats such as the writer Karl Kraus, the architect Adolf Loos, and the painter Oskar Kokoschka. Fascinated and inspired by these portraits, she applied to the studio for a job, and was accepted by the owner Hermann Schieberth (active 1910-1937).

Among the five young apprentices who worked at Schieberth's studio, Trude Fleischmann was the youngest. One morning Adolf Loos and Peter Altenberg stopped in and insisted on having their

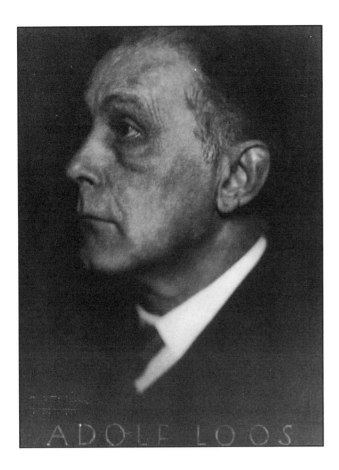

Figure 1. Trude Fleischmann, portrait of Adolf Loos, 1930. Gelatin-silver print. Collection FOTOGRAFIS Laenderbank, Vienna.

pictures taken. Disregarding objections that the boss was on a business trip, they refused to be put off. The two customers seemed to have spent the night carousing together. Finally, Trude was assigned to take the men's pictures. This she did, as she later commented, "with her heart in her mouth." Thus began in 1918 the unique portrait series of the two famous friends who later on became world-famous [Figure 1].

The uncompromising personality of Adolf Loos became the source of many legends.[2] It was extraordinarily hard for him to get commissions in Vienna, because he did not complete his academic studies in architecture and, to make matters worse, he very often lost out to young students of the famed architect Otto Wagner in competitions. His tendency to extravagance and his mania for dressing to perfection may have netted him his first commission in 1898, after his return from a three-year stay in America. He was engaged by the famed Viennese

tailoring establishment, Goldman & Salatsch, to design and built their new "Herrn Salon." At a later date, the collaboration with Leopold Goldman led to the construction of the hotly debated building on Michaelerplatz (1909-1911), Adolf Loos's major project. The Viennese public ridiculed it as "the house without eyebrows." The novelist Raoul Auernheimer commented, "One may think about the house by A. Loos what one wants to; at any rate it does not convey the impression of a laughing heir. Its contemporary appearance does not seem to give it much pleasure. Its mood seems too somber, its facade too simple, too smooth. A face without a smile— presumably because even a smile is considered an ornament." To this Adolf Loos replied, "All Viennese houses should look festive and serious; it's time to do away with superficial ornaments."[3]

In 1920 Trude Fleischmann rented her own studio in Vienna. Situated in the first district (I. Bezirk) it was light and spacious. Its address was Ebendorferstrasse Nr. 3, located near the Vienna City Hall.

Trude Fleischmann's primary interest was portraiture. Here she could bring into play her enormous sensitivity and best express her love for people. Her craving for knowledge could also find satisfaction in this particular branch of photography. It is always the unique, the something special, that Fleischmann translated into the lyric language of the human portrait. The photographs of her Viennese period are soft, almost tender, yet omitting the platitudes of her time. She worked with the slow glass-plate camera and negatives. Taking her cue from the personality of the model, she usually focused on the face and hands, and often gave the pictures a soft brown tint. She aimed to distribute light and shadow equally, but sometimes favored sharp contrasts. A good example of the latter technique is her portrait of Katharine Cornell. Sharply outlining her mouth and nose, she bestowed on the face of the American actress something reminiscent of a beast of prey, an effect heightened by the contrasting light and dark composition. The portrait of the young Hedy Lamarr is completely different in style. Softly diffused light cast over the face and background suggests softness and reveals the flawless beauty of the sixteen-year-old actress. The face offered to the viewer is open and vulnerable.

Many of Fleischmann's pictures contain something of the casual, incidental nature of a snapshot, without, however, revealing indiscretions. She always maintained a respect for the dignity of the human being before her camera. Frequently there is something remote and melancholy about individual

portraits. In the double portrait of the Viennese architect Groag, a student of Adolf Loos, and his girlfriend, the sorrow in the deadly pale young woman's face seems a cruel foreboding fulfilling itself in the picture. This young woman fled to Paris in a desperate effort to escape the Nazi persecutions and failed.

Trude Fleischmann's Vienna atelier soon developed into a meeting place for artists, musicians, and actors, similar to Madame D'Ora's atelier until 1925. The array of names of those photographed there by Fleischmann includes the leading European intelligentsia of that era. Among those sitters were the editor of *Die Fackel*, the linguist and merciless critic Karl Kraus [Figure 2], who was devoted to the "purity of the word"; the German philosopher and psychologist Ludwig Klages, from whom Freud, via Georg Groddek, derived the concept of the "Id";[4] the famous theatrical family, the Thimigs (comparable to the Barrymores); and Marianne Hainisch, the early Austrian fighter for women's rights. Many famous musicians appeared at her studio: the conductors Hans Knappertsbusch, Bruno Walter, Paul von Klenau, Wilhelm Furtwaengler. Dancers included Tilly Losch and Claire Bauroff and the Toni Birkmeyer Ballet. The sisters Wiesenthal are portrayed against the natural outdoor backgrounds they favored. Grete Wiesenthal in particular made a deep impression on Trude Fleischmann. She was fascinated by this great dancer whose work enjoyed world-wide success as "Viennese-style dancing" with its turn of the waltz, the gliding and graceful bending. Trude Fleischmann says of Grete Wiesenthal, "for me she was, and still is, the best dancer that ever existed. There was so much naturalness and spontaneity in her dancing. She was a dream! I never again met or saw anyone who danced like Grete Wiesenthal."

Fleischmann did portraits of the well-known Wagner singer Anna Bahr-Mildenburg (1872-1947, wife of writer Hermann Bahr); actress Paula Wessely (b. 1907) of the Vienna Burgtheater; Count Coudenhove-Kalergi (1894-1972), the political writer and founder of the Pan-European Union, and his wife; actors Conrad Veidt (1893-1943) and Oskar Homolka (1901-1978); and during the 1936 "Salzburg Festival" a snapshot of conductor Arturo Toscanini (1867-1957). A dozen year later, in New York, Trude created the now-famous portrait series of Arturo Toscanini and his family. A committed anti-fascist, Toscanini left Italy for good in 1937. When he died in New York City in 1957, Fleischmann received the family's permission to photograph him on his deathbed. She had done the same thing once before, many years ago in Vienna, in the case of another great

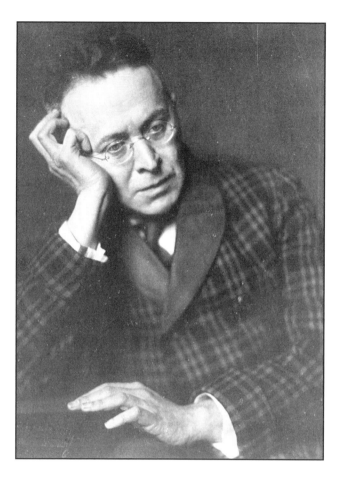

Figure 2. Trude Fleischmann, portrait of Karl Kraus, 1930. Gelatin-silver print. Collection FOTOGRAFIS Laenderbank, Vienna.

musician, the composer Alban Berg (1885-1935).

Reminiscing about that occasion long ago, there is in Trude Fleischmann's voice some of the sadness she must have felt at the untimely death of the composer. She recounts:

> Alban Berg was a wonderful human being and a great subject for photographers [Figure 3]. He was a very handsome man. He visited me often—we were actually friends. And then, Christmas Eve of 1935, the news of his death arrived. I had been invited out for the evening; however, I was called upon to take a picture of the deceased Alban Berg. I took my camera and went to the Vienna hospital where he lay, and took his picture. He lay there looking like an angel, a dead angel. He wasn't even fifty years old; he died of blood poisoning.

Nowadays, with penicillin, that would never have happened. I finally did go to where I had been invited, but I was so upset that I could enjoy nothing. It was a terribly sad thing.[5]

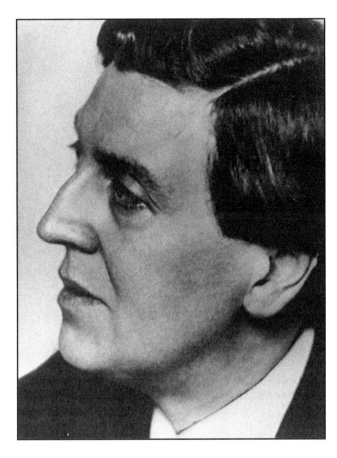

Figure 3. Trude Fleischmann, portrait of Alban Berg, 1932. Gelatin-silver print. Collection FOTOGRAFIS

The Viennese teacher Rudolf von Larisch, much admired by Trude, once remarked to her, "He whose eyes have been opened by God can see many paradises on this earth." Trude finds them everywhere: in nature, for she loves nature, and undertakes long hikes, and even skis; and in art and music, for she keeps up her lifelong friendships with artists, writers and musicians. But most of all it is photography, vocation and avocation, that is the essence of her life.

After Austria's annexation in 1938, Trude Fleischmann left Vienna. At first she went to Paris, where she could photograph and where she had friends. Half a year later she moved to England. In London she met the Austrian painter and writer Oskar Kokoschka (1886-1980) for the first time. He had just fled via Czechoslovakia to England, where he was forced to live very modestly. Twenty-five years later she met him again in New York as "the great Oscar Kokoschka." There he took Trude Fleischmann to the window of his lovely studio and said, "See, I painted that view, but now I wouldn't paint the smallest picture for less than $100,000. . . . Remember when I lived in London like a beggar?"[6]

For a while, Trude worked in London. When an American friend, Helen Post, whom she knew from her years in Vienna, dropped by for a visit during 1939, Trude was persuaded by her to leave Europe for good. Prior to her departure Trude destroyed her complete inventory of negatives, with the exception of forty-one glass negatives, and her camera. These and a very few personal things she took with her to America.

Two hours from New York City, Helen Post owned a house, surrounded by woods and meadows. Here the two women worked together, photographing, developing and enlarging. Helen post had become her student, just as the Viennese calligrapher Robert Haas had been many times before.

After two years in the country, Trude wanted to live in New York City. Together with a friend, she rented a studio in New York at 127 West 56 Street, in the center of Manhattan, and she kept it until she returned to Europe in 1969. At the age of forty-five Trude began her second career, in New York City. Her natural ways and optimistic attitude toward life opened many doors for her. As in Vienna, Paris, and London, she was soon surrounded by a large and interesting circle of friends. Again, artists sought her out to be photographed, among them emigrants such as she had once been: the Austrian actress Elisabeth Bergner (1897-1985); the German actor Albert Bassermann (1867-1952); the composer Gian Carlo Menotti (b. 1911); the singer Lotte Lehmann (1888-1976). She also photographed the young Otto von Habsburg (b. 1912); Count Richard Nikolaus Coudenhove-Kalergi (1894-1972); scientist Albert Einstein (1879-1955); the American writer Sinclair Lewis (1885-1951), and many others.

Arturo Toscanini was known to dislike being photographed. Through the efforts of a member of the Vienna Philharmonic Orchestra, Fleischmann was introduced to the conductor, and promptly received permission to photograph the maestro after a concert. The pictures met with his approval. A short time later, she received an invitation to lunch with

Toscanini. She remembers,

> He lived somewhat out of town, and so
> he had me picked up by his car. During
> dinner I sat right next to him. At one
> point during our conversations I said to
> myself, funny, I don't understand
> Italian, yet I understand every word
> Toscanini says to me. I was overjoyed
> that all of a sudden I understood Italian.
> He told me that he came from a lower-
> middle-class family—his father was a
> tailor—and that there was always
> singing in the workshop. Whoever
> worked there joined in the singing.
> Thus his love for music began. He
> said, "we were very simple people.
> And I remained like that. Being
> invited to festive suppers doesn't
> impress me at all. At home we had
> bread, butter, and cheese, with a
> glass of wine. That was all." Finally
> I told him, "Maestro, I do have to
> leave now. I have taken up a lot of
> your time, and I thank you very
> much for everything." Again, I had
> the use of his car, which returned me
> to where I lived. During the ride
> home, I asked myself how it was that
> I suddenly understood Italian? When
> I actually recalled the words he had
> spoken to me, in my mind I suddenly
> realized that he had talked to me in
> English! It simply had sounded so Italian. [7]

Trude Fleischmann was deeply impressed by New
York City and its imposing architecture. One day
somebody at *Vogue* magazine mentioned her name.
And she was invited to take some fashion shots. She
decided to experiment. Instead of photographing the
models in the studio, she took them out to the old
Brooklyn Bridge. That is where her first fashion shots
originated, against an urban outdoor background.
The pictures met with approval. Other fashion
magazines began to call her.

Her style changed in America. The pictures were
more precisely thought-out. They conveyed
simplicity, austerity. She liberated herself from the
heavy studio camera and began working with a
newly acquired Rolleiflex. The flash bulb replaced
the lighting effects she had formerly worked out in
minute detail when shooting studio pictures. Despite
all these innovative changes, her portraits remained
unmistakably the work of Trude Fleischmann.

Asked about her departure from Vienna,
Fleischmann reminisces:

> Somehow it broke my heart to leave
> Vienna, my native city. It wasn't easy,
> despite many dear friends I found in
> France, and later on in England. Also,
> at the time I was incredibly busy with
> my work and I didn't even have the
> desire to return to Vienna. Somehow,
> Vienna became a closed chapter for
> me. I really don't know at this point if I
> would have remained in Austria had
> it not been for the 1938 "Anschluss."
> I had so many friends abroad. They all
> wanted me to come and see them.
> Of course I was still young at that time.
> I honestly cannot tell....Yet I loved
> Vienna very much, the city as well
> as its surroundings. Yes, I really was
> very attached to Vienna. Three years
> ago I finally returned to Vienna and
> found it very beautiful. By now the
> resentment has also died down. But
> as for living there again? No. So I
> went to Switzerland, where I have
> friends. It is very pleasant and also
> very beautiful here. [8]

Trude Fleischmann retired from her profession in
1969, left New York, and found a new home in the
Italian part of Switzerland, in Lugano. She has been
an American citizen since 1942.

Until now, the only retrospective of her work that
has been exhibited in Austria was organized by me on
the occasion of the "Wiener Festwochen" in May
1982, in connection with the collection FOTOGRAFIS
Laenderbank in Vienna.

EXHIBITIONS
Stefan Lennert Gallery, Munich, 1979
Braunstein Gallery, San Francisco, 1981
Sammlung FOTOGRAFIS Laenderbank, Vienna, 1982
Thorpe Intermedia Gallery, Sparkill, New York, 1983
Austrian Institute, New York, 1984
Galerie Johannes Faber, Vienna, 1988

PERMANENT COLLECTIONS
The Metropolitan Museum of Art, New York
The Museum of Modern Art, New York
The National Portrait Gallery, Washington, D.C.
The New York Public Library, New York
The Allen Memorial Museum, Oberlin College, Ohio
George Eastman House, Rochester, New York
Collection FOTOGRAFIS Laenderbank, Vienna

REFERENCES

1. *Traum und Wirklichkeit Wien, 1870-1930* (Vienna, 1985),
 exhibition catalog, p. 744.

2. Linz Parnass, *Der Künstlerkreis um Adolf Loos -
 Aufbruch zur Jahrhundertwende,* Sonderheft no. 2,
 1985, pp. 6-9.

3. Parnass, pp. 7-8.

4. William M. Johnston, *österreichische Kultur und
 Geistesgeschichte, Gesellschaft und Ideen im Donauraum*
 (Vienna-Graz, 1974), p. 254.

5. Interview with Trude Fleischmann.

6. Vivian Raynor, "Time Exposure," *Connoisseur*, New
 York, p. 108.

7. Interview with Trude Fleischmann.

8. Interview with Trude Fleischmann.

Moment in the Weed Garden

Seen from a distance, her hat floated over a field of lace. Up close, her eyes held a question. The face, with its strong, straight nose above a delicate mouth, smiled the question.

She paused in her pruning, and I, aware that within minutes she would vanish forever, gazed at the summer blush shadowing the fine cheekbones, looked into the clear, grey eyes; and knew I'd take no picture. The mind would work, instead, with its first impression of hat, blossoms and summer heat.

"Please ignore me," I said. "It's the hat. It's beautiful."

And after she lowered her eyes and went about her work, I was able to go about mine.

Ed Leos
Longwood Gardens, 1987

Leland Rice's Photographs of the Berlin Wall Graffiti

Darwin Marable

Since his first unplanned pilgrimage to Berlin and accidental confrontation with *die Mauer* in 1983, Leland Rice has returned annually to photograph its graffiti. Concentrating on the area of the Berlin Wall in and near Potsdammerplatz, his large Cibachrome prints (30 x 34 inches and 48 x 117 inches) reflect the enormity of this obstacle to freedom. Rice gets microscopically close and carefully selects portions of the Wall that appeal to his artistic sensibility. Rice sees himself as a "visual archaeologist" who excavates fragments from the strata of forms, colors, lines, and inscriptions.

The twenty-eight-year-old Berlin Wall meanders 102.5 miles around and through the 750-year-old city and divides the Communist East and the non-Communist West sections of the city. The massive concrete structures vary from twelve to fifteen feet in height and include metal pipes, barbed wire and other barriers that prevent an exodus from the East.

Before 1961, thousands of East Germans fled to the West simply by crossing over the imaginary boundary, but then the East Germans, backed by the Russians, built the Wall to prevent this embarrassing emigration. The Wall traverses buildings, streets, sewers, rivers, lakes, and, outside the city, the landscape. On the Eastern side of the Wall the omnipresent eyes of the *Vopos*, the border guards, watch from their observation towers as guard dogs, mines, and sophisticated detection devices make it almost impossible to escape the East. In spite of these efforts, East Berliners have creatively tunneled, swum, and even flown by hot air balloon to the West. Seventy-seven East Germans have died and many have been injured in their attempts.

Originally only barbed wire, the Wall has increasingly become more formidable and, in the process, has become a tempting "canvas" for amateur and professional artist alike. The Wall itself is actually located two meters inside of East Berlin so that it can be easily maintained. This also allows for whitewashing by the East Germans whenever the graffiti becomes too offensive for their régime. Thus, a continually changing palette results from the battle between the artists and the East German government over the words and symbols on the Wall's surface. Although West Berliners and tourists casually initiated the graffiti, many professional artists have added to the communal efforts. In 1981, the West German artist Stefan Rolot painted a section of the Wall gold, followed in 1982 by Jonathan Borofsky's large running figures. Rainer Fettig has added his versions of Van Gogh's canvases while the American painter David Wojnarowicz painted one of his bull's heads onto the Wall. The French artists Emanuel Bouchet and Thierry Noir, alias Peng and Peng, have painted extensive areas of the Wall with images derived from Zap comic books.[1] In fact, the predominant sources of the imagery seem to be comic strips, cinema, and Neo-Expressionist painting. English is the prevalent language used. The graffiti on

the Wall is essentially populist in nature.

Graffiti is as old as civilization, has become an inspiration for many twentieth-century artists, including Picasso, and has been of special interest to photographers. Brassaï, John Gutmann, Helen Levitt, and Aaron Siskind have been fascinated by graffiti's spontaneous images. Brassaï's photographs of the walls of Paris during the 1920s range from crude incisions to more sophisticated abstract images.[2] Gutmann, then a recent émigré from Nazi Germany, concentrated on children's graffiti and political statements on the troubled waterfront in San Francisco in the late 1930s.[3] Similarly, Helen Levitt's photographs of children's graffiti in the streets of New York in the 1940s captures the fantasy, innocence, and play of childhood.[4] However, it was Aaron Siskind, a close friend of the Abstract Expressionist painter Franz Kline, who photographed the graffiti of Rome, Mexico, and Peru in the 1940s and later in the 1970s with the aim of creating more than documents of the inscriptions. For example, Siskin's "Peru 210" (1977),[5] two bold black squares on a grey wall reminiscent of Kline's paintings, have been defaced by a heart with the name, "José," and the date, "6/5/76," written on the original image, an integration of the sublime and the profane. In making this photograph, Siskind was setting a precedent for the photography of the graffiti on the Wall by Leland Rice.

A native of Los Angeles, California, Leland Rice first became interested in photography when he casually enrolled in a photography course taught by Van Deren Coke at Arizona State University at Tempe. Several years elapsed before Rice decided to study photography more seriously. He then enrolled at San Francisco State College (now San Francisco State University), where he studied with Jack Welpott and Don Worth. After receiving his M.A. in 1969, he taught at the California College of Arts and Crafts, U.C.L.A., and Pomona College. He was awarded a Photography Fellowship by the National Endowment for the Arts (1978), John Simon Guggenheim Fellowships (1979-1980), and the James D. Phelan Art Award in Photography (1986). Rice currently resides and works in the San Francisco area.

Before 1977, Rice worked exclusively in black-and-white photography. He was interested in the photograph as object, the symbolism of objects, and the satirization of the styles of other photographers. In the mid-1970s, while still working in black-and-white, he began the "Wall Site" series, wherein he photographed vacant interiors. Man is not seen, but his presence is suggested and felt. In this series, light became a more prominent element of his

photographs, often taking on a spiritual significance. But it wasn't until 1976, while teaching at the Tyler School of Art in Philadelphia, that he experienced the color field paintings of Morris Louis and Mark Rothko. Using a large-format camera and dramatically increasing the size of his prints, Rice applied his color field insights to photography and, now using color, began photographing the accidental images and paint splashes left by artists on their studio walls. In 1980, Rice shifted from interior to exterior spaces. Therefore, it was a logical development when, after a fallow period of several years, in 1984 he began the current series on the Wall, thereby integrating his past technical and aesthetic concerns.

When Rice first viewed the Wall in late 1983, he was overwhelmed and deeply moved. He says, "I came around the side of a building and there it was. Someone had written 'Yanks Out' on it, and I was struck by the brutal reality of who I was and where I was from. The whole thing was incomprehensible to me. You can be given all the reasons in the world why the Wall is there, but it still makes no sense."[6] As grim and restrictive as the Wall is, it was the stimulus for his own creativity, as the walls of the artists' studios had been a few years earlier.

The graffiti on *die Mauer* has evolved during the last several years from a simple to a more complex imagery. The message of *"Freiheit für Alle"* ["Freedom for All"] (1984) [Figure 1] is clear. The flat, childlike figures are separated from the words on the grey concrete that contains other markings, but the Wall itself predominates. In *"Arbeiten und Bauern"* ["Workers and Farmers"] (1985) [Figure 2], the image is much more complicated; the huge figure is overlayed with signatures, markings, and epitaphs. Rice's most recent documentation, "ESN" (1987),[7] is an even more intricate montage of words and images. Blue cryptic letters pervade with the signature, "Michele Grace Hottel," and the date, "2/15/87," written across the screaming face of the man. The huge red heart, the symbol of love, has been desecrated with the word, "Fuck." In Berlin dialect in the upper right is scribbled "Jo greets all Yellow fans, left, I love you completely." The balance and overlay of words and images is dramatically effective.

Rice is especially successful when he isolates painterly images that are frequently integrated with words. For example, in *"Arbeiter und Bauern"* the figure and large areas of color read almost like a de Kooning painting, but then are refuted by the various messages: "Workers and farmers do not need walls," "Harri and Vende, 7/6/1985," etc. Simpler in nature, "Sam" (1985)[8] brings to mind the paintings of Paul

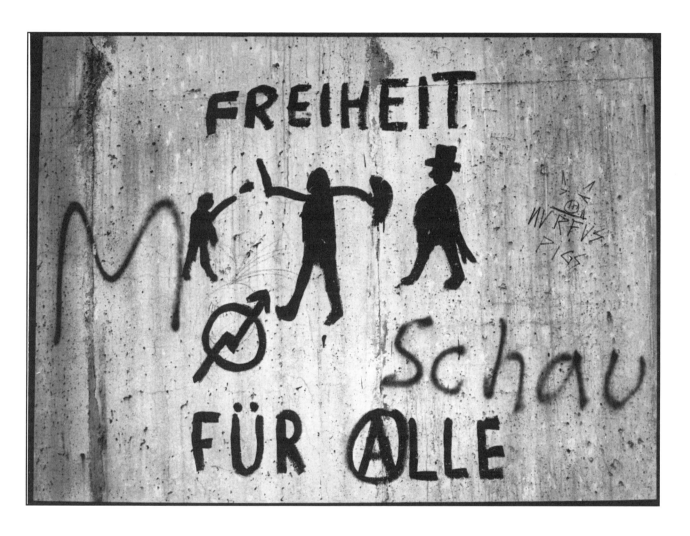

Figure 1. Leland Rice, "Freiheit für Alle," 1984. Original in color, 76.2 x 101.6 cm. Private collection.

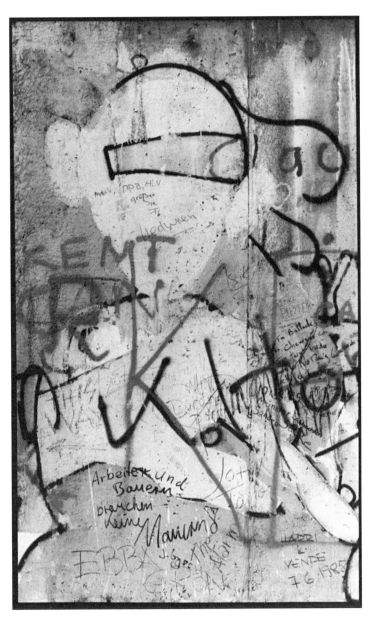

Figure 2. Leland Rice, "Arbeiter und Bauern," 1985. Original in color, 90.4 x 55 cm. Collection of the San Francisco Museum of Modern Art.

Klee, but has been made more grotesque by red paint streaming from the eyes like tears of blood. "Six Arrows" (1986)[9] is also Klee-like. The arrows float dynamically on a black background which, in turn, has been superimposed over the freer forms at the edge of the image. "Exit" (1986)[10] consists of abstract forms of blue, mauve, and yellow overpainted by a silver sign reading "exit." But the most forceful and expressionistic of these particular images is "Hunger Herr Pastor" ["Hunger, Mr. Pastor"] (1986) [Figure 3], which was obviously created by a more technically sophisticated artist. Here the use of passionate colors and skeletal shapes suggests the work of the Mexican muralist, José Clemente Orozco. "Geist" ["Spirit"] (1986) [Figure 4] is much less colorful, but no less effective. Two figures, a man and a woman, look directly at the viewer. The man's face is a clock, but without numbers. The time is five minutes after twelve. There are two animalistic ears at the top of the clock and written below, the words "phase osram." The male figure also holds out a carrot in his left hand. The words, "tic tac" and *"zu spat"* ["too late"] are poignantly repeated. To the far right there is an electric guitar. *"Geist"* is written above in large letters. The image is as surreal as the Wall. In spite of the metamorphosis and beauty wrought by these images, close inspection often reveals the grey of the bare concrete, reminding the viewer of the reality of this barrier to freedom.

The nameless and unskilled artists whom Rice records often express outrage, through political humor, at the presence of the Wall. Words prevail in "Super 8" (1984)[11] as the writer politely asks, "May we have another wall, please?" Below, in German, someone else has written, *"Turken RAUS,"* or "Turks Out," but then another has crossed out the word "Turken." A spray of maroon paint nearby looks like splattered blood as it arcs across the Wall. Opposing hands, in "Yanks Out" (1985)[12] tear apart a face formed by an outlined map of a divided Germany separated by barbed wire. Two eyes stare, East and West, but who is watching whom? At the bottom is a partially obliterated message of hate which, seen in full on the Wall, says "Commies are fags," and nearby "Communist Guards Suck!" In "Exit," the inscription reads, "Have you ever seen a antifascist protection wall?" And the writer also exclaims, "All that I want to know is on which side the fascists are on so that I can be on the other side!" The humor is both visual and literary in "So Look at Yourself Looking" (1986) [Figure 5]. The eclipsed statement in German at the top is as irrational and meaningless as *die Mauer* itself. Several faces have been sketched in looking through the Wall, while in the center two hands clutch

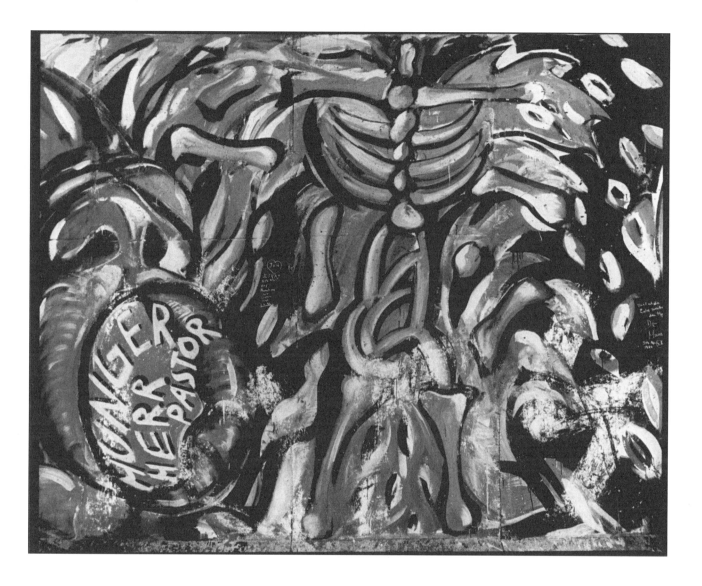

Figure 3. Leland Rice, "Hunger Herr Pastor," 1986. Original in color, 101.6 x 127.7 cm. Collection of the artist.

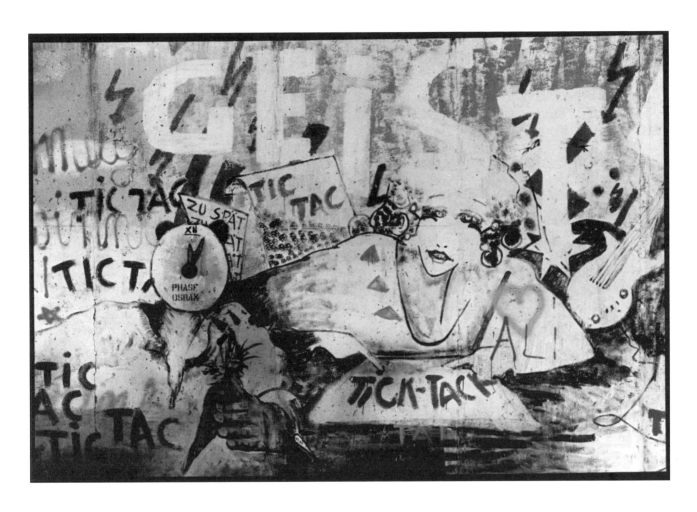

Figure 4. Leland Rice, "Geist," 1986. Original in color, 109.2 x 162.5 cm. Collection of the artist.

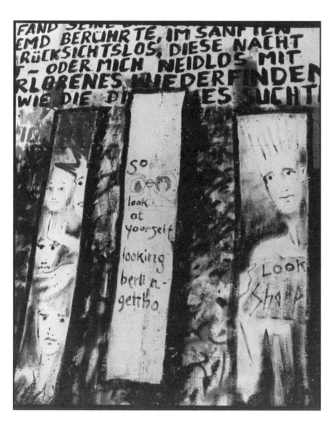

Figure 5. Leland Rice, "So Look at Yourself Looking," 1986. Original in color, 123.8 x 101.9 cm. Collection of the Baltimore Museum of Art.

binoculars that contain the images of a soldier in positive and negative reflected in the lenses and staring back at the viewer. In the center the inscription reads, "So look at yourself looking. Berlin ghetto." These literary expressions are equaled by the visual ones.

The vision of man in these images is especially poignant. The stenciled black and red figures in *"Volke"* (1984)[13] run or dance across the bleak surface of the Wall. They are flat, without depth and frozen in motion, mere silhouettes of humanity. Nothing distinguishes them but their color. As if to remind us that the figures do have substance, someone has written in chalk, *"Volke"* ["People"]. "Minimal Man" (1985)[14] is a little more individualized, but has no eyes and a forehead furrowed by anxiety. He seems to dream or imagine the small running figure to his left. Large running figures are a continual theme of the painter Jonathan Borofsky. In *"Arbeiter und Bauern,"* the alien-like figure also has no eyes, but wears a mask of concrete — the Wall itself. His huge right ear is alert and always listening. The homeless, pathetic and continually moving "little tramp" or refugee is portrayed in "Chaplin *Mauer*" (1985)[15]. His only effective weapon against anonymity and a meaningless existence is humor. Man screams out in "ESN" and is juxtaposed with a happy face on the right, but with a tear in his eye. Finally, man is envisioned as a corpse in several of the images, such as "Forever Friends" (1986)[16], where two skeletons embrace, or "Hunger Herr Pastor," where bones are consumed by fire, perhaps a premonition of nuclear disaster. The graffiti on *die Mauer* expresses the philosophy of the common man through visual imagery.

The significance of the graffiti on the Wall is as multi-layered as the images themselves. For the visitor to Berlin, the graffiti may seem like an act of defiance or an attempt to beautify an essentially ugly structure. However, the Berliners often do not even see the Wall or the graffiti. Peter Schneider, the author of the poetic novel, *The Wall Jumper* (1982) and a resident of Berlin since 1961, writes, "I really don't see the Wall anymore even if it is the only structure on earth, apart from the Great Wall of China, that can be seen from the moon with the naked eye." Concerning the response of the rest of Germany to the Wall, he says, "...the further you are from the border, the more casually each half-people imagines itself whole."[17] For these citizens the Wall and its graffiti may as well not exist. But for the rest of the world the Wall and its symbolism of the East vs. West dichotomy is a stark reality.

On an even deeper level the Wall seems to symbolize the alienation of modern man from his total psyche, the conscious and unconscious mind.[18] To extrapolate from this meaning, the West (consciousness) appears rational, open, secure and technologically advanced. In contrast, the East (unconsciousness) seems irrational, closed, unstable, mysterious and even dangerous. We easily project our own state of affairs onto the external world. We have constructed our own Berlin Walls. Onto the blank screen of *die Mauer* or the *tabula rasa* of consciousness, the artists project their doodles or associations and express a communal and truly international mind that is free and in contradiction to the tyranny that the Wall symbolizes.

Leland Rice walks a line as precarious as that of the Wall itself. These photographs could easily remain simple records of the graffiti but because of his selective vision, careful editing, and technical competence, they seem to exist on the edge of art. Just when the viewer is fascinated by the brilliant colors, markings and notations, we catch a glimpse of the concrete or a seam reminding us that we are looking at the reality of *die Mauer*.

REFERENCES

1. Cleve Gray, "Report from Berlin: Wall Painters," *Art in America*, 73 (October 1985), pp. 40-43.

2. Brassaï, *Graffiti de Brassaï* (Paris: Les Editions du Temps, 1961), p. 41.

3. Lew Thomas, ed., *The Restless Decade: John Gutmann's Photographs of the Thirties* (New York: Harry N. Abrams, 1984).

4. Helen Levitt, *In the Street: Chalk Drawings and Messages, New York City, 1938-1948*. Essay by Robert Coles (Durham, North Carolina: Duke University Press, 1987).

5. Collection of The Museum of Modern Art, New York.

6. Liz Lufkin, "Messages from the Wall," *This World, San Francisco Chronicle*, August 9, 1987, p. 7.

7. Collection of the San Francisco Museum of Modern Art.

8. Collection of the artist.

9. Collection of the artist.

10. Collection of the artist.

11. Collection of the artist.

12. Collection of the artist.

13. Collection of the artist.

14. Collection of the artist.

15. Collection of the artist.

16. Collection of the artist.

17. Peter Schneider, *The Wall Jumper*. Translated by Leigh Hafrey (New York: Pantheon Books, 1983), p. 7.

18. Carl G. Jung, ed., *Man and His Symbols* (New York: Dell Publishing Co., 1970), p. 6.

ABOUT THE CONTRIBUTORS

HANS CHRISTIAN ADAM of Göttingen, West Germany, is a photohistorian, picture researcher, and vice-chairman of the history section of the Deutsche Gesselschaft für Photographie (DGPh). He is a member of the European Society for the History of Photography and is on the advisory board of *History of Photography* journal. His special interest is nineteenth-century travel photography. In addition, he has recently published a book of historical photographs of swimmers.

WILLIAM ALLEN is dean of the College of Fine Arts at Arkansas State University in Jonesboro, Arkansas. He did his undergraduate work at the University of Alabama and took his M.A. and Ph.D. in art history at The Johns Hopkins University. It was in connection with his dissertation research on Byzantine architecture that he first came in touch with Ottoman photography. He has since published several articles on the subject.

FELICITY ASHBEE, who lives in London, is the daughter of C. R. Ashbee, an architect and designer who was active in the Arts and Crafts Movement. She is a great-niece of William Carrick, a Scottish photographer who was active in Russia from 1859-1878. After a career in the arts herself, she studied Russian to research her great-uncle's photographic career.

ANNA AUER founded the first photo gallery in Europe (Die Bruecke in Vienna) and set up the photo collection FOTOGRAFIS Laenderbank in Vienna. For that collection, she plans and organizes lecture, symposia, and exhibitions. Her specialization is the documentation of Austrian émigré photographers in 1938. She has studied on fellowships from the European Society for the History of Photography in Antwerp, the Deutsche Gesselschaft für Photographie in Cologne, and the Photographische Gesselschaft in Vienna.

WM. B. BECKER is an Emmy award-winning producer and television journalist at WXYZ-TV in Detroit, Michigan. He has written and lectured extensively on the history of photography, and is the author of *Brady of Broadway*, a biographical play about Mathew Brady. His collection of photographs from the medium's first seventy-five years is featured in his book, *Photography's Beginnings: A Visual History* (1989).

KATHLEEN COLLINS is a photohistorian, editor, and consultant specializing in the management and preservation of photographic collections. Her Ph.D. in the history of photography was awarded in 1985 by The Pennsylvania State University. Her research interests are in the propagandistic uses of photography. She directed the Washingtoniana Project at the Library of Congress (1983-1985). An illustrated guide to those collections was published by the Library of Congress last year (*Washingtoniana Photographs: Collections in the Prints and Photographs Division of the Library of Congress*).

PAOLO COSTANTINI studied at the University of Architecture in Venice. He currently teaches the history of photography in the Department of Art History at the University of Venice. He is a member of the European Society for the History of Photography, and is editorial coordinator of *Fotologia*. He has published many books and articles on photohistorical themes, most recently *Strand: Luzzara* (Milan 1989) and *L'insistenza dello sguardo; Fotografie italiane 1839-1989* (Florence, 1989).

WILLIAM CULP DARRAH is the preeminent authority on stereo photography and *carte-de-visite* photographs. He lived and taught in Gettysburg, Pennsylvania, and was a major photographic collector. His collection of *carte-de-visite* photographs was recently acquired by Pattee Library of The Pennsylvania State University. He was trained as a plant paleobotanist, and came to photohistory through his research into Powell's western survey documentation. His books, *Stereo Views* (1964), *The World of Stereographs* (1977), and *Cartes de Visite in Nineteenth-Century Photography* (1981) are standard reference works in the field. His essay on women in nineteenth-century studio photography was completed just a few weeks before his death in 1989. A full discussion of Professor Darrah's life and work is included in this volume.

RONALD FILIPPELLI is professor and head of the Department of Labor Studies and Industrial Relations at The Pennsylvania State University. He is a regular book reviewer for *History of Photography* and is the author of *Labor in the USA: A History*, and *Cold War and the Working Class: American Intervention in Postwar Italy, 1943-1953* (Stanford University Press, 1989).

LEE FONTANELLA is a professor at the University of Texas at Austin, where he has taught since 1970, after receiving his doctorate at Princeton. He is the author of *La Historia de la Fotografia en España: Desde sus Origenes hasta 1900,* and a book on Spanish literature, *La Imprenta y las Letras en la España Romantica,* in addition to other books and essays. He is now completing a book on the photographer Charles Clifford. He teaches seminars in eighteenth- and nineteenth-century Spanish literature, comparative literature, and the history of photography.

JULIUSZ GARZTECKI is a journalist, photographer, art critic and translator. Formerly, Dr. Garztecki was a professor of art at the University of Warsaw, where he taught photo history. Now he is chief advisor on foreign affairs to the Polish Socialist Party.

NACHUM TIM GIDAL was born in Munich and has lived and worked in Germany, Switzerland, Palestine, and Israel. His doctoral thesis was the first on the subject of picture reporting and the press ("Bildberichterstattung und Press"). His book, *Modern Photojournalism: Origin and Evolution, 1910-1933* (Collier Books, 1979), recounts the history of the picture press, in which he played a central role as chief photo reporter for *Picture Post,* among other important assignments. He is the author of dozens of books and published articles, and has taught the history of photography at the New School for Social Research in New York, and at Hebrew University in Jerusalem, where he lives today. He is a fellow of the Royal Photographic Society of London, and was awarded the Erich Salomon Prize in 1983 by the Deutsche Gesselschaft für Photographie.

HELLMUT HAGER has been head of the Department of Art History at The Pennsylvania State University since 1972, and is a Fellow of the Institute for the Arts and Humanistic Studies. His Ph.D. in Art History was awarded by the University of Bonn, West Germany, in 1959. His specialization is architectural history of the late Baroque in Italy, especially architecture in Rome. He is the author of *Die Anfänge des Italienischen Altarbildes* (Schroll, Munich, 1962), and *Carlo Fontana: His Drawings in Windsor Castle* [with Allen Braham] (London: Zwemmer, 1977).

MICHAEL HALLETT is a photographic historian and principal lecturer in the history of photography and graphic design in the School of History of Art & Complementary Studies at the Birmingham Institute of Art & Design (part of the Birmingham Polytechnic) in England.

GILLIAN GREENHILL HANNUM is assistant professor of art history at Manhattanville College, in Purchase, New York, where she teaches courses in modern and American art and the history of photography. She received her B.A. in Fine Arts from Principia College in 1976 and her M.A. (1981) and Ph.D. (1986) from The Pennsylvania State University. Her doctoral dissertation was entitled, "The Outsiders: The Salon Club of America and the Popularization of Pictorial Photography." She has also contributed articles to *History of Photography* and *The Museologist.* Her research interests are in American art and photography at the turn of the century.

MARGARET HARKER is emeritus professor of photography at the Polytechnic of Central London, where she used to be a Pro-Rector and head of the School of Photography. In September, 1987, she was made an honorary Doctor of Arts by the Council for National Academic Awards in recognition of a lifetime of service to photography and photographic education. Her publications include *Henry Peach Robinson, Master of Photographic Art, 1830-1901* (Basil Blackwell, 1988), *The Linked Ring, the Secession Movement in Photography, 1892-1910* (Heinemann, 1979), and *Victorian and Edwardian Photographs* (Charles Latts, 1975). She is President of the European Society for the History of Photography, and a member of the advisory board to the National Museum of Photography, Film, and Television.

RALPH L. HARLEY, JR., is associate professor and coordinator of the Division of Art History at Kent State University. He is especially interested in the beginnings of photography in Britain and has written several essays on D. O. Hill and Robert Adamson. He has recently undertaken a study of the imagery and theoretical writings of the American photographer Frederick Sommer.

MARK HAWORTH-BOOTH was born in Yorkshire and educated at Cambridge University and Edinburgh University. He was appointed to the staff of Victoria and Albert Museum, London, and has been Curator of Photographs there since 1976.

He was awarded the Hood Medal of the Royal Photographic Society in 1988 for his services to the appreciation of the art of photography. He is the author and editor of many books and articles, including *The Golden Age of British Photography, 1839-1900* (1983). His essay on "British Contemporaries," appeared in *The Art of Photography, 1839-1989* (Yale University Press, 1989).

BERNARD AND PAULINE HEATHCOTE live in Nottingham, England, where he is a medical services manager for a large international pharmaceutical company and she is a former research assistant with the Nottinghamshire Education Resources Services. Their current interest is the development of professional photographic portrait studios in the British Isles during the period 1841-1855. They have also carried out extensive research on the history of photography in Nottingham and its environs.

STEVEN F. JOSEPH, originally from Manchester, England, has a B.A. in modern languages from Oxford University and the M.B.A. from the Ecole des Affaires de Paris. Since 1985 he has been an administrator in the strategy division of the ESPRIT Programme (European Strategic Programme in Research and Development in Information Technology) at the Commission of European Communities, Brussels, Belgium. He is currently preparing a doctoral thesis at the University of Liège on the role of photography in nineteenth-century book illustration.

ESTELLE JUSSIM has taught in the graduate school of Simmons College since 1972. She was awarded a Guggenheim Fellowship in 1982, is a critic for *The Boston Review*, and has written many books and articles on the history, aesthetics, and social impact of photography and the visual arts, including *Slave to Beauty: The Eccentric Life and Controversial Career of F. Holland Day* (Godine, 1981), winner of the New York Photographic Historical Society Prize for Distinctive Achievement in the History of Photography; *Landscape as Photograph* [with Elizabeth Lindquist-Cock] (Yale University Press, 1985); *Stopping Time: The Photographs of Harold Edgerton* [ed. Gus Kayafas] (Harry Abrams, 1987); and *Visual Communication and the Graphic Arts: Photographic Technologies in the Nineteenth Century* (Bowker, 1974 and 1987). A collection of her writings, *The Eternal Moment: Essays on the Photographic Image* (1989), was published by Aperture. She is a frequent and popular lecturer in the field. Dr. Jussim serves on the Visiting Committee for the International Museum of Photography at George Eastman House, is a trustee of the Visual Studies Workshop in Rochester, and is on the advisory and editorial boards of *History of Photography* and *Exposure*. She lives in Granby, Massachusetts.

ULRICH F. KELLER is professor of the history of photography in the Department of Art History at the University of California at Santa Barbara and an adjunct curator of photography at the U.C. Santa Barbara Art Museum. He received his Ph.D. from the University of Munich in 1969, and has since received fellowships and awards from the Deutsche Forschungsgemeinschaft (for Rembrandt research), the Daguerre Award from Club Daguerre in Frankfurt/M, Germany (for "The Myth of Art Photography"), the Erich Stenger Award from the Deutsche Gesselschaft für Photographie (for *August Sander: Menschen des 20. Jahrhunderts*), Regents Humanities Research Fellowship and National Endowment for the Humanities research grant (for Nadar research), National Endowment for the Arts grant (for the exhibition, *The Highway as Habitat*), and a Guggenheim Fellowship in 1986 (for Nadar research). He has been a visiting scholar at the J. Paul Getty Museum, and has written on Paul Strand, Jacob Riis, German portrait photography, the history of photojournalism, the photography of the Warsaw ghetto, and many other subjects.

HARDWICKE KNIGHT is a medical photographer at Dunedin Hospital, New Zealand, and is with the Otago Museum at Dunedin. He is the author of *Photography in New Zealand*.

ROLF H. KRAUSS of Stuttgart, West Germany, is a member of a family intimately connected with the European camera industry and a distinguished collector of books on all aspects of photography and its history. He is currently chairman of the Sektion Geschichte of the Deutsche Gesselschaft für Photographie, and editor of its journal.

ANDREW LANYON lives in Cornwall, England, and is a decorator and a painter of photographic themes. He is the author of several books, including *The Casual Eye* and, most recently, *Second Nature* (1990). He is also the creator of two touring exhibitions with catalogs designed for the Photographer's Gallery in London: *The Rooks of Trelawne* and *The Vanishing Cabinet*.

ROBERT E. LASSAM has had a long career in photographic chemistry, working for Kodak Ltd. from 1932 on, with specialization in the Kodachrome process and materials. He served as an RAF photographer during World War II, and worked for Kodak after the war in advertising and the development of photographic trade fairs and exhibitions. He is now Curator of the Fox Talbot Museum at Lacock, Wiltshire, under the National Trust. He is an Honorary Fellow of the Royal Photographic Society and a Fellow of the Royal Society of Arts. He has received numerous awards for over fifty years of service to photography.

JULIE LAWSON studied English and art history at Cambridge University and was a postgraduate student at the Courtauld Institute of Art, University of London. Since 1984 she has been research assistant with the Scottish Photography Archive at the Scottish National Portrait Gallery, Edinburgh.

EDWARD LEOS, photographer and teacher of photography and photojournalism, has contributed photographs to exhibits at the Minnesota Museum of Art, the Colorado Photographic Arts Center, and New York's Metropolitan Museum of Art. He has written articles on photographic instruction, and on his work with very young children. In 1976 the American Association for Education in Journalism named him Teacher/Photographer of the Year. He is the author of *Other Summers*, a book describing his discovery of the work of Horace Engle, a nineteenth-century pioneer of candid photography. A professor of journalism at The Pennsylvania State University, he retired in 1978 to devote himself to explorations into photography and writing long deferred. Professor Leos lives in Lemont, Pennsylvania.

ELIZABETH LINDQUIST-COCK is professor of art history at the Massachusetts College of Art in Boston. Previously, she taught at Mount Holyoke College. She received the M.A. and Ph.D. in art history from New York University and did graduate work at the University of London and Bryn Mawr. Her specialization is the history of photography, the aesthetics of landscape (painting and photography), modern architecture, and women's studies. She is the co-author [with Estelle Jussim] of *Landscape as Photograph* (Yale University Press, 1985).

BERND LOHSE was formerly editor of the magazines, *Foto-Spiegel, Photo Magazin, Photoblätter, Iris,* and *Bildjournalist.* He is now retired and lives in Bürghausen, Germany.

WILLIAM MAIN is director of the Exposures Gallery in Wellington, New Zealand. He is the author of several books on photography in New Zealand, including *Auckland through a Victorian Lens.*

CHARLES MANN has been in charge of Rare Books and Special Collections at the Pennsylvania State University Library since 1957, and has overseen the addition of seventy thousand items to the collection. He has been a professor of English since 1966, and is a Fellow of the Institute for Arts and Humanistic Studies. His fields of expertise include the history of books and bookmaking; bibliography; Fitzgerald, Hemingway, and O'Hara; the Great Exhibition of 1851; the literature of the former British Commonwealth; history of photography; and Utopian studies. He co-authored with Philip Young the first inventory of the Hemingway papers, is associate editor of the University of Pittsburgh series on bibliography, is on the board of the Harvard Theatre Collections, and is a member of the board of the Pennsylvania State University Press.

DARWIN MARABLE graduated from the University of New Mexico with a Ph.D. in the history of photography. He is a contributor to *Artweek, Photo Metro* and *History of Photography,* and lives in Lafayette, California.

DAVID MATTISON is the author of several articles and two books on the history of British Columbia photography. He is currently writing a survey of Canadian photography for Oxford University Press Canada. He lives in Victoria, British Columbia.

CLAUDIA MAUNER, who designed the cover of this book, is a graphic designer currently working in New York City. Her B.F.A. in design was awarded in 1986 from the School of Visual Arts in New York. She has designed children's educational magazines for *Scholastic* publishers, and album covers for EMI/ Capital Records. She has also done fashion illustrations for *Seventeen* and children's illustrations for *Puffin Post.* In 1987 she was a graphic designer for a design studio in Bern, Switzerland. She holds a B.A. in drama from Vassar College (1983).

GEORGE MAUNER has written books, articles, and essays on modern European painting. Educated at Columbia University, he is Distinguished Professor of Art History and Director of the Institute for the Arts and Humanistic Studies at The Pennsylvania State University. He is the author of *Manet: Peintre-Philosophe* (1975), *The Nabis: Their History and Their Art* (1978), *Cuno Amiet* (1984), and *Three Swiss Painters* (traveling exhibition catalog, 1973).

MARIANNE VON KAENEL MAUNER was educated in Switzerland, at Bern and at the University of Geneva, where she received her translator's degree. She has worked as an interpreter, translator, and painter. She teaches consecutive and simultaneous translation and interpretation at The Pennsylvania State University in the French and German departments.

RAY MCKENZIE studied art history and philosophy at Glasgow University. Since 1975 he has taught art history at Glasgow School of Art, specializing in the history of photography. A founder member of the Scottish Society for the History of Photography, he is active in the promotion of the medium in Scotland at all levels.

ROBERT MEYER is a photo-historian, art critic, and photographer in Oslo, Norway. He has worked in forensic, advertising, travel, and television photography, and has had a number of exhibitions of his work. He is a photography critic for *Aftenposten*, the largest newspaper in Norway, and has organized exhibitions of contemporary and historical photography. He has written numerous essays, exhibition catalogs, and books, including the *Norsk Fotohistoric Journal* (two volumes). He is responsible for the creation of the Robert Meyer Collection of nearly 60,000 items, including photographs, photographica, documentation, books, and other materials for the study of Norwegian photographic history.

FLOYD AND MARION RINHART are recognized authorities in the history of pioneer American photography. They have written a number of books and articles relating to both pioneer photography and nineteenth-century social history. Their important collections of early photographic images now reside in the Department of Photography & Cinema at The Ohio State University. They lecture frequently on such subjects as early American photographic imagery, the tintype, and methods for

teaching the history of photography. Their publications on the history of photography include many essays and several important books, among which are *American Daguerreian Art* (Clarkson Potter, 1967), *American Miniature Case Art* (A.S. Barnes, 1969), *The American Daguerreotype* (University of Georgia, 1981), and the forthcoming titles, *The American Ambrotype* and *The American Tintype*. The Rinharts now live in Ft. Pierce, Florida.

NAOMI ROSENBLUM worked briefly as a graphic designer after training in fine arts. For a number of years she taught art before doing graduate work in art history at the Graduate Center, City University of New York. Her field of particular interest is the history of photography, which she teaches at Parsons School of Design in New York City. In 1977, she was one of the curators of a major retrospective exhibition of the work of Lewis Hine. She has written and lectured on many aspects of photography, both historical and contemporary, and her book, *A World History of Photography* (Abbeville, 1984, 1989) is used as a textbook for photographic history courses at many colleges and universities in the United States and Canada.

JAY RUBY is professor of Anthropology, Temple University, Philadelphia, Pennsylvania and president of The Center for Visual Communication, a research cooperative. He has edited a variety of scholarly and popular publications on American archaeology, popular culture and visual anthropology, including *Studies in Visual Communication* and *Visual Anthropology*. He co-produced and directed two ethnographic documentaries, *A Country Auction* and *Can I Get A Quarter?* and curated several photographic exhibitions. He is trained, has conducted research, and has published in archaeology, popular music, film, television, and photography. Current research interests center on the anthropological study of communication and the use of pictorial media to communicate Anthropology. He is co-editor of *Image Ethics: The Moral Rights of Subjects in Photographs, Film, and Television* (Oxford University Press, 1988).

ERNST SCHÜRER has been professor and head of the Department of German at The Pennsylvania State University since 1978. He studied German language and literature, history, and philosophy at the University of Texas at Austin (B.A.) and did his graduate work at the Free University of Berlin and Yale University (M.A. and Ph.D.) A member of Phi Beta Kappa, and a Woodrow Wilson, DAAD, and Alexander von Humboldt Fellow, he continued his postdoctoral research with a Morse Fellowship at the Academy of Arts in Berlin. His field of research is modern German literature from Naturalism to the present, with special emphasis on Expressionism, German drama, and *Exilliteratur*. He has published and edited numerous books, articles, and reviews within his specializations. In 1985 he won the National Certificate of Merit of the Goethe Institute and the American Association of Teachers of German for outstanding achievements in furthering and encouraging the study of German language and culture in the United States.

JOAN M. SCHWARTZ is Chief of Photography Acquisition and Research in the Historical Resources Branch of the National Archives of Canada in Ottawa, Ontario.

TRISTAN SCHWILDEN of Brussels, Belgium, is an antiquarian book and photography dealer and collector of early Belgian prints. He is co-author, with Steven F. Joseph, of several articles on photography in Belgium in the 19th century.

GRAHAM SMITH is professor of the history of art and interim director of the Museum of Art at the University of Michigan. He is the co-author, with Annamaria Petrioli Tofani, of *Sixteenth-Century Tuscan Drawings from the Uffizi* (Oxford University Press,1988). Dr. Smith has also published several articles treating the origins of photography in Scotland and is currently completing a study of the Brewster Album in the J. Paul Getty Museum.

BENJAMIN SPEAR began his writing activities with contributions to *The Spectator* (London), mostly on the follies and iniquities of the University system, an interest that has been amply sustained and nourished since his arrival in America a few years ago. Spear's eclectic record includes a book on chipmunks, written jointly with Ann Wilsher, as well as occasional contributions to *History of Photography* (Taylor & Francis) on various aspects of nineteenth-century photohistory. He

loves old photographs, new computers, and almost everything edible with nuts. He believes he has known H. K. Henisch for longer than any other contributor to this volume.

S. F. SPIRA founded Spiratone, the photographic equipment and supply company, and was associated with the company until a few years ago. He is a collector with interest in pre-photographic items (camera obscuras and lucidas, magic lanterns), cameras and related materials, early color photography, the pre-history of the motion picture (persistence-of-vision toys and motion-simulating devices) and early photographic books, magazines, and other printed materials. In addition, he collects photographic toys and kitsch, microphotographic items, autographs and manuscripts of important photographers and inventors, broadside and advertisements by early photographers and manufacturers, albums and viewing devices, and important nineteenth- and twentieth-century photographic images. Fred Spira lives in Whitestone, New York.

SANDRA STELTS is Rare Books Specialist in Rare Books and Special Collections in Pattee Library at the Pennsylvania State University, where she has also done graduate work in art history.

JOHN TAYLOR teaches art history and the history of photography in England, and lives in Stourbridge, West Midlands. He is an art historian, author, exhibition curator, and scholar, whose most recent book, on war photography, will be published in 1990. He has served on the editorial staff of *Ten.8* since its beginnings.

G. THOMAS is a medical doctor still in active practice at the age of 83. He has great interest in photography. By inclination a pictorial landscapist with a strong leaning to classico-romanticism, he is presently engaged in photohistorical research, with special reference to India. He has published two books, *Landscapes* and *History of Photography: India, 1840-1980*. He is the Founder Secretary of the Federation of Indian Photography since 1953, and is a Fellow of the Royal Photographic Society.

RITCHIE THOMAS is university librarian at Wright State University, Dayton, Ohio. Before that he was university librarian at the American University of Beirut, Lebanon.

PEETER TOOMING is an Estonian photohistorian and graduate of the Department of Languages at Tartu State University. He is working as director-cameraman of documentaries at Tallinn Film Studios. Films made by him include *Moments* (1976), about the history of Estonian photography, and *Fotorondo* (1978), a film popularizing photo art and history. He has had over ninety one-person exhibitions of his work in several cities in Estonia and in other republics of the U.S.S.R. and abroad. He has published many newspaper and magazine articles, and several books on the subject, including *Sketches from the Past of Estonian Photography 1840-1940, Rakvere, Photo Stories,* and *Photo! Photo? Photo....*

ANN WILSHER has been an editorial assistant on *History of Photography* since its first issue, in 1977. Her own special interests are in the life and work of James Robertson, the photographic record of the Crimean War, and the writings of Cuthbert Bede.

W. R. YOUNG, III is a photohistorian and commercial photographer in Santa Fe, New Mexico. His degrees are from the University of Arizona, Southern Methodist University, and the University of Texas. He has taught photography and photohistory at the University of Texas.

SHADOW AND SUBSTANCE

Designed and composed by Jay and Janis Ruby
in 10-point Palatino on a Macintosh Plus Computer
using Microsoft Word 4.0 for typesetting
and Pagemaker 3.02 for layout
Printed by Thomson-Shore
on 60-pound Gladfelter Spring Forge white acid free paper
Bound by Thomson-Shore
within a cover designed by Claudia Mauner